CW01044905

THE ELAND's PEOPLE

New Perspectives in the Rock Art of the Maloti-Drakensberg Bushmen
Essays in Memory of Patricia Vinnicombe

THE ELAND'S PEOPLE

New Perspectives in the Rock Art of the Maloti-Drakensberg Bushmen
Essays in Memory of Patricia Vinnicombe

EDITED BY PETER MITCHELL AND BENJAMIN SMITH

WITS UNIVERSITY PRESS

Wits University Press
1 Jan Smuts Avenue
Johannesburg
South Africa
http://witspress.wits.ac.za

Entire publication © Wits University Press 2009
Introduction and chapters © Individual authors 2009

First published 2009
This is the second volume in the Rock Art
Research Institute monograph series

ISBN 978-1-86814-498-3

All rights reserved. No part of this publication may be
reproduced, stored in a retrieval system, or transmitted in any
form or by any means, electronic, mechanical, photocopying,
recording or otherwise, without the express permission, in
writing, of both the copyright holders and the publisher.

Edited by Lee Smith
Cover design by Quba Design and Motion
Layout and design by Quba Design and Motion
Printed and bound by Ultra Litho (Pty) Limited

Contents

Acknowledgements

The blood, sweat and tears of many lie behind the reprinting of *People of the Eland* and the issuing of this companion volume. Natal University Press begun this ambitious publication project, but then handed over the process to Wits University Press in 2008. We record our special thanks to Veronica Klipp, Julie Miller, Julia Wright and the team from Wits University Press for their tireless efforts to see these volumes through to publication. Azizo da Fonseca, David Duns, Natalie Edwards, Lara Mallen, Eugene Ntjie, Alison Wilkins and Ian Cartwright gave generously of their time for the preparation and scanning of the images for this volume. Without the financial support of the Rock Art Research Institute, The National Research Foundation of South Africa, The Research Office of the University of the Witwatersrand, Emily Neilson and Lewis Levin, publication of these volumes would not have been possible. But, most all, we would not have these volumes without the work and the inspiration of Patricia Vinnicombe. She is greatly missed by all.

▼ This image was made on one of Pat Vinnicombe's last trips to the Maloti-Drakensberg. She took her team from the Rock Art Research Institute at Wits, so as to show them some of her favourite sites before they started working on the hundreds of unredrawn tracings left over from the 1960s. This image was traced and redrawn by the person who was to work on the largest section of the ambitious Vinnicombe redrawing project: Justine Olofsson.

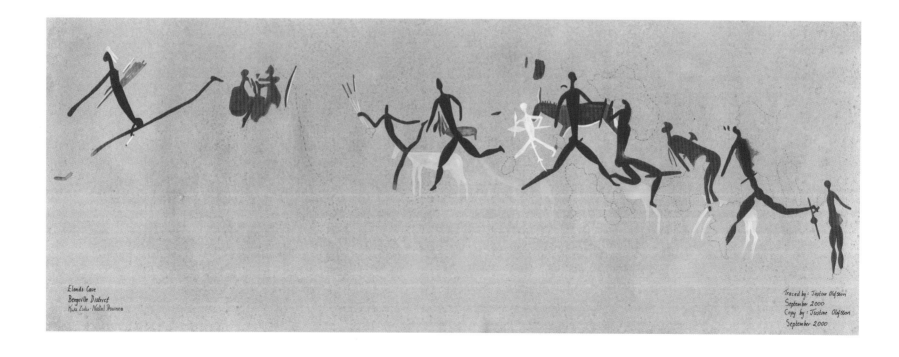

Elands Cave
Bergville District
Kwa Zulu-Natal Province

Traced by: Justine Olofsson
September 2000
Copy by: Justine Olofsson
September 2000

Contributors

Sam Challis
Rock Art Research Institute, GAES, University of the Witwatersrand, Private Bag 3, WITS, 2050, South Africa and School of Archaeology, University of Oxford, 36 Beaumont Street, Oxford, OX1 2PG, United Kingdom
sam@rockart.wits.ac.za

Janette Deacon
47 Van Riebeeck Street, Stellenbosch, 7600, South Africa (formerly, South African Heritage Resources Agency), and Rock Art Research Institute, GAES, University of the Witwatersrand, Private Bag 3, WITS, 2050, South Africa
janette@conjunction.co.za

John Hobart
Pitt Rivers Museum, University of Oxford, South Parks Road, Oxford, OX1 3PP, United Kingdom
john.hobart@prm.ox.ac.uk

Jeremy Hollmann
Department of Archaeology, Natal Museum, Private Bag X9070, Pietermaritzburg, 3200 and School of Anthropology, Gender and Historical Studies, University of KwaZulu-Natal, Private Bag X01, Scottsville, 3209, South Africa
jhollmann@nmsa.org.za

David Lewis-Williams
Rock Art Research Institute, GAES, University of the Witwatersrand, Private Bag 3, WITS, 2050, South Africa
david@rockart.wits.ac.za

Nessa Leibhammer
Johannesburg Art Gallery, Klein Street, Joubert Park, Johannesburg, South Africa and Rock Art Research Institute, GAES, University of the Witwatersrand, Private Bag 3, WITS, 2050, South Africa
nessle@global.co.za

Lara Mallen
Rock Art Research Institute, GAES, University of the Witwatersrand, Private Bag 3, WITS, 2050, South Africa and School of Archaeology, University of Oxford, 36 Beaumont Street, Oxford, OX1 2PG, United Kingdom
lara.mallen@arch.ox.ac.uk

Aron Mazel
International Centre for Cultural and Heritage Studies, Newcastle University, Newcastle-upon-Tyne, NE1 7RU, United Kingdom
a.d.mazel@newcastle.ac.uk

Lynn Meskell
Department of Anthropology, Main Quad, Building 50, 450 Serra Mall, Stanford University, Stanford, CA 94305-2340, United States of America and Rock Art Research Institute, GAES, University of the Witwatersrand, Private Bag 3, WITS, 2050, South Africa
lmeskell@stanford.edu

Peter Mitchell
School of Archaeology, University of Oxford; St Hugh's College, Oxford, OX2 6LE, United Kingdom
peter.mitchell@st-hughs.ox.ac.uk

Shiona Moodley
Department of Rock Art, National Museum, PO Box 266, Bloemfontein, 9300, South Africa
shiona@nasmus.co.za

Catherine Namono
Rock Art Research Institute, GAES, University of the Witwatersrand, Private Bag 3, WITS, 2050, South Africa
catherine@rockart.wits.ac.za

Ndukuyakhe Ndlovu
International Centre for Cultural and Heritage Studies, Newcastle University, Newcastle-upon-Tyne, NE1 7RU, United Kingdom and Rock Art Research Institute, GAES, University of the Witwatersrand, Private Bag 3, WITS, 2050, South Africa.
ndukuyakhe.ndlovu@newcastle.ac.uk

Justine Olofsson
Rock Art Research Institute, GAES, University of the Witwatersrand, Private Bag 3, WITS, 2050, South Africa
justine@rockart.wits.ac.za

David Pearce
Rock Art Research Institute, GAES, University of the Witwatersrand, Private Bag 3, WITS, 2050, South Africa
davidp@rockart.wits.ac.za

Benjamin Smith
Rock Art Research Institute, GAES, University of the Witwatersrand, Private Bag 3, WITS, 2050, South Africa
bws@rockart.wits.ac.za

Val Ward
Department of Archaeology, Natal Museum, Private Bag X9070, Pietermaritzburg, 3200, South Africa

Gavin Whitelaw
Department of Archaeology, Natal Museum, Private Bag X9070, Pietermaritzburg, 3200 and School of Geography, Archaeology and Environmental Studies, University of the Witwatersrand, Private Bag 3, WITS, 2050, South Africa
gwhitelaw@nmsa.org.za

David Whitley
W & S Consultants, Tehachapi, CA 93561, United States of America
huitli53@gmail.com

Acronyms

AMS Accelerator Mass Spectrometry

ARAL Analysis of the Rock Art of Lesotho (Project)

asl above sea level

BP Before the Present (era)

HSRC Human Sciences Research Council (South Africa)

kya thousand years before present (era)

LHWP Lesotho Highlands Water Project

LSA Later Stone Age

MDTP Maloti-Drakensberg Transfrontier Project

MIS Marine Isotope Stage

MSA Middle Stone Age

NHRA National Heritage Resources Act

NMC National Monuments Council

PPC Protection and Preservation Commission (Lesotho)

RARI Rock Art Research Institute

SAHRA South African Heritage Resources Agency

SDF Significantly Differentiated Figure

UCLA University of California, Los Angeles

Wits University of the Witwatersrand

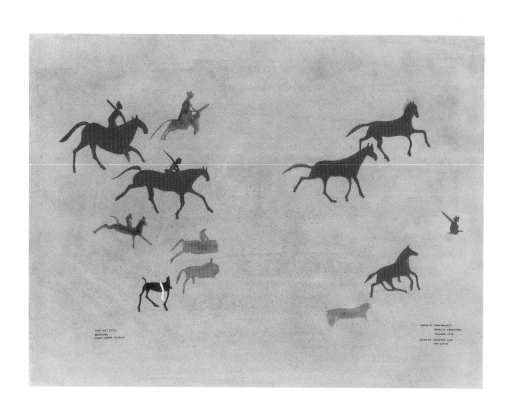

▲ Unpublished colonial contact period panel from the Vinnicombe collection housed at the Rock Art Research Institute, University of the Witwatersrand. Traced by Patricia Vinnicombe and Jean Hewlett, redrawn by Ghilraen Laue.

Publications by Patricia Vinnicombe relating to Africa

Vinnicombe, P. 1955. Early African art. *The Listener* 53(1354): 229.

Vinnicombe, P. 1960a. The recording of rock paintings in the upper reaches of the Umkomaas, Umzimkulu and Umzimvubu rivers. *South African Journal of Science* 56: 11–14.

Vinnicombe, P. 1960b. A fishing scene from the Tsoelike river, south eastern Basutoland. *South African Archaeological Bulletin* 15: 15–19.

Vinnicombe, P. 1960c. General notes on Bushman riders and the Bushmen's use of the assegai. *South African Archaeological Bulletin* 15: 49.

Vinnicombe, P. 1961. A painting of a fish trap on Bamboo Mountain, Underberg district, southern Natal. *South African Archaeological Bulletin* 16: 114–115.

Vinnicombe, P. 1963. Proposed scheme for standard representation of colour in black-and-white illustrations for publication. *South African Archaeological Bulletin* 18: 49–51.

Vinnicombe, P. 1965a. Bushman fishing as depicted in rock paintings. *Scientific South Africa* 2(12): 578–582.

Vinnicombe, P. 1965b. Reproducing rock art. *South African Archaeological Bulletin.* 20: 107.

Vinnicombe, P. 1966a. The early recording and preservation of rock paintings in South Africa. *Studies in Speleology* 1(4): 153–162.

Vinnicombe, P. 1966b. Recording rock paintings. *Man* 1(4): 559–560.

Vinnicombe, P. 1966c. On cultural exchange and the interpretation of southern African rock art. *Current Anthropology* 37: 513–514.

Vinnicombe, P. 1967a. Rock painting analysis. *South African Archaeological Bulletin* 22: 129–141.

Vinnicombe, P. 1967b. The recording of rock paintings – an interim report. *South African Journal of Science* 63: 282–284.

Seddon, J.D. & Vinnicombe, P. 1967. Domestic animals, rock art and dating. *South African Archaeological Bulletin* 22: 112–113.

Vinnicombe, P. 1968. A comparative study. *South African Journal of Science* 64(4): 196–198.

Seddon, J.D. & Vinnicombe, P. 1968. Reply to A.R. Willcox. *South African Archaeological Bulletin* 23: 39.

Vinnicombe, P. 1969 Review of Cooke, C. Rock art of southern Africa. *South African Archaeological Bulletin* 26: 92–93.

Vinnicombe, P. 1971a. Review of Rudner, I. & Rudner, J. 1970. The hunter and his art: a survey of rock art in southern Africa. *South African Archaeological Bulletin* 26: 180–183.

Vinnicombe, P. 1971b. A Bushman hunting kit from the Natal Drakensberg. *Annals of the Natal Museum* 20: 611–625.

Vinnicombe, P. 1972a. Myth, motive and selection in southern African rock art. *Africa* 42: 192–204.

Vinnicombe, P. 1972b. Motivation in African rock art. *Antiquity* 46(182): 124–133.

Vinnicombe, P. 1973. Review of Guillarmod, A.J. 1971. Flora of Lesotho. *South African Archaeological Bulletin* 28: 110.

Vinnicombe, P. 1975. The ritual significance of eland (Taurotragus orjx) in the rock art of southern Africa. In: Anati, E. (ed.) *Actes du Symposium International sur les Religions de la Prehistoire* (1972: Valcamonica): 379–400. Capo di Ponte: Centro Camuno di Studi Preistorici.

Vinnicombe, P. 1976. *People of the Eland: Rock Paintings of the Drakensberg Bushmen as a Reflection of their Life and Thought.* Pietermaritzburg: Natal University Press.

Vinnicombe, P. 1981. Review of Ritchie, C.I.A. 1979. Rock art of Africa. *The International Journal of African Historical Studies* 14: 564–568.

Vinnicombe, P. 1982. Common ground in South Africa and Australia. *South African Archaeological Society Newsletter* 5(1): 1–5.

Vinnicombe, P. 1984. Drawn from life. A review of Willcox, A.R. 1984. The rock art of Africa. *Nature* 311: 284.

Vinnicombe, P. 1985. Art of the Drakensberg hunters. *Natal Convocation News* 7: 20–21.

Vinnicombe, P. 1986. Rock art, territory and land rights. In: Biesele, M., Gordon, R. & Lee, R.B. (eds) *The Past and Future of !Kung Ethnography: Critical Reflections and Symbolic Perspectives. Essays in Honour of Lorna Marshall:* 275–301. Hamburg: Helmut Buske Verlag, Quellen zur Khoisan Forschung: 4.

Vinnicombe, P. 1987. The web of our life is a mingled yarn: reminiscences. *The Digging Stick* 4(2): 2.

Carter, P.L., Mitchell, P.J. & Vinnicombe, P. 1988. *Sehonghong: The Middle and Later Stone Age Industrial Sequence from a Lesotho Rockshelter.* Oxford: British Archaeological Reports, International Series 406.

Vinnicombe, P. 1996. On cultural exchange and the interpretation of rock art in southern Africa. *Current Anthropology* 37: 513–514.

Vinnicombe, P. 2001. Forty-years down the track. *The Digging Stick* 18(2): 1–2.

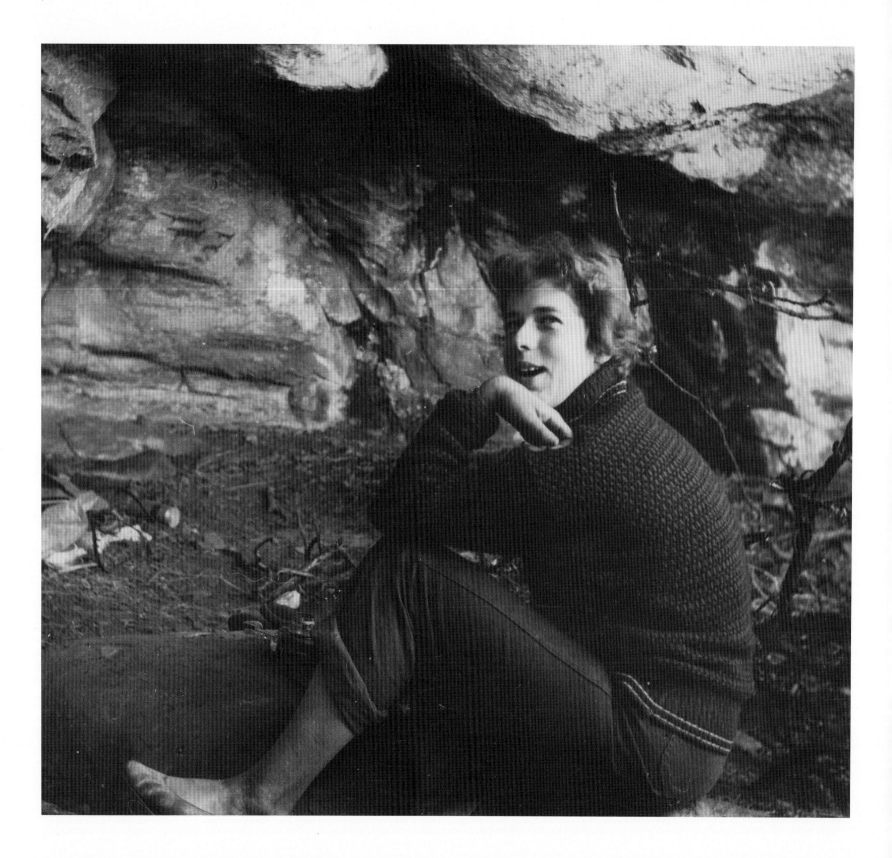

Introducing
The Eland's People

Peter Mitchell and Ben Smith

▼ **Figure 1.1**
People of the Eland (1976), first edition, the
book that inspired this volume.

▼▶ **Figure 1.2**
West Ilsley in the Underberg District, the
farm where Patricia Vinnicombe grew up.
From RARI archive.

▼▶▶ **Figure 1.3**
The mountains and their rock art formed
the backdrop of Pat's farm upbringing.
From RARI archive.

◀ **Figure 1.4a**
A young Pat Vinnicombe in a rock art site
near West Ilsley. From RARI archive.

The rock art produced by the hunter-gatherers of southern Africa's Maloti-Drakensberg Mountains is one of the aesthetically most impressive and historically most important legacies of the Bushmen (San) who lived there for many thousands of years (see notes on names at the end of this chapter). In the last thousand or more years, socio-political engagements between the San and other groups impacted greatly on San identities and on the imagery painted in the rock art. Patricia (or, as she was generally known, Pat) Vinnicombe was among the very first scholars to place the art within its socio-political context and to raise the study of that art from the level of an amateur pursuit, interpreted in the light of naïve borrowings from Western views of art or simple empiricism, to a methodologically and theoretically rigorous one capable of making profound contributions to our knowledge of the southern African past. Hence, we set out the justification for this book and for the simultaneous republication of Pat's epoch-making synthesis of the art, *People of the Eland* (Vinnicombe 1976; Figure 1.1).

Pat Vinnicombe: A biographical sketch

Born in 1932, Pat Vinnicombe grew up on the farm of West Ilsley in the Underberg District of what is now the KwaZulu-Natal Province of South Africa (Figure 1.2, 1.3). Her love for the region sprang from her intimate acquaintance with it from childhood. As a young woman, although trained formally as an occupational therapist, she began to make

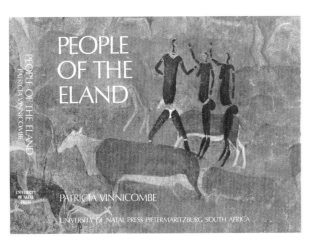

◀ **Figure 1.4b**
A young Pat Vinnicombe in a rock art site near West Ilsley. From RARI archive.

▶ **Figure 1.5**
Pat Vinnicombe tracing a site in Underberg, KwaZulu-Natal, in the mid 1960s. From RARI archive.

▶▼ **Figure 1.6**
Pat used a form of tracing on plastic sheets using brushes and watercolours. From RARI archive.

copies of some of the rock paintings near her parents' farm and others close by (Figure 1.4a, b). She moved for a brief period to the United Kingdom (1954–56) where reaction to an exhibition of her tracings at London's then Imperial Institute (now part of Imperial College) encouraged her, with the support of Barend Malan of the South African Historical Monuments Commission, to develop a detailed recording method suitable for numerical analysis of the images she was copying. By this time, too, she had won for herself sufficient recognition and credibility to start working full-time on the tracing of paintings in the uKhahlamba-Drakensberg Mountains of KwaZulu-Natal (Deacon 2003) and to begin publishing some of her work (Vinnicombe 1960a, 1960b, 1960c, 1961). She married Pat Carter, a British archaeologist, in 1961 and went to live with him in Ghana where he was chief technician in Legon University's newly established Department of Archaeology. While there,

she participated in the Ghanaian expedition to Sudan that excavated the medieval town of Debeira West ahead of the building of the Aswan High Dam. Moving next to Cambridge, she found more time to devote to her passion for rock art.

By 1967 Pat had recorded over 8 000 individual images using highly successful techniques of her own invention (Vinnicombe 1963; Leibhammer, Chapter 4 of this volume; Olofsson, Chapter 2 of this volume; Figures 1.5, 1.6). She had also begun work on their analysis (Vinnicombe 1967a, 1967b), but realised that to move beyond mere numbers and descriptive statistics she had to immerse herself much more fully in the history and ethnography of southern Africa's Bushmen. As she began to do this, she also returned to the field in a major way in a joint project with Pat Carter. Together, they embarked on several seasons of fieldwork on both the South African and the Lesotho sides of the

uKhahlamba-Drakensberg Escarpment, aiming to produce a holistic and synergistic study of the region's rock paintings and its 'dirt' archaeology. David Lewis-Williams describes in the following chapter the detailed evolution of Pat's thinking during these years (1969–74) when she not only engaged in systematic survey work in highland Lesotho, but also traced another extraordinarily large corpus of images, all the while also taking part in the excavation side of the research programme.

Pat's work in southern Africa was interrupted when, in 1971, her husband was appointed the curator of what is now the National Museum of Tanzania in Dar es Salaam. Shortly before leaving England, she submitted a paper to *Africa* (Vinnicombe 1972) that was to become a landmark in tying together San ethnography and San art, and prefigured the success of *People of the Eland*. Three years in Tanzania delayed the writing up of her southern African work but gave her valuable new experiences, allowing her to work on rock art in Tanzania and Ethiopia (Figure 1.7).

As David Lewis-Williams makes clear, and as Pat indicates in her own introduction to the volume (Vinnicombe 1976: xvi), *People of the Eland* was long in the making, and soon after it came out she and Pat Carter separated, leaving unfulfilled her intention to develop a joint publication of their research. *People of the Eland* on its own, however, is a monumental piece of scholarship and one that impacted massively on academic researchers and the public alike (Lewis-Williams 2003: 46). It remains fundamental to any understanding of the nineteenth century history of the Bushmen of the Maloti-Drakensberg region, the rock paintings left there by them and by previous generations of hunter-gatherers, and the application of anthropological theory and observations to making sense of that art. With only 1 000 copies published and almost all of those secured in private or institutional hands, it has become a collector's piece, now almost unobtainable. It is thus a privilege for us to link publication of this tribute to Pat with the republication of her original splendid monograph.

Following the appearance of *People of the Eland* in 1976 and her receipt of a doctorate from Cambridge University in 1977, Pat's life veered away from southern Africa for two decades. A last field season in Lesotho in 1976 (Bousman 1988) had taken her to a hitherto unexplored area, the Senqunyane Valley, but in 1978 she moved with her son Gavin to Australia to embark on a new career. There, she was employed initially by the Australian Institute of Aboriginal

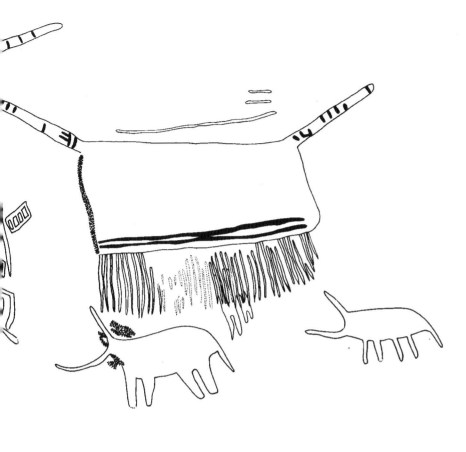

Kassim
Ethiopia
Traced by: Patricia Vinnicombe
April 1974
Redrawn by: Justine Olofsson
November 2000

■ black

▨ dark reddy orange

░ clay (off-white)

□ white

30 cm

Studies and the National Parks and Wildlife Service, completing surveys of Aboriginal sites in New South Wales. Two years later, she moved across the continent to become Research Officer in the Western Australian Museum's Department of Aboriginal Sites (Deacon 2003: 224). Until – and even beyond – her retirement in 1997, she demonstrated enviable sensitivity in handling conflicts between Aboriginal communities, government officials, archaeologists and others in relation to access to rock art sites and other sacred locations. In particular, she insisted – at a time when this was still far from being widely accepted – that Aboriginal people should be centrally involved in consultations about ancestral sites and their management (Mowaljarlai *et al.* 1988).

Aware of the uniqueness and fragility of the many tracings that she had made, after her retirement from the Western Australian Museum Pat sought to have them properly archived (Vinnicombe 2001; Olofsson 2003). To this end, she began work in 2000 (Figure 1.8) with the Rock Art Research Institute (RARI) of the University of the Witwatersrand (Wits), Johannesburg, to which she donated the bulk of her records, including more than 800 polythene tracings; other records, discussed in this volume by Hollmann and Ward (Chapter 2, Box 2), are kept at the Natal Museum, Pietermaritzburg. The process of sorting through this archive and of transferring her tracings to more permanent media was enormously facilitated by the successive visits that she paid to RARI. She was about to make another such trip when she died suddenly on 30 March 2003 while undertaking fieldwork in Western Australia.

Background and structure of *The Eland's People*

Late in 2002, Pat had suggested to Peter Mitchell that he collaborate with her in writing a sequel to *People of the Eland* that would update the conclusions that she had reached in the 1970s and produce, at last, a synthesised treatment of both the rock art and the 'dirt' archaeology of the Maloti-Drakensberg's past. By ironic coincidence, thoughts on how this might be best taken forward were ready to be mailed to her on the very day that news of her death arrived. Subsequently, it seemed to both of us that, without her, the thought of revising or altering *People of the Eland* was not an avenue to be

◀ **Figure 1.7**
A redrawing by Justine Olofsson of one of Vinnicombe's tracings from Ethiopia. From RARI archive.

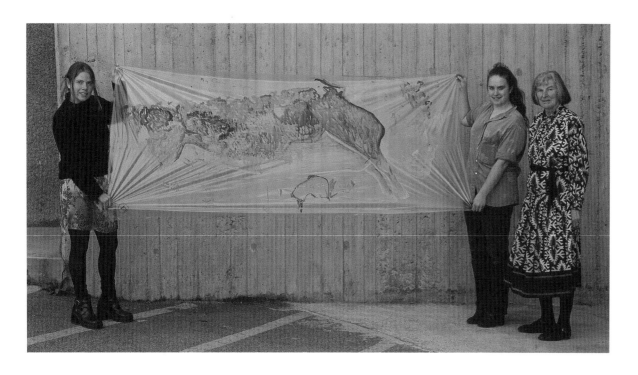

Figure 1.8
Pat Vinnicombe, Justine Olofsson and Ghilraen Laue, the core team who worked at RARI on the cataloguing, housing and rendering of more than 800 unpublished Vinnicombe copies.

pursued. Instead, when discussing how best to pay tribute to Pat, it seemed far more appropriate to leave her own landmark study untouched, but to make it available to a new generation of researchers and to a new South Africa through its republication. However, as Pat herself was aware, much new work, which she herself had encouraged, had been undertaken in her old stamping grounds since the 1970s. We therefore felt that another suitable memorial would be to bring together, in a second volume, some of those involved in that research.

Initial plans were sketched out over breakfast during the 2004 meeting in Kimberley of the then Southern African Association of Archaeologists (now the Association of Professional Archaeologists of Southern Africa). We identified a series of researchers whom, we felt, could contextualise Pat's work, and *People of the Eland* in particular, within the framework of early twenty-first century archaeology. Those whom we approached were only too delighted to contribute and, while it has taken a little longer than we had first hoped, we trust that the final product is one of which Pat herself might have been proud.

We begin with a personal memoir of Pat's life and work by David Lewis-Williams who, working at the same time as Pat, took even further her insights into the necessity of understanding Bushman rock art through reference to Bushman ethnography (Lewis-Williams 1981). In Chapter 2, David discusses how Pat first became interested in rock art and the nature of her relationships with, and influence on, others working in the same field. A particular focus of the chapter is the gestation and ultimate delivery (in more ways than one) of *People of the Eland*, as well as David's own assessment of the enduring legacy of her work.

Lynn Meskell then discusses in Chapter 3 the social and political milieu within which *People of the Eland* was written – the apartheid-dominated context of the southern Africa of the 1960s and 1970s. At the same time, she examines how broader trends in African and world archaeology influenced Pat's writing, showing how *People of the Eland* was simultaneously a product of its time and a work that pushed and challenged existing political and academic boundaries. Such challenges, some of them only now beginning to enter the mainstream of archaeological research, included surprisingly sophisticated treatments of the human body and sexuality, and a deep commitment to the writing of a social archaeology of the past.

In Chapter 4, Nessa Leibhammer takes this concern with context further to analyse in detail one particular aspect of Pat's work, namely her copying technique. Situating Pat

within a line that reaches back to the 1870s and extends forward into the present, Nessa considers how the nature of various recording techniques has impacted on the way rock art is understood, while stressing the specific values that Pat brought to the recording process. As she points out, each of the various recording methods that has been employed affects the nature of what is recorded and represented and thus yields its own unique information.

The interpretative process in which researchers engage as they record and study rock art is carried further in Chapter 5, written by a trio of rock art researchers from a new generation of scholars: David Pearce, Catherine Namono and Lara Mallen. Collectively, they focus on three of the interpretative methods that Pat employed (quantification, ethnography and history), discuss the degree to which her own contribution to them remains valid, and examine the ways in which each has developed since. In so doing, they also provide a real sense of many of the ways in which rock art research has grown since *People of the Eland* and the initial publication, and subsequent widespread acceptance, of the shamanistic paradigm first adumbrated by David Lewis-Williams (1981). They conclude by emphasising that future rock art researchers should increasingly concentrate on asking questions that are specific, for instance why individual sites and images are painted or engraved as they are, as well as others that examine spatial and temporal diversity within the art as a whole.

In Chapter 6, therefore, Aron Mazel reviews the enormous progress made since 1976 in the dating of southern African rock art, a process in which he has been at the forefront. Aron considers Pat's own pioneering work in developing a chronology of San paintings in the Maloti-Drakensberg region and then discusses the more recent work on this topic by Thembi Russell (2000), Joané Swart (2004) and others. As well as showing how our understanding of the art's chronology has improved over the past 30 years, this chapter also emphasises the implications that this better chronology holds for our understanding of the art as a whole.

One of these implications, as Aron Mazel clearly points out, is that a sound chronology is a prerequisite for drawing together the paintings and the archaeological record recovered through excavation. This was very much a concern that Pat shared, and Peter Mitchell's chapter (Chapter 7) examines this issue as part of a broader synthesis of the hunter-gatherer archaeology of the Maloti-Drakensberg region obtained via survey and excavation. Emphasising Pat's own contribution in this regard and that of Pat Carter, he asks how far the

framework of understanding that they established remains valid and how far it has changed since they finished their fieldwork. Looking at a range of topics (continuity in long-term settlement history; landscape use; interaction between regions; the impact of farmer settlement), he underlines the importance of the Maloti-Drakensberg record within southern African archaeology as a whole.

Gavin Whitelaw, too, works with excavated evidence in Chapter 8, which examines the interactions between Bushmen and the Nguni-speaking peoples living to the east of the uKhahlamba-Drakensberg Escarpment. However, his chapter also rightly emphasises the significance of drawing upon historical and ethnographic data, stressing the necessity – all too obvious to Pat in *People of the Eland* – of not seeing the San as isolated from precolonial networks of contact and interaction. Discussing divination and rainmaking, Gavin argues that Nguni classification of the San as 'asocial beings' constrained the roles that they could play in Nguni society. Using archaeological methods that are open to challenge by historians, he offers a path-breaking archaeological history of agropastoralist settlement in the Maloti-Drakensberg region and considers the ways in which San individuals and communities may have been increasingly incorporated into farmer society.

The long-standing connections between San and Bantu-speaking farmers have emerged as an important focus of rock art research in the Maloti-Drakensberg region and beyond in the decades since *People of the Eland* was first published. Pieter Jolly (1994, 1995, 1996, 2006a, 2006b), in particular, has argued that the scenes traced in 1873 in highland Lesotho by Joseph Orpen (1874) and interpreted by his Bushman guide Qing are best explained as depictions of the rituals of Nguni or Sotho speakers. They would thus reflect the assimilation of the latter's beliefs by the region's hunter-gatherers, rather than the shamanistic view of the San cosmos as argued by Lewis-Williams (1981). Much as the archaeological record attests to interaction (Chapters 7 and 8), it is not, however, clear that the parallels that Jolly sees should be explained in this way. Hammond-Tooke (1998, 1999), for example, makes a powerful argument for seeing them as the result of Nguni adoption of San ritual practices consequent upon a level of intermarriage (especially between San women and Nguni men) that is quite obvious genetically (Richards *et al.* 2004).

Chapter 9 presents important new evidence relevant to the wider issues of interaction between Bushmen and

their neighbours in the form of oral history recorded by Pat herself at Sehonghong, Lesotho, in 1971. Her interviews there with two elderly men, Ntate Sello Mokoallo and Ntate Liselo Rankoli, offer a range of comments and observations about the way of life of the last generation of hunter-gatherers to live in highland Lesotho and have never previously been published. They are accompanied by Pat's own notes, as well as additional footnotes compiled by Peter Mitchell.

We end with a sensitively drawn overview and reflection on the contents of *People of the Eland* and on this book, written by David Whitley, an American rock art specialist who also has first-hand experience of research in southern Africa. Drawing on this, he provides an international perspective on Pat's work and more recent work on the hunter-gatherer art and archaeology of the Maloti-Drakensberg region. While underlining the lasting significance of Pat's work, he also indicates some of the directions in which future research in the area that she studied for so long might profitably be directed.

These nine chapters form the bulk of the book, a book that we have chosen to call *The Eland's People* in tribute to our recognition of following in the trail that *People of the Eland* and its author helped blaze. In addition, we have commissioned a series of shorter contributions that illuminate in much finer detail many of Pat's interests. These we have interspersed through the main text as boxed inserts. The first two such articles consider the current state of the Vinnicombe archive at RARI (Box 1 by Justine Olofsson) and at the Natal Museum (Box 2 by Jeremy Hollmann and Val Ward). Drawing on her experience of collaborating closely with Pat in the long-term conservation of Pat's original tracings, Justine Olofsson then provides a second contribution in which she discusses Pat's innovative tracing and colour rendering techniques (Box 4).

Shiona Moodley (Box 3) develops the theme of the socio-political context of rock art addressed by Lynn Meskell (Chapter 3) by looking at the commodification of San rock art and the relationship between it and contemporary expressions of identity, not least in South Africa's national coat of arms (Smith *et al.* 2000). That context is, of course, central to the public presentation of rock art in museums and also *in situ* in the landscape, and several contributions examine this question. Ndukuyakhe Ndlovu (Box 5) uses his experience working with Ezemvelo KwaZulu-Natal Wildlife to discuss the presentation of Bushman rock paintings in the uKhahlamba-Drakensberg World Heritage Site, while Aron Mazel (Box 6), who began his own studies in the region not long after Pat's final field season, examines how visitor centres at Giant's Castle Main Caves, Didima and Kamberg convey information about the people who produced the art.

As Pat herself was aware, attempts at recording – and conserving – the rock art of the Maloti-Drakensberg reach back into the late nineteenth century. John Hobart (Box 7) discusses some of these early efforts, taking advantage of his own experience of researching one of these pioneers, Louis Tylor, whose copies, produced for Oxford University's Pitt Rivers Museum, Pat herself studied in 1965 (Hobart *et al.* 2002). When Tylor was making these copies – and removing fragments of other paintings! – Bushmen were still occupying Sehonghong Shelter. As Pat's informants told her there in 1971, the last generations of Maloti-Drakensberg hunter-gatherers rode – and ate – horses. Pat herself in *People of the Eland*, like John Wright at broadly the same time (Wright 1971), took great interest in the impact that the horse had on their way of life. Short-lived as it may have been, one can argue that its effects were as transformational in the Maloti-Drakensberg as in any other part of the world to which Europeans introduced them. Picking up this theme, Sam Challis (Box 8) uses his own recent doctoral study (Challis 2008) to provide a contemporary view of what that impact may have entailed.

For such reinterpretations to be possible it is vital that the art itself be protected and preserved. Pat's own interest in the Tylor copies was in part motivated by the opportunity that they could provide to monitor changes in the physical condition of particular painted sites between 1893, when Tylor worked at them, and her own day (Hobart *et al.* 2002: 65). Our last two inserts, by Janette Deacon (Box 9) and Peter Mitchell (Box 10), therefore focus on the issue of rock art conservation. Bringing to bear her own enormous experience of working with rock art and of fighting for the conservation of archaeological sites in South Africa, Janette reviews the history of rock art preservation in the country, concluding that legislation is both necessary and can be effective in achieving this goal. Almost as a mirror image, Mitchell's piece, which examines efforts to protect rock art – and the remainder of the archaeological record – in Lesotho, emphasises the urgent necessity of committing sufficient funds to allow any legislation that is enacted to be enforced, while simultaneously stressing the importance of working with local communities. Rock art as a tool for empowering the poor through bottom-up ventures in

community-based site management and tourism is surely an objective of which Pat would have approved.

No one volume can do full justice to the enormity of Pat's contribution to rock art research in general or to the history (in the broadest sense) of the Maloti-Drakensberg Bushmen in particular. We are conscious that some areas remain unexamined here and regret, in particular, that other commitments prevented John Wright, Geoff Blundell, Siyakha Mguni and Frans Prins from contributing to this book. Some of the work on which they would have touched can, however, be found by consulting Geoff's doctoral thesis (Blundell 2004), as well as the superb overview of the archaeology and history of the KwaZulu-Natal part of Pat's research area given by John Wright and Aron Mazel in their recent book *Tracks in a Mountain Range* (Wright & Mazel 2007). We hope, nevertheless, that we have gathered together a sufficient range of chapters to both honour Pat and to provide a sense of the continuing dynamism of the work that she helped set in motion.

A note on names and orthography

Bushmen, San and Khoisan

More so than in many other parts of the world, the appropriate nomenclature for discussing the peoples of southern Africa and their past is bedevilled by history. No one solution can be acceptable to everyone, but hopefully the terms that we and our fellow authors have chosen to use offer least offence and greatest clarity.

The vocabularies of southern Africa's indigenous hunter-gatherers traditionally lacked inclusive names for themselves larger than those of the linguistic unit to which they belonged. This creates a major difficulty for those who wish to talk about them. 'Bushman' first appears in written form in the late seventeenth century (as *Bosjesmans*) and came to be employed by Europeans as a generic term for people subsisting primarily from wild resources. However, it also acquired derogatory, pejorative (and, indeed, sexist) overtones, with the result that it began to be replaced in some academic writings from the 1960s with the supposedly more neutral and indigenous term 'San', a Nama word for their hunter-gatherer neighbours. Unfortunately, since this literally means 'foragers', implying that those concerned are people of lower status too poor to own livestock, it too is not without problems, one of which is that many forager groups actually speak languages identical

or closely related to those of southern Africa's indigenous herders!

Clearly, neither of these terms is ideal and people of hunter-gatherer origin in the Kalahari express different preferences. While Namibia's Ju/'hoansi choose 'Bushmen' over 'San', some Botswanan groups use 'Basarwa', a term invented by the Botswanan government, while 'San' and 'Khoe' also have their indigenous advocates (Lee & Hitchcock 1998; and cf. Moodley, Box 3 in this volume). In this confused situation we have allowed authors to employ either 'San' or 'Bushmen' as they see fit and have ourselves used both terms in this introductory chapter. They and we do so, of course, rejecting any derogatory connotations that either term may have. In spelling the names of individual Bushman groups we follow Barnard (1992), but use Ju/'hoansi, their own name for themselves, for the people commonly referred to in the literature as the !Kung, a more all-embracing, linguistic term (after Biesele 1993).

Khoisan is another term that crops up occasionally in the book. Schultze (1928) coined this as a collective designation for all southern Africa's indigenous herder and hunter-gatherer peoples. Originally intended as a biological label, it was soon also employed to reflect shared features of language and culture (Schapera 1930). An amalgam of the Nama words 'Khoe' and 'San', its literal meaning is 'person-foragers'. Though not an aboriginal term, it retains considerable popularity among scholars as a general cultural and linguistic term for both Bushmen and Khoekhoen peoples, though now sometimes spelt 'Khoesan' or 'Khoesaan'. For reasons of familiarity and consistency with our usage of 'San', here we retain the original spelling.

Maloti-Drakensberg

Just like the hunter-gatherers who once inhabited them, the mountains where Pat Vinnicombe grew up and later undertook so much of her academic work have multiple names. On the South African side of the border the Dutch-derived name 'Drakensberg' has long been employed, and remains the term with greatest international recognition. To the Zulu-speaking people who form the majority of those living in the shadow of its escarpment, however, it is 'uKhahlamba', the 'Barrier of Spears', and this is reflected in the name now used for the National Park and World Heritage Site that protect both the region's natural beauty and its outstanding rock paintings. Some of our colleagues therefore correctly refer to the region as the 'uKhahlamba-

Drakensberg'. For the inhabitants of Lesotho, however, the highlands where Pat also worked are part of the Maloti, the Sesotho word meaning 'mountains'. The conventions of English then require that this takes the form 'Maloti Mountains', unnecessary duplication as this may be. To emphasise that Pat worked on both sides of the current international border and that that border is itself irrelevant to the understanding of the art and its makers (though not to current efforts to preserve the paintings themselves), we opt here to refer to the entire area by the phrase 'Maloti-Drakensberg' or 'Maloti-Drakensberg region'. Further details of its geography are provided in the introduction to Chapter 7.

Orthography

Khoisan languages use a number of click sounds, tones and other vocalisations not found in English. The click sounds are represented as follows, with all but the first found in all Khoisan languages:

O the bilabial click, produced by releasing air between the lips, as in a kiss. Found only in !Xõ, a language spoken in southern Botswana, and in extinct Southern Bushman languages, such as /Xam, once spoken in what is now the Northern Cape Province of South Africa and well known from the wealth of ethnographic material recorded from its speakers by Lucy Lloyd and Wilhelm Bleek in the late nineteenth century (Hollmann 2004; Skotnes 2007);

/ the dental click, produced by a sucking motion with the tip of the tongue on the teeth, as in the English 'tisk, tisk';

≠ the alveolar click, produced by pulling the tongue sharply away from the alveolar ridge immediately behind the teeth, somewhere between / and ! in sound;

// the lateral click, produced by placing the tip of the tongue on the roof of the mouth and releasing air on one side of the mouth between the side of the tongue and the cheek, as in urging on a horse;

! the palatal click, produced by pulling the tip of the tongue sharply away from the front of the hard palate, something like the sound of a cork being removed from a bottle of wine.

Barnard (1992) discusses the orthography of Khoisan languages in greater detail than is possible here, except to note that most non-native speakers find it easiest to avoid pronouncing the click sounds altogether. This can be done either by ignoring them completely, pronouncing the word as if they were not present, or by substituting an approximately equivalent non-click sound: p for O, t for / or ≠ and k for // or !.

One final point: as a result of centuries of contact and intermarriage with Khoisan speakers, some of the Bantu languages spoken in southern Africa also make use of click sounds but here they are represented by conventional English letters – c for /, x for // and q for !. All three clicks occur in IsiXhosa and in IsiZulu and q alone in SeSotho.

REFERENCES

Barnard, A. 1992. *Hunters and Herders of Southern Africa: A Comparative Ethnography of the Khoisan Peoples*. Cambridge: Cambridge University Press.

Biesele, M. 1993. *Women Like Meat: The Folklore and Foraging Ideology of the Kalahari Ju/'hoan*. Johannesburg: Witwatersrand University Press.

Blundell, G. 2004. *Nqabayo's Nomansland: San Rock Art and the Somatic Past*. Uppsala: Uppsala University Press.

Bousman, B. 1988. Prehistoric settlement patterns in the Senqunyane Valley, Lesotho. *South African Archaeological Bulletin* 43: 33–37.

Challis, W. 2008. The impact of the horse on the AmaTola 'Bushmen': New identity in the Maloti-Drakensberg Mountains of southern Africa. Unpublished DPhil thesis. Oxford: University of Oxford.

Deacon, J. 2003. Pat Vinnicombe. *African Archaeological Review* 20: 223–226.

Hammond-Tooke, W.D. 1998. Selective borrowing? The possibility of San shamanistic influence on Southern Bantu divination and healing practices. *South African Archaeological Bulletin* 53: 9–15.

Hammond-Tooke, W.D. 1999. Divinatory animals: further evidence of San/Nguni borrowing? *South African Archaeological Bulletin* 54: 128–132.

Hobart, J.H., Mitchell, P.J. & Coote, J. 2002. A rock art pioneer: Louis E. Tylor and previously undescribed painted rock fragments from KwaZulu-Natal, South Africa. *Southern African Humanities* 14: 65–78.

Hollmann, J.C. (ed.) 2004. *Customs and Beliefs of the /Xam Bushmen*. Johannesburg: Witwatersrand University Press.

Jolly, P. 1994. Strangers to brothers: interaction between south-eastern San and Southern Nguni/Sotho communities. Unpublished MA thesis. Cape Town: University of Cape Town.

Jolly, P. 1995. Melikane and Upper Mangolong revisited: the possible effects on San art of symbiotic contact between south-eastern San and southern Sotho and Nguni communities. *South African Archaeological Bulletin* 50: 68–80.

Jolly, P. 1996. Symbiotic interactions between Black farmers and south-eastern San: implications for southern African rock art studies, ethnographic analogy and hunter-gatherer cultural identity. *Cultural Anthropology* 37: 277–306.

Jolly, P. 2006a. Dancing with two sticks: investigating the origin of a southern African rite. *South African Archaeological Bulletin* 61: 172–180.

Jolly, P. 2006b. The San rock painting from 'the upper cave at Mangolong', Lesotho. *South African Archaeological Bulletin* 61: 68–75.

Lee, R.B. & Hitchcock, R.K. 1998. African hunter-gatherers: history and the politics of ethnicity. In: Connah, G. (ed.) *Transformations in Africa: Essays on Africa's Later Past*: 14–45. Leicester: Leicester University Press.

Lewis-Williams, J.D. 1981. *Believing and Seeing: Symbolic Meanings in Southern San Rock Paintings*. New York: Academic Press.

Lewis-Williams, J.D. 2003. Dr Patricia Vinnicombe. *South African Archaeological Bulletin* 58: 44–47.

Mowaljarlai, D., Vinnicombe, P., Ward, G.K. & Chippindale, C. 1988. Repainting of images on rock in Australia and the maintenance of Aboriginal culture. *Antiquity* 62: 690–696.

Olofsson, J. 2003. The Vinnicombe project: a bird's-eye view. *The Digging Stick* 20(1): 1–4.

Orpen, J.M. 1874. A glimpse into the mythology of the Maluti Bushmen. *Cape Monthly Magazine* 9: 1–13.

Richards, M., Macaulay, V., Carracedo, A. & Salas, A. 2004. The archaeogenetics of the Bantu dispersals. In: Jones, M. (ed.) *Traces of Ancestry: Studies in Honour of Colin Renfrew*: 75–88. Oxford: Oxbow Press.

Russell, T. 2000. The application of the Harris Matrix to San rock art at Main Caves North, KwaZulu-Natal. *South African Archaeological Bulletin* 55: 60–70.

Schapera, I. 1930. *The Khoisan Peoples of South Africa*. London: Routledge Kegan and Paul.

Schultze, L. 1928. Zur Kenntnis des Körpers der Hottentotten und Büschmanner. *Zoologische und Anthropologische Ergebnisse einer Forschungsreise im Westlischen und Zentralen Südafrika* 5(3): 147–227.

Skotnes P. (ed.) 2007. *Claim to the Country: The Archive of Lucy Lloyd and Wilhelm Bleek*. Johannesburg: Jacana Press.

Smith, B.W., Lewis-Williams, J.D., Blundell, G. & Chippindale, C. 2000. Archaeology and symbolism in the new South African coat of arms. *Antiquity* 284: 467–468.

Swart, J. 2004. Rock art sequences in uKhahlamba-Drakensberg Park, South Africa. *Southern African Humanities* 16: 13–35.

Vinnicombe, P. 1960a. The recording of rock paintings in the upper reaches of the Umkomaas, Umzimkulu and Umzimvubu rivers. *South African Journal of Science* 56: 11–14.

Vinnicombe, P. 1960b. A fishing scene from the Tsoelike river, south eastern Basutoland. *South African Archaeological Bulletin* 15: 15–19.

Vinnicombe, P. 1960c. General notes on Bushman riders and the Bushmen's use of the assegai. *South African Archaeological Bulletin* 15: 49.

Vinnicombe, P. 1961. A painting of a fish trap on Bamboo Mountain, Underberg district, southern Natal. *South African Archaeological Bulletin* 16: 114–115.

Vinnicombe, P. 1963. Proposed scheme for standard representation of colour in black-and-white illustrations for publication. *South African Archaeological Bulletin* 18: 49–51.

Vinnicombe, P. 1967a. Rock painting analysis. *South African Archaeological Bulletin* 22: 129–141.

Vinnicombe, P. 1967b. The recording of rock paintings: an interim report. *South African Journal of Science* 63: 282–284.

Vinnicombe, P. 1972. Myth, motive and selection in southern African rock art. *Africa* 42: 192–204.

Vinnicombe, P. 1976. *People of the Eland: Rock Paintings of the Drakensberg Bushmen as a Reflection of their Life and Thought*. Pietermaritzburg: Natal University Press.

Vinnicombe, P. 2001. Forty-odd years down the track. *The Digging Stick* 18(2): 1–2.

Wright, J.B. 1971. *Bushman Raiders of the Drakensberg 1840–1870*. Pietermaritzburg: University of Natal Press.

Wright, J.B. & Mazel, A.D. 2007. *Tracks in a Mountain Range: Exploring the History of the uKhahlamba-Drakensberg*. Johannesburg: Witwatersrand University Press.

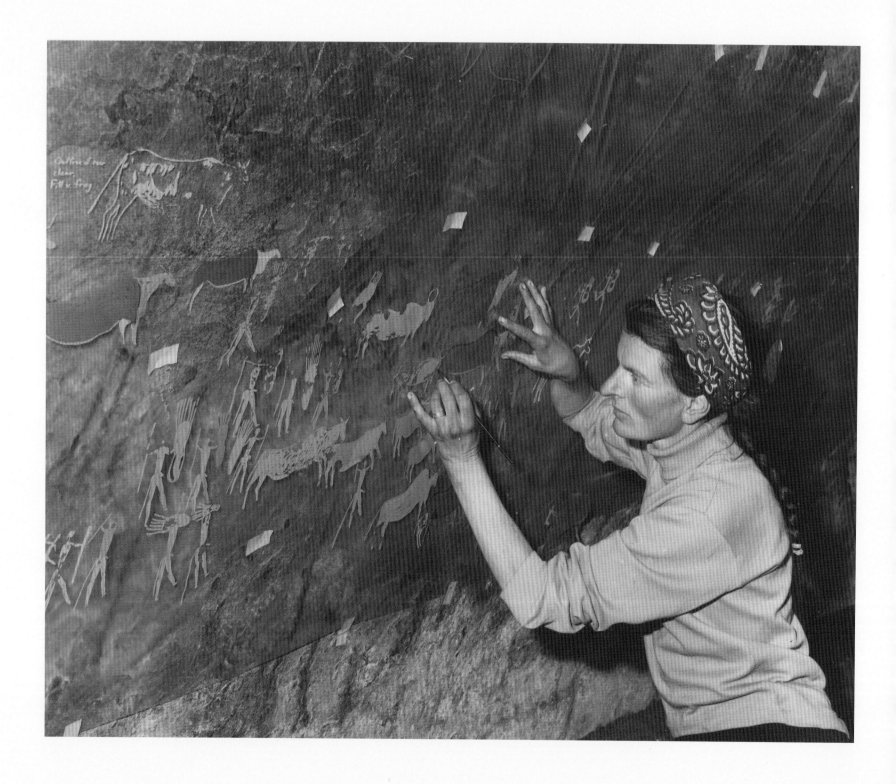

CHAPTER TWO

Patricia Vinnicombe:
A memoir

David Lewis-Williams

Asked to write a personal account of my long-time friendship and interaction with Patricia Vinnicombe, rather than a straightforward biography, I find memories proliferating as I burrow back into the past. An era when rock art research was very different from what it is now seems just yesterday, and I wonder if we have lost some of the excitement – the sheer frisson – of days when new discoveries and new insights led us on into fields that were ripe for harvest but in which the labourers were so few.

My knowledge of Pat's work began in late 1966 when I happened to be in Cape Town immediately prior to leaving to live in the United Kingdom. As usual, I took the opportunity to visit the University of Cape Town to enjoy a lively chat with Ray Inskeep about rock art and other archaeological concerns. He was in charge of, and indeed rejuvenating, the Archaeology Department; in my day as an undergraduate in the early 1950s the department had been the domain of the venerable and much admired John Goodwin. Ray was his usually ebullient self, puffing tobacco fumes around the place, but that day he was especially excited. As editor of the *South African Archaeological Bulletin*, he had just received from the printer the galley proofs of an article by Patricia Vinnicombe, and he enthusiastically gave me photocopies of the article so that I could take them with me to the United Kingdom. The article, entitled 'Rock painting analysis' (Vinnicombe 1967a), was to be published the following year. Ray knew, and easily persuaded me, that we had here the beginnings of an approach that would transform rock art enthusiasm into rock art research.

The article could not have come at a better time. By 1967, I and some others had reached what seemed to be an impasse in our rock art work (Lewis-Williams 2002). In 1960 I had published a copy of an Eastern Cape rock painting; it appeared as a cover illustration of the *South African Archaeological Bulletin*. Then, in 1962, I published, also in the *Bulletin*, an article on rock engravings near Tarkastad in the Eastern Cape Province (Lewis-Williams 1962). Seeing both in print, I was disappointed: they recorded details of rock art images but, like much else published at that time, had nothing to say about what the artists might have thought about their handiwork. My frustration was exacerbated by my early 1950s undergraduate course in social anthropology. There, under the guidance of such luminaries as Monica Wilson and, more briefly, the famous AR Radcliffe-Brown, we students learned that so-called 'primitive' people had elaborate belief systems and rituals. Surely this must also have been true of the San? But no one seemed particularly interested in the possibility, and when, from about 1958 onwards, I began to read the published sections of the Wilhelm Bleek and Lucy Lloyd Collection of 1870s San folklore, I was baffled: the legendary anthropologist Bronislaw Malinowski (1922) may have been able to discern all sorts of symbolism among the Trobriand islanders, but I could not crack the San code. In any event, professional archaeologists seemed uninterested in such matters. They were more concerned with how early people adapted to their environments and how they made a living.

We did not know each other at the time when I saw the proofs, but I learned that, like me, Pat was (at least in the beginning) working only part-time on San rock art. She

◀ **Figure 2.1**

Pat Vinnicombe tracing a complex panel of superimposed paintings. From RARI archive.

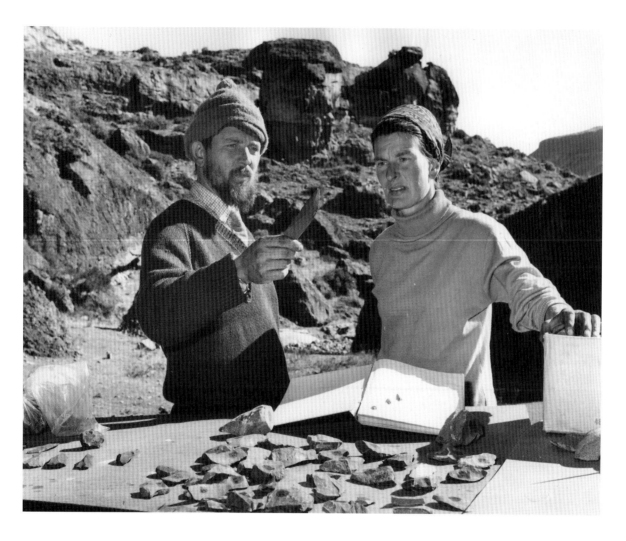

◀ **Figure 2.2**
Pat Vinnicombe and Pat Carter working at Sehonghong in Lesotho in 1971. From RARI archive.

▶ **Figure 2.3**
Pat and Pat together in Sehonghong in 1971. From RARI archive.

had trained at the University of the Witwatersrand (Wits) as an occupational therapist, but her love of the paintings had been triggered by sites on the Underberg family farm, West Ilsley, where she had grown up. It was there that she began to revel in the joys of the Drakensberg and to explore its remote valleys and cliffs.

She started her work by making copies of the images – a massive, energy-consuming task. She developed a technique using flimsy transparent polythene and tempera mixed with a detergent (Teepol became an indispensable component of the rock art researcher's equipment). In the field, she mixed her colours as best she could to match the paint on the rock. The resulting tracings were fragile and had to be treated with care: despite the detergent,

the paint tended to flake off the polythene. Perhaps the most significant aspect of her tracings is that she tried to be comprehensive and non-selective. She therefore traced every image that she came across, whether fragmentary or not (Figure 2.1).

But Ray was enthusiastic about something else that had begun to occupy Pat's attention. He and other archaeologists considered it a more significant component of research than tracings. In 1961 Pat had married the archaeologist Patrick Carter. Early in their marriage, Patrick read for Part II of the Archaeology and Anthropology Tripos at Cambridge. What is known as the New Archaeology was then battling to make the discipline more scientific, and Patrick was up to date. Influenced by Eric Higgs, his Cambridge teacher, he

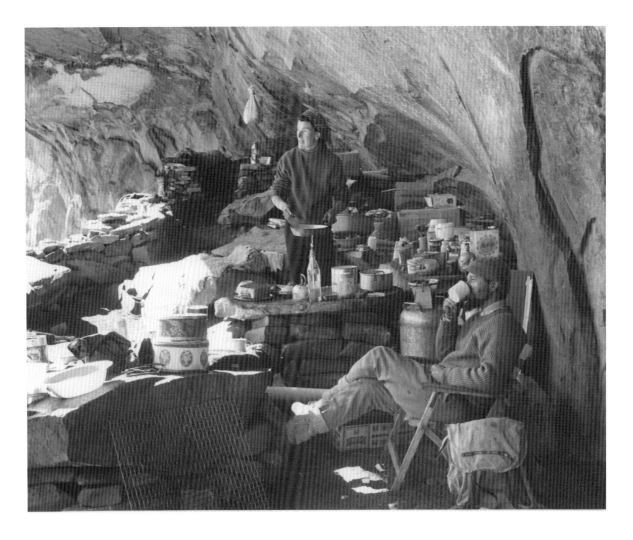

became interested in environmental change and the ways in which people related to the landscape. He later decided to study possible seasonal movements of Stone Age people between sites above and below the Drakensberg and, assisted by Pat, he accordingly excavated sites in southern Lesotho and KwaZulu-Natal (Figure 2.2).

As Patrick readily pointed out, articles on rock art had begun to look rather feeble next to all the tables, graphs, histograms and talk of cultural systems and hypothesis-testing that professional archaeologists deployed. Archaeologists like him were looking to rock art for data that would aid them in projects of the kind they were conducting (Figure 2.3). Mere copies and guesses at the meanings of unusual images were not what Patrick was

after. Professional archaeologists considered apparently commonplace images, such as paintings of antelope, to be simple narratives – what the San saw and hunted in the countryside around them. The obviously non-realistic images, such as antelope-headed beings, they dismissed as 'mythological' and therefore unintelligible. Rock art seemed to offer the professional archaeologist nothing of interest.

It was at this time that Barend Malan, secretary of what was then the Historical Monuments Commission, and Dr Corrie Schoute-Vanneck of the University of Natal guided Pat in working out a numerical recording programme that would be amenable to punchcard analysis (ready access to computers was still a long way off). Here was an approach that seemed to offer the possibility of analysing San rock

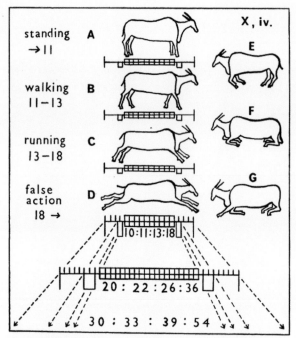

Fig. 4. Template for measuring animal leg positions. Measurements of the body and stride relationships are progressively increased in a constant ratio.

The length of body is represented by the central squared block (10, 20, 30, etc.), and the maximum stride for standing, A, by the space between the body block and the flanking rectangles (11, 22, 33, etc.). The dependent rectangles represent the length of stride for walking, B, (13, 26, 39, etc.), while the maximum stride for running, C, (18, 36, 54, etc.) is represented by the termination of the line. False action, D, is any stride which extends beyond this point.

C and D are examples of the unrealistic 'flying gallop' position.
E = Four-legs-together action.
F = Lying down, four legs gathered under body.
G = Lying down, three legs gathered under body.

Fig. 7.
XVI. *Heads.* 1. Round or oval. 2. Triangular. 3. Concave. 4. Hook. 5. Animal.
XVII. *Hairstyles and headgear.* 1. Knobs. 2. Cap of hair or skin. 3. Brimmed hat. 4. Horns or feathers. 5. Hair, thongs or flaps hanging down. 6. Hair or prongs radiating outwards.
XVIII. *Dress.* 1. Naked. 2. Apron or Gee-string. 3. Cape. 4. Short kaross. 5. Long kaross. 6. European clothing.

art in all its complexity and, moreover, doing it objectively. No wonder Ray was pleased with Pat's article: it gave details of her categories and subcategories and explained exactly how one could set about compiling a quantitative inventory of rock art (Figures 2.4, 2.5). To show that this was not simply pie in the sky, in 1967 Pat published some of her preliminary results in the *South African Journal of Science*.

She was explicit about her desire to make rock art research acceptable to professional archaeology: "If...the study of rock art is to make a meaningful contribution to the field of archaeology where quantitative techniques and statistical methods are becoming increasingly important, an analytical approach is essential" (Vinnicombe 1967a: 141). She therefore suggested that quantitative rock art records "might indicate separate clan areas", "reflect the ecological zones formerly occupied by specific animals or peoples" and help in the reconstruction of "the behaviour of the peoples responsible for the paintings" (Vinnicombe 1967a:

141). In this way, rock art research would enticingly assist mainstream archaeologists, such as her husband Patrick, in their current interests, rather than open up new avenues of understanding, though she later turned (with more success) to interpretative issues that were impossible to derive from excavations.

Pat worked in the southern Drakensberg, the hinterland beyond West Ilsley. She noted 20 categories of features for each of the 8 478 individual images in her sample. For example, when recording human figures, she noted type of dress, head types, carried artefacts, body decorations, size and so forth. Others who followed Pat's lead and took up quantitative work included Harald Pager (1971), who worked in the Didima Gorge, KwaZulu-Natal Drakensberg, Gerhard and Dora Fock (1979, 1984, 1989), who worked in the semi-arid northern parts of South Africa, and Lucas Smits (1971), who worked in Lesotho. I completed two studies, one in the Giant's Castle area and another in the

▲◀ **Figure 2.4**
Pat Vinnicombe designed complex templates for measuring animal and human body postures for the purposes of rock art quantification. From Vinnicombe 1967.

▲ **Figure 2.5**
This table shows how Pat categorised head shapes, hairstyles, headgear and dress for the purposes of quantification. From Vinnicombe 1967.

Barkly East District (Lewis-Williams 1972, 1974). We all believed we were laying empirical foundations for reliable inductions of various kinds; we would avoid the selectivity of earlier rock art researchers and the numerous photographers of our own time, whose work Pat criticised for its lack of rigour but the value of which she nevertheless recognised (Vinnicombe 1972).

I first met Pat and Patrick in about 1971. They gave joint lectures at the Natal Museum in Pietermaritzburg, he on his archaeological work and she on her rock art recording. The occasion was memorable for two reasons. The first was an amusing incident. At the end of the lectures, there was time for questions. A woman in the audience stood and delivered a long, complicated discourse that no one could really follow. Then, as she concluded, she asked a question that was equally hard to understand but that seemed to demand an extensive answer. After a significant pause, the ever-irascible Patrick Carter rose and said distinctly into the microphone, 'No!' He immediately sat down again. There was a baffled silence and then the meeting continued.

But more importantly, I was able to chat briefly with Pat and we arranged to meet a week or so later at the Good Hope rock shelter near Sani Pass, where Patrick was excavating. There we unrolled our respective tables and graphs and studied them, completely absorbed in what were for us new and exciting data.

Patrick rather unexpectedly made tea. Despite his reputation for prickliness, he assisted Pat in every way he could. She later wrote about his role in:

> encouraging, even bullying me, to complete the tedious painting analysis and to commit my views to paper … [H]e sat laboriously pressing buttons of a calculating machine while I sang out interminable sets of figures … [I]t is through his influence that I have been able to see the paintings in the wider perspective which has been essential to a deeper understanding of their significance. (Vinnicombe 1976: xviii–xix)

During the afternoon, Pat's brother John arrived with provisions for the excavators. He (she called him "a true man of nature") did much to assist in the daunting task she had undertaken, often in the remote southern Drakensberg areas that he too loved (Vinnicombe 1976: xviii).

On this occasion, Pat was especially interested in the patterns in superimposition that I was beginning to find in the art (Lewis-Williams 1972, 1974). She frequently referred to my work and its implications in her subsequent book *People of the Eland*. These patterns confirmed a view that we both held: the images were not random doodlings or simple narratives of Stone Age life, but rather parts of an intricate system of symbols. Hopes were high. Quantification seemed to be providing a decisive break with the past, and promising results were coming in from various parts of southern Africa. Everything seemed set for a 'New Archaeology of rock art'.

Were our hopes fulfilled, at least in the way that Pat and I then expected them to be? To answer that question we need to note that there was a less positive side to the quantitative turn that research had taken. It led to a difference of opinion between Pat and me, though it never threatened our friendship and we were always able, on the comparatively rare occasions when we met, to discuss matters amicably; after all, we had far more in common and this one difference did not loom large. For her, disagreements were not a platform for confrontation and denunciation. We wanted to know more about something that was dear to both of us; to use San rock art for contrived academic dispute or personal posturing would, in Pat's view, have sullied the study. Sometimes Pat's generosity of spirit had unfortunate consequences. She was always open about her ideas, though she was more cautious after a couple of distasteful incidents with other rock art researchers who purloined her work and published her ideas before she was able to. Rock art research is no prelapsarian Eden.

The difference of opinion between Pat and me was fairly simple, but it had far-reaching implications. I found the years of intensive quantitative fieldwork to be ones of growing frustration – tempered, it must be said, by an increasing appreciation of the detail and variety of the art that evaluating and measuring each image of the thousands in my samples forced on me. It sounds *passé* today to say that the numbers did not speak to us, that they did not provide explanations. A simple example: quantification confirmed that there was a numerical emphasis on eland in the art of the south-eastern mountains (something that was in fact evident upon inspection and had long been noted), but the tables and graphs did not say *why* this was so. Because they were working in an academic climate of impressive anthropological studies of symbolism, some researchers inferred from the numbers that the eland was an important

animal symbolically. On the other hand, one could equally argue that it was *unimportant* to the San because anyone could and did paint it, whereas the wildebeest, an antelope seldom depicted (as Pat's and other researchers' inventories showed), was so supreme that few people were permitted to paint it. Numbers do not speak unambiguously.

Although Pat remained confident in her desire for what she and others saw as hard, numerical facts, the silence of the numbers forced her to explore another approach to the uncovering of meaning. When she was again in Cambridge with Patrick and was working on *People of the Eland*, she approached Dr Edmund Leach (later provost of King's College), a leading authority on symbolism and advocate of Claude Lévi-Strauss's structuralist ideas. He consented to read Joseph Millerd Orpen's (1874) report of interviews with the Lesotho San man, Qing, and some other material that Pat gave him. After a few days, so she told me, she returned to Leach's study and he sat back and rattled off a startling interpretation of San symbolism that led to her exploration of the ideas expressed by sacrifice (Vinnicombe 1975: 386). Working from ethnography rather than numbers, Leach confirmed that the eland was an important animal symbolically. Also as a result of his contribution, Pat turned to Radcliffe-Brown's book *Structure and Function in Primitive Society*. It had been published in 1952, my first year as an undergraduate and, with Radcliffe-Brown himself as a visiting lecturer, had impacted powerfully on my own thinking. In 1972, I had ended an article on my quantitative work in the Giant's Castle area of the Drakensberg with an emphasis on San beliefs and by intentionally echoing one of Wilhelm Bleek's memorable phrases: "The only possibility of clarifying the themes which most deeply moved the mind of the prehistoric Bushman lies in the, albeit fragmentary, mythology" (Lewis-Williams 1972: 65). This is a view with which Pat agreed. But what were these 'themes'? What, exactly, did the eland symbolise? The folklore, not the numbers, held the answer.

The difference of opinion between Pat and me did not concern the value of San ethnography, but rather the question of whether it is possible to induce meanings from numbers and, indeed, the value of the whole quantitative research enterprise. In darker moments I still think it was all a waste of time, but Pat rightly pointed out to me, and I had to concede, that quantification had at least given us an especially good idea of the paintings and their often minute details, not just of those that caught our eye because of

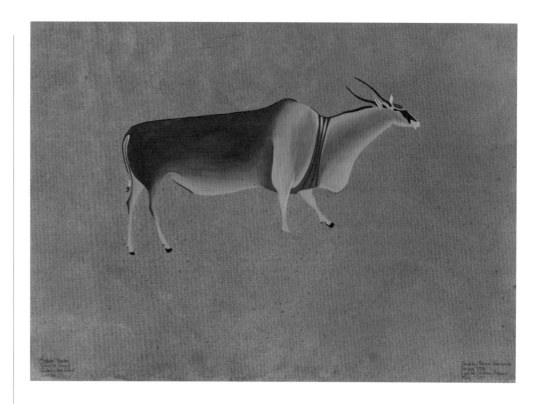

their beauty or intriguing form, but of the vast bulk of the images. *Every* image had to be carefully studied in 'close-up' before whole panels could be assessed. This sustained close attention to painting after painting seems to inculcate in researchers a perspective on the art that differs from the one that those who stand back and view only the general sweep of the images tend to develop. One sometimes senses a lack of such thorough knowledge in the work of some recent researchers who view the art in more general and cursory ways.

Then, of course, there is another problem. San ethnography itself, at least on superficial readings, does not speak any more unambiguously than numerical inventories. This was why my late 1950s encounter with the Bleek and Lloyd Collection was unproductive. The recorded tales, myths and rituals have to be interpreted by researchers. If ethnography is not interpreted, the 'explanation' that it contains remains locked in San terms, exactly the same terms that render the significance of the painted images opaque to Western minds. As it happened, Pat's reading of the ethnography led her in one direction; mine led me along rather different lines.

▲ **Figure 2.6**
Pat concluded *People of the Eland* by stating that the eland served as a link between the material and spiritual worlds. Tracing by Pat Vinnicombe. Redrawing by Justine Olofsson.

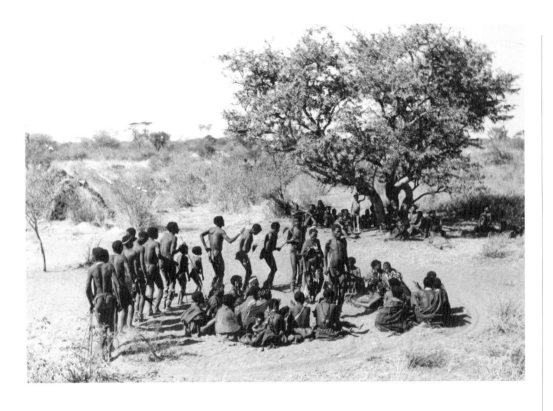

▲ **Figure 2.7**

One of the points of discussion between Pat Vinnicombe and David Lewis-Williams was how much emphasis should be placed on the trance dance when interpreting the rock art. Photograph by Lorna Marshall.

Probably as a result of Leach's influence, she tended to think in wide-ranging Lévi-Straussian concepts. She concluded her article on sacrifice with a summary statement:

> Among the Southern Bushmen, the eland became the symbol through which natural phenomena, human experience, cosmic events and divine activity were inextricably inter-related: the eland was the pivot of a value structure around which the stability of the social organism was dependent. (Vinnicombe 1975: 397)

She ended *People of the Eland* with a comparable but even more deeply felt peroration. It is worth quoting in full:

> The eland epitomised more than the regulated unity of the Bushman band: it served as a link between the material and spiritual worlds. The eland was the medium through which the oppositions of life and death, of destruction and preservation, were resolved. The eland was connected with the practical here and now as

well as with the less tangible concepts of fertility, regeneration, eternity. The eland was the focus of the Bushman's deepest aesthetic feelings and his highest moral and intellectual speculations. The Mountain Bushmen were known to be people 'of the eland', and in sharing the eland's name, they partook of the eland's entity. As the wind was one with man, so man was one with the eland. (Vinnicombe 1976: 353)

Today few researchers would disagree in general terms with these ideas, though some of the details – such as Pat's suggestion that the eland symbolised "the periodic amalgamation of Bushman bands" (Vinnicombe 1976: 352) – are hard to confirm (Figure 2.6). It is when one comes down to more specific issues that Pat and I began to diverge. What does "the focus of the Bushman's deepest aesthetic feelings and his highest moral and intellectual speculations" mean? Would San rock painters have thought in those terms? If not, what *were* they thinking? I felt that we had to identify exactly how and by what means the eland came to assume importance in San beliefs, rituals and art. Vague and broad statements about 'the art' are more likely to be accepted by readers than are precise ones – but words can be a smokescreen.

I wrestled with this problem in *Believing and Seeing* (Lewis-Williams 1981), my PhD thesis that I completed and submitted in 1977 but was not able to publish for four years. In the thesis I drew on San ethnography to argue that, for the San, the principal route to the spirit world was through the great healing (or trance) dance – as the San themselves indeed say (Figure 2.7). Moreover, their three major rites of passage (girls' puberty and boys' first-kill rituals and marriage observances) had much in common with concepts manifested in the healing dance. All three *rites de passage* were key, interrelated repositories of meaning in San thought: the eland, that much painted antelope, featured in each in one way or another, as well as in the healing dance. While I was finishing off my thesis in 1976, I anxiously awaited the publication of *People of the Eland*: having read only one or two of Pat's chapters, I did not know to what extent she would pre-empt *Believing and Seeing*. As it turned out, I had time to insert references to her book, but I was relieved to find that she and I had taken different approaches to the problem of meaning. Later, Pat made it clear that she did not contest my approach; at that

▲ **Figure B1.1**
One of over 40 unpublished Vinnicombe
recordings from the Harerge Province of Ethiopia.
From RARI archive.

Justine Olofsson

Patricia Vinnicombe amassed vast amounts of materials during her research into Bushman rock art, which began in the early 1950s in the Underberg District of South Africa. Some of this was published in *People of the Eland* (Vinnicombe 1976) and the various papers that she wrote, but much remained in boxes and files. On retirement from her post at the Western Australian Department of Aboriginal Affairs, Vinnicombe set aside time to return to South Africa, with much of her rock art material. She wanted to bring closure to the work. In 2000, she initiated what has become known as the Vinnicombe archive at Wits. She decided to donate her collection to the Rock Art Research Institute (RARI) of the University of the Witwatersrand because she wanted it to be accessible to future generations of researchers.

By far the biggest part of what she donated was her polythene tracings. When Vinnicombe arrived at RARI in 2000, she employed two research assistants (Justine Olofsson and Ghilraen Laue) to help her catalogue the tracings and transfer as many as possible onto permanent paper. As well as numerous recordings from the Underberg, Mount Fletcher and Mount Currie Districts of South Africa, there were many from Lesotho and over 40 from the Harerge Province of Ethiopia.

It was realised very quickly once work began in March 2000, that many more tracings existed than Vinnicombe remembered, more than 800 in total, and that to catalogue all of them and transfer selected ones to permanent paper was going to take a number of years. With grants from Irene Staehelin, the Bradshaw Foundation and the Swan Fund, it was possible to employ me part time to work on the collection while Vinnicombe went back to Australia. To date, I have transferred over 300 tracings to permanent paper and completed cataloguing all the tracings. There are five catalogues entered in Excel format, the original tracings being stored in archival hanging files:

1. Survey in southern Drakensberg, South Africa and eastern Lesotho (the principal survey area discussed in *People of the Eland*), 1958-1961
2. Survey of the Senqu River, Lesotho, 1974
3. Survey of the Senqunyane River, Lesotho, 1976
4. General catalogue of places outside the principal survey area
5. Survey of rock art in the Harar and Dire Dawa areas of Ethiopia at the invitation of Professor Desmond Clark, 1974.

In addition to the tracings and colour renderings, the Vinnicombe archive at RARI contains an assortment of historical materials pertaining to Vinnicombe's rock art studies over the years. These include:

- **Files of her correspondence** with many influential and important archaeologists and rock art researchers,[1] other academics, government officers, museum directors, and the public. These letters capture Vinnicombe's depth of interest in, and her commitment to, the area of rock art research and archaeology, as well as her strong humanitarian bent. In themselves, they are valuable additions to the history of rock art research. Among these are letters documenting Vinnicombe's long struggle to get *People of the Eland* published, a correspondence with various publishers that started as early as 1970 and continued until the book was finally published by the University of Natal Press in 1976, after Vinnicombe had raised private funds to include the many colour plates. This correspondence is particularly interesting because it provides insight into the great resistance at the time to a symbolic, as opposed to a literal, interpretation of rock art, of which Vinnicombe was one of the first exponents.

- **Historical records** from the 1800s of Bushman activity in the Maloti-Drakensberg area. These were copied from the Natal provincial archives in Pietermaritzburg, some by hand, others on an old Xerox machine, when Vinnicombe was researching *People of the Eland*. These letters and reports give testimony to the ongoing struggles between the Bushmen, European colonists and Bantu-speaking peoples.

- **Rough transcripts** of chapters of *People of the Eland* and other papers that Vinnicombe wrote. In these drafts, corrections have been made by hand, making it possible to trace how her ideas and thoughts progressed.

- **Numerical analyses** in the form of cards, charts and tables of a number of painted shelters in her survey area. These methods (first outlined in Vinnicombe 1967) influenced rock art research for years to come.

At the time of her death, Vinnicombe was planning another visit to RARI to continue overseeing the transferral of selected tracings to permanent paper. However, her death did not mark the end of work on the collection. RARI continues work on cataloguing the collection and digitising and making accessible the entire archive. Vinnicombe's foresight in developing the arrangements for this in donating her records to RARI for safekeeping will ensure that her collection will remain an invaluable asset to current and future rock art researchers.

NOTE

1. Raymond Dart, Brian Fagan, Harald Pager, David Lewis-Williams, Alex Willcox, among others.

REFERENCES

Vinnicombe, P. 1967. Rock painting analysis. *South African Archaeological Bulletin* 22: 129–141.

Vinnicombe, P. 1976. *People of the Eland: Rock Paintings of the Drakensberg Bushmen as a Reflection of their Life and Thought*. Pietermaritzburg: Natal University Press.

Vinnicombe, P. 2001. Forty-odd years down the track. *The Digging Stick* 18(2): 1–2.

time she merely felt that I tended to emphasise the dance rather too much. This was a disagreement (if it could be called that) with which we could easily live – but more of this anon. Our corner of Eden was peaceful enough.

Prior to the publication of *People of the Eland*, I had a harrowing experience with it. While Pat and Patrick were living in Cambridge (or rather, in the village Toft just outside Cambridge) in the early 1970s, Pat completed her *magnum opus*. In 1972, I stayed for a few days in London on my way back from a conference in Italy. Pat asked me to take the manuscript of her book to the University of Natal Press. She had enjoyed no luck with other publishers, but this university press seemed eminently appropriate for obvious reasons. We arranged to meet for supper before a concert at the Festival Hall. When she arrived at the restaurant, she told me that she had still not completed work on the manuscript, but an hour or so would do the trick. So she remained in the restaurant for the first half of the concert. At interval I found that she had finished her work and had parcelled up the manuscript into a bulky package criss-crossed with adhesive tape. She pointed out that some of the items, such as a photograph she had obtained from the widow of the University of Cambridge Professor Miles Burkitt, were unique; no copies existed, so I was to be especially careful with the parcel. She did not dare to entrust it to the postal services. I swallowed hard but accepted what I saw as a terrifying responsibility: I was not flying directly to Johannesburg, but via Greece and Crete.

Having clutched the parcel for most of the time, trying not to let it out of my sight, I was about to leave Crete for Athens and then fly directly on to South Africa. I had already suffered a couple of nasty experiences, having absent-mindedly left the parcel on museum cases and so forth, but without the ultimate mishap. Before boarding the plane in Herakleion on my way to Athens, I recklessly decided to put the parcel in my luggage. It was a mistake. The luggage was lost and, after appalling events in Athens and altercations with airport authorities who did not seem to appreciate the value of the missing parcel, I had to leave without it. I spent the late-night flight back to South Africa wondering how I would break the news to Pat. I could think of no way.

At this point it is advisable to cut short a protracted and agonising story and to say that, eventually, my case was traced to Canada where a baffled and no doubt equally angry doctor with a name similar to mine fortunately refused to accept it. He was unaware of the treasure it contained. The airline flew the case back to South Africa. After picking it up in Durban, I at once drove directly to Pietermaritzburg and delivered the manuscript into the safe hands of Mobbs Moberly at the University of Natal Press. It was some while before I could bring myself to tell Pat how nearly *People of the Eland* had been lost, but I eventually did. Being the sort of person she was, she was horrified not so much by the narrow squeak that her work had suffered but by my agonies. To compensate me she gave me a copy of the Larousse *Encyclopedia of Mythology*. She inscribed the book: "To thank you, David, very warmly, for all the trouble and anxiety you suffered on my behalf. Let us hope it proves worth the effort." Well, it did prove worth the effort. After Pat had herself raised funds to subvent the many colour plates, the University of Natal Press published the book and it became one of the great milestones of southern African rock art research. Only a thousand numbered copies were printed. It has become a much sought-after piece of Africana.

At about the same time as the *People of the Eland* near-catastrophe, Pat suggested that I spend time at Clare Hall, the Cambridge postgraduate college with which she was associated. I therefore applied to the college and was fortunate enough to be able to spend a sabbatical from 1974 to 1975 in Cambridge. During that time I got to know Pat better, though, as always, we saw each other far less frequently than we would have liked; for most of my time in Cambridge she was in South Africa. What to do with the enigmatic numbers was a frequent topic of our conversation. She allowed me to read her chapter on baboons (already with the University of Natal Press, but she was going over it), and I sensed a logical break between her numerical record of baboon depictions (she eventually said only that baboons constituted a mere 2 per cent of the total number of wild animals depicted) and her recourse to studies of baboon behaviour and San mythology. I took the view that a symbol meant whatever it meant, regardless of how many times the San painted it.

After *People of the Eland* was published, Cambridge University conferred on Pat a PhD degree. A regulation that permitted the conferment of the degree for a published book and residence in Cambridge was invoked to counter her lack of undergraduate training in anthropology or archaeology. Never was a PhD better deserved.

Following her separation and divorce from Patrick,

▶ **Figure 2.8**
One of the unpublished treasures from the recent work of Pat Vinnicombe at the Rock Art Research Institute. The redrawing of an animal headed snake was made by Justine Olofsson.

in 1978 Pat and her son Gavin moved to Australia where, understandably enough, she became interested in that continent's rock art. She held a post at Western Australia's Department of Aboriginal Affairs. Working from that institution, she cooperated with Aboriginal people in the study of their art. Principally, though, she became concerned with Aboriginal rights, land claims and welfare. She devoted herself fully and selflessly to the interests of the people.

On her retirement, Pat consolidated her contact with the Rock Art Research Institute (RARI), which now occupies up-to-date facilities in the impressive Origins Centre at Wits, Johannesburg. Many of the field copies that she had made in the 1950s and 1960s had never been redrawn. She had moved home a number of times, and some of her records had been mislaid. The loss of her punchcards dealing with superimpositions was a particular cause of distress. On the other hand, many boxes of material survived. They were a treasure trove. In addition to a large number of polythene tracings, there were photographs that she and Patrick had taken in the 1960s, correspondence files, copies of historical records that she had made in the Pietermaritzburg archives and that had featured prominently in *People of the Eland*, material and copies relating to rock art in Ethiopia that she had made under the auspices of Professor Desmond Clark, and her numerical analyses of the 8 478 individual images in her southern Drakensberg sample. Pat resolved to donate all this material to RARI so that it would be available to future students.

Cataloguing and curating this collection posed problems. With generous support from Irene Staehelin, an effective supporter of the San who has established a San Centre, !Khwa-ttu, in the Western Cape Province, Pat made trips to South Africa in 2000, 2001 and 2002. With grants from the Bradshaw Foundation and the Swan Fund, RARI was able to employ Justine Olofsson and Ghilraen Laue as assistants who would work on the project, even when Pat had returned to Australia (See Figure 1.8 on page 6).

TABLE B2.1. THE 255 VINNICOMBE REDRAWINGS ACCESSIONED IN THE HUMAN SCIENCES DEPARTMENT, NATAL MUSEUM

NM Access No.	PV site name	PV site No.	NM Access No.	PV site name	PV site No.	NM Access No.	PV site name	PV site number	NM Access No.	PV site name	PV site No.
A31	Lioness Shelter	U11	A207	Mpongweni	G3	A251	Sangwana 1	J18	A376–382	Tsuayi's Shelter	K1
A32	Good Hope 2	F2	A208	Mpongweni	G3	A252	Sangwana 1	J18	A383–386	Langalibalele's Shelter	K2
A33		E11	A209	Scotston	J8	A253	Coralynn (Lammermoor)	L37	A387	WI, CL, Kilmun	L34, L37, J21
A34	Forres 4	R4	A210	Scotston	J8	A254	Coralynn (Lammermoor)	L37	A388	West Ilsley	L36
A35	Good Hope 1	F1	S211	The Rocks A	J9	A255	Bamboo Mountain	H2	A389	Redversdale	M5
A36		W23	S212	Sangwana	J18	A256	Good Hope 1	F1	A390	Bonnievale 2	M8
A37	West Ilsley 2	L32	S213	Kilmun	J21	A257	Mpongweni	G3	A391–392	Bonnievale 1	M7
A38	Mpongweni North	G3	S214	Sangwana	J18	A258	Section Shelter	W6	A393	Bonnievale 2	M8
A39	Good Hope 1	F1	A215	Kilmun	J21	A259			A394	Beersheba 1	M9
A40	Wriggly Snake Shelter	W25	A216	Kilmun	J21	A260	Eagles Nest	P1	A395–396	Eagles Nest	P1
A41	Khomo Patsoa	W21	A217	Kilmun	J21	A261	Coralynn (Lammermoor)	L37	A397–402	Thule 1	P3
A42	Alicedale 5	M15a	A218	Corrielynn	L37	A302–303	The Bushes 1	B1	A403	Thule 1b	P4
A43	Ant-eater Shelter	W32	A219	Corrielynn	L37	A304–305	The Bushes 3	B3	A404–411	Thule 2	P5
A44	Waterfall, Paddock	Z7	A220	Corrielynn	L37	A306–311	Pickett's Shelter	B4	A412–414	Bellevue 2	Q3
A45	Kilmun	J21	A221	Belfast	M2	A312	SW of Pickett's Shelter	–	A415–427	Bellevue 3	Q4
A47	Snowhill	F17	A222	Leqoa River	U8	A313	Throttling Shelter	B9	A428	Bellevue 4	Q5
A48	Kilrush 2	N2	A223	Leqoa River	U8	A314	Cross-legged Shelter	B10	A429	Bellevue 6 & 7	Q7, Q8
A49	Hartebeest heads	V10	A224	Leqoa River	U11	A315		C3	A430		S1
A50	Bundoran	B12	A225	Tsoelike River	V10	A316	Robbers Cave	C5	A431	Veryana	S2a
A51	Bokfontein	R6	A226	Tsoelike River	V10	A317–319	Eagle Krantz	C6	A432	Sheltered Vale 1	S3
A52	Belleview 8, Tsuayi's Shelter	Q14, K1	A227	Tsoelike	W17	A320	Lizard Shelter	C13	A433–436	Pamlaville	T1
A53	White Horse Shelter	L9	A228	XL Farm	L26	A321	Horseshoe Rock	C9	A437		
A54		W33	A229	West Ilsley	L32	A322	Windy Palace	C11	A438		U6
A55		W31	A230	West Ilsley	L32	A323–324	Black Cave	C12	A439		U7, U11
A56	Belmont	O1	A231	West Ilsley	L32	A325	Lizard Shelter	C13	A440–441	Lioness Shelter	U11
A57	Bird Shelter	W28	A232	West Ilsley	L32	A326		C15	A442	Moshebi's Shelter	W1
A58	Berriedale	Q1	A233	Moshebi's Shelter	W1	A327	Liche Ya Batwa	E2	A443		W6
A59	York Farm, Ongeluksnek		A234	Qudu River	X5	A328	Grindstone Shelter	E4	A444		W11
A60	Qacha's Nek		A235	Qudu River	X5	A329	Snowhill	E20	A445		W12
A61		R6	A236	Khubedu River	X3	A330–331	Good Hope 1	F1	A446		W17
A62		D5	A237	Qudu River	X5	A332			A447		W22
A67	Good Hope 1	F1	A238	Sehonghong Shelter	X4	A333	Good Hope 1	F1	A448		W23
A68	Scafel	G1	A239	Sehonghong	X6	A334–A340	Pinnacle Rock	F12	A449		X1
A69	Jackal Shelter	U1b	A240	Sehonghong	?X4	A341			A450	Sehonghong Shelter	X4
A132	Ha Edward, Leqoa	U1b	A241	Sebaaieni's Cave	–	A342	Boundary Rock	G2	A451–452	Seqhole's Shelter	X7
A133	Kilmun	J21	A242	Poachers Shelter	–	A343–361	Mpongweni North	G3	A453–454	Makhenokeng 1	X8
A199	West Ilsley	L32	A243	Poachers Shelter	–	A362–363	Whyte's Shelter (Bamboo Mountain)	H2	A455–459	Makhenokeng 2	X9
A200	Tsoelike River	W23	A244	Qachas Nek	–	A364–365		H3	A460–464	Duma Duma	X11
A201	Horseshoe Rock	C9	A245	Sehonghong Shelter, Rain Dance	X4	A366–368	Mpongweni South	H8	A465	Wilsons' Cutting	Z1
A202	Good Hope 2	F2	A246	Coralynn (Lammermoor)	L37	A369–371	Snake Shelter	I3	A466–467	The Falls	Z2
A203	Good Hope 2	F2	A247	Sangwana 1	J18	A372	Varnished Shelter	J3	A468		E7
A204	Ikanti 1	F18	A248	Good Hope	F1	A373	Scotston	J8	A469	Ikanti 3	F20
A205	Mpongweni	G3	A249	Scafel	G1	A374	Lammermoor 1	J19	A470	Bellevue 1	Q2
A206	Mpongweni	G3	A250	Sangwana 1	J18	A375	Kilmun	J21	A471	Corrielynn (Lammermoor)	L37
									A555	Khoma Patsoa	W21

Notes: Information based on the Natal Museum Archaeological Accessions register and Vinnicombe's (1976) *People of the Eland*.
Whilst all sites were numbered, not all were given site names.
NM = Natal Museum; PV = Patricia Vinnicombe

BOX 2. THE VINNICOMBE COLLECTION AT THE NATAL MUSEUM

Jeremy Hollmann and Val Ward

The Natal Museum has 255 of Vinnicombe's rock art copies in its collection (Table B2.1). Vinnicombe made these copies at an early stage of her rock art research career and they are therefore a unique and valuable record of her original work in the Maloti-Drakensberg region. Many of the early copies, redrawn from Vinnicombe and her colleagues' field tracings, were made thanks to a grant from the South African Human Sciences Research Council (HSRC), the forerunner of today's National Research Foundation. During this period of Vinnicombe's career (1959 to July 1961) the Natal Museum's Director at the time, Dr Pringle, offered Vinnicombe the use of facilities at the Natal Museum. A long tracing box was prepared especially for her use. On 4th March 2003 she recalled that:

> I would collect up tracings made in the field, prepare the backgrounds on suitably sized paper on the farm, and then cart everything off to Maritzburg (i.e. the Natal Museum in Pietermaritzburg) for a concerted and concentrated transfer session … Dr Pringle allowed me a key, and I often worked until late at night.

For a time these copies were kept by the HSRC in a custom-built box that Vinnicombe later fondly referred to as 'the box' (still kept in a Natal Museum storeroom). Vinnicombe later borrowed 'the box' and the tracings it contained from the HSRC to complete a numerical analysis of the images. It was sent to Vinnicombe in the United Kingdom and was then consigned from Cambridge to the Natal Museum in about 1970 (Vinnicombe pers. comm. 4th March 2003), where the copies were kept as a loan from the HSRC. In the early 1990s Natal Museum archaeologist Tim Maggs requested that the HSRC 'donate' Pat Vinnicombe's redrawings, and the colour prints made of these redrawings for the purposes of publication by Robert Gorneman, to the Natal Museum. This was agreed and the material was taken over and accessioned into the Natal Museum's rock art collections.

The Natal Museum's collection of Vinnicombe copies has recently been digitised under the auspices of the South African Rock Art Digital Archive (SARADA) and may be viewed on their website.[1]

NOTE

1 See http://www.sarada.co.za.

PERSONAL COMMUNICATION

Pat Vinnicombe, 4 March 2003

Together, they compiled five catalogues in Excel format (referred to in Box 1). Perhaps the most valuable of these enables researchers to find depictions of a wide range of subject matter – such as eland, rhebuck, human beings, rain animals and buck-headed figures.

But the core of the collection remains the copies. As Pat carefully unfolded over 800 polythene tracings, she was surprised at how many there were – tracings that had not been looked at since the 1960s or 1970s. As the tracings were unfolded, Pat was able to recall the sites where she had made them and, sometimes, amusing stories about the people and adventures involved. I, for one, was amazed at how interesting these tracings were, and I watched fascinated as many of them were gently – reverently – spread out on a table. Under Pat's direction Justine recreated the tracings in full colour on paper (Figure 2.8). RARI now has nearly 250 of these full colour paper renderings and about fifty black-and-white copies of her unpublished recordings; all too many of the original paintings have disappeared since Pat made the tracings. The copies that were published in *People of the Eland* and some others are in the Natal Museum in Pietermaritzburg; they have been electronically scanned. All this extraordinarily rich material is available to researchers at RARI.

This Indian summer of interest in San rock art was for Pat an exciting experience. She was able to look back on her life's principal work after a break of four decades – a privilege given to few. She and I were able to revive old points of discussion and to resolve some of the (mild) points of disagreement we had considered in years gone by. At the beginning of her project at RARI she wrote:

> When most of the tracings were made some 40 years ago, postures such as arms held back, flexed torso and knees, and somersaulting or prostrate figures had not yet been specifically identified with trance. Although I recognized the recurrence of these postures in the painted record, their significance escaped me. One of my principal reactions therefore, when unfolding the images that had been stored in a tin trunk for so long, was the inescapable realisation that many of them (though not necessarily all) undoubtedly relate to the trance experience as initially identified by Lewis-Williams. Aspects of interpretation expressed in *People of the Eland* will definitely need re-thinking. A mass of new and exciting images awaits cogitation, clarification and, it is hoped, eventual publication. (Vinnicombe 2001: 20)

We were moving closer together in our understanding of San rock art. She was rethinking *People of the Eland*; I was rethinking *Believing and Seeing*. She was surprised to see just how many of the images in her tracings were clearly related to contact with the spirit realm through the medium of the trance dance, and I was seeing all over again a significant point that had forced itself upon me as I was finishing off *Believing and Seeing*: it is difficult, despite long and close searching and my earlier conviction that connections must have existed, to tie southern Drakensberg images to other San rituals (such as rites of passage) as unequivocally as one can see that they are associated with the dance and the spiritual potency that is activated in that and other contexts (Lewis-Williams & Pearce 2004). Perhaps the situation is different in other parts of southern

◀ **Figure 2.9**
Patricia Vinnicombe and
David Lewis-Williams at the
ALTA conference on rock art
in northern Norway in 1993.
RARI archive.

Africa. Both Pat and I were finding once more that the close attention to each image that quantification necessitated all those years ago was paying dividends, not because we were able logically to induce meanings from numbers, but because our knowledge of the images thus obtained made the linking of them to specifics of San beliefs and rituals more effective (Figure 2.9).

It is a great pity that Pat was not, as she wished, herself able to revise "[a]spects of interpretation expressed in *People of the Eland*". Her book remains an expression of its time, and those who comment on it should remember this limitation and not judge it by present-day standards of knowledge and theory.

There is, however, a component of her work that has not been affected by the passing of time. I and others hope that the present volume, linked as it is to the reprinting of *People of the Eland*, will mark the beginning of a further project that will realise Pat's wish that her "mass of new and exciting images" will reach a wide public and not languish unseen in archive cabinets. It is estimated that there are between 250 and 300 especially interesting polythene

tracings that urgently require redrawing. Full colour copies of them should be prepared and published as soon as possible.

Pat's work on this project was cut short by her unexpected death in 2003 while at a conference in Australia. No account of her life and contribution to San rock art research would be complete without some comment on her as a person. All who knew her felt privileged. Her youthful decision to train as an occupational therapist speaks of her deep concern for humanity. She was always warm-hearted and generous. In the timbered cottage in Toft, as well as at West Ilsley, she was a welcoming and delightful hostess. Walks through Cambridgeshire fields or the Drakensberg valleys were always happy and stimulating occasions. Her passing left a gap that cannot be filled. She will be remembered for a long time not only by her many friends, but also by students and others as they turn to her publications and to the Vinnicombe archive at RARI. Above all, she will be remembered as the meticulous, scholarly, sensitive and innovative author of *People of the Eland*

Fock, G.J. & Fock, D. 1979. *Felsbilder in Südafrika I, die Graiverungen auf Klipfontein, Kaapprovinz*. Cologne: Böhlau Verlag.

Fock, G.J. & Fock, D. 1984. *Felsbilder in Südafrika II, Kinderdam und Kalahari*. Cologne: Böhlau Verlag.

Fock, G.J. & Fock, D. 1989. *Felsbilder in Südafrika II, die Felsbilder im Vaal-Oranje-Becken*. Cologne: Böhlau Verlag.

Lewis-Williams, J.D. 1962. The Tarkastad rock engravings. *South African Archaeological Bulletin* 17: 24–26.

Lewis-Williams, J.D. 1972. The syntax and function of the Giant's Castle rock paintings. *South African Archaeological Bulletin* 27: 49–65.

Lewis-Williams, J.D. 1974. Superpositioning in a sample of rock paintings from the Barkly East district. *South African Archaeological Bulletin* 29: 93–103.

Lewis-Williams, J.D. 1981. *Believing and Seeing: Symbolic Meanings in Southern San Rock Paintings*. London: Academic Press.

Lewis-Williams, J.D. 2002. *A Cosmos in Stone: Interpreting Religion and Society through Rock Art*. Walnut Creek: AltaMira Press.

Lewis-Williams, J.D. & Pearce, D.G. 2004. *San Spirituality: Roots, Expressions and Social Consequences*. Walnut Creek: AltaMira Press.

Malinowski, B. 1922. *Argonauts of the Western Pacific: An Account of Native Enterprise and Adventure in the Archipelagoes of Melanesian New Guinea*. London: Routledge and Kegan Paul.

Orpen, J.M. 1874. A glimpse into the mythology of the Maluti Bushmen. *Cape Monthly Magazine* 9: 1–13.

Pager, H. 1971. *Ndedema*. Graz: Akademische Druck Verlagsanstalt.

Radcliffe-Brown, A.R. 1952. *Structure and Function in Primitive Society*. London: Routledge.

Smits, L.G.A. 1971. The rock paintings of Lesotho, their content and characteristics. *South African Journal of Science Special Publication* 2: 14–19.

Vinnicombe, P. 1967a. Rock painting analysis. *South African Archaeological Bulletin* 22: 129–141.

Vinnicombe, P. 1967b. The recording of rock paintings: an interim report. *South African Journal of Science* 63: 282–284.

Vinnicombe, P. 1972. Motivation in African rock art. *Antiquity* 46: 124–133.

Vinnicombe, P. 1975. The ritual significance of eland (*Taurotragus oryx*) in the rock art of southern Africa. In: Anati, E. (ed.) *Les Religions de la Préhistoire*: 379–400. Capo di Ponte: Centro Camuno di Studi Preistorici.

Vinnicombe, P. 1976. *People of the Eland: Rock Paintings of the Drakensberg Bushmen as a Reflection of their Life and Thought*. Pietermaritzburg: Natal University Press.

Vinnicombe, P. 2001. Forty-odd years down the track. *The Digging Stick* 18(2): 1–2.

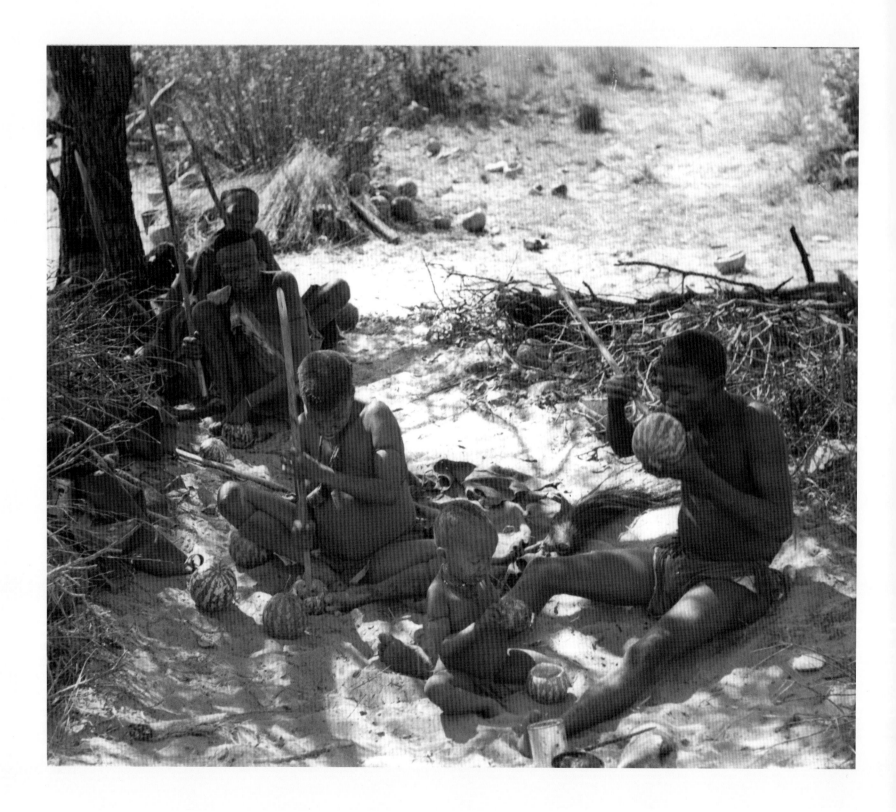

Contextualising
People of the Eland

Lynn Meskell

◀ **Figure 3.1**
Through a contextual approach that emphasised cognition, Pat Vinnicombe avoided many of the problems that mired the use of ethnography in archaeology in the 1960s and 1970s. Photograph by Lorna Marshall.

One could say that *People of the Eland* was, in various ways, a product of its temporal and spatial location. Although written during the dark days of apartheid, it is a work that nonetheless struggled with the identity categories and myths generated by that society and its colonial forebears. As one obvious example, there is a constant tension within the text between the tropes of the romantic 'Bushman' and the more aggressive 'Bantu' invader from the north. As was the prevalent explanation at the time, the author claims this movement into South Africa occurred at least a millennium ago – not surprisingly, the current archaeological evidence now challenges this view, pushing the dates back an additional 1 000 years.

Yet, there is a distinct divergence from many of the other writings of the time, whether steeped in culture historical or positivist traditions. *People of the Eland* is a social history, one might venture even a social archaeology, where multiple strands of evidence are woven together to create a particular slice of life. Here textual sources are used to develop a dialogue with the artistic record, the archaeological findings and the work of social anthropologists. In this sense it is very much a modern work, one that finds resonance with a contemporary generation of archaeologists who seek a more sensuous, lived and complex account of people's experiences in the past. Instead of the flat accounts of prehistoric economies, the economic–rationalist notions of behaviours that are still being produced to this day, or sterile cross-cultural analogies of such communities, the volume attempts actively to people the past, to include historical subjects and moments, through this progressive interplay of evidential sources. To some degree, this is possible because of the very richness of the data at hand, but it is also a tribute to the scholarly willing and intent that accompanies it and Vinnicombe is to be lauded for the creative vision that made such a volume possible.

In many ways *People of the Eland* presages both the kinds of work now being done by a generation of young scholars, such as Geoffrey Blundell (2004) and his writing on the social history of the Drakensberg, as well as a new vision for rock art studies that has emerged in South Africa. Quite simply, Vinnicombe was ahead of her time in the sorts of scholarly engagements she pursued. First, she was a contextualist who drew together complex data sets in rigorously quantitative and qualitative ways. She was no culture historian or processualist, but rather conformed to the kinds of research that we were later to witness with postprocessualism. Second, she was conducting empirically grounded social archaeology, considering issues such as symbolism, cognition, ritual, animality, and human social relations. Third, hers was an early form of embodied archaeology, taking seriously the evidence for culturally specific conceptions of the somatic self and understandings of sexuality. Although I never had the honour of meeting Patricia Vinnicombe, I think I can safely say that she was following no one's lead, and that it was her own scholarly intuition and complex familiarity with the Maloti-Drakensberg material that produced such outstanding and innovative work. In what follows, I hope to highlight her significant contribution by demonstrating the very different and ground-breaking nature of her research.

Timely developments

Archaeology as a discipline in the 1960s and 1970s was undergoing various transitions from cultural–historical approaches that had held sway for decades to the interventions of positivist science that were being made by North American and, to a lesser degree, British archaeologists. At the time at which Vinnicombe wrote, both trends would have been in full swing, and many practitioners are today still locked in various permutations of these disciplinary positions.

In historiographic terms, processual or new archaeologists of the 1960s and 1970s were interested in identifying social factors in the past, but were significantly less focused on the subjective nature of their interpretations and upon the social impacts of their research in contemporary settings. This situation changed markedly with the postprocessual critique that foregrounded social and symbolic factors and underlined the importance of contextual studies of society: these developments were built on the recognition that processual approaches were insufficient, both methodologically and theoretically. Classic works by archaeologists who taught or began their research careers at Cambridge University, such as Ian Hodder (1982, 1984, 1986) and Mike Shanks and Chris Tilley (1987a, 1987b), were influential in this radical revision of archaeology.

Postprocessual archaeology is an explicitly social archaeology. Other ways of framing postprocessualism include interpretive or contextual archaeologies. This work has encompassed major shifts in the subject matter, methodologies and wider responsibilities of archaeology in the past 20 years. An explicit focus on 'the social' in terms of identity, meaning and practice can certainly be seen as a positive transition in archaeology. It is an outcome of the discipline's growing engagement with social theory in fields as diverse as history, social anthropology, linguistics, sociology, human geography, literary theory, and gender studies. While archaeology has always engaged with questions of temporality, under a social archaeology this has entailed a more theorised undertaking, whether in the form of monumentality, memory, diasporas or landscapes. *People of the Eland* stands apart from these divisions and, to a large degree, their epistemic wrangling, yet I would argue it represents both a contextual and a social archaeology. Perhaps it was due to Vinnicombe's own biography

and placement that she managed to skirt many of the shortcomings of her time and produced such an original text. As she says herself, the volume was the product of some eight years of writing conducted in various parts of the world.

Let me say something more to contextualise archaeology throughout the 1960s and 1970s, focusing on Euro–American traditions and, to some extent, looking at a closer parallel to the South African situation, that of Australia. Technological determinism, environmental determinism and the attenuation of social contexts of development and meaning were very much the order of the day. Following the anthropological writings of Leslie White, culture was simply an equation of environment times technology (Trigger 1989). While it is easy for many of us today to read these as inherently negative trends, at the time they were considered scientific and rigorous means to examine law-like propositions about the past and past behaviour. Flattening out a culture's various social specificities was akin to reducing the background noise of cultural difference and targeting the core operations that drove social evolution across the globe. Therefore, while there was a social dimension to this period of scholarship, it is not necessarily the kind of social archaeology that is practised today, nor something that I myself would advocate.

Although the use of ethnographic analogy held sway in the 1960s and 1970s, it was a very different type of anthropological influence than that which we see in Vinnicombe's work. In the most general terms and often quite clumsily, observations from ethnographic fieldwork were retrodicted across time and space to the nether regions of prehistory. These included studies of adaptation to the environment, technological developments, the impacts of ecological stress and so on. It was thought that material traces of such events could be read off, quite literally, from ethnographic examples of hunter-gatherer lifestyles, usually from Africa or Australia as they were considered the most 'primitive' and 'pristine' of such groups. If one could do this, then one could make certain predictions in a variety of locales, whether at Shanidar Cave in Iraq or for Nunamiut sites in Alaska. This type of ethnoarchaeology is problematic on a number of levels. First, it erases culture and therefore variability: similar results may stem from very different social processes. The interesting and important contribution archaeologists can

make is premised on the study of social life and culture over the long term. This was effectively elided. Second, the explanations generated become self-fulfilling and teleological, their pattern or system already determined in law-like fashion. Third, the interpretations offered may be offensive to the peoples who are the subjects of such analyses since they are positioned as static and unchanging from deep prehistory to the present, mere research tools who hold no intrinsic interest for the researcher (Meskell 2005).

In Binford's (1980) famous example of hunter-gatherer settlement systems and site formation processes, he uses a Bushman case study focusing upon the G/wi. Following the original work of another researcher, he infers the distances and proximities travelled while foraging from home bases. These data, gleaned from the Bushmen, are then used in archaeological terms as predictive tools with which to estimate the spatial context of the discard and abandonment of artefactual assemblages at prehistoric archaeological sites. Binford asserts that only two basic patterns of organisation are discernible in the ethnographic record, and that archaeological sites in general should similarly reflect one or other of these patterns. Such a narrow range of social practice was determined for the Bushmen and subsequently this patterning was used predictively to speak for all hunter-gatherer societies (Figure 3.1). As a neo-evolutionist, Binford saw this as an inherently positive step since he argued for a high degree of regularity in human behaviour that comparative ethnographic examples might reveal (Trigger 1989: 300). However, this leads to serious issues of anti-historicism that have epistemic and ethical ramifications. As archaeologists, we are well aware that such analogical reasoning was ubiquitous during the 1960s and 1970s, and yet it has remained in the background of much archaeological theorising since.

In Australia, the climate of research could also be described as generally positivistic, with environment and adaptation as key research themes. Stephanie Moser has eloquently documented how Australian archaeology in the 1960s and 1970s was heavily fieldwork-based, attempting to outline regional differences across the continent and ascertain cultural and temporal sequences. This was hardly the kind of nuanced social archaeology that Vinnicombe practised, either in southern Africa or in her later work in Australia. However, at the time a very different suite of concerns drove Australian research:

The research strategy was one that primarily involved locating occupational sequences of stratified sites and carrying out excavations in order to reconstruct the major changes in Aboriginal subsistence. While initially the research strategy centred on using archaeology to investigate the Aboriginal past, this shifted when the antiquity of this past was recognised, with the focus turning to the significance of this antiquity for the changing nature of human occupation of the continent. In association with this … [archaeology] developed an interest in the ecological and environmental context of sites and in human adaption to changing landscapes. The basic aim was to produce detailed regional studies that explored the relationship between subsistence patterns and the environment. (Moser 1995: 142)

Moser also points to another trend that identified the potentials of an ethnographic approach, though this too was driven by narrow concerns such as the ecology and technology of Stone Age hunter-gatherers, as living peoples were then considered to be. Again, the direction was to identify the cultural generalities that would override the specificities of cultural group, location or temporal positioning. In essence, it was a particular kind of economic prehistory based upon the belief that "human behaviour was thought to have been profoundly influenced by the technology and means of production of a society, and also by the ecological interaction of that society with its environment" (Moser 1995: 146). Moser points out too that, like its South African counterpart, Australian archaeology was characterised by racist assumptions (Hall 1998; Shepherd 2003a, 2003b).

A social approach

People of the Eland is very much a social archaeology. The subtitle of the volume makes it clear that this is a work that gives credence to the life and thought of a people in a particular location. Taken at its broadest, social archaeology refers to the ways in which we conceptualise the relationships between others and ourselves, society and history, in both past and present contexts. Regarding materiality as central, it explores how we express ourselves through the things

BOX 3. THE SOCIO-POLITICS OF ROCK ART

Shiona Moodley

The indigenous hunter-gatherer societies of southern Africa have been considered a 'people of crisis' since the early nineteenth century and the presentation of their history has been the focus of successive academic debates. In archaeological and anthropological studies we can see changing perceptions from writings about a thieving vagrant society, to peaceful primitive Stone Age relics, to an economic underclass and so on. Rock art research, in contrast, has given us an improved understanding of hunter-gatherer spirituality and this has succeeded in creating a paradigm shift in the way southern African hunter-gatherer societies are perceived (Lewis-Williams & Pearce 2004). This has had important social and political implications for the descendants of these ancient hunter-gatherer communities. Has rock art in southern Africa emerged as a major player in understanding these issues and creating a new identity for the post-apartheid South Africa?

A name or an identity?

Rock art research has raised important concerns regarding the colonial portrayal of hunter-gatherers. Nowhere was this more visible than amidst the changing political climate of the 1990s. Rejecting rigid past perceptions, terms such as 'San' and 'Bushmen' were challenged by researchers as it became increasingly clear that they were contributing to popular misconceptions. Both terms are widely deemed to be derogatory and researchers argue whether they refer to a cultural identity or to a socio-economic status (Lee 1976, 1992; Wilmsen & Denbow 1990). At the Khoisan Identities and Cultural Heritage meeting in Cape Town in 1997 (Bank 1997), it was agreed that the general term 'San' should be used to designate those peoples formerly termed 'Bushmen', while specific group names should be employed to refer to specific groups. By so doing, the descendants of these hunter-gatherer groups hoped to be able to impart dignity to the name 'San', thereby dispelling all negative connotations. While debates over San and Khoekhoen identities continue, rock art research has successfully demonstrated the existence of different traditions relating to these identities in rock art (Hall & Smith 2000; Smith & Ouzman 2004).

Global commodification

An unanticipated effect of the successful dissemination of rock art research was a widespread commercialisation of San rock art imagery. In the newly emerging post-apartheid South Africa, it suddenly became 'trendy' to use rock art images on greeting cards, coffee mugs, t-shirts and even bed sheets. This phenomenon, aptly named 'Bushmanophilia', exploited San cultural identity for financial gain (Gordon 1995: 28). Years of research have demonstrated the intricate religious symbolism inherent in the rock art, yet little thought was given to the ethical appropriateness of commercially reproducing these images. In this way, by popularising San rock art, well-meaning research had the unforeseen consequence of causing inappropriate commercial exploitation of the art. However, on a more positive note, this practice influenced San descendants to lay claim to their ancestral cultural resources. The !Xun and Khwe San communities, for example, successfully purchased the farm Wildebeest Kuil, just outside Kimberley in South Africa's Northern Cape Province, as part of a government land reform initiative. And, in 2001, the community opened the Wildebeest Kuil Rock Art Centre (Figure B3.1), thereby ensuring open access to the rock engravings and providing an outlet for !Xun and Khwe San craft products. This initiative, which received technical assistance from the Rock Art Research Institute of the University of the Witwatersrand and the McGregor Museum in Kimberley, stands as an example of how rock art tourism can work to the benefit of local communities.

Rock art as a national identity in South Africa

By the mid-1990s, as well as creating a consumer demand for rock art commercial products, numerous rock art publications had also started to promulgate a fuller popular appreciation for San culture (Jeursen 1995: 120).

This meant that the San were not only acknowledged as South Africa's first people, but also revered in their contribution to the struggle for the nation's freedom.

This understanding is celebrated in South Africa's national coat of arms, which draws on powerful symbols of fertility, peace, wisdom, authority and humanity, all qualities celebrated by the post-apartheid nation (Figure B3.2). Complying with this intention, the national motto was designed to be a beacon of South Africa's democracy. Employing the extinct language of the /Xam San people, its words !ke e: /xarra //ke literally mean 'People who are different join together' (Smith et al. 2000: 468). The popular interpretation 'Unity in diversity' reminds South Africans of their differences and of their acceptance of these in their struggle to create a new national identity.

The central image in the coat of arms is a human figure derived from a San rock painting on the Linton Panel, a piece which was removed from a rock shelter in the Eastern Cape Province in 1918 and that is now on display in the South African Museum in Cape Town. The panel has provided an important source of information, helping researchers to unlock many of the hidden meanings in southern African rock art (Lewis-Williams 1988). In the coat of arms, the human figure is mirrored so as to evoke an attitude of greeting, thus "demonstrating the transformation of the individual into a social being who belongs to a collective and interdependent humanity" (Mbeki 2000). The figure is a constant reference to our distant past and the tragedy of lives lost due to past inhumanity.

In these ways rock art research has influenced public and political perceptions of the San. Rock art research has therefore been well justified in its incorporation of critical social interpretation and in being explicitly political. The positive image of the San projected by rock art research has contributed to national reconciliation and to the acceptance of a new national identity in South Africa that both acknowledges the past and looks towards the future.

▲ **Figure B3.1**
Visitors at the Wildebeest Kuil Rock Art
Centre near Kimberley. From RARI archive.

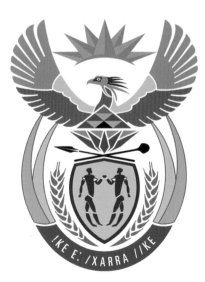

▶ **Figure B3.2**
South Africa's national coat of arms

REFERENCES

Bank, A. (ed.) 1997. *The Proceedings of the Khoisan Identities and Cultural Heritage Conference*. Cape Town: Institute for Historical Research and Infosource.

Gordon, R.J. 1995. Saving the last South African Bushman: a spectacular failure? *Critical Arts* 9(2): 28–48.

Hall, S.L. & Smith, B.W. 2000. Empowering places: rock shelters and ritual control in farmer-forager interactions in the Northern Province. *South African Archaeological Society Goodwin Series* 8: 30–46.

Jeursen, B. 1995. Rock art as a bridge between past and future: a common cultural heritage for the new South Africa. *Critical Arts* 9(2): 119–130.

Lee, R.B. 1976. Introduction. In: Lee, R.B. & DeVore, I. (eds) *Kalahari Hunters-Gatherers: Studies of the !Kung San and their Neighbours*: 3–24. Cambridge: Harvard University Press.

Lee, R.B. 1992. Art, science, or politics? The crisis in hunter-gatherer studies. *American Anthropologist* 94: 31–54.

Lewis-Williams, J.D. 1988. *The World of Man and the World of Spirit: An Interpretation of the Linton Rock Paintings*. Cape Town: South African Museum.

Lewis-Williams, J.D. & Pearce, D.G. 2004. *San Spirituality: Roots, Expressions, and Social Consequences*. Cape Town: Double Storey.

Mbeki, T.M. 2000. Speech delivered at the unveiling of the coat of arms, Kwaggafontein. Pretoria: Office of the President.

Smith, B.W., Lewis-Williams, J.D., Blundell, G. & Chippindale, C. 2000. Archaeology and symbolism in the new South African coat of arms. *Antiquity* 284: 467–468.

Smith, B.W. & Ouzman, S. 2004. Taking stock: identifying Khoekhoen herder rock art in southern Africa. *Current Anthropology* 45: 499–526.

Wilmsen, E.N. & Denbow, J.R. 1990. Paradigmatic history of San-speaking peoples and current attempts at revision. *Current Anthropology* 31: 489–523.

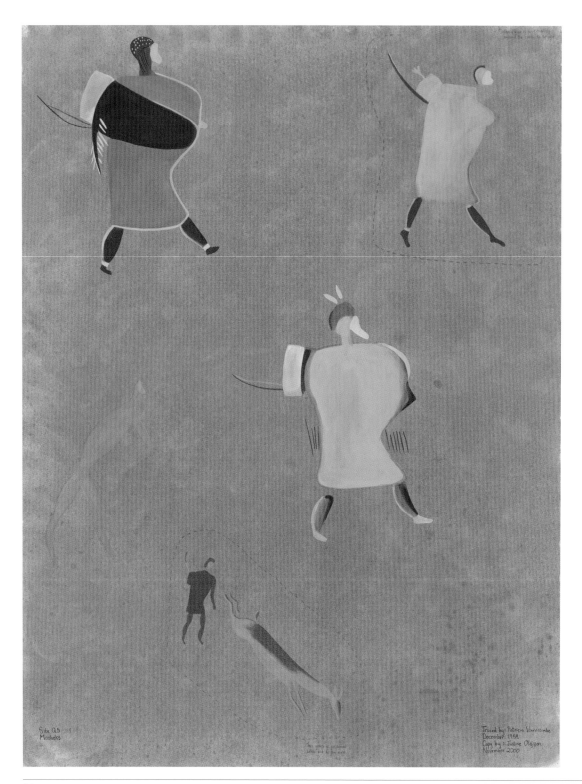

Figure 3.2
Vinnicombe warned against naturalistic
interpretations of kaross-clad figures
such as this. Tracing by Pat Vinnicombe.
Redrawing by Justine Olofsson.

▲ **Figure 3.3**
The Maloti-Drakensberg
mountains, the home of
Vinnicombe's *People of the Eland*.
From RARI archive.

and routines. While it acknowledges the influences of external factors and settings, it does not reduce society to unilinear systems, whether founded upon environment or technology. Rather, it seeks to have a dialogue between these factors and the social and symbolic dimensions of past lifeways. Again, context is key, drawing together as much information as possible from a particular locality and building a rich picture of ancient life in that spatio-temporal setting. We implicitly see this kind of work in Vinnicombe's writing about the Maloti-Drakensberg Bushmen.

While Vinnicombe's work focuses upon the descriptive elements of the rock art panels, she does acknowledge the spiritual dimensions to certain images, such as the red lines dotted with white that were considered the "thinking strings" of the Maloti-Drakensberg Bushmen (Vinnicombe 1976: 147). Later work has verified the importance of these images that link worlds in Bushman thought through employing a direct ethnographic method (Lewis-Williams 1981). In the same vein, Vinnicombe (1976: 250) warned against "too naturalistic an interpretation of the kaross-clad figures, [since] there are indications that not all these paintings are mundane representations, but are likely to have mythological or supernatural associations" (Figure 3.2). Many researchers have suggested more recently that too great an emphasis has been placed on the shamanic or spiritual dimensions of rock art and that a more balanced view would take into account elements of social life and historic events more generally (see Solomon 1997, 1999; Lewis-Williams 1999). Perhaps it is this very balance that we might return to in contemporary scholarship.

Vinnicombe drew upon multiple lines of evidence from history, ethnography, archaeology and representational data. She used archaeological evidence from excavations to ascertain that the rock art of the Maloti-Drakensberg Mountains was not a simple matter of representing animals that comprised the basic diet (Figure 3.3). By extension, researchers had previously envisaged that the depictions of antelope could have formed part of hunting magic rituals. However, as Vinnicombe demonstrates by a close contextual analysis, the proportion of antelope at 77 per cent of the total corpus, and of eland at 35 per cent, vastly outweighs their frequency in the region's archaeozoological assemblages. It is clear that some species in particular captured the Bushman imagination. Here again, Vinnicombe drew heavily upon the mythic narratives of the /Xam Bushmen to flesh out the mythic meanings of specific

that we make and use, collect and discard, value or take for granted, and seek to be remembered by (Hall 2001). It involves an appreciation of the multiple entailments of our very being-in-the-world. A social archaeology conceptualised as an archaeology of social being can be located at the intersections of temporality, spatiality and materiality. To take these concepts as a focus of research is to explore the situated experiences of material life, the constitution of the object world and, concomitantly, their shaping of human experience (Meskell & Preucel 2004). The nature of social archaeology can be said to be twofold: one aspect underscores the importance of social factors in the constitution of ancient lifeways, the other recognises the social responsibilities and ramifications of archaeological practice in the experience of more recent and contemporary communities (Meskell 2002).

Much of the implicit theoretical direction within *People of the Eland* could be described as postprocessual or contextual in spirit. Contextualism is best described as a kind of interpretive archaeology that came to the fore in the 1980s, was more firmly established in the 1990s and continues to be one of the most rigorous archaeologies practised in the discipline today. It examines the internal cohesion of social groups and the specificities of their world views and practices that are embedded in daily life

species. In recent years, archaeology and anthropology have seen a concerted effort to counter the long-term effects of anthropocentrism by foregrounding studies of animality (Ingold 1994; Morris 2000; Philo & Wibert 2000; Meskell & Joyce 2003). There is the recognition that animal worlds may be permeable and overlap with human lifeworlds. In the section entitled 'Animal Subjects', Vinnicombe works through various species categories, also considering domestic fauna, and their place in the symbolic world of the Bushmen (Figure 3.4). Put simply, Vinnicombe presents us with an empirically grounded and quantitative analysis that seeks to quantify the patterning and variation between human, animal and abstract imagery and between species representations.

Vinnicombe identified the pre-eminence of the eland and in doing so set the stage for the discovery of the ritual and trance world of the Bushmen and its centrality in current interpretations of rock art. Coupled with these realisations was her attention to Bushman music and dance and the connective linkages between the experiences of the animal and human worlds.

> Many Bushmen dances are based on episodes in the lives of animals, when the hunter's inborn talent for mimicry and imitation is vividly displayed … mimetic performances in other parts of Africa have been shown to express not only an individual's experience on behalf of the community, but also to reaffirm the solidarity of the social group. There is little doubt, therefore, that the Bushmen attach far greater significance to their animal dances than is apparent to observers for whom mime is no longer an integral part of social expression. (Vinnicombe 1976: 307)

Vinnicombe connected these performances to representations in the rock art and attached concomitant social meanings to human, animal and spirit relations. Some ceremonies brought rain, others celebrated puberty, and yet others were of a frenzied nature and related to curing and protection. Vinnicombe devotes considerable attention to the role of trance in Bushman communities, with detailed descriptions and ethnographic photos that are juxtaposed with rock art imagery. She relates the power of trance to elements of rock art representations such as sweat and bleeding, and talks of bodily transformations

through trance performance. Later in the volume, she draws attention to the cognitive dimension of ritual, perhaps heralding an approach for which she was not always directly credited. The work of Wilhelm Bleek is also invoked to explain the significance of trance and the overlapping spheres of animal, human and supernatural worlds. She states:

> in addition to those members of the band who specialised in the power to cure ills, there were also those who claimed power over animals, and others over the weather. For want of better terms, these may be referred

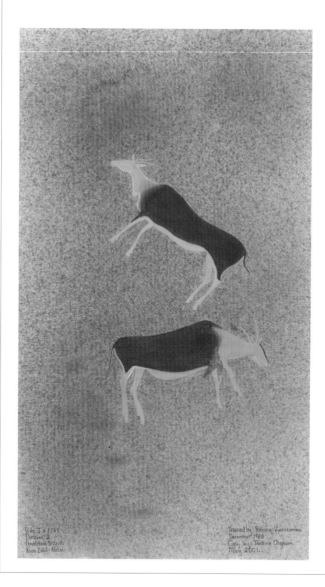

◀ **Figure 3.4**
Vinnicombe showed that it was symbolically significant species, such as eland, rather than food species that dominated the rock art. Tracing by Pat Vinnicombe. Redrawing by Justine Olofsson.

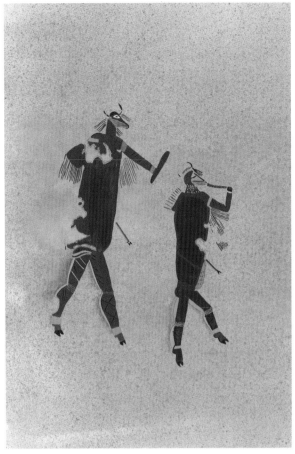
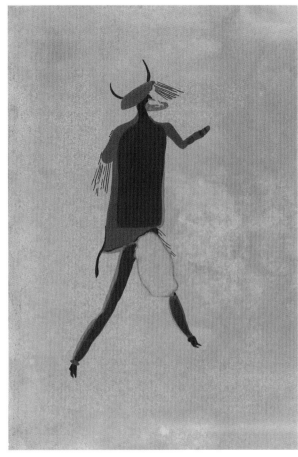

Figures 3.5a & b
Vinnicombe thought that concepts associated with Game and Rain sorcerers were key to the interpretation of therianthropic figures. Tracing by Pat Vinnicombe. Redrawing by Justine Olofsson.

to as Medicine, Game, and Rain sorcerers. The concepts associated with Game and Rain sorcerers have considerable bearing on the interpretation of therianthropic paintings. (Vinnicombe 1976: 330)

Therianthropic figures in the paintings represent sorcerers in either spirit or flesh (Figure 3.5a and 3.5b), and have direct relationships with specific species. Vinnicombe also identified the spirit or essence (*n!ow*) that links birth, life and death of all humans and certain game animals as relevant, something more recently explored by John Parkington (1996). Moreover, she recognised paintings of rain animals using the ethnographic records compiled by Bleek and Lloyd (Hollmann 2004), correctly suggesting that some Bantu-speaking agropastoralists also called upon the Bushmen to perform these rituals. In relation to this, the /Xam sorcerer could summon clouds "unequalled in

beauty", and manufacture lightning, and was said to have "sneezed" while he was at work so that "blood poured out of his nostrils" (Vinnicombe 1976: 339). Ideas such as these have been verified by a number of scholars and continue to be the accepted wisdom in southern African rock art studies (Lewis-Williams & Pearce 2004).

In the book's final chapter, 'Thinking Strings: Conscious and Subconscious Perception', Vinnicombe surveys her collected evidence and quite rightly concludes that the Maloti-Drakensberg rock art does not merely reflect the daily life of the Bushmen. The explicit selectivity of scenes offers a meaningful window onto the Bushman world view and, though she acknowledges that the time of the Bushmen has passed, "there are significant clues in the literature to enable one to correlate at least some aspects of the art with the Bushmen's mode of thinking" (Vinnicombe 1976: 347). Writing against the accepted wisdom of the time, she

bravely challenged the stereotypes promulgated by other rock art researchers such as Willcox (1965), who claimed that magic was unlikely to be a motive for the painting and that while some may have been narrative, most was 'art for art's sake' undertaken purely for the pleasure of the artist. Vinnicombe effectively dismantled such views through a compelling quantitative and historical analysis that was also deeply humanising.

Given that many of Vinnicombe's contemporaries, such as Willcox, were primarily interested amateurs, the sophistication of her research and the revelatory nature of her findings on the centrality of trance experience, mark her out as one of the most influential scholars of prehistoric art. Her insights continue to dazzle today and this volume marks an important recognition of her contribution – one that is far greater than was recognised by her contemporaries. Given the climate of writing, in the racist and sexist South Africa of the 1960s and 1970s, this is perhaps not surprising.

Embodying the evidence

As I argued in the opening of this chapter, *People of the Eland* marked another major departure in its attention to philosophies of the body. In the chapter entitled 'Human Subjects', Vinnicombe takes seriously the centrality of the masculine body, specifically the sexualised male body. Archaeological studies of the body took shape in the mid-1990s and continue to the present, yet were virtually unknown in a climate of positivist research. While ascertaining the social meaning behind the exaggerated male genitalia, Vinnicombe drew on both Bushman myth and cross-cultural studies of Australian Aborigines. She offered various interpretations, from a connection to hunting or sexual prohibition, to initiation and teaching. Although she could not offer conclusive narratives, and no one has subsequently addressed such issues seriously, Vinnicombe (1976: 246) cautioned that viewing these images from a simply humorous or lascivious perspective would be both misleading and unscholarly. Linked to her brief study of sexuality she explored the evidence for gendered clothing, headgear, ornamentation and body paint, drawing upon representations and historical records from colonial times. One evocative image reproduced in the volume features two Bushman hats from Botswana. One is

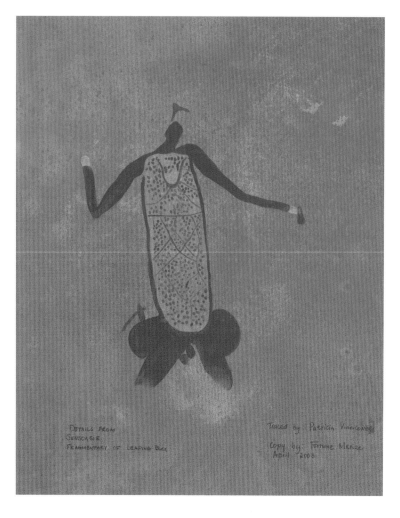

made from matted grass seeds and the other of vegetable fibre covered with spider webs: both were set with ostrich feathers (Vinnicombe 1976: Figure 162). Vinnicombe rightly remarks on the ingeniousness of these creations and exudes a genuine pleasure at the aesthetics and prowess of their makers. In this extended chapter she links bodily practices to ritual and spiritual spheres. For example, she outlines the cosmological significance of particular colours and how colour was mobilised in Bushman ceremonies around puberty, marriage and death. There is also a discussion of tattooing and scarification and the related ritual resonances of associated practices such as boys' puberty rights after the successful shooting of a specific number of antelope. In rock art panels the decoration of the human face is mimetically connected to particular animals, including eland and gemsbok, suggesting

▲ **Figure 3.6**
Vinnicombe's discussion of the sexual body is a topic that has only recently been addressed in mainstream archaeological theorising. Tracing by Pat Vinnicombe. Redrawing by Justine Olofsson.

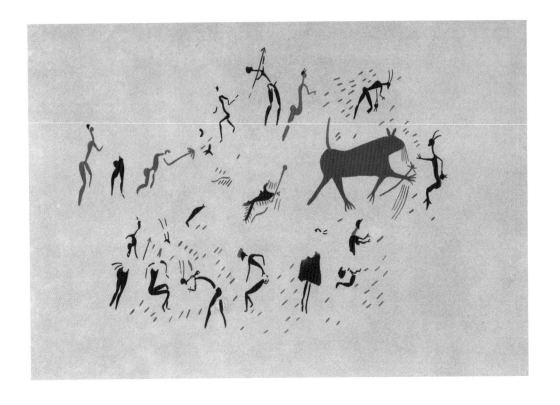

▲ **Figure 3.7**
By using the ethnographic records compiled by Bleek and Lloyd, Vinnicombe recognised images like this to be representations of rain animals. Tracing by Pat Vinnicombe. Redrawing by Justine Olofsson.

a close ritual relationship and metaphorical connectivity. The richness of her material, coupled with her deft use of ethnographic and ethnohistoric materials, results in the kind of social archaeology of the body that we have only recently seen emerge in the discipline. Moreover, in all of these discussions she resists the ethnocentrism and racist assertions that implicitly characterised many of her South African contemporaries.

Vinnicombe's treatment of masculinity is another topic of increasing importance in social archaeology (Meskell 1996, 2001; Knapp & Meskell 1997; Joyce 1998, 2000; Knapp 1998; Meskell & Joyce 2003), yet one that was relatively unknown at the time *People of the Eland* was written. As with all social archaeologies, Vinnicombe draws upon multiple data sets, moving between different registers, using the data contextually. She describes the enigmatic representations of penis 'infibulations', the single or double bars that cross the penis, some of which are decorated with tassels or other ornamentation. She also takes issue with the term 'infibulation', arguing that it suggests an attached ring to the foreskin preventing sexual intercourse: African ethnographic parallels lend little support. Similarly, while

penis sheaths have been documented among Khoe- and Bantu-speaking communities, their use by Bushmen was not noted. Interestingly, she notes a report from the Mpendle District of South Africa's Eastern Cape Province where "Bantu youths wearing a split mealie-stalk clipped on to the prepuce prior to circumcision, and the Bushmen may have had a similar habit concerned with puberty rites" (Vinnicombe 1976: 258). Other oral histories and songs are collected here as she assembles various possible interpretations for this particular bodily representation. Discussion then shifts to sexual mores and prohibitions, drawing upon ethnographic narratives from the region. There are other intimations, however, that diverge from the sexual and refer back to prohibitions on urination during hunting events so as not to weaken the power of the hunt. Importantly, Vinnicombe also allows for the possibility that the world of representations was not necessarily isomorphic with the lived experiences of the Maloti-Drakensberg Bushmen. Her final suggestion is that penis infibulation represents a metaphorical barrier, a prohibition rather than an actual embodied practice (Figure 3.6). To date, the whole issue of masculine imagery, as well as the phallic nature of representation in Bushman rock art, has been a much-avoided topic. Given the developments in gender archaeology over the past decades, not to mention archaeologies of the body and sexuality, this is a particularly odd omission. Here again, we see that Vinnicombe was conducting ground-breaking research from her own intuitive perspective. Instead of being trapped by the narrow, positivist analytic modes of her day, she pursued her own innovative and often provocative research agendas.

Within her discussion of the sexual body is a treatment of bodily fluids, again a topic that has only recently been addressed in mainstream archaeological theorising (Meskell & Joyce 2003). The extra-somatic self has been one of the more interesting avenues leading from the archaeology of the body. Looking at modes of representation for fluids such as perspiration, she uses historic and ethnographic accounts to demonstrate its potency and supernatural powers amongst the Bushmen. Using stories of the /Xam deity /Kaggen, she cites the healing properties of perspiration and how it could act as a conduit that could transmit the properties of one object to another. Within this fluid economy, human sweat held important roles in medicine dances, sorcerer initiation and so on – bodily postures depicted in much of the art appear to correlate

◀ **Figure 3.8**
Vinnicombe with son Gavin, at Sehonghong. Her people oriented approach to archaeology and her strong social commitment created the strongest form of social archaeology. From RARI archive.

with the ritual activities described. Vinnicombe took seriously the sensuous nature of embodied rituals, and considered that bodily and spiritual substances – whether blood, saliva or spirit – were potent forces. As she states, "whilst a great number of the decorative devices shown in the paintings may be taken as literal representations of ornamentation, some of the features are almost certainly symbolic representations of abstract ideas" (Vinnicombe 1976: 260).

Vinnicombe was eager in these descriptions not to follow too literal a path, but rather to explore the metaphysical world of the Bushmen, to give them the spiritual sophistication that was so often only attributed to more 'civilised' peoples at the time of writing. In this manner, she laid the interpretive groundwork for many who followed and for the kinds of epistemic developments for which southern African rock art is famous today (Figure 3.7).

On reading the volume I was struck by the sophisticated nature of her analytical and theoretical work. She derived her interpretations from an empirically grounded familiarity with the material, not from the academic trends of the day,

whether processualism or structuralism. In this manner her work represents the strongest form of social archaeology, one that was attentive to gender, the body, social life, ritual and spirituality and, ultimately, politics (Figure 3.8). Vinnicombe deserves a great deal of recognition for the professionalisation of rock art studies in South Africa and for moving them onto a level of serious scholarship. She paved the way for future developments and provided the inspiration for us all to follow her lead.

ACKNOWLEDGEMENTS

This research was supported by a Mellon New Directions Fellowship and funding from the Institute for Social and Economic Research and Policy at Columbia University. I am grateful to Ben Smith, Geoff Blundell, Thembi Russell and all the staff at the Rock Art Research Institute at the University of the Witwatersrand, South Africa. My work would not have been possible without the support of many people, including Martin Hall, Peter Mitchell, Nick Shepherd and Lindsay Weiss.

REFERENCES

Binford, L.R. 1980. Willow smoke and dogs' tails: hunter-gatherer settlement systems and archaeological site formation. *American Antiquity* 45: 4–20.

Blundell, G. 2004. *Nqabayo's Nomansland*. Uppsala: Uppsala University Press.

Hall, M. 1998. Archaeology under apartheid. *Archaeology* 41: 62–64.

Hall, M. 2001. Social archaeology and the theatres of memory. *Journal of Social Archaeology* 1: 50–61.

Hodder, I. 1982. *Symbols in Action*. Cambridge: Cambridge University Press.

Hodder, I. 1984. Archaeology in 1984. *Antiquity* 58: 25–32.

Hodder, I. 1986. *Reading the Past*. Cambridge: Cambridge University Press.

Hollmann, J.C. (ed.) 2004. *Customs and Beliefs of the /Xam Bushmen*. Johannesburg: Witwatersrand University Press.

Ingold, T. 1994. *What is an Animal?* London: Routledge.

Joyce, R.A. 1998. Performing the body in Prehispanic Central America. *Res: Anthropology and Aesthetics* 33: 147–166.

Joyce, R.A. 2000. A Precolumbian gaze: male sexuality among the ancient Maya. In: Schmidt, R. & Voss, B. (eds) *Archaeologies of Sexuality*: 263–283. London: Routledge.

Knapp, A.B. 1998. Who's come a long way baby? Masculinist approaches to a gendered archaeology. *Archaeological Dialogues* 5: 91–106.

Knapp, A.B. & Meskell, L.M. 1997. Bodies of evidence in prehistoric Cyprus. *Cambridge Archaeological Journal* 7: 183–204.

Lewis-Williams, J.D. 1981. The thin red line: southern San notions and rock paintings of supernatural potency. *South African Archaeological Bulletin* 36: 5–13.

Lewis-Williams, J.D. 1999. 'Meaning' in southern African San rock art: another impasse? *South African Archaeological Bulletin* 54: 141–145.

Lewis-Williams, J.D. & Pearce, D.G. 2004. *San Spirituality: Roots, Expression and Social Consequences*. Walnut Creek: AltaMira Press.

Meskell, L.M. 1996. The somatisation of archaeology: institutions, discourses, corporeality. *Norwegian Archaeological Review* 29: 1–16.

Meskell, L.M. 2001. Archaeologies of identity. In: Hodder, I. (ed.) *Archaeological Theory: Breaking the Boundaries*: 187–213. Cambridge: Polity Press.

Meskell, L.M. 2002. The intersection of identity and politics in archaeology. *Annual Review of Anthropology* 31: 279–301.

Meskell, L.M. 2005. Archaeological ethnography: conversations around Kruger National Park. *Archaeologies* 1: 83–102.

Meskell, L.M. & Joyce, R.A. 2003. *Embodied Lives: Figuring Ancient Maya and Egyptian Experience*. London: Routledge.

Meskell, L. & Preucel, R. (eds) 2004. *A Companion to Social Archaeology*. Oxford: Blackwell.

Morris, B. 2000. *Animals and Ancestors*. London: Berg.

Moser, S. 1995. Archaeology and its disciplinary culture: the professionalisation of Australian prehistoric archaeology. Unpublished PhD thesis. Sydney: University of Sydney.

Parkington, J.E. 1996. What is an eland: n!ao and the politics of age and sex in the paintings of the Western Cape. In: Skotnes, P. (ed.) *Miscast: Negotiating the Presence of the Bushmen*: 281–290. Cape Town: University of Cape Town Press.

Philo, C. & Wibert, C. 2000. Animal spaces, beastly places. In: Philo, C. & Wibert, C. (eds) *Animal Spaces, Beastly Places*: 1–34. London: Routledge.

Shanks, M. & Tilley, C. 1987a. *Social Theory and Archaeology*. Cambridge: Polity Press.

Shanks, M. & Tilley, C. 1987b. *Re-constructing Archaeology*. London: Routledge.

Shepherd, N. 2003a. State of the discipline: science, culture and identity in South African archaeology, 1870–2003. *Journal of Southern African Studies* 29: 823–844.

Shepherd, N. 2003b. 'When the hand that holds the trowel is black …': disciplinary practices of self-representation and the issue of 'native' labour in archaeology. *Journal of Social Archaeology* 3: 334–352.

Solomon, A. 1997. The myth of ritual origins? Ethnography, mythology and interpretation of San rock art. *South African Archaeological Bulletin* 52: 3–13.

Solomon, A. 1999. Meaning, models, and minds: a reply to Lewis-Williams. *South African Archaeological Bulletin* 54: 51–60.

Trigger, B.G. 1989. *A History of Archaeological Thought*. Cambridge: Cambridge University Press.

Vinnicombe, P. 1976. *People of the Eland: Rock Paintings of the Drakensberg Bushmen as a Reflection of their Life and Thought*. Pietermaritzburg: University of Natal Press.

Willcox, A.R. 1965. *The Rock Art of South Africa*. Johannesburg: Wageningen Press.

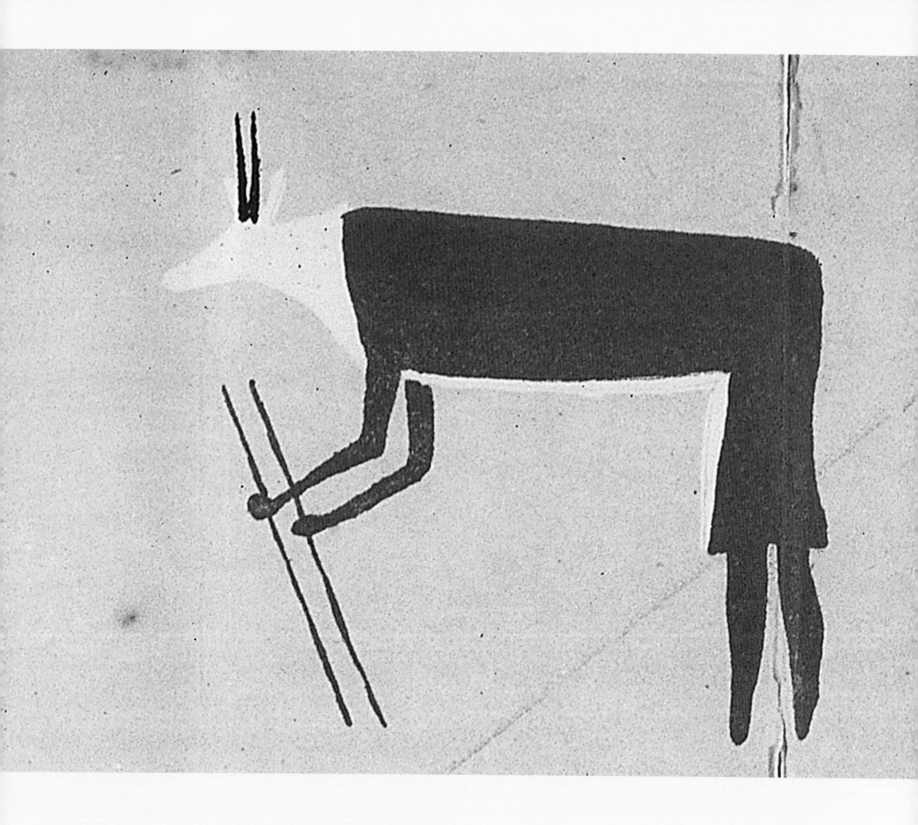

Originals and copies:
A phenomenological difference

Nessa Leibhammer

It has not been sufficiently realised that the images, as they have been studied
and presented to the public in easily accessible books, have had a powerful
yet subtle influence on the formation of popular ideas about the San.
(Lewis-Williams 1996: 12)

Secluded in rock shelters in remote areas where few visit on a regular basis, rock paintings[1] rely on pictographic copies to capture, constitute and explain information about their enigmatic nature. Renderings have been many and various, and while the methods of copying have been extensively documented, the visual and material differences embedded in these graphic recordings have generally not been explored as an important factor in the understanding of this art form. Significantly, these copies are all rendered through graphic conventions determined by Western visual conventions. Original[2] rock paintings made by the San and the copies that have been created by amateurs, scholars and artists working within Eurocentric aesthetic traditions are also products of different phenomenological paradigms. The copies have a life of their own, not necessarily in isolation from what the original stands for, but as transpositions. Copies, created through the conventions of Western representation, play a significant role in how rock art is comprehended and understood.

This chapter explores how copies made in South Africa by Joseph Millerd Orpen (1828–1923), Reinhardt Maack (dates unknown: circa late nineteenth to early twentieth century), the Abbé Breuil (1877–1961), Walter Battiss (1906–82), Harald Pager (1923–85), Patricia Vinnicombe (1932–2003), and the Rock Art Research Institute (RARI) of the University of the Witwatersrand (Wits), Johannesburg, vary in the manner in which their visual information has been filtered through these conventions and paradigms.

Part I: Introducing images

The nature of images

Most people read, write and have a familiarity with how language is constructed and used. In contrast, few create images on a regular basis or have a theoretical means for exploring them. In comparison with linguistic analysis, images remain under-theorised and artistic creativity remains shrouded in mystique. The relationship between a pictographic copy and its original is often understood as profound, transparent or in some way without artifice – in other words, 'unmediated'. If this were so, then the copy would not be open to a reflexive reading in the manner that language has been. However, all images are rendered through pictorial conventions that are in actuality signs, systems and codes with different modalities. Each convention is a perspective, more or less effective that, while yielding information perhaps unique to it, both excludes and includes other information. Pictographic images, like written and spoken language, can therefore be discussed and the conventions used to render them opened to comment, review and critique.

Copies are never exact replicas of the original. They will always capture data selectively and these selections are meaningful, as are the methods and materials chosen for rendering. They both add and subtract visual information in translation from the original. Pictographic copies are inclined to reduce the aspects of the original that the copier[3] considers unimportant and to accentuate, or draw out, those that are considered significant. Copiers have also been known to elaborate images in ways that are not necessarily appropriate to the original.

◀ **Detail from Figure 4.1**

A system of signs

Semiology is the general science of signs that provides one possible vehicle with which to think about and discuss pictographic images. This science concerns itself with whatever conveys meaning in the world (Colapietro 1993). It is based largely on the work of Charles Saunders Peirce (1839–1914) and Ferdinand de Saussure (1857–1913), who together are considered the founders of contemporary semiology (Colapietro 1993: 173–174). However, whereas Saussure established a system for language, Peirce sought to establish a general theory of signs, which applied to all manner of things in the world as well as language.

The difference in the approach of these two systems lies in the fact that, in modern European languages, words never resemble what they describe. For example, a scripto-visual image D-O-G does not look like its corresponding concept, a furry, four-legged creature that barks. Pictographic images, on the other hand, may resemble what they represent, enabling one to recognise, for example, the houses in Gerard Sekoto's painting of Sophiatown.[4] Because he dealt with the properties of language, Saussure proposed an arbitrary relationship between a signifier (the word D-O-G) and a signified (the dog). In contrast, Peirce proposed both arbitrary and non-arbitrary connections between signifieds (referents) and signifiers (representations). He also held that those representations that are mimetic, such as the Sekoto painting, have a motivated and non-arbitrary relationship with what they describe.

Extending the theory of visual semiotics, Peirce established that there are three types of image: the iconic, the indexical and the symbolic. An iconic image bears a formal resemblance to the original object, such as the houses by Sekoto and the portrait of the Mona Lisa; an indexical image has some real, natural or physical connection with the original, as in a photograph, an x-ray, smoke from a fire or the slivered carcass of a cow in a Damien Hirst artwork;[5] and a symbolic image does not necessarily bear a resemblance to the original but has a socially constructed association through habit and usage, as can be seen in the road sign for a four-way stop. An image is not restricted to being constituted by one sign type only and may contain all three (Colapietro 1993: 183). Thus, tracings of rock art images in black ink with coded systems for colour are both iconic and symbolic, a watercolour copy of such an image would be iconic only and a photograph would be indexical and iconic.

Image and text

In all spheres of study, text and image are in constant dialogue with each other and mutually dependent. Once created, pictographic images always carry the potential for multiple interpretations through recontextualisation. Information, as understood to be located in the pictorial, is also dependent on the prior knowledge and experience each individual viewer brings to the image. Bryson notes that, in visual art:

> If the image is inherently polysemic, this is not *by excess* of a meaning already possessed by the image, as hagiography would have it, but *by default*, as the consequence of the image's dependence on interaction with discourse for its production of meaning, for its *recognition*. (Bryson 1983: 85, emphasis in the original)

Pictographic images are thus always over-determined, carrying more information than the originator intended, and polysemic in that they carry a potential for having many meanings.

Photography as 'truth'

Photographs that convincingly replicate the scene before the camera lens have been considered to be "messages without a code".[6] Because of their apparent veracity to the original, photographic images are sometimes believed to be ultimate stand-ins for the absent original. Richards explains that because technology is mechanical and chemical, it suggests a transfer that is in no way handled or worked in the way that a mimetic drawing might be (Colin Richards pers. comm. 1999). Photographs have therefore, in the past, been considered to be the perfect tool for capturing unmediated 'truth' about the world.

Understandably, some archaeologists have expressed a preference for photographs over pictographic copies, as in Professor C Van Riet Lowe's[7] foreword to Willcox's (1973) publication *Rock Paintings of the Drakensberg: Natal and Griqualand*. There, he holds that an artist's copy:

> must ever remain not merely one artist's impression of another artist's work, but also an inevitable distortion of the original … It is because of this that one welcomes the wider use of photography, especially in colour. (Willcox 1973: Foreword)

However, photography is not neutral and has its conventions. Scale, tonal range, focus, lighting quality, distance, detail and resolution are all qualities determined by the conventions of the photographic process.

The selectivity of the camera is of a different category to either human vision or the rendered image. The photographer, for example, is constrained by the rectangular framing of the camera lens and must choose what is included within this frame and what is excluded. Moreover, the camera and film do not possess the versatility to select privileged information and reject what could be referred to as 'visual noise'. The photographic image is, therefore, partial and variable, and not as faultless a copy as sometimes thought.

Photography versus tracing as the preferred method of recording

There has been much debate over photography, as opposed to tracing, as the best primary means of recording rock art. Although he admits it is not a perfect system, Lucas Smits believes that colour-slide photography is best because he feels that it can capture more information than the eye can see and it is not subject to human interpretation. The photograph seemingly offers 'empirically' accurate data captured in a 'scientific' manner. Smits believes that this provides a neutral basis on which multiple interpretive exercises can be performed. He writes that:

> systematic colour slide photography is one of the acceptable, though imperfect, recording methods that aim to secure all available information [and that this is] impartial and unselective. (Smits 1991: 250)

However, as discussed earlier, photography is not impartial or unselective. It is subject to visual interferences, the limitations of the camera and the technological constraints of the photographic process.

David Lewis-Williams, professor emeritus of cognitive archaeology at Wits, contests the idea that photography can provide an objective platform on which interpretive acts may be performed (Lewis-Williams 1990b: 126). He endorses tracing by skilled and informed individuals as the preferred means of copying, arguing that no copy is objective but, if those doing the tracing are knowledgeable and graphically competent, then the result will be at an acceptable level of accuracy, the decisions and selections made will be appropriate and information useful and relevant.

Substantiating the claim that colour photography does not provide the best method of capturing images, veteran rock art recorder Harald Pager explained that:

> Colour photography is, unfortunately, a less accurate method of reproduction than is generally believed. Inevitably the human eye will see more details than the camera can capture and many of the barely visible rock paintings can still be seen and recognised from various oblique angles but are literally invisible from a right angle camera position. (Pager 1971: 81)

Researchers, however, do agree that multiple methods of copying should occur. They differ over which is most able to capture information that serves scholarship best.

Part II: The copies

Orpen and conventions of plane, ground and perspective

The ability to capture data effectively will depend on many factors, not least the varying technical facility and aesthetic comprehension of the individual doing the copying. In addition, to add to the list of factors determining variance, copies cannot escape being subjective, influenced by individual interpretations of what the original might mean. It is evident that while Joseph Millerd Orpen had the information to enable a developed reading of rock art, he did not yet have the conceptual and sociological framework within which to comprehend it and it is more than likely that this lack of insight influenced the visual appearance of his copies.

Born in Ireland and emigrating to South Africa in 1848, his duties as magistrate took him into areas of the Maloti-Drakensberg Mountains where many rock paintings are located. Orpen was unique for his time in that he not only copied the images, but also obtained unique evidence from a San man named Qing, who accompanied him to rock art sites and explained the meanings of some of the images to him. Although he did not fully understand this information, Orpen faithfully recorded the explanations anyway (Lewis-Williams 2003: 20–24).

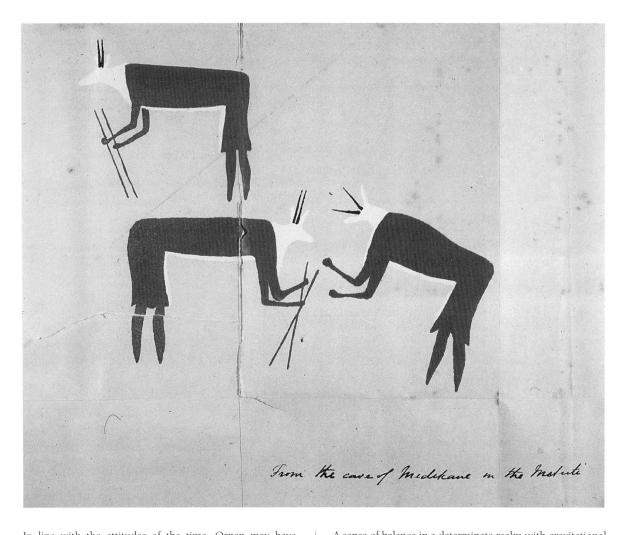

From the cave of Medikane in the Malute

◀ **Figure 4.1**
Joseph Orpen's rendering of the therianthrope panel at Melikane, Lesotho (after Orpen 1874).

In line with the attitudes of the time, Orpen may have thought that these images were depictions of customs and daily life, or of people wearing masks, costumes or hunting disguises (Lewis-Williams 1990a: 50). His copy of the three figures from Melikane Shelter, Lesotho, reflects this reading in the way it has been rendered (Figure 4.1): smooth, evenly applied planes of colour block in the bodies with crisp, well-defined edges. The figures seem corporeal and tangible. The layers of paint are opaque, lending a feeling of physical weight to the forms. This is partly the result of the solid colour, but also a consequence of the way the figures have been positioned within the format of the paper. Two have their legs perpendicular to the bottom edge and their backs parallel to it, a position that stabilises the forms within the horizontal and vertical elements of the rectangular frame. Although no background detail is visible, the sticks held by the two left-hand figures also have their lower ends positioned at an imagined ground plane.

A sense of balance in a determinate realm with gravitational forces is implied in the image. Solid bodies appear to occupy space in the physical world and this illusion is constructed through specific Western visual traditions. These are the conventions of plane, ground and perspectival illusionism. The figures also have proportions that are more anthropomorphically normative when compared with the copy by Vinnicombe of the same group (Figure 4.2). Orpen probably had no formal art training and operated as an interested amateur. It could be that an absence of technical and artistic skill in the handling of the paint determined the visual reading of the image. But it is also likely that, had his knowledge of the art and world view of the San been different, Orpen would have articulated the image differently. For example, he could have drawn on the numerous interpretations of spiritual states of transcendence existing in Western traditions of painting, such as in the Sistine Chapel frescoes by Florentine artist

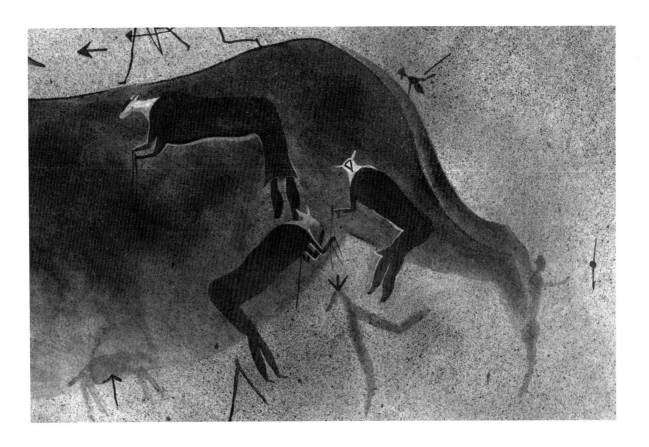

▶ **Figure 4.2**
Vinnicombe's rendering of the therianthrope panel at Melikane, Lesotho. From Natal Museum archive.

Michelangelo (1475–1564) or the visionary images of English artist William Blake (1757–1827). But, the manner in which his copy has been rendered limits the scope for a transcendent reading.

Orpen sent his copies to Wilhelm Bleek, a German philologist working in Cape Town with /Xam San people, learning and recording their language and mythology. Bleek was greatly excited by the images (Lewis-Williams 1996: 307), recognising that they provided the first opportunity to bring together text and image to develop a nuanced and informed reading of rock art. Yet, it seems that neither Bleek nor Orpen had sufficient grasp of the underlying beliefs of the San to apply what had been recorded linguistically to the painted images. It may be that Orpen's copies, being so 'earth-bound', did not lend themselves to the metaphysical possibilities implied in the images. However, both men had a sense that these were not just primitive doodles and accredited the San with a sophisticated thinking and way of life.

As racism gathered momentum in the years following Bleek and Orpen, San people came to be regarded as primitive, occupying the lowest rung of the evolutionary scale. Writing about the period before the advent of the studies of Vinnicombe, Lewis-Williams (1990a: 50) explains that:

> Many people continued to record the art, and there are large collections made by such enthusiasts … Unfortunately, most of these copies are, by today's standards, somewhat inaccurate. The early recorders missed details (or recorded features that did not exist), rearranged paintings to fit a page and, most damaging of all, selected paintings and engravings that interested them.

It seems likely that because San art was considered simplistic, without a developed symbolic and spiritual system of thought underpinning it, this gave copiers licence to manipulate it as they saw fit.

Maack, Breuil and the 'White Lady'
Perhaps the most well-documented case of misinterpretation and manipulation of a rock art image is that of the 'White Lady of the Brandberg'. In 1917 German surveyor

Reinhardt Maack discovered an enigmatic striding figure painted on a rock face in the Brandberg. His copy, now in the RARI archives, is similar in style to those made over 40 years earlier by Orpen. The form has been simplified, and a significant amount of detail left out. Colour has been applied in flat solid areas and the brush strokes are not evident. The facial profile is generalised and no features are evident, no genitalia are visible and the hands are fingerless. Yet the figure has a distinctive hieratic elegance in its profiled posture and decorative embellishments (Figure 4.3).

This copy caught the interest of the Abbé Breuil, a French archaeologist, palaeontologist and cleric who, during his lifetime, was considered to be the foremost authority on Palaeolithic cave art. Breuil believed that the more sophisticated images found on cave walls in southern Africa could not have been produced by "primitive Bushmen" and that "he could identify depictions of Minoans, Phoenicians and other Mediterranean people in southern African rock art" (Lewis-Williams & Dowson 1989: 6).

It was only in 1947, when Breuil visited the Brandberg site in Namibia, that he was able to make his own copy of the 'White Lady' (Figure 4.4). Given his attitudes towards the art, and his style of rendering, it is not difficult to see how he reinforced his conceptual (mis)reading through his pictographic copy. After tracing the images, Breuil confidently applied watercolour washes on paper. His style is loose, with visible brushstrokes forming an important component in the general appearance of the image. Uneven rock surfaces, irregularities, gaps in the outlines of painted areas of the form and nuances of light and shadow are always factors in the reading and misreading of rock art images, and opportunities for the copier to fill in details creatively. Breuil mutes these details, losing significant visual information as his broad brushstrokes confidently delineate the image.

Shifts in the pressure of the brush on paper, the speed of application, the viscosity of the paint and the level of absorption of the paper all make for subtle shifts in the final form and appearance. Watercolour is notoriously difficult to control and an unskilled painter will not have the technical facility to copy even a well-defined form accurately, let alone one with so many margins for error. And within these margins of licence and error there is the mindset of the copyist, who will 'read' and articulate concepts of his or her own.

In contrast to the later copies of this figure by Pager (Pager n.d.; Figure 4.5), Breuil drew on a well-known

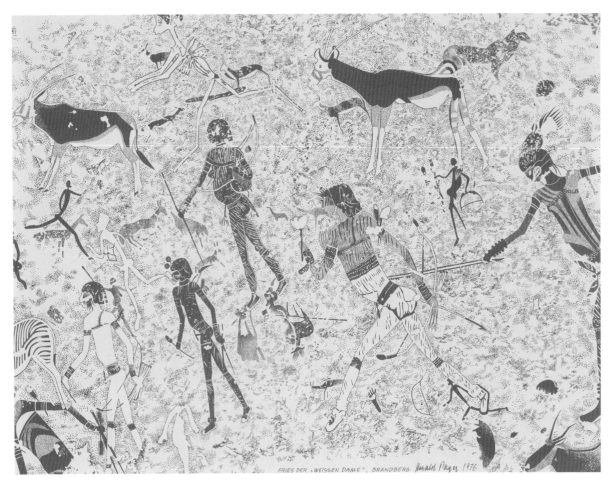

FRIES DER »WEISSEN DAME«, BRANDBERG *Harald Pager* 1976

◄ **Figure 4.3**
Rheinhard Maack's rendering of the 'White Lady of the Brandberg', Namibia. From RARI archive.

◄▼ **Figure 4.4**
Henri Breuil's rendering of the 'White Lady of the Brandberg'. From RARI archive.

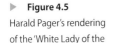

▶ **Figure 4.5**
Harald Pager's rendering of the 'White Lady of the Brandberg'. From RARI archive.

aesthetic paradigm for his copy. Where the face in Pager's copy is strangely mysterious with curious hair and facial features, Breuil's copy evokes a clearly defined 'Grecian' aesthetic with profile, eyes, eyebrows, nose and mouth all present in a light-coloured visage topped by a coiffure of red hair. Of this misrepresentation, Lewis-Williams and Dowson (1989: 7) write that, "Certainly, the White Lady lacks the Mediterranean profile that Breuil claimed for it."

Thus, while an image may be considered sensually and visually satisfying, the specific information the researcher seeks may not be present in that particular modality or, alternatively, may have been creatively embellished. With reference to anatomical drawings of the Renaissance period, visual theorist Martin Kemp (1996: 83) explains how:

> For anatomists, the visual power of naturalistic representation was a powerful and central tool in the rhetoric of the real, and could be used as

an expression of the impulse to reconstruct the fabric of the body on the basis of direct hands-on experience. The representations served as a powerful form of visual pointing, both to their own features and, potentially to those of the actual object. However, we should remain alert to the fact that this visual pointing could draw apparent convincing attention to what was not there.

Clearly any image will not do – images must yield the salient information needed for research.

An artist enraptured

There is little doubt that some of the most aesthetic of all copies made of southern African rock art are those by Walter Battiss – artist, teacher and innovator (Figure 4.6). Battiss grew up on a farm near Koffiefontein in the Free

State, an area rich in rock engravings. Art historian Karin Skawran (2005: 16) writes that "perhaps the single most important event in the life of Walter Battiss is his discovery of Southern African rock art". Throughout his life many hours were devoted to copying images across the length and breadth of South Africa, either on his own, with Breuil or on expeditions organised by the then Transvaal Museum (Giles Battiss pers. comm. 12 March 2006). Unlike Breuil, and counter to the beliefs of the time, Battiss firmly held that rock art was the work of the San. In it he found inspiration for his own art and he felt a profound empathy for what he referred to as the "artists of the rocks". Long-time friend Murray Schoonraad (1985: 41) explains that:

> Battiss believed that their [Bushman] rock art was a reflection of the artists themselves. They painted very directly – they were talking about themselves and this, he felt, was marvellous... There came to him a revelation that there is something primitive in all of us.

This observation says more about Battiss's relationship to his own art than about rock art: that the images an artist depicts are, in reality, an extension of self – a paradigm of being that is distinctly Western. In the copies of rock art by Battiss, a sense of individualism and personal spirit is evident. His control of line, colour and design was masterful, and his visual 'ownership' of the images confident. Figures and animals are aestheticised in a sensitive and poetic way. Battiss truly 'felt' the genius of the images and enhanced them with his acute visual perception, taking delight in the abstractions of form.[8]

During Battiss's formative years, in the first part of the twentieth century, artists were seeking to break with the nineteenth century illusionist interpretations of reality that were so much a part of the European tradition. Coupled with this iconoclasm came the notion that 'primitive' artists, such as those from Africa, were closer to nature, more in touch with the 'essences' of life and therefore freer, unconstrained by the trappings of civilisation. Artists who pursued this new genre adopted lifestyles and approaches that they imagined would facilitate their ability to be creatively unfettered and spontaneous. Both artists and art were thought to reflect fresh, childlike innocence and the naïveté of the 'primitive'. It was imagined that artists such as Battiss could achieve a "fellow-feeling for the primitive in the humble recognition of the essential oneness of art" (Van Riet Lowe 1948: 13).

In the tradition of Pablo Picasso and other early modernist painters, Battiss did not concern himself much with what the rock art might have meant to its makers. He wrote:

> The first is to ignore all theories and look at the originals of prehistoric art as one would look at paintings in an art gallery, that is, to look at them so that the *eye* enjoys them for their calligraphy, their colour, their composition, their form and structure. (Battiss 1948: 22)

But certain features puzzled him. He continued:

> In representations of the eland I have sometimes noticed additional lines on the back of the animal and wondered if they could represent birds. In one instance, at Friede's site near Schweizer Reneke, they have a festooned appearance quite unlike birds, and so they remain a puzzling addition. Perhaps they are part of a rocky background. (Battiss 1948: 47)

Battiss utilised a wide range of copying methods, including watercolour on transparent plastic, meticulously drawn images in black ink with dotted details, tracings painted with brush and black ink, and delicate watercolours on white paper. Precise colour choices and information regarding the works were meticulously recorded in notebooks. His archive is filled with copies of rock art on flimsy cellophane paper. Schoonraad (1985: 41) explains how Battiss first placed cellophane paper over the rock face and then made a replica by copying the outlines. These were then transferred to white paper and the copy later completed in watercolour.

Although it would be difficult to substantiate, given the early date of these copies, Battiss may well have been the innovator of the use of transparent plastic in the copying process. Furthermore, his choice of blue paint as a substitute for white on the plastic copies is also intriguing. It is a convention that Vinnicombe also uses, lending an uncanny resemblance to their tracings.

▲ **Figure 4.6**

Walter Battiss's rendering of a Free State contact period painting. From RARI archive.

Breakthroughs

While Battiss left a rich and aesthetically valuable body of works, two researchers in the late 1960s developed approaches to copying that led to breakthroughs in the understanding and interpretation of rock art. Both Harald Pager and Patricia Vinnicombe advanced the study of rock art in that they tried to come to grips with the material in a systematic manner. Their work set out to capture all the images on the rock surface and all visible data as meticulously as possible, regardless of whether they considered them to be of aesthetic merit, thereby eliminating subjective selection as much as possible.

Designer, artist and photographer Harald Pager[9]

became interested in rock art in the 1960s. The two years that he devoted himself to the study of the art in the Didima Gorge, KwaZulu-Natal, South Africa, resulted in the extensive collection of copies now housed in the RARI archives. Pager had a technical facility that few copyists could match and he used this to great advantage. He also differed from most copiers of rock art in that he was the only one to include the rock surface as an integral and important part of the image. In most pictographic copies the rock surface is either excluded or acknowledged in a minimal or gestural sort of way.

Pager developed two methods of copying, both of them very time-consuming. In the first method, which

BOX 4. VINNICOMBE'S TRACING AND COLOUR RENDERING TECHNIQUE

Justine Olofsson

Patricia Vinnicombe developed her own techniques for recording and rendering the figures in the hundreds of painted sites that she studied. She often spent more than a fortnight in the field surveying large inaccessible areas and this necessitated the development of an accurate but fast, dependable and portable method of tracing. Once she got back from these trips, she was able to spend more time on the rendering process.

By far the largest part of what Vinnicombe donated to the Rock Art Research Institute (RARI) of the University of the Witwatersrand comprised her many hundreds of polythene tracings. Tracing rock art is an important recording method. As Vinnicombe noted, photography provides a more realistic impression of a site, eliminates the personal factor and is relatively quick. However, it fails to record sufficient detail, especially of superpositions or fine decorations that tend to get lost in the grain of the rock. In her own words, "the two methods, photography and tracing, are complementary to one another and are both essential for rock art research" (Vinnicombe 1960: 12).

Vinnicombe's colour tracing technique

Vinnicombe covered the paintings that she recorded with polythene plastic, the corners of which she attached to the rock surface. She then traced the exact outlines of the paintings using a brush and watercolour paints mixed (Figure B4.1) with a small amount of Teepol (a slightly corrosive liquid detergent) so that the paint adhered to the plastic (Figure B4.2). She developed her own colour chart specifically tailored to capture the subtleties of colour in Bushman paintings: A was black, B white, C maroon red, D yellow ochre and so on. Although she traced the images using colours close to the actual colours of the images, she also noted these on the tracing, using annotations like CAD (maroon red + black + yellow ochre). Although she tried to capture these colours in the tracing, sometimes she did not have all the colours available in the field so the codes provided an important reference. Once she got back home, she could consult the colour chart and mix the exact colour combinations.

Vinnicombe's colour rendering technique

The colour rendering process began with the preparation of the background. Vinnicombe used 300 gram acid-free watercolour paper and poster paints. With a sponge and blower, she would create a textured background, using colours as close as possible to those of the actual rock surface.[1] She did not attempt to capture the contours of the rock surface unless there was a very obvious crack, chip or drip mark going through the paintings. Once this background had dried, she would stick the tracing behind it and use a light table to transfer the traced image. First, using a pencil very lightly, she captured the outlines of figures. Then, referring to the colour codes, she would mix the exact combinations and fill in the traced shapes. Vinnicombe always paid careful attention to the paint quality, for example, transparent stain, film or chalky/powdery, trying to get it as close to that of the original as she could (Vinnicombe 1967). She used various combinations of watercolours, poster paints and pastels (Figure B4.3).

Before there was electricity at West Ilsley, the Underberg family farm where she grew up, the local school made space available to her for the light table that she needed. She worked there, sometimes up to 12 hours a day, capturing the beauty and subtlety of the images as accurately and truthfully as she could. Later, once electricity was installed at the farm, she moved her light box there. This enabled her to work even longer hours.

I learned the colour rendering technique from Vinnicombe and developed a style with which Vinnicombe was happy (Figure B4.4). Currently, over 300 of Vinnicombe's polythene tracings have been transferred to permanent paper at RARI. Although works on paper are fugitive, every attempt has been made to ensure that archivally stable materials are used. This collection will provide a valuable record for researchers in the future.

NOTE

1. She would record these on the tracing, for example khaki grey with dark grey splodges.

REFERENCES

Vinnicombe, P. 1960. The recording of rock art paintings in the upper reaches of the Umkomaas, Umzimkulu and Umzimvubu rivers. *South African Journal of Science* 56: 11–14.

Vinnicombe, P. 1967. Rock painting analysis. *South African Archaeological Bulletin* 22: 129–141.

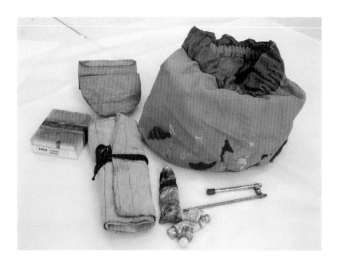

◀◀ **Figure B4.1**
Vinnicombe's colour rendering equipment. From RARI archive.

◀ **Figure B4.2**
Example of a Vinnicombe polythene tracing. From RARI archive.

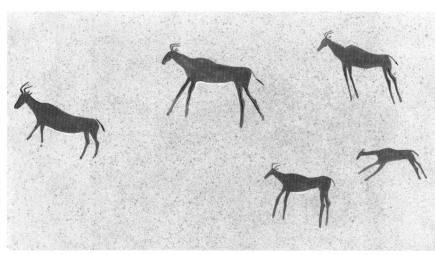

▲ **Figure B4.3**
Colour rendering done by Justine Olofsson using Vinnicombe's method. From RARI archive.

▶▲ **Figure B4.4**
Justine Olofsson working on rendering a Vinnicombe tracing in the Rock Art Research Institute. From RARI archive.

also proved to be very expensive, Pager photographed the painted images and their surrounding rock matrix on black-and-white film. He then blew these up to life size and returned to the original sites with them in hand. Setting up in front of the paintings, and using oil paints, he recopied the images in colour onto the enlargements,[10] using the photographed shapes as guides. A strange visual dislocation occurs as the painted forms, superimposed on the visually and graphically dissimilar photographic ground, seem to 'float' above the rock surface. This causes a visual disjunction between the image of the rock surface and the painted objects, quite unlike the integrated relationship between the original painted image and its rock matrix. This disjunction is heightened by the crisply defined painted edges of animals that contrast with the black and white rock surface below. Furthermore, the photographic paper is smooth and shiny and the paint spreads seamlessly over the surface, unlike the original where the pigment has soaked into the granular matt surface, around bulges, curves, fissures and indentations (Figure 4.7).

Pager's second method of copying involved tracing from the rock image onto transparent paper. After this was done, he filled in the details with monochrome ink in front of the original. Using dots, lines and solid areas he copied the surface of rock as well as the forms of the paintings. These images are constituted as visual continua – rock surface and figure are given equal visual weight. Colour is purged, but complexity of form, absences and fine nuances are captured in these painstakingly detailed recordings that are close in method and appearance to the later RARI copies.

A broad sweep with attention to detail

Patricia Vinnicombe started tracing the rich legacy of rock art in the Underberg area of the Drakensberg in the 1950s. Importantly, she "tried to be comprehensive and non-selective tracing every image that she came across, whether fragmentary or not" (Lewis-Williams, this volume). At first she just sketched, but became dissatisfied as these were not accurate enough. The method she perfected, and then used throughout her life, was to lay thin polythene sheets down on the rock face onto which she traced the image (Figure 4.8). The soft plastic was preferred because it could bend and flex to the shape of the rock surface beneath. Using ballpoint pens, Koki and colour washes as close to the original colour as possible, she traced forms and partially painted them in. The paint consisted of watercolour tempera mixed with the

commercial detergent Teepol, which acted as a fixative. The mix had to be carefully judged: too much would corrode the plastic, too little would peel off. In *People of the Eland*, Vinnicombe describes her method of copying thus:

> The outlines of the paintings were carefully followed with a fine brush dipped in Indian ink or water-colour paint mixed with a wetting agent. Where there was variation of hue and shading, the actual colours were blocked in. Before removal from the rock face, a vertical line was drawn on the polythene so that the group could be correctly oriented in the final reproduction, and the sheet was clearly labelled with the site name and number, and the date of the observations. The hues of the original paintings were then accurately matched against a special prepared colour chart which has since been related to the Munsell soil colour chart, and the relevant symbols were recorded on the polythene. (Vinnicombe 1976: 126)

The copies were taken back to the studio and a few were translated onto pre-prepared watercolour paper.[11] Vinnicombe not only recorded the painted image, but also tried to articulate background colour and texture. She was aware of the significance of the rock surface, but did not focus too much attention on this. On the tracing she would note the type of background and then, using this as a reference, prepare the final copy paper with a general simulation of the colour and texture of the original surface. The copy on polythene was then laid down on a light box with the prepared paper over it and traced. Outlines were drawn lightly onto the prepared paper with HB or harder pencil. The tracing was then removed from underneath and Vinnicombe (or one of her assistants) would work with it next to her, using Reeves watercolour, black ink and chalk pastels for redrawing. Vinnicombe felt comfortable with the polythene method because she was able to get clarity and accuracy.

But the original sketches were not very complete and there was often room for interpretation. Vinnicombe had seen many rock art paintings and had an uncanny understanding of their aesthetic style. She would correct her assistants' copies, intuitively 'filling in' detail and bringing her visual memory to bear on the final process (Justine

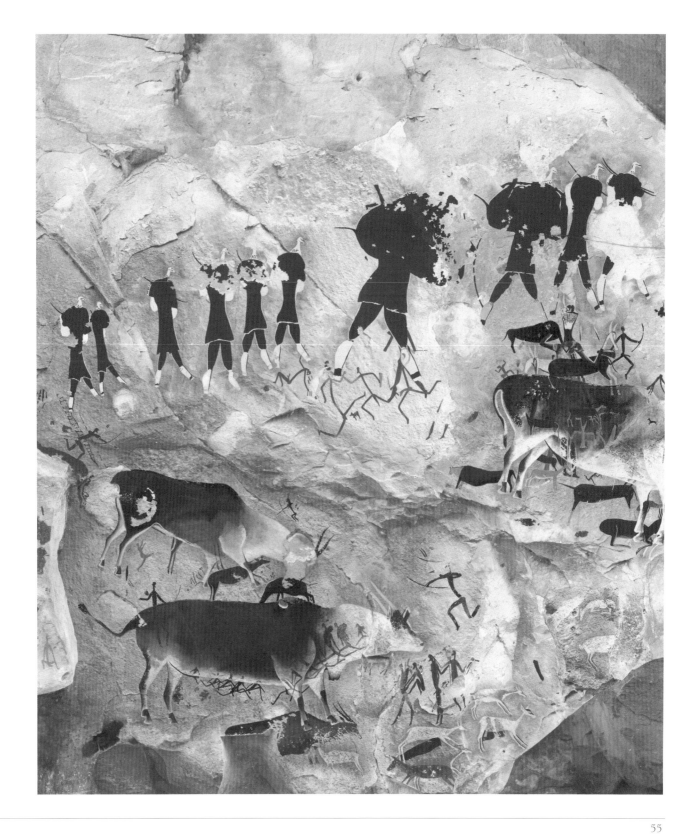

▶ **Figure 4.7**
A painted photographic
reproduction by Harald Pager from
Didima Gorge. From RARI archive.

◀ **Figure 4.8**
A Vinnicombe tracing, showing her textual annotations. From RARI archive.

Olofsson interview 21 February 2006). Just how much intuition was needed became clear to Justine Olofsson when she became Vinnicombe's research assistant in 2000. Olofsson recalls the subjectivity of the process, especially when faced with layers upon layers of painted forms. She explained that it is "hard to know what is what when it is all ears and legs" (Justine Olofsson interview).

When comparing Orpen's copy of the three figures at Melikane with Vinnicombe's, it is easy to distinguish significant differences in approach and form (Figure 4.2). Vinnicombe has given the image a sense of being out of balance. The top figure has a torso that is very elongated in relation to the rest of the body. It leans forward at an angle and the shoulder line is slanted. The whole image is tilted in the picture plane and the colour washes are translucent, adding a sense of the ethereal. Evident in the background are the large hindquarters of an eland onto which the three figures have been painted – a detail completely absent in Orpen's copy. The vast shift in scale between the hindquarters and the three shaman figures also accentuates the unreal nature of space in the Vinnicombe copy.

The graphic language of 'science'

The approach that Vinnicombe and Pager had pioneered, where every image was studied close up with a "sustained close attention to image after image [and its subsequent careful tracing and rendering] seems to inculcate in researchers a perspective on the art that differs from the one which those who stand back and view only the general sweep of the images tend to develop" (Lewis-Williams, this volume). This new method seemed to bypass some of the more subjective looking and recording that had been prevalent before. But these recording conventions still did not fully satisfy the desire for a more controlled study of the works since they included what could be thought of as 'messy' elements, such as colour, paint texture and the inclusion of rock surface visual 'noise'.

A copying method was subsequently developed by David Lewis-Williams and has been followed by RARI researchers ever since. In it images are traced from the original onto a single matt Ozatex[12] sheet (Figure 4.9) and then redrawn in black ink. After the Ozatex is taped to the rock surface, the tracing is done on site using 3.5 mm

▶ **Figure 4.9**
A Rock Art Research Institute tracing.
From RARI archive.

clutch pencils that break if too much pressure is put onto the surface. Two or three people work on a single drawing so that the veracity of the decisions taken regarding the form of the original can be checked. Discussion ensues over what is or is not there and researchers generally reach a compromise with about 90 per cent in agreement and 10 per cent contested (Geoff Blundell pers. comm. February 2006).

Where the image is clear it is shown with a solid line, where unclear as a dotted line. Ultraviolet light is used to show up detail that the eye cannot see. Background is largely eliminated, except for the occasional notation of crevices and other rock surface features. These tracings are annotated with details on colour and surface features and taken back to the Institute where they are translated into monochrome ink (usually black) renderings. Different colours are represented through varying densities of stipple. RARI have a code for this but it is not universally used as other institutions have developed their own.

Recording every feature of the paintings is of primary importance. The iconographic forms are traced with close attention to detail and form, even if these do not make 'sense'. Colour assumes a secondary role. This is probably due to the difficulty of controlling its unruly aspect. Not only does the introduction of colour bring with it brushstrokes or the marks resulting from colouring in, it is also difficult to match colour exactly. Even in the same sample, colour is not constant, being subject to the changeability of ambient light. Furthermore, when set against different backgrounds, colour tends to shift.[13] Equally, individual interpretations of colour are subjective. Ian Hodder, postprocessual archaeologist and director of the Çatalhöyük excavations in Turkey, comments that, when asked to evaluate the colour of soil samples, ten excavators will give ten different soil colour gradations under the same circumstances (Ian Hodder pers. comm. August 1998). Colour has been expunged from the RARI copies, but is noted through a coded key related to the density of black dots.

Of all the conventions, the RARI convention of copying leans towards the scientific in its desire to stabilise and control information by minimising variables. Barbara Stafford[14] (1996: 46–47) writes that:

> in the increasingly arduous early modern quest for reliable means of dissecting true visual proof from false appearance, the crucial point was how to free images from a welter of contaminants. Who would reduce these light and color composites to homogeneity? Who, or what, would purge adulterating ambiguity, expunge error, exaggeration, and other carnal abuses so that ocular evidence might be rational, a pure and perfect surrogate for the real thing?

The convention of black ink illustration is one generally reserved for engineering and other technical drawings where accuracy is assumed. The black line on white field is the graphic method of maximum contrast and minimum visual noise. It leaves the viewer little room for doubt in its clear definitions of form. The convention focuses and defines shape in an unambiguous manner yet its authority can be misleading. Dowson (1996: 318) explains his relationship to this method of copying as follows:

> So I used tracings of mine that accurately capture the outline and detail, that is, the iconographic content, of the image. But, in a sense, even these re-productions are highly inaccurate. For instance, they downplay colour (I used a diagrammatic system to represent different colours); the texture of the rock surface is missing; and they ignore numerous artistic skills, such as the use of brushstroke and shading.

The copying method is functional in that the tracer and re-drawer do not necessarily need to have well-developed artistic skills. In fact, this would probably be a disadvantage as too much individual artistic licence would be inappropriate. Equally, concentrating on colour, messy rock surface and any sense of texture would draw attention away from the salient form of the image. So, while these are not perfect copies, they are possibly the most useful for the purpose of academic investigation and scholarship.

Conclusion

This chapter has shown how the range of graphic conventions employed in the creation of copies is varied, each having a different relationship to the thing represented and yielding unique information. Furthermore, pictographic images are not simply reflective of archaeological knowledge, but are themselves constitutive of that knowledge, shaping and determining information. The study of semiology reveals that even seemingly objective renderings are not transparent windows to the world of fact, but are fundamentally interpretations articulated through visual conventions. There will never be a perfect copy and so copies add, change and reduce information that is available in the original. As such, they sometimes serve as indices, sometimes as icons and at other times as symbols. Developing a language with which to discuss and analyse these images assists in the understanding of how knowledge is embedded and communicated by the visual.

NOTES

1. Because Patricia Vinnicombe worked in the Maloti-Drakensberg, an area where there are only paintings, this chapter will only concern itself with this rock art form.
2. It could be argued that the rock art 'originals' are in fact copies themselves but this relationship has been dealt with in mainstream rock art scholarship and so, for the purposes of this chapter, will not be explored here.
3. 'Copier' in this chapter means an individual doing the copying.
4. *Yellow houses. A street in Sophiatown* by Gerard Sekoto. Medium: oil on board. Date: 1940. Collection: Johannesburg Art Gallery.
5. Flash Art (Summer 1996: 114–115).
6. See discussion on Roland Barthes in Mitchell (1986).
7. Founder and first director of the Archaeological Survey of the Union of South Africa.
8. Schoonraad describes Battiss's uncanny ability to intuit what was not always visible. He writes that, in the 20 years they collaborated, he 'never ceased marvelling at the uncanny manner in which he [Battiss] intuited the way the primitive artist had worked. Often, part of a painting or petroglyph had deteriorated or was partially obliterated, or invisible at first glance, because of a dark shadow. Yet Battiss would say what

the painting or engraving originally looked like, and it would be possible, after studying the work through a magnifying glass, or waiting for the sun to change its position to fill in the missing parts. I could never prove him wrong!' (Schoonraad 1985: 43).

9. Pager trained as a commercial artist in Austria before coming to South Africa (Geoff Blundell pers. comm. April 2006).

10. He used photographic paper glued to muslin cloth but this is very fragile. The collection travelled around South Africa and got badly damaged. It also shrank. The works were restored but not well. They were mounted on a thick surface that has buckled.

11. Saunders Waterford paper that had been textured and coloured to approximate the rock surface.

12. Professional quality tracing paper.

13. Mid-tone yellow for example shifts colour value when set against various other colours. Against green it becomes dull, moving towards beige, whereas against blue it seems more vibrantly 'lemon' yellow.

14. Barbara Maria Stafford is an art historian and a professor at the University of Chicago. She has a particular interest in the phenomenon of modern visual culture.

REFERENCES

Battiss, W. 1948. *The Artists of the Rocks.* Pretoria: Red Fawn Press.

Bryson, N. 1983. *Vision and Painting: The Logic of the Gaze.* New Haven: Yale University Press.

Colapietro, V.M. 1993. *Glossary of Semiotics.* New York: Paragon House.

Dowson, T.A. 1996. Re-production and consumption: the use of rock art imagery in southern Africa today. In: Skotnes, P. (ed.) *Miscast: Negotiating the Presence of the Bushmen*: 315–322. Cape Town: University of Cape Town Press.

Kemp, M. 1996. Temples of the body and temples of the cosmos: vision and visualization in the Vesalian and Copernican Revolutions. In: Baigrie, B.S. (ed.) *Picturing Knowledge: Historical and Philosophical Problems Concerning the Use of Art in Science*: 40–85. Toronto: University of Toronto Press.

Lewis-Williams, J.D. 1990a. *Discovering Southern African Rock Art.* Cape Town: David Philip.

Lewis-Williams, J.D. 1990b. Review of: Pager, H. 1989. The rock paintings of the upper Brandberg: Part I Amis Gorge. Cologne: Heinrich-Barth-Institute. *South African Archaeological Bulletin* 45: 126–136.

Lewis-Williams, J.D. 1996. The ideas generally entertained with regards to the Bushmen and their mental condition. In: Skotnes, P. (ed.) *Miscast: Negotiating the Presence of the Bushmen*: 307–314. Cape Town: University of Cape Town Press.

Lewis-Williams, J.D. 2003. *Images of Mystery: Rock Art of the Drakensberg.* Cape Town: Double Storey.

Lewis-Williams, J.D. & Dowson, T.A. 1989. *Images of Power.* Johannesburg: Southern Book Publishers.

Mitchell, W.J.T. 1986. *Iconology: Image, Text, Ideology.* Chicago: University of Chicago Press.

Orpen, J.M. 1874. A glimpse into the mythology of the Maluti Bushmen. *Cape Monthly Magazine.* 9: 1–13.

Pager, H. 1971. *Ndedema. A documentation of the rock paintings of the Ndedema Gorge.* Graz: Akademische Druck.

Pager, H. 1976. The rating of superimposed rock paintings. *Almagoren* 5: 205–218.

Pager, S-A. n.d. *A Visit to the White Lady of the Brandberg.* Windhoek: Typoprint.

Schoonraad, M. 1985. Battiss and prehistoric rock art. In: Skawran, K & Macnamara, M. (eds) *Walter Battiss*: 40–54. Johannesburg: A.D. Donker.

Skawran, K. (curator) 2005. *Walter Battiss – Gentle Anarchist.* Johannesburg: Standard Bank Art Gallery.

Smits, L. 1991. Photography versus tracing? In: Pager, S-A., Swartz, B.K. Jr. & Willcox, A.R. (eds) *Rock art: The Way Ahead*: 247–252. Johannesburg: SARARA Occasional Publications 1.

Stafford, B.M. 1996. *Good Looking: Essays on the Virtue of Images.* Cambridge: The MIT Press.

Van Riet Lowe, C. 1956. Foreword. In: Willcox, A.R. *Rock Paintings of the Drakensberg: Natal and Griqualand East*: 5-6. London: Max Parrish.

Vinnicombe, P.V. 1976. *People of the Eland: Rock Paintings of the Drakensberg Bushmen as a Reflection of their Life and Thought.* Pietermaritzburg: Natal University Press.

Willcox, A.R. 1956. *Rock Paintings of the Drakensberg: Natal and Griqualand East.* London: Max Parrish.

PERSONAL COMMUNICATIONS

Giles Battiss, 12 March 2006
Geoff Blundell, February and April 2006
Ian Hodder, August 1998
Justine Olofsson, 21 February 2006, interview
Colin Richards, 1999

Meaning then, meaning now:
Changes in the interpretative process in San rock art studies

David Pearce, Catherine Namono and Lara Mallen

Meaning is what it is all about today in the study of San rock art. A few recent studies consider dating (e.g. Mazel & Watchman 1997, 2003), sequence (e.g. Russell 2000; Pearce 2002, 2006; Swart 2004), chemical analysis (e.g. Hughes & Solomon 2000), quantification (e.g. Lenssen-Erz 2001) and conservation (e.g. Hœrle & Salomon 2004; Hœrle 2005, 2006; Deacon 2006; Hall *et al.* 2007; Meiklejohn *et al.* 2009). But these studies are in the minority and outside the mainstream of San rock art research. It is difficult for researchers at the beginning of the twenty-first century to imagine a time when it could have been different, when meaning was not king; it seems inconceivable that a time existed when we did not know something of what the art was about.

That was exactly the case, though, in the 1960s and 1970s when Patricia Vinnicombe was working on her book *People of the Eland* (Vinnicombe 1976). Other studies at the time consisted mainly of guesswork by amateurs and quantification by a new generation of professional researchers, of whom Vinnicombe (1967a) herself was a pioneer. Vinnicombe was faced with the fundamental problem of having to say **something** about the art, of finding some sort of order to the paintings. In retrospect, the way of doing this may be obvious; it was not at the time.

She was not alone in her quest. Together with Harald Pager and David Lewis-Williams, Patricia Vinnicombe is one of the three names most often cited as having ushered in this 'modern' era of San rock art research in southern Africa. Pager (although making some limited use of ethnography) is probably best known for his recording of the art. His magnificent, full-colour, full-size copies of the Didima Gorge paintings (Pager 1971)

have never been replicated, and his tracings in the Brandberg (now the Dāures massif), Namibia (Pager 1989), set the standard for professional recording of rock art in southern Africa. In addition to his graphical recording of rock art, he is also well known for his numerical recording: if his programme of quantification was not the most extensive, it was certainly published in the greatest detail (Pager 1971).

Lewis-Williams's contribution is also readily apparent. His use of ethnography, not in a general way, but in the explanation of details of ritual and belief (Lewis-Williams 1981), is largely credited with our current understanding of San rock art. His introduction of neuropsychological insights is also well known (Lewis-Williams & Dowson 1988; Lewis-Williams 2001a).

Vinnicombe's contribution, on the other hand, is less clearly defined: she pioneered the quantitative approach in southern African rock art studies; she made extensive use of San ethnographies; she tried to link historical events to rock art; and her book, *People of the Eland,* is certainly well illustrated with many excellent copies. Broadly speaking, however, Vinnicombe chose three interrelated ways of approaching the art: quantification, a study of San ethnography and a consideration of regional history. She therefore collected quantitative data on certain categories of images and then sought information on these themes from San ethnographies and ethnohistorical documents. Her approach is clear in the structure of her book: there is a chapter on eland, another on baboons and so forth. Whilst her approach was extremely innovative in the southern African context, it was a product of methodological movements in the wider intellectual world (Figure 5.1).

◀ **Figure 5.1**

Patricia Vinnicombe, David Lewis-Williams and Emmanuel Anati at the Valcamonica rock art symposium in Italy in 1972. From RARI archive.

BOX 5. THE PRESENTATION OF BUSHMAN ROCK ART IN THE UKHAHLAMBA-DRAKENSBERG

Ndukuyakhe Ndlovu

The uKhahlamba-Drakensberg Park[1] was inscribed as the fourth South African World Heritage Site in November 2000 after meeting four selection criteria, two each for natural and cultural significance. This semi-circular border between the South African province of KwaZulu-Natal and the inland mountain Kingdom of Lesotho also boasts a high level of endemic and globally threatened plant species. Besides nature, the uKhahlamba-Drakensberg Park contains many rock shelters with the largest and most concentrated group of paintings south of the Sahara made by hunter-gatherer people. Discovered about 150 years ago by Europeans, rock art paintings were initially considered primitive and crude. However, these paintings are today thought not only to be of outstanding quality but also to give voice to the complex spiritual beliefs of the precolonial Bushman inhabitants of the region.

The research of Patricia Vinnicombe, among others, was instrumental in bringing the rock art of the uKhahlamba-Drakensberg to the fore within southern African archaeology. The current presentation of the area as a treasure trove of rock art and as the 'Rosetta Stone' of rock art interpretation is directly attributable to research by Vinnicombe and others. Had it not been for this work, the uKhahlamba-Drakensberg Park might not have been proclaimed a mixed World Heritage Site and therefore the presentation of its rock art to the public would be very different from what it is today. Following the declaration of the uKhahlamba-Drakensberg Park as a World Heritage Site, South Africa's president at the time, Thabo Mbeki, approved the use of rock art[2] in the country's new national coat of arms (see Box 3, Figure B3.2), the highest visual symbol of the state. There could be no better demonstration of the significance of rock art for understanding the history of this country (Smith *et al.* 2000).

The declaration of the uKhahlamba-Drakensberg Park as a World Heritage Site presented its managers with a challenge to reposition their strategy, following not only national but also international regulations. Before its declaration, biodiversity conservation took precedence over cultural resources management. As a result, the professional staff of the current management authority still does not include any culturally sensitive and professionally qualified archaeologists or anthropologists.

This lack of professional capacity seriously hampers the management and presentation of rock art in the World Heritage Site. Although rock art has attracted the interests of many people for aesthetic reasons and academic research over the years, its presentation to the public has been very limited. Prior to the declaration, the only ones who knew the localities of a few of the rock art paintings were those who hiked the steep valleys of the uKhahlamba-Drakensberg Park, the few tourists with a rock art interest, as well as local communities and researchers. The location of all but a handful of rock art sites was, and still is today, a closely guarded secret. Other sites were intentionally omitted from maps, be they for hikers, road users or others. This restriction in access to site location details was presumed to be in the interests of the proactive management of rock art. This long-standing low-key approach to presentation has changed considerably, and in a positive direction, since the award of World Heritage status.

The new status of the uKhahlamba-Drakensberg Park has been significant in luring tourists to the region, boosting the steady increase in tourist numbers since the ending of apartheid in 1994. A number of tourism destinations market the uKhahlamba-Drakensberg Park not only for its pristine environment, but also as a rock art destination. This has increased the demand for visits to painted rock art sites. However, this growing interest puts rock art sites under considerable human threat. To manage rock art sites better, the relevant provincial authorities have established a custodian policy which states that no visitor is allowed to access any painted shelter except in the company of a custodian. However, as with any legislation, the effective implementation of this policy is a great challenge. In addition, the growing interest in rock art has encouraged entrepreneurs to produce products themed on rock art, such as clothing, kitchen utensils, stationery and so on. This entrepreneurial activity has further broadened the popular awareness of rock art and ensured that more and more people want to see examples of the original art.

This has led to the development of a greater public rock art infrastructure. To accommodate those with either disabilities or time constraints, two rock art centres, namely Kamberg (Figure B5.1) and Didima (Figure B5.2) and an open-air museum at Main Caves, Giant's Castle, have been constructed. This has changed the presentation of rock art in the uKhahlamba-Drakensberg considerably. Whereas in the past rock art sites could be visited by only a few, the existence of these rock art centres has ensured that any person with an interest in rock art can be guided to one or more of a group of carefully chosen rock art sites deemed appropriate for public visitation. At Kamberg Rock Art Centre, visitors have an opportunity to watch an audio-visual show and to take a guided tour to Game Pass Shelter. Didima Rock Art Centre features a display hall, traditional fireside storytelling, and an auditorium where visitors can watch an inspiring audio-visual show. There is also an option for visitors to access three rock art sites close to the centre.

Besides tourism, Bushmen in KwaZulu-Natal are increasingly requesting access to rock art sites to use them for spiritual purposes. This is part of the living heritage still evident in the uKhahlamba-Drakensberg Park. Kamberg hosts the annual Eland Ceremony, bringing together Bushman descendants from across the uKhahlamba-Drakensberg to celebrate their heritage and to share it with others.

NOTES

1. In Zulu, the word *uKhahlamba* means 'Barrier of Spears'. Dutch-speaking European settlers in the 1830s named the mountains *Drakensberg*, meaning 'Mountain of Dragons'.
2. The human figure comes from the Linton Panel, a famous panel of rock art now housed and displayed in the South African Museum in Cape Town. In 1918, this panel was removed from the farm of Linton in the Maclear District of the Eastern Cape Province (Lewis-Williams 1988).

REFERENCES

Lewis-Williams, J.D. 1988. *The World of Man and the World of Spirit: An Interpretation of the Linton Rock Paintings.* Cape Town: South African Museum.

Smith, B.W., Lewis-Williams, J.D., Blundell, G. & Chippindale, C. 2000. Archaeology and symbolism in the new South African coat of arms. *Antiquity* 74: 467–468.

▲▶ **Figure B5.1**
Kamberg Rock Art Centre in the central Drakensberg. From RARI archive.

▶ **Figure B5.2**
Ndukuyakhe Ndlovu (left) and the Didima Rock Art Centre in the northern Drakensberg. From RARI archive.

In this chapter we recount briefly the various areas of research to which Vinnicombe contributed, before moving on to a discussion of the ways in which each of these has changed and grown in the ensuing years. We do this by following three interpretative methods she employed: quantification, ethnography and history. We do not provide an exhaustive review of all work conducted in these three fields, indeed, these are the subjects of other chapters in this volume. Instead, we highlight studies that were methodologically important in the development of research. For this reason, we do not discuss every piece of research conducted in the past 30 years, particularly not those that have come and gone without making any major impact on the general trajectory of study. We follow this methodological discussion with a consideration of how we see San rock art research changing in the future.

Quantification

In the 1960s, Vinnicombe embarked on an innovative programme of numerical analysis of San rock art images in the southern Maloti-Drakensberg region. The novelty of her programme was twofold. First, she introduced quantitative techniques to the study of San rock art. Using these techniques, she believed, researchers would be able to unravel the meaning of the art. Her second innovation was the development of a detailed set of categories and subcategories of art. She used these categories in her own studies, but, significantly, they were also adopted, with some modification, by other researchers (Pager 1971; Lewis-Williams 1972, 1974).

Vinnicombe's introduction of a quantitative programme was very much in line with broader movements in archaeology at the time. The then New Archaeology sought to make archaeology more 'scientific' so as to make the discipline more 'objective' and increase perceptions of its status in relation to the natural and biological sciences. The collection and statistical analysis of quantitative data was one of the ways this paradigm was manifested. Raising the status of rock art research was certainly an explicit goal of quantitative studies; at the time, rock art studies in southern Africa were largely the domain of interested amateurs.

Similar trends were manifest in other parts of the world. In Europe, André Leroi-Gourhan (1968) was studying rock paintings in the Upper Palaeolithic caves of

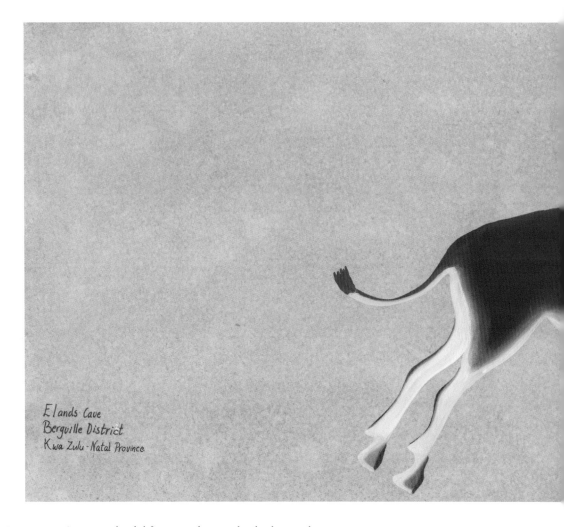

Elands Cave
Bergville District
Kwa Zulu-Natal Province

France. Coming as he did from an ethnographic background, the species and sex of animals depicted in the caves seemed obvious candidates for themes to use in ordering the imagery. In accepting the primacy of species and sex and their supposed symbolic significances in constructing his categories, Leroi-Gourhan was conforming to a prominent theme in Western anthropological thought. Ethnographic work from many parts of the world had shown that people use animals as social and other kinds of symbols. His narrow focus on species and sex, of course, masked many other potential ways of categorising the images. One could, for instance, define equally valid categories on the basis of size, colour or technique of animal depictions, amongst many other characteristics. It was nevertheless this influential study that led Vinnicombe towards quantification and ethnographic study in southern Africa.

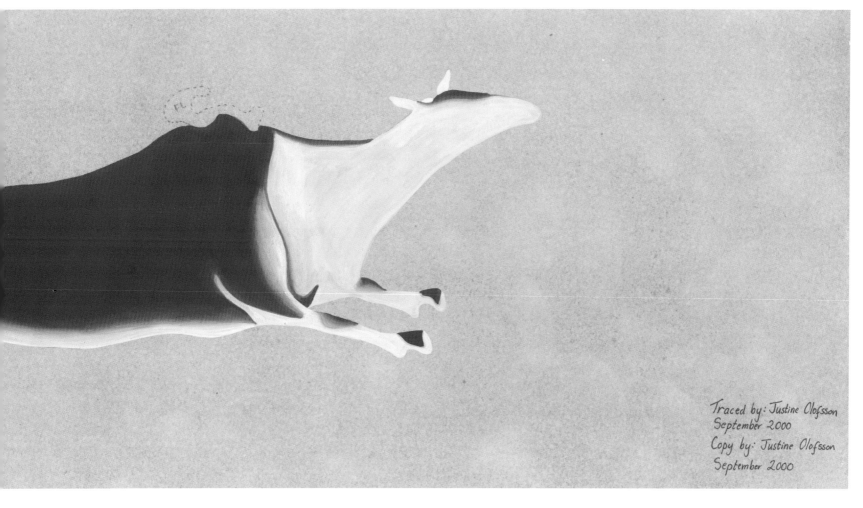

Traced by: Justine Olofsson
September 2000
Copy by: Justine Olofsson
September 2000

▲ **Figure 5.2**

Vinnicombe argued that eland served as a link between the material and spiritual worlds of the San. Traced and redrawn by Justine Olofsson.

The quantitative study that Vinnicombe undertook in the Maloti-Drakensberg Mountains analysed a total of 8 478 individual images (Vinnicombe 1967a, 1967b, 1976). A number of characteristics were recorded for each figure.

For each human figure, for instance, 20 different categories of data were recorded. She suggested that her numerical techniques, in addition to helping to understand the art that was analysed, would provide a means of comparing art in different regions of southern Africa. This proposition was soon to be explored as researchers began using similar techniques in other areas.

At the same time as Vinnicombe, Timothy Maggs (1967), working in the Western Cape Province, used numerical analysis to assess the content of rock art in that area. He quantified features of 1 471 images of human figures, animals and handprints. Although his initial intention was to obtain an objective assessment of the content of the art, he conceded that in some instances it was impossible to avoid a certain element of subjectivity (Maggs 1967: 100–101).

Pager also began a large recording programme in the KwaZulu-Natal Drakensberg. It consisted of copying paintings and later quantifying them. He recorded a total of 12 767 individual images from more than 17 sites in the Didima Gorge (Pager 1971: 321, 323). Following this, he began an even more ambitious recording programme in the Brandberg of Namibia. In 1963 the University of Cologne had begun a major research project that focused on empirical accuracy of documentation and analysis of the rock art of southern Africa (Lewis-Williams 1990: 126). This project grew into what later became known as

BOX 6. **VISITOR ATTRACTIONS IN THE UKHAHLAMBA-DRAKENSBERG: MAIN CAVES, KAMBERG AND DIDIMA**

Aron D Mazel

Inspired largely by the insights generated by Patricia Vinnicombe and David Lewis-Williams, the rock paintings of the uKhahlamba-Drakensberg have played a significant role during the last three decades in stimulating new interpretations of rock art throughout the world. Alongside this development we have seen the construction of a substantial archive of the region's abundant rock art, a vastly improved understanding of the hunter-gatherer past through excavations, and the direct dating of the paintings (see Wright & Mazel 2007). It is therefore unsurprising that 1) archaeology, and particularly rock art, featured prominently in the uKhahlamba-Drakensberg becoming a World Heritage Site in 2000, and 2) that the region has been at the forefront in the public presentation of rock art and hunter-gatherer archaeology and history in southern Africa. With regard to the latter issue, the last decade has witnessed the upgrading of the Giant's Castle Main Caves visitor attraction (1998) and the development of rock art centres at Kamberg (2002) and Cathedral Peak (2003) (see Ndlovu, Box 5 in this volume, for additional background information). At Main Caves, new on-site text panels were developed along with a boardwalk to provide visitors with improved access to the paintings (Figure B6.1a, b); at the Kamberg Rock Art Centre visitors are shown an audio-visual presentation and have the option to visit Game Pass Shelter 1 and to purchase a booklet entitled *The Unseen Landscape: A Journey to Game Pass Shelter* (Blundell 2002); and, at the Didima Rock Art Centre at Cathedral Peak, there are museum-type displays supported by an audio-visual presentation; visitors have the option to visit Lower Mushroom Shelter, Brotherton Rock and Procession Shelter (Jeremy Hollmann pers. comm. 20 December 2007). All site visits are done in the company of a guide, who also provides interpretation.

I visited these attractions in 2007 as part of a project investigating the presentation of San archaeology and history (including rock art) in the uKhahlamba-Drakensberg, and how this has responded to the findings of local archaeological research since the 1980s. This visit built on previous trips to Main Caves (2001) and Kamberg Rock Art Centre (2002). The research has concentrated on the fixed displays and the Kamberg audio-visual presentation. This short insert briefly investigates the approaches taken in the interpretation of rock art and of the excavated past. It is worth noting that although the Didima and Kamberg visitor attractions have been called 'Rock Art Centres', both have a wider display remit and also cover other aspects of San archaeology and history.

For the rock art, the three attractions approach its interpretation differently. Kamberg only presents the shamanistic explanation, pioneered by David Lewis-Williams (1981; Lewis-Williams & Pearce 2004), while Main Caves and Didima acknowledge that more than one interpretation is currently favoured by archaeologists (i.e. the shamanistic explanation and the mythological approach developed by Ann Solomon [1997]). At Main Caves the shamanistic explanation and the mythological approach are presented on the same panel as competing approaches, while at Didima they are presented separately in adjacent cases with no reference evident of their being competing hypotheses. This lack of acknowledgement is further reflected in the explanation of therianthropic figures. In the 'Mythology' showcase at Didima it is stated that, "It is believed by some that paintings of therianthropes, made up of animal and human features, are representations of the First San," while in the 'Trance Hypothesis' showcase the text reads as follows: "It has been suggested that, in some instances, the spiritual healer could harness the power of an important animal, which could possibly explain

paintings of half-human half-animal figures." Nowhere are the Didima visitors informed that these are different ways of interpreting the same figures. Leaving aside the merits of these competing hypotheses, it is clear that the visitors to these three attractions receive an inconsistent message regarding the interpretation of the rock art.

A similar picture emerges regarding the approaches taken to the presentation of the excavated hunter-gatherer past. At Main Caves this issue is dealt with in relation to the excavation of Main Caves South and San relations with Bantu-speaking farmers and European colonists during the last 2 000 years. In contrast, at Kamberg the excavated past is completely ignored in both the audio-visual presentation and the accompanying booklet (Blundell 2002). Furthermore, on the back cover of the commercially available video of the audio-visual presentation, purchased by the author at Kamberg in 2002, it is erroneously stated that, "With the Bushmen now gone from the area, all that remains is their rock art and their stories as told by Zulu communities of the Drakensberg", without reference to the fact that there is much excavated hunter-gatherer material in the region (Mazel 1989; Mitchell, this volume). At Didima there is some, but still limited, reference to the excavated record. It includes, however, a mock Middle Stone Age (MSA) excavation, which is completely misplaced as no MSA excavations have ever taken place in the uKhahlamba-Drakensberg, as opposed to the highlands of Lesotho on the other side of the Escarpment (Carter 1978). Neither at Kamberg nor at Didima is there any mention of the rock shelters in the vicinity of the centres that have yielded extensive and varied archaeological assemblages (e.g. Collingham Shelter and Mhlwazini Cave) and that have contributed substantially to the understanding of the uKhahlamba-Drakensberg hunter-gatherer past (Mazel 1990, 1992).

Finally, there is a series of displays at Didima about rock art and 'every day life' covering 'Fish & Fish Spearing,' 'Plant Food & Foraging' and 'Paints & Preparation', but except for brief mention that bone fish hooks have been found, there is no reference to excavated remains that shed light on these themes. With this, the opportunity to integrate information from rock art and the excavated record was lost. Display of excavated artefacts would have significantly enriched the exhibits and provided visitors with a greater appreciation of the uKhahlamba-Drakensberg hunter-gatherer past.

To conclude, it is clear that while Main Caves, Kamberg and Didima visitor attractions have greatly improved the presentation of uKhahlamba-Drakensberg San archaeology and history for the public, some issues have not been adequately dealt with and others have been omitted altogether. These will require redressing in future initiatives.

REFERENCES

Blundell, G. 2002. *The Unseen Landscape: A Journey to Game Pass Shelter*. Johannesburg: Rock Art Research Institute.

Carter, P.L. 1978. The prehistory of eastern Lesotho. Unpublished PhD thesis. Cambridge: University of Cambridge.

Lewis-Williams, J.D. 1981. *Believing and Seeing: Symbolic Meanings in Southern San Rock Paintings*. London: Academic Press.

Lewis-Williams, J.D. & Pearce, D.G. 2004. *San Spirituality: Roots, Expression and Social Consequences*. Walnut Creek: AltaMira Press.

Mazel, A.D. 1989. People making history: the last ten thousand years of hunter-gatherer communities in the Thukela Basin. *Natal Museum Journal of Humanities* 1: 1–168.

Mazel, A.D. 1990. Mhlwazini Cave: the excavation of late Holocene deposits in the northern Natal Drakensberg, Natal, South Africa. *Natal Museum Journal of Humanities* 2: 95–133.

Mazel, A.D. 1992. Collingham Shelter: the excavation of late Holocene deposits, Natal, South Africa. *Natal Museum Journal of Humanities* 4: 1–52.

Solomon, A.C. 1997. The myth of ritual origins? Ethnography, mythology and interpretation of San rock art. *South African Archaeological Bulletin* 52: 3–13.

Wright, J.B. & Mazel, A.D. 2007. *Tracks in a Mountain Range: Exploring the History of the uKhahlamba-Drakensberg*. Johannesburg: Witwatersrand University Press.

PERSONAL COMMUNICATION

Jeremy Hollmann, 20 December 2007

▶ **Figures B6.1a & b**
Boardwalk at Main Caves, Giant's Castle, central Drakensberg. From RARI archive.

the 'Cologne School'. The University of Cologne, with funding from the German Research Council, supported Pager's (1989, 1993, 1995, 1998, 2000) and later Tilman Lenssen-Erz's (2001) quantitative studies in the Brandberg. These studies yielded vast volumes of numerical data and statistical analyses. Proponents of the Cologne School argue that empirical accuracy of rock art documentation allows for explanations for the rock art to evolve *directly* from the data (but see Lewis-Williams 1990).

The difficulty with all the quantitative studies is that although they produced a great deal of information – researchers knew for the first time, for instance, the percentages of depictions of eland in a given area – the meaning of the paintings did not flow from this information. Vinnicombe's analysis did, however, show that the rock paintings were not merely a reflection of the daily pursuits of San (Vinnicombe 1976: 347). She observed that selectivity of subject matter marked adherence to specific conventions. She concluded, however, "the presentation of numerical data in support of the selective and repetitive characteristics of the art is nevertheless relatively meaningless unless the rationale underlying the preferences is understood" (Vinnicombe 1976: 347). The selectivity shown by the painters themselves led Vinnicombe (1976: 349) to seek explanations in a general anthropological approach and, in particular, in a theory of ritual. She argued, for instance, that eland (Figure 5.2) served as a link between the material and spiritual worlds of the San (Vinnicombe 1976: 353).

One study that attempted to look at the relationships between categories, and produced significant results, was that of Lewis-Williams (1972, 1974), who quantified paintings in the Giant's Castle area of the KwaZulu-Natal Drakensberg and the Barkly East District of the Eastern Cape Province. Although most of the data he collected remained as opaque to understanding as those of other researchers collecting similar material, his superpositioning study did produce substantive results: he found that certain categories of image occurred in statistically significant relationships with other categories. This point, however, was where the limitations of the study became apparent: it was not possible to say what the meanings of the relationships were.

Lewis-Williams's greatest contribution as far as quantification was concerned was probably his argument against it. After he tried to use the techniques, and found

them lacking, he argued cogently against the use of quantification. His criticism was largely logical in nature. He pointed out that the programme of quantification was essentially empiricist (as distinct from good empirical work) and based on flawed inductive logic (Lewis-Williams 1983, 1984). We do not review the ensuing debates here. As Thomas Dowson (1990: 172) points out, "[c]ritiques of the practice of empiricism in rock art research have become almost as tedious as empiricism's continued practice".

Now that few researchers persist with such quantitative studies (but see e.g. Lenssen-Erz 1989, 2001; Eastwood 2003, 2005), many researchers seem to ignore this important debate from the 1980s. It is a great pity that this is the case because several of the points made apply more widely than to quantification alone. Although few researchers now make explicitly empiricist arguments, the unwitting use of arguments of this kind seems to be creeping back into rock art studies and, indeed, archaeology more widely.

Possibly the greatest benefit (and certainly not an intended one) of the quantitative programme is that it forced researchers to look in great detail at a very large number of paintings. It was the resulting familiarity with the art and its fine details that allowed for more detailed, ethnographically based interpretations. Arguments ceased being made about 'the art' and instead were made about individual figures and details of those figures.

Unfortunately, and as with empiricist arguments, this extremely important experience of earlier researchers is being forgotten. Many subsequent students of San rock art have not paid as much attention to these fine – but all-important – details of the paintings. When interpretative statements are made about 'the art' without recourse to details of particular images, we end up with largely abstract statements that, although they may appear reasonable in theoretical terms, are unable to explain details of rock art images. An example of this type of explanation is the so-called 'mythical' interpretation of San rock art (Solomon 1997), which may sound reasonable in abstract terms, but which is unable to provide interpretations for individual images. The problem results from a combination of researchers' being insufficiently familiar with enough rock art in the field and failing to design research that takes sufficient cognisance of the fine detail of rock art.

▶ **Figures 5.3a & b**
David Lewis-Williams found that many paintings depicted actions and equipment related to the trance dance; conversely, he found few images that related to other rituals. Photo by Lorna Marshall. Photo from RARI archive.

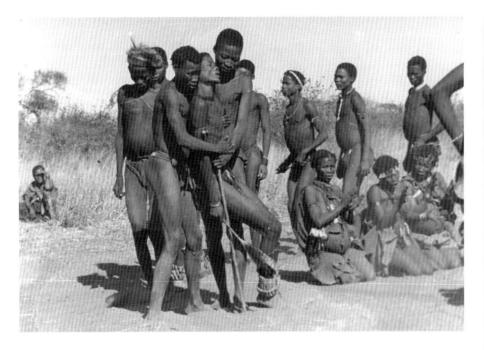

Ethnography

Although Vinnicombe was not the first researcher to use ethnography to help interpret San rock art, she did so in a much more detailed way than many of her predecessors. Whereas most earlier researchers tended to use ethnography in rather general terms (e.g. Lee & Woodhouse 1970), Vinnicombe used it more extensively and in greater detail. The *way* she used the ethnography, however, did not differ significantly from that of her predecessors. Like them, she drew direct links between the pictures and the ethnography. This approach is what has, rather disparagingly, been referred to as 'ethnographic snap': researchers search ethnographies for all the information they can find about a particular subject in the paintings (eland, for instance) and then take that information to explain paintings of that subject. Whilst the information about the subject does likely reflect indigenous knowledge on the topic, it cannot be said to necessarily explain the meaning behind the **painting** of that subject.

In Vinnicombe's case, this approach translated into searching the published ethnographies for references to animals and then trying to link the details from the ethnographies to the paintings. In this process she correlated some paintings with mythical accounts and others with the rituals described. Unfortunately, she was never able to link the mythical events she recounted to the paintings in detailed ways. Despite this obvious shortcoming, some later researchers have attempted similar correlations with similar lack of success (e.g. Solomon 1997).

Lewis-Williams overcame this problem by using ethnography in more specific ways. He was able to narrow down the context of meaning by linking rock paintings to San ritual (Lewis-Williams 1981). He discussed in detail the most prominent rituals in San society: girls' initiation, boys' first kill, marriage and the trance dance. He expressed his discussion explicitly in terms of Peirsian semiotics. Using the language of icons, indices and symbols, he argued for the specific function of signs in San society. He suggested that the images depicted in San rock art were symbolic, and that although many were polysemic, their context (i.e. a rock face) focused the associations of the symbol (Lewis-Williams 1981, 1998, 2001b). The use of ethnography in this non-literal way was a major step forward that has allowed for detailed insights into San rock art. Unfortunately, this same step has not been taken in most other branches of archaeology.

In linking his ethnographic data from San ritual to rock paintings, Lewis-Williams found that many paintings depicted actions and equipment related to the trance dance (Figures 5.3a, b); conversely, he found few images that related to other rituals (Lewis-Williams 1981). John Parkington and colleagues (Parkington 1996; Parkington & Manhire 1997; Parkington *et al.* 1996) have subsequently argued that some of these rituals are depicted in rock paintings in the Western Cape Province, but Judith Stevenson (2000) has shown that certain details suggested to be related to initiation rituals may in fact relate to other ritual and gender contexts.

Most subsequent uses of ethnography in the study of San rock art have followed a similar method. Cases have been multiplied, details refined and geographical spread increased, but the underlying method has remained essentially the same. A number of other methods for studying San rock art have, however, grown out of the use of ethnography. Probably the best known of these is the use of neuropsychology.

Ethnographically informed studies of San art showed that it was essentially religious, relating to shamanistic practices, beliefs, experiences and cosmology (Lewis-Williams & Dowson 1999; Lewis-Williams & Pearce 2004). Shamanistic ritual (the trance dance) led participants into altered states of consciousness (Katz 1982). This insight from the ethnography led researchers to examine the neuropsychological literature to find out what people in altered states of consciousness actually experienced in that state (for details see Lewis-Williams & Dowson 1988; Lewis-Williams 2001a). Information on the phenomena experienced by those in altered states proved useful in understanding certain enigmatic San paintings (e.g. Lewis-Williams 1995; Blundell 1998). Although knowledge of San ethnography led researchers to pursue neuropsychology as an interpretative method, it is important to note that it itself is not an ethnographic method. It is an independent, non-ethnographic line of evidence that can be pursued in addition to ethnography.

While interest in neuropsychology was an outgrowth of the ethnographic approach that developed after the publication of *People of the Eland*, another outgrowth of the ethnographic method, and the associated awareness of symbolism, used extensively in recent research was one which Vinnicombe's work in some ways prefigured: natural modelling. It, too, is not an ethnographic method, but one

▲▲ **Figure 5.4**
Northern Sotho paintings have been linked to boys' initiation. Photo from RARI archive.

▲ **Figure 5.5**
Vinnicombe saw contact imagery as a narrative record that she hoped to correlate with historically known events. Tracing by Pat Vinnicombe. Redrawing by Justine Olofsson.

stimulated (at least in southern Africa) by ethnography. Natural modelling refers to the modelling of symbols and non-real, supernatural aspects of belief on real, natural phenomena, often animals and their behaviour. In this way, symbols are often derived from natural phenomena in a 'logical' (rather than arbitrary) way (Whitley 2001). Southern African researchers drew on methodologically innovative studies in North America (Whitley 1994, 2001) to undertake studies explicitly using natural models to explain features of southern African San rock art (Hollmann 2002; Mguni 2004, 2005; Mallen 2005). The use of explicit natural models in this way allows researchers to link observable features of the natural world to features of rock art not directly explained by ethnography. This method, of course, is a type of analogy and subject to the methodological constraints of that type of argument (see Wylie [1982, 1985] for methodological considerations in analogy arguments).

The success of the ethnographic approach in understanding and interpreting San rock art has led the approach to be more widely used, both in other branches of southern African archaeology (Mitchell 2005) and to interpret other traditions of rock art in southern Africa. The most prominent of the other art traditions that ethnography has helped interpret are those made by Northern Sotho-speaking people in the northern parts of South Africa. These studies have linked the so-called Late White rock art (Figure 5.4) to boys' and girls' initiation rituals (Moodley 2004, 2008; Namono 2004; Namono & Eastwood 2005).

With the past success of the ethnographic method clearly demonstrated, it seems likely that it will throw light on other, so far enigmatic, traditions of rock art in southern Africa. The as yet uninterpreted geometric tradition attributed to herder people (Smith & Ouzman 2004) is, for example, also likely to be understood through ethnographic studies.

History

Linking San rock art to historical documents represents an ongoing quest, which had its inception in the publication of *People of the Eland* (Vinnicombe 1976). Vinnicombe's goal of writing a history of the south-eastern San opened the way for what has become an increasingly important research avenue, made all the more attractive by its

potential to place rock art research more firmly within the broader field of archaeology through its contribution to an understanding of social change. Vinnicombe devoted the opening chapters of *People of the Eland* to finding a link between written colonial documents relating to the Maloti-Drakensberg Mountains and the San rock paintings found in shelters throughout that region. She drew a distinction between images with 'traditional' subject matter and those that displayed colonial-period subjects or 'contact' imagery (Figure 5.5). Whilst she used an ethnographic approach to interpret the supposedly traditional subjects, she envisaged the contact imagery as a painted substitute for historical records written by the San. She thus saw contact imagery as a narrative record that she hoped to correlate with historically known events.

By her own admission (Vinnicombe 1976: 9), this approach proved to be substantially more difficult in practice than she had envisaged. Indeed, Geoffrey Blundell (2004: 63) has suggested that certain major dichotomies arose from her publication of *People of the Eland*. First, the distinction she made between 'contact' and 'traditional' imagery, and the different approaches to their interpretation, proved to be a hindrance. Second, her attempt to write an 'insider's' history of the San relied almost entirely on colonial outsider records. Despite her best efforts, she did not manage to use the 'contact' art as evidence for the San point of view. These issues have remained pertinent in the decades since her study, and subsequent research has turned to various social theories in attempts to overcome these dichotomies and incorporate San rock art into the writing of southern African history.

Colin Campbell (1986, 1987) made a ground-breaking contribution to this effort when he put forward a structural-Marxist approach to understanding change in the San rock art in the Maloti-Drakensberg region. He used the notion of symbolic labour (an idea introduced into Marxist theory by Maurice Godelier [1975, 1977] and first applied to San rock art by Lewis-Williams [1982]) to suggest that San interaction with colonists and Nguni speakers led to social change through the development of a new element in the relations of production, what he termed the *"shamanistic relation of production"* (Campbell 1987: 46, original italics). Focusing on 'contact' rock art, as categorised by Vinnicombe (1976), he suggested that this imagery was used as a backdrop that reinforced the new social order (Figure 5.6). Importantly, Campbell was able

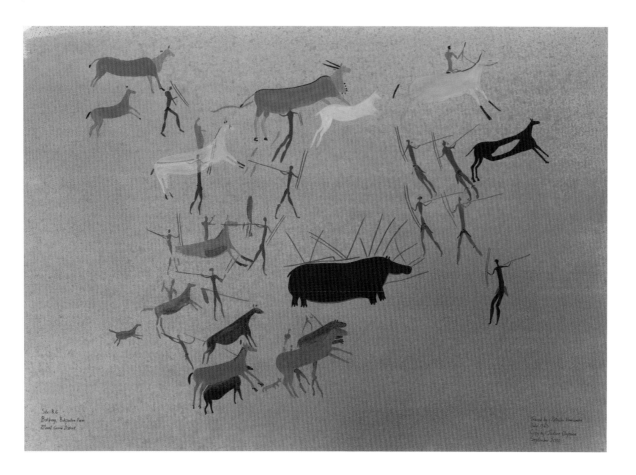

◀ **Figure 5.6**
Both Patricia Vinnicombe and Colin Campbell made a division between 'contact' and 'traditional' imagery. Images such as this one were classified as 'contact' based on their inclusion of horses. However, this kind of classification led both researchers to ignore a substantial corpus of rock art that may have played a major role in interactions. Tracing by Patricia Vinnicombe. Redrawing by Justine Olofsson.

to see the San as active agents in their relationships with others. However, Vinnicombe's division between contact and traditional imagery, which he maintained, meant that he ignored a substantial corpus of rock art that may have played a role in the interactions that he considered.

Thomas Dowson (1994, 1995, 1998, 2000) took the process of historicising San rock art a step further by employing structuration theory (as described by Bourdieu 1977; Giddens 1984). This approach provided a more nuanced explanation of social change in San societies within the Maloti-Drakensberg region. Focusing on the last 2 000 years, Dowson argued that interaction between San and newly arrived Nguni speakers precipitated change in San society, from which San shamans benefited. Focusing on 'traditional' imagery, he suggested that three phases of social change are evident in rock art in the Maloti-Drakensberg Mountains: communal groups, consortium groups, and pre-eminent shamans (Dowson 1994, 2000).

He argued that by manipulating the rules of painting, shamans were attempting to manipulate the cosmos. Importantly, he saw the art not only as a reflection of this process but as actively involved in the negotiation of social change. Perhaps the most important problem with Dowson's work is that he suggests that the social change amongst the San who produced the paintings he considers was initiated by economic changes brought about by interaction amongst San, Bantu speakers and Europeans. In the absence of dating of the specific images he considers, this position is an assumption based on broader revisionist concepts of San history. Without direct dating or associations with contact period imagery, the phases he identifies could equally well illustrate changes amongst pre-contact hunter-gatherers. Dowson's innovation in considering rock paintings to be part of active agency relationships should not, however, be underestimated. Much recent research is based on this concept.

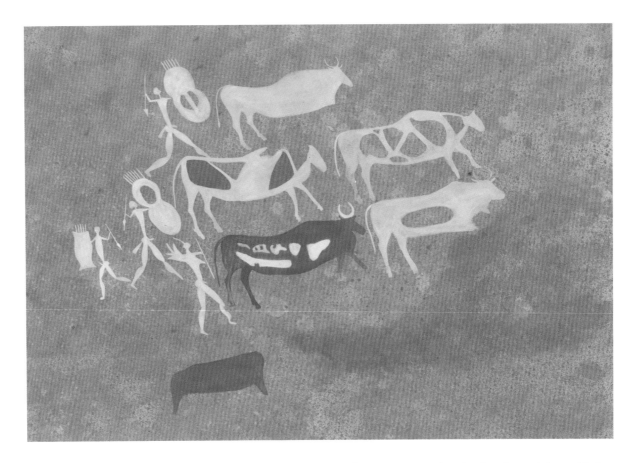

▶ **Figure 5.7**
One marker of interaction is that domestic ungulates took on symbolic meaning within the San shamanic worldview. Tracing by Patricia Vinnicombe. Redrawing by Justine Olofsson.

In addition to these structural-Marxist and structurationist approaches, other perspectives that have been termed interactionist (Blundell 2004) have also been brought to bear on the question of how to historicise San rock art. Less explicitly theoretical, these studies have sought to combine oral traditions, written historical information, and archaeological and rock art data. An early study focusing on images of domestic stock in San rock art found a correlation between paintings of fat-tailed sheep in the Cederberg Mountains of South Africa's Western Cape Province and the location of known pastoralist sites during the colonial era (Manhire *et al.* 1986). Building on this early research, an important study by Johannes Loubser and Gordon Laurens (1994) in the Caledon River Valley, Free State Province, considers the effects of the spread of Sotho-Tswana-speaking agropastoralists on the San rock art of the area. They conclude that the depiction of images such as domestic ungulates, derived from a Sotho-Tswana socio-economic world, suggests that these images came

to have meaning within the San shamanistic world view (Figure 5.7). Similarly, Simon Hall (1994) focuses on the southern Eastern Cape Province and argues that evidence from excavated material, rock art and ethnographic data suggests that San–Bantu-speaker interaction in that area was not a simple one-way process, but rather led to mutual social restructuring.

Importantly, each of these studies focuses on a specific geographical area and the particular interactions amongst the people within it, as opposed to wide, overarching generalisations. They also combine numerous strands of evidence, creating a detailed picture of the fit between the rock art and the broader historical and excavated data. However, they tend to focus only on explicit contact imagery and do not consider the role of the broader corpus of rock art in these processes of interaction.

A slight variation on these interactionist approaches is that put forward initially by Francis Thackeray (1984, 1988, 1990), and more recently by Pieter Jolly (e.g. 1995,

1996a, 1996b, 2005) and Frans Prins (1990, 1994, 1999). Given the evidence for long periods of contact with Bantu speakers, both Prins and Jolly have suggested that, contrary to the earlier work of Vinnicombe and Lewis-Williams, San paintings should not be interpreted exclusively in terms of San ethnography, but that interpretation should consider also the ethnography of Bantu speakers.

Jolly (1996b) suggests that the establishment of a symbiotic relationship between the San and Bantu speakers in the Drakensberg may have meant that the San adopted some of the ritual and religious elements of their agropastoralist neighbours, and that aspects of their art should thus be interpreted from the Bantu-speakers' perspective. Prins (1994, 1999) emphasises evidence for intermarriage amongst San and Bantu speakers, concluding that all San rock art may be seen as 'contact' imagery. Although Prins and Jolly do not conceptualise the relationships between San and Bantu speakers in the same way, both positions overlook evidence for multidirectional and changing relationships in which the San often played an influential role (recently, Jolly (2007) has softened his previous position somewhat, and has acknowledged this multi-directional flow of influence, although he maintains an emphasis on the dominance of agro-pastoral religious beliefs). Important examples of this include linguistic evidence concluding that the Nguni languages from this south-eastern region of South Africa have incorporated clicks from San languages (e.g. Louw 1977, 1979; Herbert 1990a, 1990b, 1995). In addition to this, the anthropologist David Hammond-Tooke (1997, 1998, 1999, 2002) has argued extensively that certain distinctive cultural elements found amongst south-eastern Nguni speakers are not found in any other Bantu-speaking group, but were borrowed from the San. His argument for cultural borrowing contradicts the idea of a unidirectional flow of information from Bantu speakers to San, and emphasises the need for a more nuanced conception of the ways in which San rock art and historical information may be combined.

The challenge of combining San rock art and historical information has been taken up by Sam Challis (2008), whose work in the Maloti-Drakensberg region integrates ethnographic and historical information with a recurring set of images: dancing groups, baboons, horses, and baboon and horse therianthropes. Based on coherence of style and regional location, he argues that this category of images was made by the AmaTola, a creolised group of

mounted raiders who occupied the area in the nineteenth century. Prolonged precolonial interaction amongst hunter-gatherers, pastoralists and agropastoralists in this region, he argues, resulted in a coalescence of certain cultural beliefs. Drawing on the ethnography of San, Khoekhoen and Bantu-speaking groups, all of whom are represented among the AmaTola, Challis highlights overlapping beliefs. The connection between this multi-ethnic group and the rock art allows Challis to circumvent one of the problems of earlier interactionist approaches, which focused on the directionality of cultural borrowing. Instead, the concept of 'cultural coherence' (Challis 2008: 146), established with recourse to ethnographic and painted data, is used to provide new insights into the worldview of a creolised raiding group. Importantly, Challis notes that 'every instance of interaction was different' (2008: 44). In focusing on the particular case of the AmaTola, he is able to build a detailed and nuanced understanding of this group and a subcategory of rock art that is linked to them. Individual cases of focused and nuanced research such as this will collectively allow us to build up a broader picture that more accurately reflects the complexity of inter-ethnic interaction in the historical period and its relationship to the production and consumption of rock art (see also Mallen 2008).

▲ **Figure 5.8**
Nomansland. The southern Drakensberg was the home of the last San painters. From RARI archive.

In contrast, Blundell (2004) has suggested that the key to overcoming some of the difficulties inherent in previous approaches to historicising San rock art is theoretical. Blundell suggests that the adoption of social theories of a structural type, typical of the approaches already discussed, creates the impression that the art was something that was intellectualised. Drawing on ethnographic and painted evidence, he argues that the art was experienced rather than intellectualised and that the production and consumption of rock art needs to be seen as an embodied process. Using theories of embodiment to explain social change in the San communities in Nomansland (northern Eastern Cape Province; Figure 5.8), Blundell argues that a particular category of anthropomorphic images, described as significantly differentiated figures (SDFs; similar to Dowson's pre-eminent shamans), were depictions of "powerful individual potency-owners" (Blundell 2004: 176). He suggests that a progression in the painted evidence from SDFs to large-headed SDFs represents a shift in the role of San ritual specialists through time. He argues that as global and local processes of interaction came to have more of an effect on Nomansland, the changing role of San ritual specialists from healers to rainmakers served to decrease the importance of the post-cranial body in ritual and some classes of rock art (Blundell 2004: 177). Arguing that the body is intimately tied up with identity construction, he suggests that we should see this change in the depiction of images as evidence of a shift in the way individual identity was constructed in ritual in the San communities of Nomansland (Blundell 2004: 177).

Directions

A preliminary examination of the trajectory of rock art research in southern Africa suggests that **methodological** changes have played a far greater role in advancing study of the art than the application of new theories. In particular, the ethnographic method has proved pivotal in our current understanding of the art. Indeed, it is telling that this method has remained constant whilst one theory after another has come and gone. On the other hand, one should consider that it was probably broad theoretical changes that led to the adoption of the ethnographic method in the first place, or at least provided the conditions necessary for its adoption. Research so far has led us to a position in which we now know a great deal about San rock art, certainly much more than was known when Vinnicombe was writing *People of the Eland*. Indeed, it would

be fair to say that we broadly understand what San rock art is about, both at the level of the art corpus and at the level of many classes of imagery. It is no longer necessary for researchers to argue over this broad understanding or to justify it in each publication: the broad-level, ethnographically derived understanding of San rock art as religious in nature and relating to shamanistic practices is now generally accepted and understood. This is, of course, not to say that one cannot criticise details of interpretations – many such details do require revision – and new emphases can usefully be employed. The pre-Vinnicombe days of "gazing and guessing" (Lewis-Williams 2002), where any guess seemed as good as any other, are, thankfully, now long gone. One can no longer promote contrary opinions of the art simply for the sake of having a different opinion or appearing critical (Whitley 2006). Unless these contrary opinions are strongly grounded in San ethnography, San history, details of the rock art, and are able to explain even more specific details within San art than the current explanation, they should be rejected. If researchers wish to contest the broad-level interpretation they need to present an alternative, more persuasive explanation that accounts for more of the data and is internally consistent, rather than simply making claims that cannot be substantiated by the available evidence.

The next challenge for researchers is not the continued justification of the overall understanding of the art, but an engagement with the art on a much finer scale. This is, in a way, what Vinnicombe was attempting to do in *People of the Eland*. Subsequent research has now made such studies possible. Instead of understanding 'the art', researchers need to begin to work out detailed interpretations for individual shelters. The accumulation of and relationship between paintings in a particular shelter has often been discussed in terms of the physical sequence of paintings, but much still needs to be done when we consider these same accumulations and relationships in cognitive, symbolic and social terms. Similarly, the relationships between particular sites need to be examined.

In addressing these challenges researchers need to beware: a major trend in world archaeology is towards theorisation. Whilst not in any way wishing to deny the important role of theory (our discussion has illustrated how changing theory has helped refine interpretations), researchers need to be cautious of relying too heavily on it. Here we do not refer to the use of theory in interpretation,

but to the imposition of wholesale theoretical explanations – gender or landscape, for instance – without recourse to details of the art and ethnography. It is, after all, only one part of a suite of tools researchers need to use in crafting an interpretation. The relationship between theory and data is one that has changed repeatedly in studies of San rock art. Researchers have to guard against the pendulum swinging too far in either direction (Dowson 2001: 313). The unintentional lesson of quantification has much to teach students answering these new questions: researchers must engage with details of the rock art images.

A second area, on a much larger scale of analysis, which is also beginning to open up, is the consideration of regional diversity. This is an area into which frequent, but not particularly successful, forays have been made. Vinnicombe's suggestion that quantitative studies could show regional variations in San rock art was certainly correct. Differences of composition and frequency can (and have) certainly be demonstrated. The next step is to answer the questions of why the differences occur and what those differences mean. Answering those questions will once more return researchers to consideration of fine details of the art and locally specific ethnographies and historical sources.

The work Vinnicombe pioneered has come a long way since she introduced her innovations. We are, however, by no means approaching the end of the intellectual trajectory upon which she embarked almost 50 years ago. The quest for more detailed meaning in rock art research continues. Although now equipped with an ever-growing collection of interpretative tools, the task ahead remains a challenging and exciting one.

Acknowledgements

Our thanks go to the editors for inviting us to contribute to this volume. We thank colleagues and a referee who commented on drafts of this chapter. The Rock Art Research Institute is funded by the South African National Research Foundation and the University of the Witwatersrand. Neither institution is responsible for the views expressed herein.

References

Blundell, G. 1998. On neuropsychology in southern African rock art research. *Anthropology of Consciousness* 9: 3–12.

Blundell, G. 2004. *Nqabayo's Nomansland: San Rock Art and the Somatic Past*. Uppsala: Uppsala University Press.

Bourdieu, P. 1977. *Outline of a Theory of Practice*. Cambridge: Cambridge University Press.

Campbell, C. 1986. Images of war: a problem in San rock art research. *World Archaeology* 18: 255–267.

Campbell, C. 1987. Art in crisis: contact period rock art in the south-eastern mountains of southern Africa. Unpublished MSc thesis. Johannesburg: University of the Witwatersrand.

Challis, W. 2008. The impact of the horse on the AmaTola 'Bushmen': New identity in the Maloti-Drakensberg Mountains of southern Africa. Unpublished D.Phil thesis. Oxford: University of Oxford.

Deacon, J. 2006. Rock art conservation and tourism. *Journal of Archaeological Method and Theory* 13(4): 379–399.

Dowson, T.A. 1990. Rock art research's umbilical cord: a review of *Africa Praehistorica*, Vol. 1, The rock paintings of the Upper Brandberg: Part I Amis Gorge, Heinrich-Barth-Institut, Köln. *Cimbebasia* 12: 172–176.

Dowson, T.A. 1994. Reading art, writing history: rock art and social change in southern Africa. *World Archaeology* 25: 332–345.

Dowson, T.A. 1995. Hunter-gatherers, traders and slaves: the 'Mfecane' impact on Bushmen, their ritual and their art. In: Hamilton, C. (ed.) *The Mfecane Aftermath: Reconstructive Debates in Southern African History*: 51–70. Johannesburg: Witwatersrand University Press.

Dowson, T.A. 1998. Rain in Bushman belief, politics and history: the rock-art of rain-making in the south-eastern mountains, southern Africa. In: Chippindale, C. & Taçon, P.S.C. (eds) *The Archaeology of Rock-Art*: 73–89. Cambridge: Cambridge University Press.

Dowson, T.A. 2000. Painting as politics: exposing historical processes in hunter-gatherer rock art. In: Schweitzer, P.P., Biesele, M. & Hitchcock, R. (eds) *Hunters and Gatherers in the Modern World: Conflict, Resistance and Self-determination*: 413–426. New York: Berghahn Books.

Dowson, T.A. 2001. Queer theory and feminist theory: towards a sociology of sexual politics in rock art research. In: Helskog, K. (ed.) *Theoretical Perspectives in Rock Art Research*: 312–329. Oslo: Novus Forlag.

Eastwood, E.B. 2003. A cross-cultural motif in San, Khoekhoe and Northern Sotho rock paintings of the Central Limpopo Basin,

southern Africa. *South African Archaeological Bulletin* 58: 14–26.

Eastwood, E.B. 2005. From girls to women: female imagery in the San rock paintings of the Central Limpopo Basin, southern Africa. *Before Farming* [online version] 2005/3, Article 2.

Giddens, A. 1984. *The Constitution of Society: Outline of the Theory of Structuration.* Cambridge: Polity Press.

Godelier, M. 1975. Modes of production, kinship, and demographic structures. In: Bloch, M. (ed.) *Marxist Analyses and Social Anthropology*: 3–27. London: Malaby Press.

Godelier, M. 1977. *Perspectives in Marxist Anthropology.* Cambridge: Cambridge University Press.

Hall, K., Meiklejohn, I., Arocena, J., Prinsloo, L., Sumner, P. & Hall, L. 2007. Deterioration of San rock art: new findings, new challenges. *South African Journal of Science* 103: 361–362.

Hall, S. 1994. Images of interaction: rock art and sequence in the Eastern Cape. In: Dowson, T.A. & Lewis-Williams, J.D. (eds) *Contested Images: Diversity in Southern African Rock Art Research*: 61–82. Johannesburg: Witwatersrand University Press.

Hammond-Tooke, W.D. 1997. Whatever happened to /Kaggen? A note on Cape Nguni/Khoisan borrowing. *South African Archaeological Bulletin* 52: 122–124.

Hammond-Tooke, W.D. 1998. Selective borrowing? The possibility of San shamanistic influence on Southern Bantu divination and healing practices. *South African Archaeological Bulletin* 53: 9–15.

Hammond-Tooke, W.D. 1999. Divinatory animals: further evidence of San–Nguni borrowing. *South African Archaeological Bulletin* 54: 128–132.

Hammond-Tooke, W.D. 2002. The uniqueness of Nguni mediumistic divination in southern Africa. *Africa* 72: 277–292.

Herbert, R.K. 1990a. The sociohistory of clicks in southern Bantu. *Anthropological Linguistics* 32: 120–138.

Herbert, R.K. 1990b. The relative markedness of click sounds: evidence from language change, acquisition and avoidance. *Anthropological Linguistics* 32: 295–315.

Herbert, R.K. 1995. The sociohistory of clicks in Southern Bantu. In: Mesthrie, R. (ed.) *Language and Social History: Studies in South African Sociolinguistics*: 51–67. Cape Town: David Philip.

Hœrle, S. 2005. A preliminary study of the weathering activity at the rock art site of Game Pass Shelter (KwaZulu-Natal, South Africa) in relation to its conservation. *South African Journal of Geology* 108: 297–308.

Hœrle, S. 2006. Rock temperatures as an indicator of weathering processes affecting rock art. *Earth Surface Processes and Landforms* 31: 383–389.

Hœrle, S. & Salomon, A. 2004. Microclimatic data and rock art conservation at Game Pass Shelter in the Kamberg Nature Reserve, KwaZulu-Natal. *South African Journal of Science* 100: 340–341.

Hollman, J.C. 2002. Natural models, ethology and San rock-paintings: pilo-erection and depictions of bristles in southeastern South Africa. *South African Journal of Science* 98: 563–567.

Hughes, J.C. & Solomon, A.C. 2000. A preliminary study of ochres and pigmentaceous materials from KwaZulu-Natal, South Africa: towards an understanding of San pigment and paint use. *Southern African Humanities* 12: 15–31.

Jolly, P. 1995. Melikane and Upper Mangolong revisited: the possible effects on San art of symbiotic contact between south-eastern San and Southern Nguni and Sotho communities. *South African Archaeological Bulletin* 50: 68–80.

Jolly, P. 1996a. Interaction between south-eastern San and southern Nguni and Sotho communities *c.* 1400 to *c.* 1800. *South African Historical Journal* 35: 30–61.

Jolly, P. 1996b. Symbiotic interaction between black farmers and south-eastern San. *Current Anthropology* 37: 277–305.

Jolly, P. 2005. Sharing symbols: a correspondence in the ritual dress of black farmers and the south-eastern San. *South African Archaeological Society Goodwin Series* 9: 86–100.

Jolly, P. 2007. Before farming? Cattle kept and painted by the southeastern San. *Before Farming* [online version] 2007/4, Article 2.

Katz, R. 1982. *Boiling Energy: Community Healing Among the Kalahari Kung.* Cambridge (MA): Harvard University Press.

Lee, D.N. & Woodhouse, H.C. 1970. *Art on the Rocks of Southern Africa.* London: Purnell.

Lenssen-Erz, T. 1989. The conceptual framework for the analysis of the Brandberg rock paintings. In: Pager, H. *The Rock Paintings of the Upper Brandberg: Part I Amis Gorge*: 361–370. Köln: Heinrich-Barth-Institut.

Lenssen-Erz, T. 2001. *Gemeinschaft-Gleichheit-Mobilität: Felsbilder im Brandberg, Namibia, und ihre Bedeutung. Grundlagen einer textuellen Felsbildarchäologie.* Köln: Heinrich-Barth-Institut.

Leroi-Gourhan, A. 1968. *The Art of Prehistoric Man in Western Europe.* London: Thames and Hudson.

Lewis-Williams, J.D. 1972. The syntax and function of the Giant's Castle rock paintings. *South African Archaeological Bulletin* 27: 49–65.

Lewis-Williams, J.D. 1974. Superpositioning in a sample of rock paintings from the Barkly East District. *South African Archaeological Bulletin* 29: 93–103.

Lewis-Williams, J.D. 1981. *Believing and Seeing: Symbolic Meanings in Southern San Rock Paintings*. London: Academic Press.

Lewis-Williams, J.D. 1982. The economic and social context of southern San rock art. *Current Anthropology* 23: 429–449.

Lewis-Williams, J.D. 1983. Introductory essay: science and rock art. *South African Archaeological Society Goodwin Series* 4: 3–13.

Lewis-Williams, J.D. 1984. The empiricist impasse in southern African rock art studies. *South African Archaeological Bulletin* 39: 58–66.

Lewis-Williams, J.D. 1990. Documentation, analysis and interpretation: dilemmas in rock art research. *South African Archaeological Bulletin* 45: 126–136.

Lewis-Williams, J.D. 1995. Seeing and construing: the making and 'meaning' of a southern African rock art motif. *Cambridge Archaeological Journal* 5: 3–23.

Lewis-Williams, J.D. 1998. *Quanto?* The issue of 'many' meanings in southern African San rock art research. *South African Archaeological Bulletin* 53: 86–97.

Lewis-Williams, J.D. 2001a. Brainstorming images: neuropsychology and rock art research. In: Whitley, D.S. (ed.) *Handbook of Rock Art Research*: 332–357. Walnut Creek: AltaMira Press.

Lewis-Williams, J.D. 2001b. Monolithism and polysemy: Scylla and Charybdis in rock art research. In: Helskog, K. (ed.) *Theoretical Perspectives in Rock Art Research*: 23–39. Oslo: Novus Forlag.

Lewis-Williams, J.D. 2002. *A Cosmos in Stone: Interpreting Religion and Society through Rock Art*. Walnut Creek: AltaMira Press.

Lewis-Williams, J.D. & Dowson, T.A. 1988. The signs of all times: entoptic phenomena in Upper Palaeolithic art. *Current Anthropology* 29: 201–245.

Lewis-Williams, J.D. & Dowson, T.A. 1999. *Images of Power: Understanding San Rock Art* (second edition). Johannesburg: Southern Book Publishers.

Lewis-Williams, J.D. & Pearce, D.G. 2004. *San Spirituality: Roots, Expressions, and Social Consequences*. Cape Town: Double Storey.

Loubser, J. & Laurens, G. 1994. Depictions of domestic ungulates and shields: hunter-gatherers and agro-pastoralists in the Caledon River Valley area. In: Dowson, T.A. & Lewis-Williams, J.D. (eds) *Contested Images: Diversity in Southern African Rock Art Research*: 83–118. Johannesburg: Witwatersrand University Press.

Louw, J.A. 1977. The adaptation of non-click consonants in Xhosa. *Khoisan Linguistic Studies* 3: 74–92.

Louw, J.A. 1979. A preliminary survey of Khoi and San influence in Zulu. *Khoisan Linguistic Studies* 8: 21–89.

Maggs, T.M.O'C. 1967. A quantitative analysis of the rock art from a sample area in the western Cape. *South African Journal of Science* 63: 100–106.

Mallen, L. 2005. Linking sex, species and a supernatural snake at LAB X rock art site. *South African Archaeological Society Goodwin Series* 9: 3–10.

Mallen, L. 2008. Rock Art and Identity in the North Eastern Cape Province. Unpublished MA thesis. Johannesburg: University of the Witwatersrand.

Manhire, A.H., Parkington, J.E., Mazel, A.D. & Maggs, T.M.O'C. 1986. Cattle, sheep and horses: a review of domestic animals in the rock art of southern Africa. *South African Archaeological Society Goodwin Series* 5: 22–30.

Mazel, A.D. & Watchman, A.L. 1997. Accelerator radiocarbon dating of Natal Drakensberg paintings: results and implications. *Antiquity* 71: 445–449.

Mazel, A.D. & Watchman, A.L. 2003. Dating rock paintings in the Ukhahlamba-Drakensberg and the Biggarsberg, KwaZulu-Natal, South Africa. *Southern African Humanities* 15: 59–73.

Meiklejohn, K.I., Hall, K. & Davis, J.K. 2009. Weathering of rock art at two sites in the KwaZulu-Natal Drakensberg, southern Africa. *Journal of Archaeological Science* 36: 973–979.

Mguni, S. 2004. Cultured representation: understanding 'formlings', an enigmatic motif in the rock art of Zimbabwe. *Journal of Social Archaeology* 4: 181–199.

Mguni, S. 2005. A new iconographic understanding of formlings, a pervasive motif in Zimbabwean rock art. *South African Archaeological Society Goodwin Series* 9: 34–44.

Mitchell, P.J. 2005. Why hunter-gatherer archaeology matters: a personal perspective on renaissance and renewal in southern African Later Stone Age research. *South African Archaeological Bulletin* 60: 64–71.

Moodley, S. 2004. *Koma*: the crocodile motif in the rock art of the Makgabeng Plateau, Limpopo Province, South Africa. Unpublished MA thesis. Johannesburg: University of the Witwatersrand.

Moodley, S. 2008. *Koma*: the crocodile motif in the rock art of the northern Sotho. *South African Archaeological Bulletin* 63: 116–124.

Namono, C. 2004. *Dikgaatwane tsa Basadi*: a study of the link between girls' initiation and rock art in the Makgabeng

Plateau, Limpopo Province, South Africa. Unpublished MA thesis. Johannesburg: University of the Witwatersrand.

Namono, C. & Eastwood, E.B. 2005. Art, authorship and female issues in a Northern Sotho rock painting site. *South African Archaeological Society Goodwin Series* 9: 77–85.

Pager, H. 1971. *Ndedema: A Documentation of the Rock Paintings of the Ndedema Gorge.* Graz: Akademische Druk.

Pager, H. 1989. *The Rock Paintings of the Upper Brandberg: Part I Amis Gorge.* Köln: Heinrich-Barth-Institut.

Pager, H. 1993. *The Rock Paintings of the Upper Brandberg: Part II Hongorob Gorge.* Köln: Heinrich-Barth-Institut.

Pager, H. 1995. *The Rock Paintings of the Upper Brandberg: Part III Southern Gorges.* Köln: Heinrich-Barth-Institut.

Pager, H. 1998. *The Rock Paintings of the Upper Brandberg: Part IV Umuab and Karoub Gorges.* Köln: Heinrich-Barth-Institut.

Pager, H. 2000. *The Rock Paintings of the Upper Brandberg: Part V Naib Gorge (A) and the Northwest.* Köln: Heinrich-Barth-Institut.

Parkington, J.E. 1996. What is an eland? *N!ao* and the politics of age and sex in the paintings of the Western Cape. In: Skotnes, P. (ed.) *Miscast: Negotiating the Presence of the Bushmen*: 281–289. Cape Town: University of Cape Town Press.

Parkington, J.E. & Manhire, A.H. 1997. Processions and groups: human figures, ritual occasions and social categories in the rock paintings of the Western Cape, South Africa. In: Conkey, M.W., Soffer, O., Stratmann, D. & Jablonski, N.G. (eds) *Beyond Art: Pleistocene Image and Symbol*: 301–320. Berkeley: California Academy of Sciences.

Parkington, J.E., Manhire, A.H. & Yates, R. 1996. Reading San images. In Deacon, J. & Dowson, T.A. (eds) *Voices From the Past: /Xam Texts and the Bleek and Lloyd Collection*: 212–233. Johannesburg: Witwatersrand University Press.

Pearce, D.G. 2002. Changing men, changing eland: sequences in the rock paintings of Maclear District, Eastern Cape, South Africa. *American Indian Rock Art* 28: 129–138.

Pearce, D.G. 2006. A comment on Swart's rock art sequences and use of the Harris Matrix in the Drakensberg. *Southern African Humanities* 18(2): 173–177.

Prins, F.E. 1990. Southern Bushman descendants in the Transkei: rock art and rainmaking. *South African Journal of Ethnology* 13: 110–116.

Prins, F.E. 1994. Living in two worlds: the manipulation of power relations, identity and ideology by the last San rock artist of the Transkei, South Africa. *Natal Museum Journal of Humanities* 6: 179–193.

Prins, F.E. 1999. Dissecting diviners: on positivism, trance-

formations, and the unreliable informant. *Natal Museum Journal of Humanities* 11: 43–62.

Russell, T. 2000. The application of the Harris Matrix to San rock art at Main Caves North, KwaZulu-Natal. *South African Archaeological Bulletin* 55: 60–70.

Smith, B.W. & Ouzman, S. 2004. Taking stock: identifying Khoekhoen herder rock art in southern Africa. *Current Anthropology* 45: 499–525.

Solomon, A.C. 1997. The myth of ritual origins? Ethnography, mythology and interpretation of San rock art. *South African Archaeological Bulletin* 52: 3–13.

Stevenson, J. 2000. Shaman images in San rock art: a question of gender. In: Donald, M. & Hurcombe, L. (eds) *Representations of Gender from Prehistory to Present*: 45–66. London: Macmillan.

Swart, J. 2004. Rock art sequences in the uKhahlamba-Drakensberg Park, South Africa. *Southern African Humanities* 16: 13–35.

Thackeray, J.F. 1984. Masquerade and therianthropes in art. *The Digging Stick* 2: 2.

Thackeray, J.F. 1988. Southern African rock art and Xhosa beliefs associated with *abantubomlambo. Pictogram* 1: 2–3.

Thackeray, J.F. 1990. On concepts expressed in southern African rock art. *Antiquity* 64: 139–144.

Vinnicombe, P. 1967a. Rock painting analysis. *South African Archaeological Bulletin* 22: 129–141.

Vinnicombe, P. 1967b. The recording of rock paintings: an interim report. *South African Journal of Science* 63: 282–284.

Vinnicombe, P. 1976. *People of the Eland: Rock Paintings of the Drakensberg Bushmen as a Reflection of Their Life and Thought.* Pietermaritzburg: Natal University Press.

Whitley, D.S. 1994. Shamanism, natural modelling, and the rock art of far western North America. In: Turpin, S. (ed.) *Shamanism and Rock Art in North America*: 1–43. San Antonio: Rock Art Foundation.

Whitley, D.S. 2001. Science and the sacred: interpretive theory in U.S. rock art research. In: Helskog, K. (ed.) *Theoretical Perspectives in Rock Art Research*: 130–157. Oslo: Novus Forlag.

Whitley, D.S. 2006. Is there a shamanism and rock art debate? *Before Farming* [online version] 2006/4, Article 7.

Wylie, A. 1982. An analogy by any other name is just as analogical: a commentary on the Gould–Watson dialogue. *Journal of Anthropological Archaeology* 1: 382–401.

Wylie, A. 1985. The reaction against analogy. *Advances in Archaeological Method and Theory* 8: 63–111.

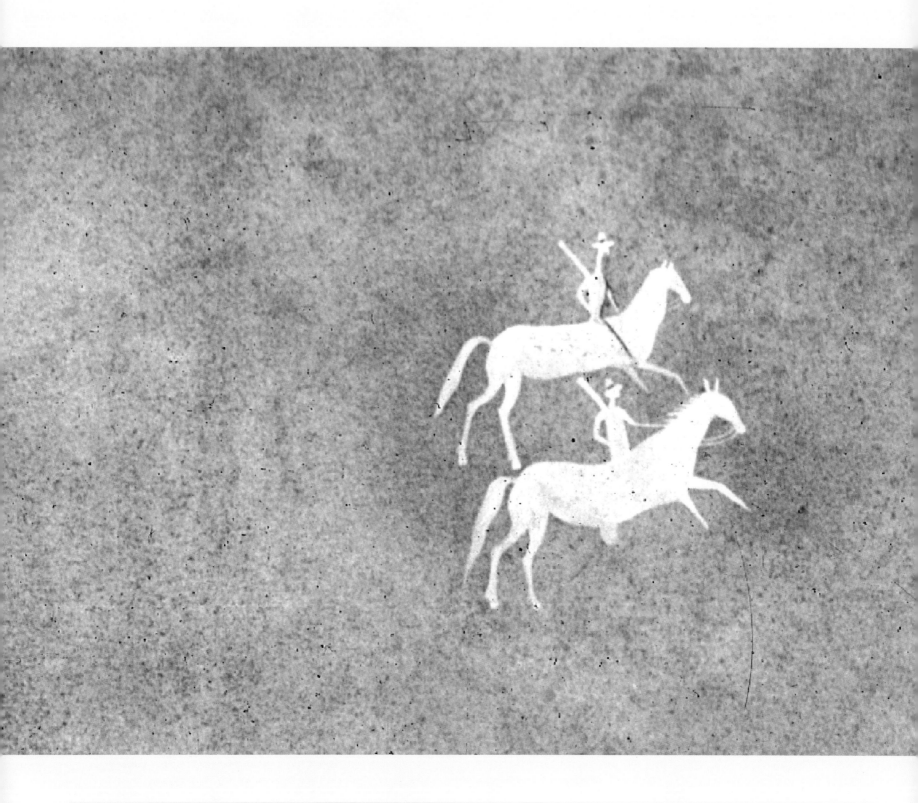

CHAPTER SIX

Images in time:
Advances in the dating of Maloti-Drakensberg rock art since the 1970s

Aron D Mazel

At present it would seem that the only real hope for dating the rock-art is the discovery of single occupations, with hearths, in shelters or caves exhibiting art of a single style. (Seddon & Vinnicombe 1967: 112)

… the dual research project undertaken by Patrick Carter and myself of integrating the art and archaeology of Lesotho and the Natal uplands, sadly did not materialise. (Vinnicombe, this volume)

These quotations reflect the long-standing interest that Patricia Vinnicombe had in not only dating the Maloti-Drakensberg paintings, but also in integrating the information from the art with that derived from the excavation of rock shelters. It is particularly evident from the second quotation that Vinnicombe and Carter realised that an improved understanding of hunter-gatherer history in the Maloti-Drakensberg area would benefit from "integrating the art and archaeology"[1] and this was something to which they aspired when undertaking their fieldwork in the 1960s and 1970s. However, reflecting back on their research some years later, Vinnicombe commented that their vision "sadly did not materialise". No doubt, there are numerous reasons for this. One of them, it seems likely, was the absence of an absolute chronological framework for the paintings with which to underpin efforts to connect these data sets. However, Vinnicombe and Carter were certainly not alone in this because the lack of integration is a problem that has frustrated archaeologists

working elsewhere in southern Africa and other parts of the world for a long time.

Encouragingly, the last decade has witnessed significant progress in the absolute and relative dating of the Maloti-Drakensberg paintings and it would have been gratifying for Vinnicombe, before her untimely death, to have witnessed some of the major developments in the dating of the paintings since the 1970s: the discovery of the painted slab at Collingham Shelter, which dates back to at least 1 800 years ago (Mazel 1992a, 1994); the first radiocarbon date on a painting (Mazel & Watchman 1997); and the production of the first Harris Matrix scheme from Main Caves North (Russell 1997, 2000). These and subsequent developments have given some cause for optimism regarding the dating of the paintings and, building on these developments, we have finally begun a move towards the integration of information from rock art with excavation data that Vinnicombe and Carter sought.

This chapter has two aims: first, to track the advances in the dating of the paintings during the last 30 years and to situate them within the debates and contexts in which they have occurred; and, second, to outline the current understanding regarding the dating with a view to considering some of its implications for developing a more nuanced understanding of Maloti-Drakensberg precolonial and early colonial history. Geographically, the focus in this chapter is on the uKhahlamba-Drakensberg Mountains (hereafter the Drakensberg) of KwaZulu-Natal because a considerable amount of chronologically inspired rock art research has taken place in this region but, where appropriate, reference will be also made to adjacent areas

◀ Detail of Figure 6.1

such as the Maloti Mountains. For the purposes of this chapter, the Drakensberg is defined as the area between Royal Natal National Park in the north and Bushman's Nek in the south.

The changing face of dating the Drakensberg paintings since the 1970s

Attempts to sequence the paintings go back to at least the 1930s with Mason's (1933) research in the Cathkin Park and Cathedral Peak areas of the northern Drakensberg. However, it was Harald Pager (1971), working in the northern Drakensberg, and Vinnicombe (1976), working in the southern Drakensberg, Lesotho and East Griqualand, who developed the first rigorous sequences of rock art not only in these areas but, as far as I know, in southern Africa as a whole. Drawing on various criteria such as colour schemes, subject matter and techniques of application, Pager and Vinnicombe showed clearly that the imagery created by the hunter-gatherers was subject to change over time. Although two decades passed before their sequencing work was built on, it is evident that it laid the foundation for the Harris Matrix sequences produced by Russell (1997, 2000) and Swart (2004). In developing their sequences, Pager and Vinnicombe drew on the intimate knowledge of the paintings that they had acquired through extensive hours of first-hand engagement by observing, tracing, photographing and reproducing them. Pager's (1971) sequence concentrated on eland paintings alone, while Vinnicombe (1976) drew on a fuller range of imagery. Vinnicombe recognised four phases in the rock art, while Pager recognised seven styles. As I discuss later, their sequences have generally stood up well against the recent, more detailed sequences developed using the Harris Matrix methodology (Russell 1997, 2000; Swart 2004).

Given the substantial number of domestic animals and colonial imagery represented in the southern Drakensberg, it is unsurprising that Vinnicombe (1976) focused much attention on these paintings, suggesting a narrow age band for their production and, in some instances, even offering possible specific dates for individual paintings. She argued that it was improbable that the paintings on the KwaZulu-Natal side of the Drakensberg post-dated 1870 and believed that most must have been executed before 1850. As she commented: "Because of the unique combination of accurate and graphic portrayal by the Bushman artists, together

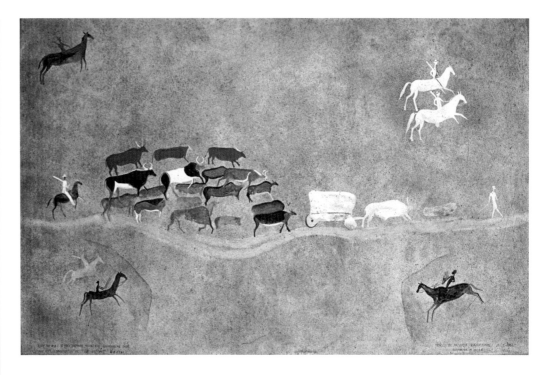

▲ **Figure 6.1**
Bamboo Mountain 5: Vinnicombe copy showing horsemen with hats and guns, cattle and a wagon which may represent Captain Gardiner's 1835 expedition which passed nearby to the site. From Natal Museum archive.

with detailed archival documentation, these paintings are among the very few that can be dated to within such narrow limits of time" (Vinnicombe 1976: 158). In terms of actual scenes, Vinnicombe speculated whether the painted scene of a wagon on Bamboo Mountain was not perhaps a hunter-gatherer representation of Captain Gardiner's 1835 expedition, which passed nearby to the site in which it is painted (Figure 6.1), and whether the scene showing 22 horsemen in the upper Lotheni might not reflect Harding's commando, which travelled through this area in 1847. Furthermore, drawing on archival evidence, she believed that paintings of domestic animals were already present in the upper Mzimkhulu in 1849 and that painted scenes showing cattle and horse raids could be tentatively related to events that took place in the area in 1847 and 1848. Colin Campbell (1987) later challenged Vinnicombe's hypothesised attribution of certain painted scenes to actual events, but did not provide adequate evidence to indicate why this is not necessarily the case. This is an interesting issue that requires further research and debate.

Despite the progress that Vinnicombe made in sequencing the paintings, she appeared to be despondent about the efficacy of her results, as reflected in this comment:

A study of the relationship between the various layers of paintings in an effort to recognise phases of development and thereby establish a chronological framework for relative dating proved disappointing in many respects. There was little correlation between subject matter, style and size, but some consistency emerged in the colour and application of the paints. Although as many as six layers of paintings were observed at many sites, only four clearly recognisable but overlapping phases can be isolated in a general study. (Vinnicombe 1976: 139)

The comment is particularly interesting in the light of the difficulty experienced by Swart (2004: 29) in relating her seven-phase sequence at Ngwangwane 8 with Vinnicombe's four-phase sequence for the southern Drakensberg. Interestingly, the tension experienced by Vinnicombe and Swart in formulating layers of painting by combining smaller stratigraphic units resonates with the experience of excavators making the same decisions with earth-based archaeological deposits. One of the key differences, however, is that with rock art the original material can be revisited and reassessed because the research processes used are not destructive.

▼ **Figure 6.2**
Bundoran 1: Eland from which paint sample ND4 was taken. Photo by Aron Mazel.

More or less concurrently with Pager and Vinnicombe developing their sequences, Denninger (1971), from Stuttgart, was exploring the possibility of dating the paintings using the paper chromatography method, which is based on the presence of amino acids in the paint (but see also Pager 1971; Willcox 1971). Tests were conducted on paintings at Royal Natal National Park, Cathedral Peak, Cathkin Park and Giant's Castle. Denninger's results indicated that the paintings were done mostly during the last 500 years, although an eland from Cat Cave in the Mhlwazini Valley (Cathkin Park) was dated to around 800 years ago (Denninger 1971). Both Pager (1971) and Vinnicombe (1976) reflected on the applicability of Denninger's results to their painting sequences, but the 1980s critiques (Rudner 1983, 1989; Thackeray 1983) of Denninger's work showed that there were flaws in his methodology and this technique has not been pursued.

An enigmatic aspect of Vinnicombe's (1976) consideration of the age of the paintings is that after commenting that the greatest age for the paintings is 800 years, based on Denninger's results, she reported that "exfoliated fragments of sandstone from the shelter wall showing indications of ochreous paint were found in a layer that dated to AD 450 at Sehonghong [in the Lesotho highlands]" and concluded that, "This is certain evidence, therefore, that paintings were in existence at Sehonghong prior to AD 450, although it has not been possible to relate the fragmented exfoliations to paintings still visible on the rock face" (Vinnicombe 1976: 143). However, it is feasible that these fragments, which were recovered from a trench close to the back wall, were intrusive and that they may be more recent in date (Peter Mitchell pers. comm. 2007). Nonetheless, it is unclear why Vinnicombe did not make more of this discovery and explore the implications of it for her painting sequence and Denninger's conclusion regarding the maximum age of the paintings. Although listed by Anne Thackeray (1983) in her review of the dating of southern African rock art, the Sehonghong painted rock was overlooked by Mazel (1992a, 1994) when he used the recovery of a painted slab from Collingham Shelter to argue that the paintings in the Drakensberg dated back to at least 1 800 years ago.

Following the flurry of activity surrounding the dating of the Drakensberg paintings from the 1960s to the mid-1970s, by the late 1970s research into the dating of paintings in the Drakensberg had come to a standstill. Although both Vinnicombe and Pager retained an interest

in Drakensberg rock art following the publication of their seminal monographs in the 1970s, neither continued to work on the dating of Drakensberg rock art. Two decades passed before this issue was again actively researched, with Mazel and Alan Watchman pursuing the Accelerator Mass Spectrometry (AMS) radiocarbon dating of the paintings and Thembi Russell, Alan King and Joané Swart developing Harris Matrix sequences. There might have been less of an interval had the paint samples collected by Mazel in April 1980 from Never-ending Shelter, Cyprus 3 and Bundoran 1 (Figure 6.2) in the southern Drakensberg, for the University of Cape Town's AMS radiocarbon rock art dating project, yielded positive results (van der Merwe *et al.* 1987). As we shall see, the absence of research did not signal an absence of interest and debate surrounding the chronology of the rock art and its use in the construction of hunter-gatherer history.

Along with Vinnicombe and Pager, David Lewis-Williams was the third key player in rock art research in the Drakensberg during the 1960s and 1970s. However, unlike the former two, Lewis-Williams has sustained an active research programme in the area up to the present. Lewis-Williams's doctorate (1977, published in 1981), which dealt with the rock art of the Giant's Castle and Barkly East areas, did not specifically address the dating of the paintings and the general avoidance of this issue has been a feature of his subsequent research. An interesting difference in research profile of these three rock art personalities is that, to the best of my knowledge, Lewis-Williams, unlike Vinnicombe (1976; Cable *et al.* 1980) and Pager (1971), has not been involved in rock shelter excavations and one can only speculate on the influence this has had on his approach to the dating of the art. Given the commanding role that Lewis-Williams has played in the development of southern African and Drakensberg rock art studies since the 1970s, it is appropriate to consider briefly his approach to the dating of rock art.

Lewis-Williams revealed his approach to the dating of rock art in his introductory essay to the *New Approaches to Southern African Rock Art* published in the early 1980s: "Some writers, for instance, consider the present impossibility of dating much of the art to be an insuperable barrier to interpretation. Certainly, we need a way of dating parietal art, but I doubt if this is the most urgent need in the study of our rock art today as it was considered to be a decade ago (Inskeep 1971)" (Lewis-Williams 1983: 10; see also Lewis-Williams [1993] for further comment regarding his views on dating in rock art studies). It would appear that Lewis-

Williams has maintained the same position regarding the chronology of the paintings since the early 1990s and his reluctance to engage with this issue is reflected in his recent publication *Rock Art of the Drakensberg* (Lewis-Williams 2003). Absent from this is any reference to the chronology of the Drakensberg paintings, yet at the time of publication, firmer knowledge was available from the recovery of a 1 800-year-old painted slab from Collingham Shelter (Mazel 1992a, 1994), the first direct radiocarbon date on a Drakensberg painting (Mazel & Watchman 1997), and the Harris Matrix sequence from Main Caves North (Russell 1997, 2000). Others, too, have noted Lewis-Williams's avoidance of chronological matters. For example, Flett and Letley (2003: 99), reviewing Lewis-Williams's *Images of Mystery*, commented: "The age of the art, the possible lengthy time-spans between episodes of painting and the difficulties surrounding the problem of chronology are not touched on."

Given Lewis-Williams's general avoidance of matters chronological together with his research not being linked to any excavation research, it was interesting to note his recent defence of South African archaeologists to the charge from Chris Chippindale (2006: 3) that they have "chosen – profitably! – to pursue other interests" rather than temporal change in rock art. Lewis-Williams (2006: 6) goes on to "set the record straight", citing, among other things, his 1981 and 1984 publications as evidence of his own attention to this issue. While not wanting to become embroiled in this debate here, I should like to point out that these two publications, which were done more than 20 years ago, represent a minor part of Lewis-Williams's prodigious publication output during the last three decades (Herbert 1998; RARI website[2]). It would seem to me to be fair to conclude that chronology and temporal change are aspects of rock art studies that have not benefited from Lewis-Williams's remarkable engagement with the rock art of the Drakensberg during the last four decades.

The early 1990s witnessed a brief but spirited interaction between Mazel (1993) and Dowson (1993) that touched on the age of the paintings and revealed different methodological perspectives concerning the construction of San hunter-gatherer history. These tensions were reflected in Lewis-Williams's (1993) view that archaeological emphases on chronology marginalise the role of rock art in the construction of the hunter-gatherer past (however, see Parkington [1998: 36–37] for a response to this). Dowson

▲ Figure 6.3
Collingham Shelter: Piece of collapsed ceiling with paintings on it. Redrawing by Paul den Hoed.

▲▶ Figure 6.4
Collingham Shelter: Painted slab from deposits dating to 1 800 years ago. Redrawing by Paul den Hoed.

(1993: 642) was of the opinion that the hunter-gatherers "have painted their history", and further that "rock art negotiates their history more than occupational debris and early colonial reports". Mazel (1993), on the other hand, believed that the construction of hunter-gatherer precolonial history had to be done with reference to data generated through the study of the rock art **and** the excavation of rock shelters. A few years later, after commenting that the "last quarter-century of studying southern African rock-art has been a famous success – although the art is uncertainly dated", Dowson (1998: 73) bemoans what he believes to be the ignoring of his research into the relationship between rainmaking and rock art in the south-eastern mountains of southern Africa on chronological grounds: "Studies like these [i.e. his theorising of the art] go unnoticed by the chronocentrics because they effectively challenge their chronocentrism" (Dowson 1998: 73). Dowson does not identify the 'chronocentrics' to whom he was referring and, as far as I know, there has been no published response to his comments. While the 1980s and 1990s represented a bleak period in the dating of the Drakensberg paintings, they nonetheless witnessed significant strides in advancing our knowledge of hunter-gatherer history through the collection of surface artefacts and the excavation of rock shelter deposits. Research during this time included:

- southern Drakensberg – Charlie Cable's collection of surface artefacts and the publication of Patricia Vinnicombe and Patrick Carter's 1971 excavation of Good Hope Shelter (Cable *et al.* 1980; Cable 1984); and
- northern Drakensberg – Mazel's collection of surface artefacts and the excavation of four rock

shelters in the northern Drakensberg (Mazel 1984a, 1984b, 1990, 1992a) and the publication of Maggs's 1974 excavation of Driel Shelter on the outskirts of the northern Drakensberg (Maggs & Ward 1980).

In addition to the above-mentioned research, Peter Mitchell (1996a, 1996b, 2002) and John Hobart (2003, 2004) have built on Carter's excavation-based research in Lesotho with the reassessment of material from some of Carter's excavations and the excavation of other sites.

All the excavation-based research has allowed for an appreciation of some elements of hunter-gatherer life in the Drakensberg that was not possible before, such as the time-depth of their Holocene occupation, subsistence strategies, relationships with the coastal zone, and the early introduction of pottery prior to the arrival of agriculturalist societies in KwaZulu-Natal (for a recent summary of these and other issues, see Wright and Mazel [2007]). Notwithstanding the importance of the insights that were gained, they served to confirm that we were still dealing with two sets of data which, except for the colonial paintings, we were unable to integrate, and therefore unable to forge stronger understandings of hunter-gatherer history in the Drakensberg. This was particularly frustrating given that a major thrust of Mazel's hunter-gatherer research in the Thukela Basin, which includes the northern Drakensberg, has been to construct a social history for San hunter-gatherers (Mazel 1987, 1989a, 1989b, 1992b). Wadley's (1989) review of Mazel's (1989a) interpretation of Thukela Basin hunter-gatherer social history supports this view.

The study of rock art in southern Africa has been carried out by a mixture of recorders and researchers: respectively, those people who saw their role as preserving the art through copying and/or photography, and those who expended their energy trying to interpret and understand it.

As Pat Vinnicombe herself appreciated, it was work carried out in the nineteenth and early twentieth centuries in and around the Maloti-Drakensberg region that laid the foundations for our modern understanding of rock art, not only in that region, but across southern Africa. Although preceded by the activity of George William Stow, a geologist by training, and active in recording rock art in the Eastern Cape since 1867, a fundamental departure came in 1873 when Joseph Orpen talked with Qing, a Bushman from south-eastern Lesotho, about the meaning of certain painted images from Melikane, Mangolong (Sehonghong) and Upper Mangolong shelters in the Lesotho highlands. Orpen (1874) published Qing's explanations and much additional material the following year in the *Cape Monthly Magazine*, accompanied by a comment from Wilhelm Bleek who presciently observed that the art was "filled with religious feelings" (Orpen 1874: 130).

Although sadly neither followed up by its author nor by Bleek himself, who died in 1875, Orpen's article marked the beginning of a wave of interest that saw further copies of Bushman paintings being made in the Maloti-Drakensberg region. Among these enthusiasts was Sir Henry Bulwer, Governor of Natal, who, in 1875, asked the father and son team of Mark and Graham Hutchinson to go to the Giant's Castle area to copy Bushman paintings. These copies now reside in the Natal Museum, Pietermaritzburg, and in the Library of Parliament in Cape Town. Eighteen years later and at Giant's Castle Main Cave, the younger Hutchinson met Louis Tylor, another key early recorder, operating on behalf of his uncle, the anthropologist EB Tylor. Louis Tylor located more than thirty sites and made detailed records and copies of the art at them. Sent to Oxford where his uncle worked, these copies still survive in the Pitt Rivers Museum, where Pat Vinnicombe studied them in the 1960s. Her own fieldwork relocating Tylor's sites in the field and that of Val Ward (1997; Ward & Maggs 1994) provides an important

series of observations on rock art deterioration that now extends back over a century, although she found attempts at discovering more about Louis Tylor himself elusive; more recent research (Hobart *et al.* 2002) has filled in much of his biography.

Contemporary with Tylor was Brother Otto Mäeder of the Roman Catholic mission at Mariannhill who, in 1893 and 1894, took a number of photographs and made drawings of rock art near Underberg, KwaZulu-Natal, followed twenty years later by further work in the Kei Valley, Eastern Cape Province. A recent evaluation (Flett & Letley 2007) emphasises the high quality of his recording and the perceptiveness of his evaluations of the art, despite attempts by Raymond Dart (1925) to implicate him in his own outlandish claims for the presence of assorted Ancient Near Eastern or Mediterranean subjects in the paintings.

A symptom of this growing level of interest in the art (further discussed by Vinnicombe 1976: 119–121) and a catalyst for a new wave of study, in 1904 the Cape House of Assembly passed a resolution recommending the protection of Bushman paintings. Natal followed suit, and

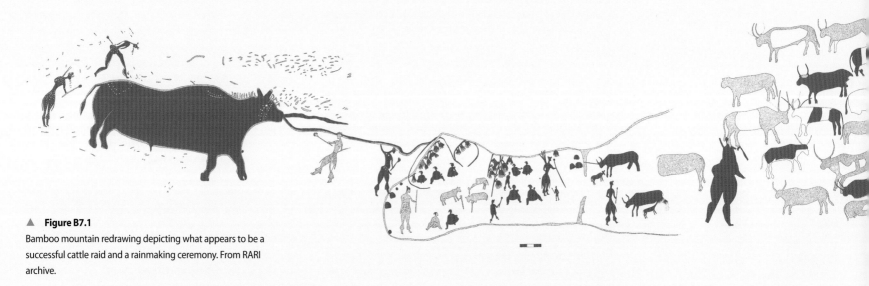

▲ **Figure B7.1**
Bamboo mountain redrawing depicting what appears to be a successful cattle raid and a rainmaking ceremony. From RARI archive.

in 1909/10 a survey of rock art sites covering the length of the Drakensberg led to many pieces of art being copied or removed to the 'safety' of museums. The well-known slab from Bamboo Mountain (Figure B7.1) depicting what appears to be a successful cattle raid and a rainmaking ceremony (Vinnicombe 1976: 45; Campbell 1987) and now exhibited in the Natal Museum, Pietermaritzburg, was among them. The following year, the new Union government enacted legislation to protect Bushman rock art and other archaeological resources (Deacon, this volume). However, despite the important records made in the succeeding decades by a range of scholars and avocational archaeologists, it was only with the much more systematic and thorough work of Pat Vinnicombe and her contemporaries (especially Harald Pager and David Lewis-Williams in South Africa and Lucas Smits in Lesotho) that the quantum leap forward in research intensity was initiated. This led rock art research out of the empiricist impasse of assuming that the meaning of the paintings could be inferred by direct observation and into the anthropologically much more sophisticated and ethnographically informed subject that it is today.

REFERENCES

Campbell, C. 1987. Art in crisis: contact period rock art in the south-eastern mountains of southern Africa. Unpublished MSc thesis. Johannesburg: University of the Witwatersrand.

Dart, R.A. 1925. The historical succession of cultural impacts upon South Africa. *Nature* 115: 1–15.

Flett, A. & Letley, P. 2007. Brother Otto Mäeder: an examination and evaluation of his work as a rock art recorder in South Africa. *Southern African Humanities* 19: 103–121.

Hobart, J.H., Mitchell, P.J. & Coote, J. 2002. A rock art pioneer: Louis E. Tylor, and previously undescribed painted rock fragments from KwaZulu-Natal, South Africa. *Southern African Humanities* 14: 65–78.

Orpen, J.M. 1874. A glimpse into the mythology of the Maluti Bushmen. *Cape Monthly Magazine* 9: 1–13.

Vinnicombe, P.V. 1976. *People of the Eland: Rock Paintings of the Drakensberg Bushmen as a Reflection of their Life and Thought.* Pietermaritzburg: Natal University Press.

Ward, V. 1997. A century of change: a report on rock art deterioration in the Natal Drakensberg, South Africa. *Natal Museum Journal of Humanities* 9: 75–97.

Ward, V. & Maggs, T.M.O'C. 1994. Changing appearances: a comparison between early copies and the present state of paintings from the Natal Drakensberg as an indication of rock art deterioration. *Natal Museum Journal of Humanities* 6: 153–178.

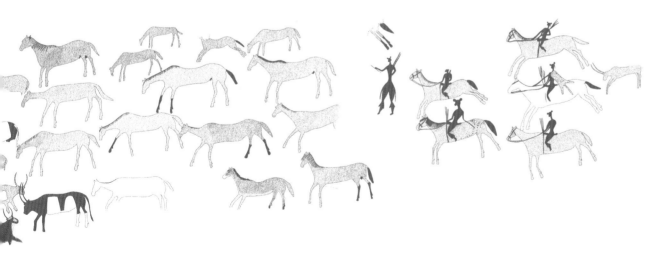

◀ **Figure 6.5**
Esikolweni Shelter: dated orange and white eland. Photo by Aron Mazel.

Returning to the actual dating of the paintings, a significant, though fortuitous, breakthrough in our knowledge of the age of the Drakensberg paintings came with the excavation of Collingham Shelter in 1988 (Mazel 1992a, 1994). Paintings identified on the underside of the collapsed ceiling (Figure 6.3) indicated that it had been painted at least 650 years ago, while a painted slab found in a 1 800-year-old deposit (Figure 6.4) showed that hunter-gatherers were painting in this area a lot earlier than was previously thought. Seven radiocarbon dates have been processed from the Collingham Shelter deposits, which reach a maximum thickness of only 45 centimetres. They show that possibly over 90 per cent, but certainly more than 85 per cent, of the deposit dates to between 1880 and 1770 BP (Mazel 1992a: 4–10). It is therefore highly unlikely that this slab, found in the lower part of the sequence, derives from the more recent deposit. Of additional significance is that the central human figure on the slab (Figure 6.4) is a spindly male form whose arms are behind his back in the posture adopted by Kalahari shamans when asking God for potency, indicating the considerable age of this type of ritual behaviour in the Drakensberg.

Remarkably, for a region so well endowed in rock art, only Collingham Shelter and Sehonghong (Vinnicombe 1976; Mitchell 1996a) excavations have yielded painted stones, although it is noteworthy that, unlike the Collingham Shelter slab, none of the Sehonghong spalls have recognisable imagery. These painted stones have recently been added to with the discovery of four stones from the surface of Cascades 2 in the central Drakensberg which bear the remains of paint and pigment (Swart & Escott 2003). One of the stones appears to have four rhebuck painted on it. Together, these painted stones provide hope for the recovery of more painted rocks in future excavations.

The chance finding of the Collingham Shelter painted slab was followed by two new initiatives specifically aimed at improving our understanding of the age of the Drakensberg paintings: 1) an AMS radiocarbon dating programme undertaken by Mazel and Watchman in the central and northern Drakensberg, and 2) the development of Harris Matrix sequences by Russell, King and Swart in the northern, central and southern Drakensberg. As Swart (2004) has noted, King's (1998) Junction Shelter sequence has insufficient detail

▲▲ **Figure 6.6**
Main Caves North: Eland overlying dated crust (ANDRA
15 and 16). Photo by Aron Mazel.

▲ **Figure 6.7**
Main Caves North: Rhebuck overlying dated crust
(ANDRA 17). Photo by Aron Mazel.

▲▲ **Figure 6.8**
Highmoor 1: Eland overlying dated crust (ANDRA 21) .
Photo by Aron Mazel.

▲ **Figure 6.9**
Highmoor 1: Hartebeest overlying dated crust
(ANDRA 19). Photo by Aron Mazel.

for meaningful comparison with the other sequences and it is therefore not considered further.

Mazel and Watchman's dating programme has thus far proceeded in two phases. During the first phase, Mazel collected paint samples in the northern Drakensberg and submitted them to Watchman for processing and dating; during the second phase Watchman collected samples from the central Drakensberg. The initial phase led to the first AMS radiocarbon dates on Drakensberg paintings of 330 ± 90 BP and 420 ± 340 BP, although the latter date was rejected because of its large standard deviation (Mazel 1996a; Mazel & Watchman 1997; Figure 6.5). The 330 BP date, from Esikolweni Shelter, was obtained on a piece of plant fibre in the paint. The second phase, in which the carbon in salt-rich crusts that underlie and overlie some of the paintings was dated, yielded a further seven radiocarbon determinations (Mazel & Watchman 2003; Figures 6.6–6.10; Table 6.1). Despite some concerns, discussed below, about the efficacy of the latter dates because they do not directly date the paintings, they indicate that the surviving Drakensberg parietal art was first made by the hunter-gatherers before 2000 years ago. These dates, and the Collingham Shelter slab, show that Drakensberg paintings are considerably older than previously thought.

Addressing the dates obtained by Mazel and Watchman, Blundell (2004: 67, 68) comments that:

> so far a handful of images have been dated. While this work is important and provides a very broad chronological framework, the number of dates, their poor resolution and inescapable doubts about the integrity of the material actually dated

◀ **Figure 6.10**
White Elephant Shelter: Human underlying dated crust (ANDRA 25) .
Photo by Aron Mazel.

do not inspire confidence in many researchers that direct dating is the answer to the problems of integrating rock art into the writing of San history.

Unfortunately, Blundell (2004) does not provide any data to support his criticisms of the dates, which makes it difficult to respond to them. It is curious, however, that he refers to the "poor resolution" of the dates when, in fact, the standard deviations for the older Drakensberg rock art dates generally vary between 65 and 80 years, while the standard deviations for comparably aged dates on charcoal samples

TABLE 6.1. ACCELERATOR RADIOCARBON DATES ASSOCIATED WITH ROCK PAINTINGS AT SELECTED SITES IN THE UKHAHLAMBA-DRAKENSBERG WORLD HERITAGE SITE

Sample	Site	Radiocarbon age (bp)	Association between paint and whewellite in crust
ANDRA 12 (OZD446)	Barnes	1060 ± 65	Dark encrustation covers red paint
ANDRA 25 (OZD452)	White Elephant	1930 ± 65	Encrustation covers red human
ANDRA 19 (OZD450)	Highmoor 1	2310 ± 70	Encrustation under red hartebeest
ANDRA 17 (OZD449)	Main Cave North	2360 ± 70	Encrustation under polychrome rhebuck
ANDRA 16 (OZD448)	Main Cave North	2760 ± 80	Encrustation under bichrome (red and white) eland
ANDRA 21 (OZD451)	Highmoor 1	2770 ± 75	Accretion under red eland
ANDRA 15 (OZD447)	Main Cave North	2900 ± 80	Encrustation under bichrome (red and white) eland

Source: Modified from Mazel & Watchman (2003: 67)

from excavations in the Thukela Basin vary between 50 and 60 years. The degree of difference between these dates is therefore largely comparable and it is unlikely that much better resolution is going to be forthcoming on either type of material in the foreseeable future.

Moreover, Blundell (2004) appears to conflate his concerns about the reliability of the dates obtained thus far with the importance of developing a secure chronology for the paintings to enable their connection with information derived from archaeological deposits in the construction of San hunter-gatherer history. It is appreciated that the desired integration of the rock art and excavation data sets will require more than simply the direct dating of the paintings and the creation of a robust chronological framework for them, but full exploration of this issue is beyond the scope of this chapter.

The second major dating initiative in the Drakensberg since the 1990s has been the application of the Harris Matrix methodology to the paintings. As Russell (2000) has indicated, the paintings lend themselves to this form of analysis because, in many instances, the 'regularity' with which the painters have superimposed images has led to the development of large complex multilayered panels. Russell (1997, 2000) was the first to take up this challenge at Main Caves North in the central Drakensberg, where she developed sequences for four panels and from these extrapolated seven layers of paint. She concludes that her results correspond well with the sequences proposed by Vinnicombe (1976) and Pager (1971), despite the fact that her sequence was based on only one site, while those of Pager and Vinnicombe were based on substantially more.

Following on from Russell, Swart (2004) has completed Harris Matrix sequences for Ngwangwane 8 (southern Drakensberg) and Eland Cave (northern Drakensberg). Comparison of her Eland Cave sequence with Pager's shows that "Pager's colour sequence corresponds closely with Eland Cave's general colour sequence" (Swart 2004: 29). Although unable to make a detailed comparison between her Ngwangwane 8 sequence and Vinnicombe's because "of a lack of detailed categories in the Vinnicombe sequence" (Swart 2004: 29), she does note significant correspondences between them. Moreover, she has noted similarities and differences between her sequences and the Main Cave North sequence produced by Russell (1997, 2000), some of the details of which are addressed in the next section of this chapter.

Time and space in the Drakensberg paintings: The picture so far

The first years of this century have already provided new insights into the age of the paintings and allowed us to start teasing out new patterns in the chronological relationship between the rock art and the excavated deposits of the Drakensberg. These developments have been underpinned by the relative stratigraphic evidence inferred through the sequencing of the paintings by Vinnicombe, Pager, Swart and Russell and the direct dating of the paintings and associated crusts by Watchman and Mazel. I first address the absolute age of the rock art before dealing with the information derived from the sequencing projects.

While we do not know – and may never know – exactly when hunter-gatherers first started painting in the Drakensberg, we can be relatively confident that this began before 2 000 years ago, and possibly even before 3 000 years. Evidence for the paintings being older than 2 000 years derives from oxalate-rich crusts that are between 2 300 and 2 900 years old and underlie paintings of eland, hartebeest and rhebuck at Main Caves North and Highmoor 1. It is thought that the time lapse between the oxalate formation and the paintings is likely to be hundreds, rather than thousands, of years (Mazel & Watchman 2003). Confidence in these dates is augmented by the fact that the Main Caves North dates of 2900 and 2760 BP derive from the crust which overlies the same eland painting (Figure 6.6; Mazel & Watchman 2003). Noting the difference of only 240 radiocarbon years between these dates derived from Main Caves North, Mazel and Watchman (2003: 8) comment that: "Given the potential for variability in oxalate deposition across a surface and the vagaries of sample collection and preparation on a micro-undulating surface, the duplication of measurements points to a high degree of confidence and reliability in the method." Additional information supporting the idea that painting began before 2 000 years ago is the dating of the oxalate crust overlying the painting of a seated human at White Elephant Shelter, which provides a minimum age of 1930 BP for the image.

There was an opportunity at Highmoor 1 to establish the rate of growth of oxalate crusts because two layers of paint, separated by encrustation, were exposed by graffiti that cut deeply into the rock face. However, it was not possible to date the samples removed despite 'intense efforts and elaborate approaches using manual and laser

techniques' (Mazel & Watchman 2003: 8). These samples have, however, highlighted the possibility that further instances of similarly stratified levels of paint may exist elsewhere in the Drakensberg. Locating and sampling them should form part of further research.

Mazel and Watchman's (2003) and Russell's (1997, 2000) chronological research on the paintings at Main Cave North has made it possible for the first time in the Drakensberg to directly connect radiocarbon dates to a painting sequence. A painted eland, the overlying crust of which has been dated to 2 900 and 2 760 years ago, belongs to the second oldest layer identified by Russell (see also later comments by Swart [2004]). We have no indication at present of the time that may have lapsed between the different paint layers but it may have been several hundreds of years, which raises the possibility that earliest paintings may pre-date 3 000 years ago. Circumstantial evidence supporting this possible scenario is 1) that hunter-gatherers were living in the southern Drakensberg from 8 000 years ago (Cable *et al.* 1980) and the northern Drakensberg from 5 000 years ago (Mazel 1984b), and 2) that the painting tradition at Maqonqo Shelter in the eastern Biggarsberg, KwaZulu-Natal, dates to between around 5 000 and 3 500 years ago (Mazel 1996b; Mazel & Watchman 2003). It seems likely that there was contact between the hunter-gatherers in these two areas during this time (Mazel 1989a).

However, as tantalising as the above possibility is, it needs to be tempered by the fact that, other than for the Collingham Shelter slab, the excavated record in the Drakensberg has yielded hardly any supporting evidence to indicate the age of the paintings. No pieces of ochre, which would have been used to make paint, were recovered from the earlier deposits at Good Hope Shelter (Cable *et al.* 1980), while only six pieces of unground ochre were recovered from the pre-3000 deposits at Diamond 1 (Mazel 1984a, 1984b), with one more piece reported by Willcox (1957) from the 60–75 centimetre deposits at Main Cave North, which Mazel (1984a, 1984b) believes pre-dates 3 000 years ago. More ochre remains have been recovered from the later, 2 000–3 000-year-old deposits at Clarke's Shelter and Diamond 1 (Mazel 1984a) and Mhlwazini Shelter (Mazel 1990). It is likely that ochre was not just used for making paint, but also for body decoration, as attested to by the recovery of small balls of ochre in four tufts of human hair from the 1 800-year-old deposits at Collingham Shelter (Mazel 1992a). Outside of the Drakensberg it is significant that ochre, along with ochre-stained items, is a recurrent feature of deposits dating to the last 25 000 years at Sehonghong in the Lesotho highlands (Mitchell 1994, 1995, 1996a, 1996b).

The dating of excavated deposits (Mazel 1990, 1992a) indicates that hunter-gatherers abandoned the northern Drakensberg around 1 600 years ago for about a millennium in the wake of agricultural communities arriving in the low altitude areas of the central Thukela Basin. The pause in occupation is supported by the radiocarbon estimates for the paintings from Main Cave North, Highmoor 1, White Elephant Shelter and Barnes Shelter, along with the direct date on a painting from Esikolweni Shelter and the 1 800-year-old painted slab from Collingham Shelter. The date at which hunter-gatherers reoccupied the northern Drakensberg around 600 years ago corresponds with the establishment of agriculturalist communities in areas adjacent to the northern Drakensberg.

Turning our attention to the more recent nineteenth century rock paintings, it has already been shown that horses and colonial paintings, save for one scene at Sigubudu Shelter 1 which comprises both men with guns and guns by themselves (Figure 6.11), occur only in the south, and that the overwhelming majority of cattle paintings are also located in that area (Mazel 1982; Manhire *et al.* 1986). Stylistic differences are evident between the paintings of cattle in the north and those in the south (Manhire *et al.* 1986). The absence of paintings of horses and colonial imagery in the north suggests that the paintings of cattle, and indeed sheep, in this area pre-date the devastation experienced in the upper Thukela region during the upheavals of the 1820s (Mazel 1982; Manhire *et al.* 1986). While the paintings of cattle and sheep could have been done at any time after the agriculturalists first entered the Thukela Basin around 1 500 years ago, it is likely that they were done some time after these communities settled in the foothills around 600 years ago, when hunter-gatherer communities reoccupied the Drakensberg. Addressing the age of paintings of domestic animals and colonial imagery in the southern Drakensberg, Vinnicombe (1976), as mentioned earlier, argued that most are likely to have been painted before 1850, and that it is improbable that any were executed after the early 1870s.

Scenes depicting rainmaking are absent from the northern Drakensberg but are found in the southern Drakensberg (Vinnicombe 1976; Mazel 1982; Dowson

▲ **Figure 6.11**
Sigubudu 1: Crouching men with
guns and guns by themselves.
Photo by Aron Mazel.

1998) and in the Harrismith area to the north of the Drakensberg (Dowson 1998). Drawing primarily on the work of Aukema (1989) in northern South Africa, Dowson (1998) argues that there is evidence of rainmaking among early agriculturalists pre-dating 1 000 years ago, but this does not shed light on the antiquity of the rainmaking scenes in the Drakensberg. The geographical distribution of these scenes suggests that they may be contemporaneous with the paintings of horses, colonial scenes and the majority of the cattle in the south. The occurrence of rainmaking scenes in the Harrismith area (Dowson 1998) presents an interesting twist to this pattern with uncertain chronological implications and is deserving of additional research.

The rock art sequencing undertaken by Pager (1971), Vinnicombe (1976), Russell (1997, 2000) and Swart (2004) has permitted a generalised understanding of some of the major changes that have characterised the development of Drakensberg rock art for over 2 000 years. It has also shown that there are likely to be regional, and possibly even site and intra-site, sequences within the general scheme. Some of the complexities and regional nuances have been revealed by the Harris Matrix sequences developed by Russell (1997, 2000) and Swart (2004). Pager's sequencing work differs from the others in that he concentrated on only eland paintings while they focused on the full spectrum of paintings available to them.

Russell (2000) summarises and compares the sequences developed by herself, Pager (1971) and Vinnicombe (1976), and I draw upon this in the following discussion (Table 6.2). Before continuing, however, two points need to be noted about the earliest phase of paintings identified by Russell and Pager: firstly, Russell's Layer 1 does not necessarily consist of only the oldest paintings at Main Cave North because she has included all the paintings that are painted directly on the shelter wall and some might relate to the later layers of paint; and, secondly, Pager's earliest style is hypothetical as "there are no monochrome red … eland in the whole Research Area" of KwaZulu-Natal's Didima Gorge (Pager 1971: 354).

It is evident from Table 6.2 and from Swart's (2004) Ngwangwane 8 and Eland Cave sequences that the earliest paintings in the Drakensberg are monochrome red, some of which are stained into the rock. Both humans and indeterminate animals were painted during the earliest phase, although there may be differences between sites and possibly even between areas. Swart (2004) has indicated that animals are more prevalent in some sites and humans in others. It is also possible that the oldest monochrome paintings were originally bichrome and that the white has disappeared with time.

The overlying second layer sees the introduction of human and animal bichrome figures (including eland) and there is some blending of colours. This phase at Main Cave North contains the bichrome eland (Figure 6.6), of which the overlying crust has been dated to between 2900 and 2760 BP. It is of interest that the crust overlying a bichrome eland at Highmoor 1 has been dated to roughly the same period (i.e. 2770 BP) (Figure 6.8). Swart has tentatively linked the Main Cave North dates to Eland Cave and Ngwangwane Shelter 8 "since Eland Cave and Ngwangwane 8 both have red and white eland in Phase 2 and therefore correspond well with Russell's sequence, the earliest rock art at these two sites could be similarly old", but notes that "I would, however, be cautious in linking the Main Caves date to Phase 2 only at Eland Cave and Ngwangwane 8, as red and white eland also occur in more recent phases" (Swart 2004: 32).

According to Vinnicombe (1976: 139), the third phase, which is roughly mid-sequence (Table 6.2), "is marked by the full development of the shaded polychrome technique" and the introduction of elements of perspective. She believes these techniques were "almost exclusively"

used for antelope paintings and, in particular, eland and rhebuck. Monochrome, bichrome and polychrome paintings of animals also characterise this phase, along with paintings of humans with facial and decorative features. Swart (2004) and Russell (2000) note the appearance of rhebuck during this phase, and Swart suggests that this accompanies the introduction of other animals, such as bushpig, hartebeest, reedbuck and felines. Interestingly, the crusts underlying a rhebuck at Main Caves North and a hartebeest at Highmoor 1 have been dated to 2360 and 2310 BP respectively.

Swart (2004) has shown that therianthropes were introduced at Eland Cave and Ngwangwane Shelter 8 shortly after eland, but it is uncertain whether this was during Layer 2 or 3. They appear at Main Cave North later in the sequence, but this discrepancy may relate to the fact that we are dealing with only three sites. Pinning down the introduction of therianthropes to the painted sequence represents a key challenge for future sequencing research.

Russell's Layer 4 at Main Cave North, which consists solely of monochrome white rhebuck, has not been identified by any of the other researchers, although Swart mentions that monochrome white rhebuck appear in the middle of the sequences and that rhebuck (without specifying their colour) "thereafter seem to play a significant role at these three sites from the middle of the sequences onward, and especially towards the final phases" (Swart 2004: 31). In this respect, Challis (2005) has made an interesting suggestion that the rhebuck may have been elevated to a higher position in the rituals of the Drakensberg hunter-gatherers through time, and I certainly endorse the call for more research into, among other things, its distribution through time.

Overlying Layer 4, Russell (2000) shows that there is a correspondence between her Layer 5 and Pager's (1971) Style 5, which reflects a continuation of the emphasis on shaded figures. Similarities are also evident between the overlying two layers (i.e. 6 and 7) recognised by Russell (2000) and Pager (1971), which generally contained unshaded paintings along with the usual array of red and white colours and the addition of bright colours such as yellow and pink. It is difficult clearly to relate Vinnicombe's Phase 4 to the sequences developed by Pager (1971) and Russell (2000) because it would appear from Table 6.2 that Vinnicombe lumped three phases into one. Commonalities between her fourth phase and Russell's Layers 5–7 are evident though, as reflected in the decrease in shaded polychromes and the

TABLE 6.2. COMPARISON OF DEVELOPMENTAL SEQUENCES FOR THE ROCK ART OF THE MALOTI-DRAKENSBERG REGION

Pager	Vinnicombe	Main caves North
STYLE ONE: Monochrome dull red.	**Phase One:** Dark red/maroon stain. Possibly monochrome. Horizontal blocks (animal).	**Layer One:** Monochrome dark purple bovids and human figures. Monochrome orange paint and monochrome brown human figures. Bichrome dark purple and white bovids. Paint is stained into rockface.
STYLE TWO: Bichrome dull red and white.	**Phase Two:** Human figures and animals in shades of red with white details. Stain or thin film of paint. Some blending.	**Layer Two:** Bichrome human figures (red and white). Polychrome eland (purple/ maroon, white and black).
STYLE THREE: Shaded in two colours: dull red and white. Black introduced for human figures.	No equivalent.	No equivalent.
STYLE FOUR: Shaded polychrome only. Black used for horns, hooves and back stripe.	**Phase Three:** Shaded polychromes (rhebuck and eland). Use of perspective. Fine details on human figures. Unshaded monochromes, bichromes and polychromes persist. Paint is thick and brushstrokes show. Lots of colours and blending. Black for details.	**Layer Three:** Polychrome shaded eland and bovids (pink, brown, purple, orange, black and white). Human figures bichrome (orange and brown). Black for details. Thick paint and brushstrokes.
No equivalent	No equivalent	**Layer Four:** Monochrome white (rhebuck).
STYLE FIVE: Shading continues with the addition of yellow and orange.	**Phase Four:** Shaded polychromes decrease. Black, yellow and orange increase. Red less common. Paint is powdery and lacks binding medium. No brushstrokes show. Eland are stylised (stiffer, more block-like representations), polychrome or bichrome in yellow/orange with white heads, necks and bellies.	**Layer Five:** Shaded polychromes.
STYLE SIX: Unshaded polychrome eland in bright yellow, red and orange with black and white. Black and dull red are combined.	Equivalent to Phase Four.	**Layer Six:** Monochrome pink (rhebuck and ovals) and monochrome brown-red (therianthropes).
STYLE SEVEN: Unshaded monochromes and bichromes in white, black, bright red, yellow and orange. A few shaded motifs.	Equivalent to Phase Four.	**Layer Seven:** Bichrome (yellow and white) and polychrome (yellow, white and black) eland.

Source: After Russell 2000

increasing range of colours used by the artists. Furthermore, Swart (2004: 29) notes that "Vinnicombe's Phases 3 and 4 compare well to the final phases at Ngwangwane 8, except that Ngwangwane 8 has no images depicting European contact". The absence of colonial imagery is also evident in Russell's Main Caves North sequence, although paintings belonging to this period are known from Main Caves South. One of the challenges facing the future sequencing of the paintings in the southern Drakensberg will be to separate Vinnicombe's Phase 4 into finer stratigraphic units.

Conclusion

Considering the relationship between the chronology of the art and the interpretive approaches deployed during the last few decades, Blundell (2004: 61) has commented that: "It is sometimes said that one of the reasons the hermeneutic approach has been so successful is because it ignored the dating of southern African rock art." He attributes this situation, on the one hand, to the difficulties associated with dating the art and the paucity of dates and, on the other, to the fact that the hermeneutic approach emerged from an anthropological approach to the art that did not emphasise change through time. This approach has encouraged rock art researchers in the Maloti-Drakensberg region to minimise the variety of expression in it and the possibility of change through time in favour of generalisation and implicit acceptance of a static framework of understanding. However, our improving appreciation of the chronology of the rock art makes it increasingly difficult to pursue this approach without acknowledging the extensive time-depth of the rock art and its dynamic nature. Indeed, building on the platform set by Vinnicombe and Pager in the 1970s, the last decade has witnessed encouraging progress in the absolute and relative dating of the paintings. Although there is still a vast amount of work to be done, at least we now have a better sense of the age of the paintings and a slowly emerging hint of the way in which they can be connected to archaeological deposits in the Drakensberg. We must ensure, however, that the progress of the last decade is capitalised on during the coming decade and that the challenge of successfully connecting excavation-based data with those from the rock art record enables us to develop a greater appreciation of hunter-gatherer history in the Maloti-Drakensberg region as a whole.

ACKNOWLEDGEMENTS

I thank Peter Mitchell and Ben Smith for inviting me to contribute this chapter to the memorial volume to Patricia Vinnicombe, and Ann Macdonald and Peter Mitchell for their editorial input. My research in the Drakensberg has been supported by the Human Sciences Research Council, the Anglo-American Chairman's Fund and the James A Swan Fund.

NOTES

1 I should like to make the point at the outset that I view the rock art as being an integral part of the archaeological record and not separate from it.
2 Available at http://rockart.wits.ac.za/origins/index.php?section=46, accessed on 28 November 2006.

REFERENCES

Aukema, J. 1989. Rain-making: a thousand-year-old ritual. *South African Archaeological Bulletin* 44: 70–72.

Blundell, G. 2004. *Nqabayo's Nomansland: San Rock Art and the Somatic Past*. Uppsala: Uppsala University Press.

Cable, J.H.C. 1984. *Economy and Technology in the Late Stone Age of Southern Natal*. Oxford: British Archaeological Reports, International Series 201.

Cable, J.H.C., Scott, K. & Carter, P.L. 1980. Excavations at Good Hope Shelter, Underberg District, Natal. *Annals of the Natal Museum* 24: 1–34.

Campbell, C. 1987. Art in crisis: contact period rock art in the south-eastern mountains of southern Africa. Unpublished MSc thesis. Johannesburg: University of the Witwatersrand.

Challis, W. 2005. 'The men with rhebok's heads; they tame elands and snakes': incorporating the rhebok antelope in the understanding of southern African rock art. *South African Society Goodwin Series* 9: 11–20.

Chippindale, C. 2006. Northern Australian rock art, South African rock art – so similar, so different. *The Digging Stick* 23(1): 1–3.

Denninger, E. 1971. The use of paper chromatography to determine the age of albimous binders and its application to rock paintings. *South African Journal of Science Special Publication* 2: 80–83.

Dowson, T.A. 1993. Changing fortunes of southern African archaeology: comment on A.D. Mazel's 'history'. *Antiquity* 67: 641–644.

Dowson, T.A. 1998. Rain in Bushman belief, politics, and history: the rock-art of rain-making in the south-eastern mountains, southern Africa. In: Chippindale, C. & Taçon, P.S.C. (eds) *The Archaeology of Rock-Art*: 73–89. Cambridge: Cambridge University Press.

Flett, A. & Letley, P. 2003. Review: Lewis-Williams, J.D. 2003. Images of mystery: rock art of the Drakensberg. *South African Archaeological Bulletin* 58: 98–99.

Herbert, K. 1998. Rock art of south-eastern South Africa, and Lesotho, 1807 to 1997: an annotated bibliography. *Natal Museum Journal of Humanities* 10: 33–149.

Hobart, J. 2003. Forager-farmer relations in south-eastern southern Africa: a critical reassessment. Unpublished DPhil thesis. Oxford: University of Oxford.

Hobart, J. 2004. Pitsaneng: evidence for a Neolithic Lesotho? *Before Farming* 4: 261–270.

Inskeep, R.R. 1971. The future of rock art studies in southern Africa. *South African Journal of Science Special Publication* 2: 101–104.

King, A.G. 1998. Superpositioning and the art of fallen rock, Junction Shelter, Didima Gorge, KwaZulu-Natal. Unpublished BSc (Hons) thesis. Johannesburg: University of the Witwatersrand.

Lewis-Williams, J.D. 1977. Believing and seeing: an interpretation of symbolic meanings in Southern San rock paintings. PhD thesis. Pietermaritzburg: University of Natal.

Lewis-Williams, J.D. 1981. *Believing and Seeing: Symbolic Meanings in Southern San Rock Paintings*. London: Academic Press.

Lewis-Williams, J.D. 1983. Introductory essay. Science and rock art. In: Lewis-Williams, J.D. (ed.) *New Approaches to Southern African Rock Art. South African Archaeological Society Goodwin Series* 4: 3–13.

Lewis-Williams, J.D. 1993. Southern African archaeology in the 1990s. *South African Archaeological Bulletin* 48: 45–50.

Lewis-Williams, J.D. 2003. *Images of Mystery: Rock Art of the Drakensberg*. Cape Town: Double Storey.

Lewis-Williams, J.D. 2006. Setting the record straight. *The Digging Stick* 23(2): 6–8.

Maggs, T. & Ward, V. 1980. Driel Shelter: rescue at a Late Stone Age site on the Thukela River. *Annals of the Natal Museum* 24: 35–70.

Manhire, A., Parkington, J., Mazel, A.D. & Maggs, T. 1986. Cattle, sheep and horses: a review of domestic animals in the rock art of southern Africa. *South African Archaeological Society Goodwin Series* 5: 22–30.

Mason, A.Y. 1933. Rock paintings in the Cathkin Peak area, Natal. *Bantu Studies* 7: 131–158.

Mazel, A.D. 1982. Distribution of painting themes in the Natal Drakensberg. *Annals of the Natal Museum* 25: 67–82.

Mazel, A.D. 1984a. Diamond 1 and Clarke's Shelter: report on excavations in the northern Drakensberg, Natal, South Africa. *Annals of the Natal Museum* 26: 25–70.

Mazel, A.D. 1984b. Through the keyhole: a preliminary peep at the lithic composition of Later Stone Age sites in the central and upper Tugela Basin, Natal, South Africa. In: Hall, M., Avery, G., Avery, D.M., Wilson, M.L. & Humphreys, A.J.B. (eds) *Frontiers: Southern African Archaeology Today*: 182–193. Oxford: British Archaeological Reports, International Series 207.

Mazel, A.D. 1987. The archaeological past from the changing present: towards a critical assessment of South African Later Stone Age studies from the early 1960s to the early 1980s. In: Parkington, J.E. & Hall, M. (eds) *Papers in the Prehistory of the Western Cape, South Africa*: 504–529. Oxford: British Archaeological Reports, International Series 332.

Mazel, A.D. 1989a. People making history: the last ten thousand years of hunter-gatherer communities in the Thukela Basin. *Natal Museum Journal of Humanities* 1: 1–168.

Mazel, A.D. 1989b. Changing social relations in the Thukela Basin 7000–2000 BP. *South African Archaeological Society Goodwin Series* 6: 33–41.

Mazel, A.D. 1990. Mhlwazini Cave: the excavation of late Holocene deposits in the northern Natal Drakensberg, Natal, South Africa. *Natal Museum Journal of Humanities* 2: 95–133.

Mazel, A.D. 1992a. Collingham Shelter: the excavation of late Holocene deposits, Natal, South Africa. *Natal Museum Journal of Humanities* 4: 1–52.

Mazel, A.D. 1992b. Gender and the hunter-gatherer archaeological record: a view from the Thukela Basin. *South African Archaeological Bulletin* 47: 122–126.

Mazel, A.D. 1993. Rock art and Natal Drakensberg hunter-gatherer history: a reply to Dowson. *Antiquity* 67: 889–892.

Mazel, A.D. 1994. Dating the Collingham Shelter rock paintings. *Pictogram* 6(2): 33–35.

Mazel, A.D. 1996a. Dating the paint: revealing the age of southern African rock art. *Optima* 42(2): 16–19.

Mazel, A.D. 1996b. Maqonqo Shelter: the excavation of Holocene deposits in the eastern Biggarsberg, Thukela Basin, South Africa. *Natal Museum Journal of Humanities* 8: 1–39.

Mazel, A.D. & Watchman, A.L. 1997. Accelerator radiocarbon

dating of Natal Drakensberg paintings: results and implications. *Antiquity* 71: 445–449.

Mazel, A.D. & Watchman, A.L. 2003. The dating of rock paintings in the Natal Drakensberg and the Biggarsberg, KwaZulu-Natal, South Africa. *Southern African Humanities* 15: 59–73.

Mitchell, P.J. 1994. Understanding the MSA/LSA transition: the pre-20 000 BP assemblages from new excavations at Sehonghong rock shelter, Lesotho. *Southern African Field Archaeology* 3: 15–25.

Mitchell, P.J. 1995. Revisiting the Robberg: new results and a revision of old ideas at Sehonghong Rock Shelter, Lesotho. *South African Archaeological Bulletin* 50: 28–38.

Mitchell, P.J. 1996a. Filling the gap: the early and middle Holocene assemblages from new excavations at Sehonghong Rock Shelter. *Southern African Field Archaeology* 5: 17–27.

Mitchell, P.J. 1996b. Sehonghong: the late Holocene assemblages with pottery. *South African Archaeological Bulletin* 51: 17–25.

Mitchell, P.J. 2002. *The Archaeology of Southern Africa*. Cambridge: Cambridge University Press.

Pager, H. 1971. *Ndedema: A Documentation of the Rock Paintings of the Ndedema Gorge*. Graz: Akademische Druck.

Parkington, J. 1998. Resolving the past: gender in the Stone Age archaeological record of the Western Cape. In: Kent, S. (ed.) *Gender in African Prehistory*: 25–37. Walnut Creek: AltaMira Press.

Rudner, I. 1983. Paints of the Khoisan rock artists. *South African Archaeological Society Goodwin Series* 4: 14–20.

Rudner, I. 1989. *The Conservation of Rock Art in South Africa*. Cape Town: National Monuments Council.

Russell, T. 1997. Sequencing rock paintings: the application of the Harris Matrix to rock art at Main Caves North, Giant's Castle Game Reserve, KwaZulu-Natal. Unpublished BSc (Hons) thesis. Cape Town: University of Cape Town.

Russell, T. 2000. The application of the Harris Matrix to San rock art at Main Caves North, KwaZulu-Natal. *South African Archaeological Bulletin* 55: 60–70.

Seddon, J.D. & Vinnicombe, P. 1967. Domestic animals, rock-art and dating. *South African Archaeological Bulletin* 22: 112.

Swart, J. 2004. Rock art sequences in the uKhahlamba-Drakensberg Park, South Africa. *Southern African Humanities* 16: 13–35.

Swart, J. & Escott, B. 2003. The Cascades painted stones. *Southern African Humanities* 15: 75–89.

Thackeray, A. I. 1983. Dating the rock art of southern Africa. *South African Archaeological Society Goodwin Series* 4: 21–26.

Van der Merwe, N.J., Sealy, J. & Yates, R. 1987. First accelerator carbon-14 date for pigment from a rock painting. *South African Journal of Science* 83: 56–57.

Vinnicombe, P. 1976. *People of the Eland: Rock Paintings of the Drakensberg Bushmen as a Reflection of their Life and Thought*. Pietermaritzburg: University of Natal Press.

Wadley, L. 1989. Gender relations in the Thukela Basin. *South African Archaeological Bulletin* 44: 122–126.

Willcox, A.R. 1957. A cave at Giant's Castle Game Reserve. *South African Archaeological Bulletin* 12: 82–97.

Willcox, A.R. 1971. Summary of Dr. Edgar Denninger's reports on the ages of paint samples taken from rock paintings in South and South West Africa. *South African Journal of Science Special Publication* 2: 84–85.

Wright, J.B. & Mazel, A.D. 2007. *Tracks in the Mountains: Exploring the History of the uKhahlamba-Drakensberg*. Johannesburg: Witwatersrand University Press.

PERSONAL COMMUNICATION

Peter Mitchell, 2007

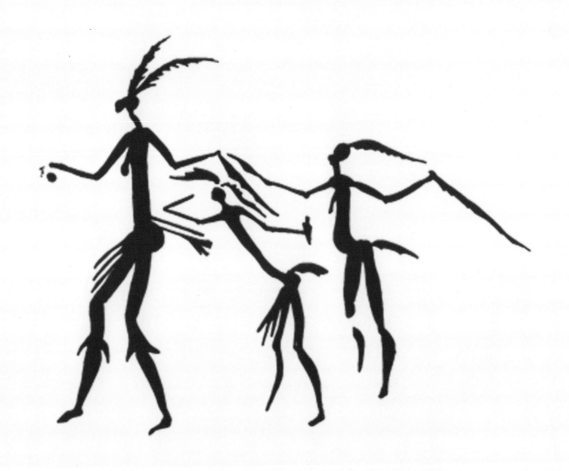

Gathering together a history of the *People of the Eland*:
Towards an archaeology of Maloti-Drakensberg hunter-gatherers

Peter Mitchell

P atricia Vinnicombe is justly remembered as a towering figure in the development of rock art research in southern Africa and a leading practitioner of ethically responsible heritage management in her adopted homeland of Australia. Reading *People of the Eland* one is also struck by the closeness of the relationship that she saw between the archaeological record that she traced and recorded with such care and enthusiasm and the archaeological record below the surface that could only be reached through excavation. Indeed, the original intention of the project she initiated with Pat Carter in 1969 was to write a holistic history of the hunter-gatherers of the Maloti-Drakensberg that drew equally upon excavated and parietal sources, oral traditions and archival texts. As it happened, their divorce meant that this combined study was never produced. *People of the Eland* summarised Pat's own monumental achievement in understanding the paintings and nineteenth century history of the Maloti-Drakensberg Bushmen, while Carter's (1978) doctoral thesis explored the region's deep-time archaeological record. An integrated study of the Maloti-Drakensberg's hunter-gatherer past using both rock art and 'dirt' archaeology remains elusive even today. This chapter has four goals: to record Pat's own contribution to the production of Maloti-Drakensberg hunter-gatherer history from excavation and field survey; to outline the results that she and Pat Carter obtained from that work; to sketch the history of hunter-gatherer archaeology in the region since their pioneering efforts; and to present the results of this in a way that spans the geopolitical and disciplinary divisions that have historically constrained research. First, however, I introduce the Maloti-Drakensberg region itself.

◀ Detail from Figure B8.1

The Maloti-Drakensberg: Geography, climate, ecology

The Maloti-Drakensberg Mountains are southern Africa's highest, reaching some 3 000 metres above sea level (asl). West of the uKhahlamba-Drakensberg Escarpment, the Lesotho landscape remains rugged, dissected by the Senqu River and its numerous tributaries. Beyond the Senqu, two further mountain chains – the Central and Front Ranges of the Maloti – intervene before one reaches Lesotho's lowlands and the Caledon River, the country's western border with South Africa (Figure 7.1). The South African part of the region falls within two provinces, KwaZulu-Natal and the Eastern Cape (where the relevant area can most simply be called 'Nomansland').[1] Numerous rivers, notably the Thukela, Bushman's and Mooi in the north, the Mngeni and Mkhomazi in the centre, and the Mzimkhulu and Mzimvubu in the south, drain from the Escarpment into the Indian Ocean. Farther south, in the Eastern Cape, the Langkloof is one of many rivers flowing into the Kraai, which in turn feeds into the Senqu after the latter's entry into South Africa. Another distinctive topographic feature is the 'Little Berg', a prominent sandstone terrace ~1 800–1 700 metres asl, which is rich in rock shelters and runs parallel to, but at some distance from, the top of the Escarpment. Ongeluks Nek is among the main passes linking Nomansland and Lesotho, with Sani Pass and Bushman's Nek being two of the easiest routes between Lesotho and KwaZulu-Natal.

Part of southern Africa's summer rainfall pattern, the Maloti-Drakensberg's climate is affected by variation in

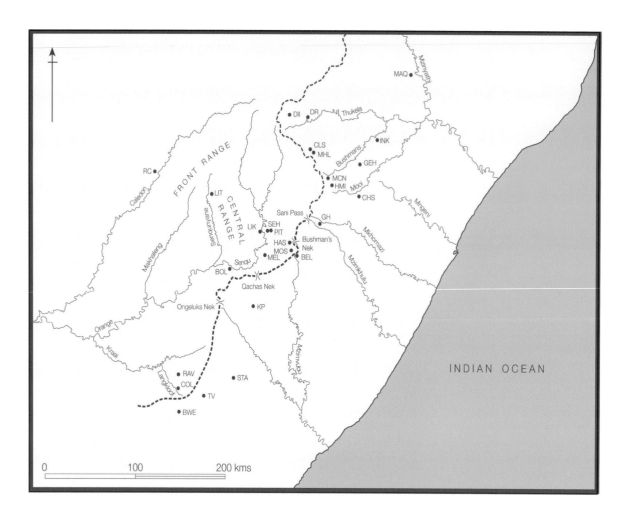

◀ **Figure 7.1**
The Maloti-Drakensberg region showing the location of archaeological sites excavated by Carter and Vinnicombe and other sites mentioned in the text. Site names are abbreviated thus: BEL Belleview; BOL Bolahla; BWE Bonawe; CHS Collingham Shelter; CLS Clarke's Shelter; COL Colwinton; DI1 Diamond 1: DR Driel; GEH Gehle; GH Good Hope; HAS Ha Soloja; HM Highmoor 1; INK iNkolimahashi; KP Kenegha Poort; LIK Likoaeng and Likoaeng North; LIT Lithakong; MAQ Maqonqo; MEL Melikane; MHL Mhlwazini; MCN Main Caves North (Giant's Castle); MOS Moshebi's Shelter; PIT Pitsaneng; RAV Ravenscraig; RC Rose Cottage Cave; SEH Sehonghong; STA Strathalan A and B; TV Te Vrede. At this level of resolution some sites are not shown: Esikolweni is near Mhlwazini, Barnes Shelter and White Elephant Shelter near Main Caves North and 2928DB34 near Likoaeng. The dashed line indicates the uKhahlamba-Drakensberg Escarpment. Map by Peter Mitchell.

altitude and by distance from the Drakensberg Escarpment, which exercises a pronounced rain-shadow effect on areas to its west. Thus, mean annual rainfall exceeds 1000 mm along the Indian Ocean coast and against the Escarpment, but falls to 780 mm in the Sehlabathebe Basin on the Lesotho/KwaZulu-Natal border and to <600 mm in the Senqu Valley. Nomansland experiences rather more than this, between 700 and 830 mm per annum. Temperature is another critical factor, for while summers are warm, with maximum temperatures exceeding 30°C even at 2 000 metres asl, in the highest reaches of the mountains mean annual values are as low as 6°C. Snow is thus not uncommon on high ground, with frost a serious problem for crop growth across Lesotho and Nomansland. Highland valleys also experience marked temperature inversion effects, and aspect significantly influences both vegetation and present-day settlement locations.

Because of the broadly north–south alignment of the Escarpment and the Indian Ocean coast, regional ecology is best viewed as a series of north–south trending slices. Simplifying greatly and remembering that farming has now drastically altered the 'natural' landscape, forest and scrub forest interspersed with grassland once dominated along the coast and below about 900 metres asl. Farther inland, grassland was once increasingly common, with trees and shrubs confined to sheltered locations, especially along the Escarpment and in Nomansland and the Senqu Valley. Several different grassland types are recognised, varying in their palatability and suitability for large ungulates: areas above 2 130 metres (less on south-facing slopes) and those receiving higher rainfall typically sustain 'sourer' grasses. Nutritious in early summer, they are of little use to grazers later in the year, unlike lower altitude 'sweetveld'. This contrast is important as it informs models of how hunter-gatherers may have exploited the regional landscape. Vinnicombe (1976), Carter (1978), Cable (1984) and Opperman (1987) give detailed accounts of regional ecology and resource availability.

Figure 7.2
Life at Sehonghong during the
excavation in 1971. From RARI
archive.

Pat Vinnicombe, 'dirt' archaeologist

There can be little doubt that Pat Carter's decision to initiate archaeological fieldwork in the Maloti-Drakensberg flowed from his marriage to Pat Vinnicombe as much as from his previous experience of working at the Natal Museum in 1958–59. Their joint fieldwork, conducted over several years (1969–71 and 1974), included excavations at six sites; four (Ha Soloja, Melikane, Moshebi's Shelter, Sehonghong) in Lesotho, two more (Belleview and Good Hope) in South Africa (Figure 7.1). Carter's unpublished fieldwork notes make plain that Pat was involved in all aspects of

this work.[2] At Good Hope and Sehonghong, for example, she collected samples for radiocarbon dating, while at Ha Soloja and Melikane she drew the section drawings that remain their principal stratigraphic records. She also played a full part in excavating, but her principal energies were inevitably devoted to recording the many rock paintings at all six excavated sites and others nearby, as well as in carrying out additional survey work and (at Sehonghong) oral history research of her own (Vinnicombe, this volume). Pat's joint accreditation in the authorship of the report on the Sehonghong excavations (Carter *et al.* 1988) testifies to the depth of her involvement (Figure 7.2).

Pat's personal participation in the 'dirt' archaeology side of fieldwork in Lesotho and the uKhahlamba-Drakensberg was not her first experience of excavation. She had, for example, previously worked in Sudan on excavations directed by Peter Shinnie (1990). She also brought to *People of the Eland* a profound knowledge of past archaeological research in the wider region, as well as her own observations, commenting that, "My own surface collections from the area under survey come from 80 shelters, and amount to more than 1 500 artefacts; all of them [able to] pass without comment in 'Smithfield B', 'C' or 'N' assemblages" (Vinnicombe 1976: 113). Even as she wrote, however, she was aware of the dubious validity of such designations and of the alternative interpretations of assemblage variability that she and Carter, among others, were helping to develop.

What was known when *People of the Eland* was written?

As her introduction makes clear, writing *People of the Eland* took time, from the first chapter in 1962 to the last in 1970, with a further six years elapsing before the work finally appeared in print (Vinnicombe 1976: xvi). At its outset no archaeological work whatever had been undertaken in highland Lesotho, while South Africa's side of the border had seen only brief survey work (Malan 1955; Wilson 1955) and limited excavations at disappointingly shallow rock shelters (Chubb & King 1932; Stein 1933; Wells 1933; Albino 1947; Willcox 1957; Farnden 1966). Carter (1978: 37) succinctly noted that "no stratified sequence and no absolute dates of relevance were available … the only justified use of the available data is to indicate where some archaeological sites occur". Mountainous terrain, still in the 1960s easier to access from horseback than by road in Lesotho and even parts of South Africa, the attractions of working more comfortably elsewhere, and a consensus that the Maloti-Drakensberg was a "refuge area, peripheral to the main stream of prehistory" (Carter 1978: 32, citing Davies 1947) account for this lack of knowledge.

Vinnicombe and Carter overturned this ignorance, excavating at the six sites already mentioned and discovering and mapping over 300 more painted rock shelters and surface artefact scatters. The result was a well-dated cultural stratigraphic sequence that established that people had been present in the Maloti-Drakensberg for over 100 000 years

(Carter & Vogel 1974; Carter 1978). Moreover, convinced of the explanatory potential of ecological variables for understanding human behaviour over archaeologically definable timescales, Carter (1969a, 1970, 1978) developed models to explore how hunter-gatherers had exploited the regional landscape. Detailing the scale and effects of climate change necessarily formed part of this (Carter 1976). So too did concepts that, though now perhaps overlooked or discounted, were then at the cutting edge of archaeological interpretation. The emphasis placed on outlining possible seasonal movements between sites and across the regional landscape, the utility of site catchment analysis and of measuring site aspect and temperature in constructing these models, and the suggestion that people practised patterns of seasonal aggregation and dispersal in which rock art and its associated ritual activity were principally a summer (aggregation) phenomenon, exemplify this methodological and theoretical innovativeness (Carter 1970, 1978; cf. Mazel 1982a, 1983; Wadley 1987).

To consider these points in more detail, rare finds of Early Stone Age hand axes and cleavers from open-air locations left no doubt of the antiquity of people's presence in the Senqu Valley and East Griqualand. Extensive Middle Stone Age (MSA) deposits at all four sites excavated in highland Lesotho confirmed this, supported by numerous surface scatters there and below 1 800 metres asl near Kenegha Poort.[3] Carter (1978: 143–156) grouped this MSA material into two successive industries (I and II), largely on the basis of the Moshebi's sequence (Carter 1969a). He also noted there and at Sehonghong a succession of small blade/large blade/small blade assemblages. A third assemblage – associated with smaller blades and backed crescents – was identified toward the base of the Melikane deposits and correctly attributed to the Howieson's Poort (Carter 1978: 148). Yet older MSA assemblages occur there and perhaps at Ha Soloja (Volman 1981; Mitchell 1992). Recently obtained Optically Stimulated Luminescence dates from Melikane and Sehonghong place some temporal constraints on these occupations, indicating pulses of activity ~80 and ~61 kya (thousands of years ago), followed by several more during Marine Isotope Stage (MIS) 3 (Jacobs *et al.* 2008).

All four highland Lesotho sites produced late MSA assemblages of MIS 3 date that Carter (1978: 263–264) grouped within his 'MSA Industry II'. Above them, he recognised a succession of three Later Stone Age (LSA) industries. The oldest (LSA Industry 3) was present only

TABLE 7.1. CULTURAL STRATIGRAPHIC-SEQUENCE FOR THE MALOTI-DRAKENSBERG (AFTER CARTER 1978)*

| kya | Sehlabathebe Basin | | | Senqu Valley | |
	Belleview	Ha Soloja	Moshebi's	Melikane	Sehonghong
<1.5	LSA Industry 1	LSA Industry 1	LSA Industry 1	LSA Industry 1	LSA Industry 1
≤3.3≥	LSA Industry 2	?	LSA Industry 2	LSA Industry 2	LSA Industry 2
8.6?	Oakhurst?	?	-	-	
13	-	?		-	LSA Industry 3
≥20	-	MSA Industry I	MSA Industry I	MSA Industry I	
>40	-	?	MSA Industry II	?	MSA Industry I
>42	-	?	?	Howieson's Poort	?
					?

Source: after Carter (1978: 166)

* Carter's (1978) discussion of his MSA Industries I and II is sometimes confused (cf. Carter 1978: 143 with Carter 1978: 263). Here, I have followed the designations used in his own summary chart (Carter 1978: 166). The presence of an Oakhurst-like assemblage at Belleview is not discussed in his thesis, but is raised in the relevant fieldnotes (Carter 1969b). The likely presence of a Howieson's Poort assemblage at Melikane is implicit, given discussion of the stratigraphic position of large backed segments there (Carter 1978:264).

at Sehonghong, although subsequent analyses hint that it may also occur at Melikane and Moshebi's (Carter *et al.* 1988: 196). Carter (1978: 161) correctly noted its remarkable similarity to the 'Pre-Wilton' of Rose Cottage Cave in the eastern Free State (Malan 1952). Both are now recognised as instances of the geographically much more widespread Robberg Industry first described in detail by Deacon (1978). More recent work at Rose Cottage (e.g. Wadley 1996) confirms the close similarities between its sequence and that at Sehonghong. Of Carter's remaining two LSA industries, Industry 2 recalled in general terms the Wilton Industry as known from its Eastern Cape Province type-site. However, Carter (1978: 163–164) refrained from using 'Wilton' in his analysis and kept the similarly less specific term 'Industry 1' for overlying assemblages that included bone fish hooks and various items pointing to contact with farming societies or European settlers (iron artefacts, glass beads, pottery). Unlike Industry 2, which may have been absent from the highly disturbed upper

deposits at Ha Soloja, Industry 1 occurred not only there, but also at all the other sites considered in Carter's (1978) thesis: Belleview, Melikane, Moshebi's and Sehonghong. Explicitly absent from this scheme, however, was anything resembling the non-microlithic Oakhurst Complex then only recently identified by Sampson (1974).

Table 7.1 summarises the preceding information for Carter and Vinnicombe's research area as a whole. Taken together, the dated sequences they obtained clearly established the potential of the Maloti-Drakensberg region – and especially of its Lesotho Highlands component – for investigating a series of questions that have been taken up over subsequent decades. The transition from MSA to microlithic LSA technologies, the adaptations made to the colder, drier stadial conditions of the Last Glacial Maximum, and the interactions between hunter-gatherers and iron-using agropastoralists are but three topics that continue to resonate in southern African archaeology (Mitchell 2002).

But it was past exploitation strategies, not artefacts, that

BOX 8. TAKING THE REINS: THE INTRODUCTION OF THE HORSE IN THE NINETEENTH-CENTURY MALOTI-DRAKENSBERG AND THE PROTECTIVE MEDICINE OF BABOONS

Sam Challis

This contribution highlights the recent discovery of the most likely authors of much of the nineteenth-century 'contact' art in the Maloti-Drakensberg, their introduction of the horse to this region, and their belief in the protective powers of the baboon. The tables in *People of the Eland* show that the horse constitutes the second most painted animal in Patricia Vinnicombe's research area (Vinnicombe 1976: 155). While this may only raise a few eyebrows, it is perhaps more important to note that Vinnicombe's 'research area' comprises all of the Drakensberg from Giant's Castle southwards to the Mount Fletcher District of the Eastern Cape. In addition, it includes most of the back range of the Maloti Mountains that connects westward of this region, and the Lesotho stretches of the Senqu (Orange) and Senqunyane rivers. Her work spanned decades and its legacy, especially that of the tracings made, is profound.

Work of this nature generates the substance of the all-important research questions of the future. Vinnicombe's finding, that horses were painted in such proliferation that they are second only to eland in number, prompted the question: 'What was the impact of the arrival of the horse on the peoples of the south-eastern mountains in the nineteenth century?' The question can be approached using historic and ethnohistoric sources, and also by using the archaeological record – the rock art of the nineteenth century.

Histories have been written of the nineteenth century Bushmen, inspired by the colonial archives (Wright 1971) in combination with the painted record (Vinnicombe 1976), but these have received criticism insofar as the paintings are used to 'illustrate' the historical text, thus compounding the problem of viewing the images as a 'record' of events (Campbell 1986, 1987). Analysis of statistics against distribution has proven useful in highlighting the different conditions pertaining to the introduction of different domesticated animals (Manhire *et al.* 1986). More recent histories (Blundell 2004) have achieved a greater degree of synthesis between the written record and the painted record as expressed by the Bushmen themselves.

This has largely been achieved through the detailed examination of tracings.

While there is little doubt that some hunter-gatherers continued to paint 'traditional' subject matter well into, if not throughout, the contact period (Loubser & Laurens 1994; Blundell 2004), the corpus of art more commonly associated with colonial contact is drastically different. Instead of friezes of shaded polychrome eland, herds of rhebok, or images of hartebeest and trance buck, we see herds of cattle being driven by people on horseback, and a handful of paintings of wagons (Woodhouse 1990). When eland are painted, they are usually being hunted from horseback or being butchered afterwards.

The horse riders shown in these paintings are depicted in fine-line block style with great consistency over Vinnicombe's research area (Vinnicombe 1960). They bear items of material culture that differentiate them from figures in precolonial paintings: hats and guns, spears (assegais) and knobbed fighting sticks (knobkerries). Different headgear, which might otherwise be used to differentiate culture, is worn by people within the same groups. They are frequently depicted wearing wide-brimmed hats, often with long feathers in them (assertions that hats, guns and horses are diagnostic of Europeans are hopelessly inadequate, yet still pervasive in rock art research). Alongside such figures are those adorned with knobbed headdresses, probably bladders worn in the hair (Vinnicombe 1976: 47, 89; Jolly 2006), as well as those depicted just wearing the long feathers – either one or two – in central dancing groups (Vinnicombe 1976: 49, 297).

There is a pattern, first observed by Lee and Woodhouse (1970) and then Solomon (1996), in which certain sites in the southern Maloti-Drakensberg contain paintings of remarkable similarity portraying images of horses in association with dancers wearing feathered headdresses. Observing just two sites, Mpongweni North and Barnes' Shelter, 60 kilometres distant from one another, Lee and Woodhouse (1970) wondered if they were perhaps the work of the same individual. Solomon

(1996: 294) included a third site traced by Vinnicombe (1976: 317, Figure 224) in Lesotho (Figure B8.1), yet was concerned solely with art–historical questions of style as might be used by one artist or several within a tradition. Had Solomon continued, she would have discovered that the similarities between those three sites are just the tip of the proverbial iceberg. Coupled to this pattern is another which has gone entirely unnoticed: horses and horse riders are found painted in association with baboons, or people dancing with baboon features, normally the head and tail (Figure B8.2). Baboons tie together images of people with knobbed headdresses, and people wearing hats and carrying guns, people dancing and people riding.

Baboon figures painted in the Horse Site Dancing Groups suggest one element of this painted phenomenon quite clearly: the baboon was central (cf. Lewis-Williams 1981) to the religious ideology of the horse riders. But why baboons?

Archival work conducted by John Wright (1971) and Patricia Vinnicombe (1976) unearthed statements from 1850, some reproduced in *People of the Eland* (Vinnicombe 1976: 73, 74), in which Bushmen, so-called Coloured people, and European clergymen gave the name of the people whom they believed to be responsible for the majority of stock raids against Bantu-speaking and European farmers below the Drakensberg escarpment. It transpires that the group on whom, rightly or wrongly, the blame was laid were called the AmaTola. Owning many cattle and horses, they lived in the region that we now find most densely painted with cattle, horses and baboons. The nineteenth century rock art of that area is very likely their work.

The creolised nature of the nineteenth-century 'Bushmen' of the Drakensberg is now being recognised (Blundell 2004; Wright 2007; Wright & Mazel 2007). The AmaTola were 'a large tribe of Bushmen, Hottentots [Khoekhoe speakers], and runaway slaves' (Cape Archives G.H. 23 1850: 417), and they would almost certainly have included many members of Bantu-speaking descent (e.g. Jolly 1994). There has been some

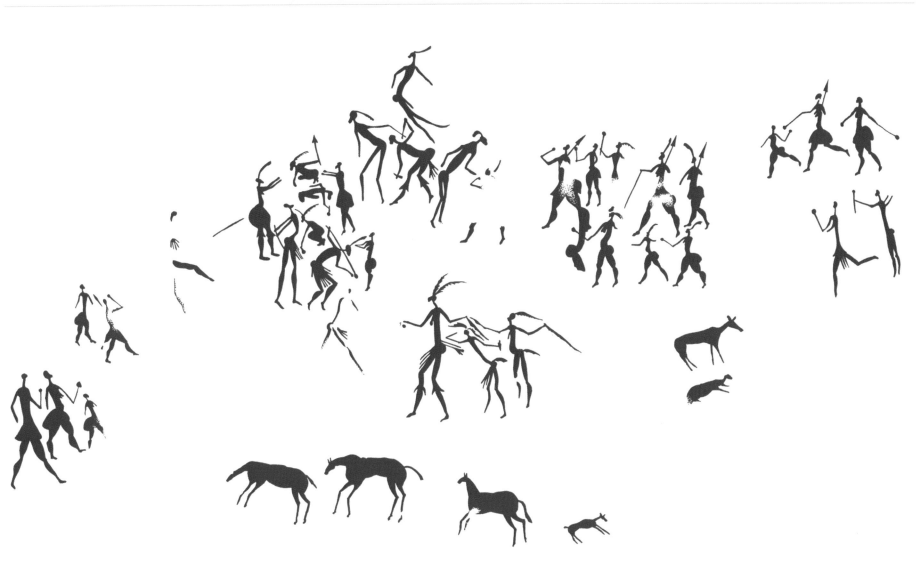

▲ **Figure B8.1**
Horse dance painting. Redrawn by Sam
Challis from Patricia Vinnicombe colour
redrawing.

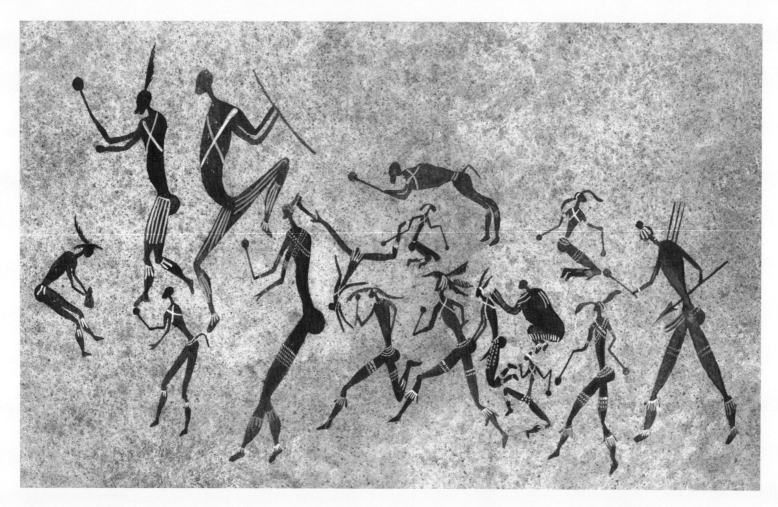

debate as to whether Bushman and Bantu-speakers' cosmologies were affected by one another, and to what degree (e.g. Jolly, 1996a, 1996b, 2000; Hammond-Tooke 1998, 1999), but it seems the AmaTola raiders held beliefs that were shared by Bushmen, Bantu speakers *and* Khoekhoe speakers. Recent research (Challis 2008) suggests that the AmaTola brought horses into the Drakensberg from the Eastern Cape frontier and forged themselves a new identity around the symbols of the horse and the baboon (Figure B8.3). Owing to extensive precolonial interaction between hunters, herders and farmers, these diverse cultures shared the belief that the baboon was a symbol of protection, associated with certain root medicines which made it invulnerable to sickness or evil and gave it knowledge of approaching danger (Hollmann 2004: 11). Baboons were thus enabled to raid crops and livestock (Estes 1992: 510) and to escape unharmed. Among the raiders, the Bushmen were renowned for their ability to harness the potency of certain animals during ritual dances. The rock art shows dancing groups changing into baboons and horses. Horses were seen to be 'like' baboons in that they have the same running gait, and carry juveniles in the 'jockey position' (Estes 1992: 513, 518) and also carried one out of harm's way. The creolised raiders believed they could appropriate, in ritual, the protective powers of the baboon and by association the horse and thus remain unharmed on mounted raids into the colonies. When individuals of different cultures came together in the face of nineteenth-century colonisation, they were able to creolise around a shared belief in order to survive on the colonial frontier.

▲ **Figure B8.2**
Baboon dance painting. Tracing and redrawing by Patricia Vinnicombe (1976; fig. 217).

Blundell, G. 2004. *Nqabayo's Nomansland: San Rock Art and the Somatic Past*. Uppsala: Uppsala University.

Campbell, C. 1986. Images of war: a problem in San rock art research. *World Archaeology* 18: 255–268.

Campbell, C. 1987. Art in crisis: contact period rock art in the south-eastern mountains of southern Africa. Unpublished MSc thesis. Johannesburg: University of the Witwatersrand.

Cape Archives 1850. GH (Government House) 8/23, Letters received from Chief Commissioner, British Kaffraria, 1846–52: 329–501.

Challis, W.R. 2008. The impact of the horse on the AmaTola 'Bushmen': new identity in the Maloti-Drakensberg Mountains of southern Africa. Unpublished DPhil thesis. Oxford: University of Oxford.

Estes, R.D. 1992. *The Behavior Guide to African Mammals*. Berkeley: University of California Press.

Hammond-Tooke, W.D. 1998. Selective borrowing? The possibility of San shamanistic influence on Southern Bantu divination and healing practices. *South African Archaeological Bulletin* 53: 9–15.

Hammond-Tooke, W.D. 1999. Divinatory animals: further evidence of San/Nguni borrowing? *South African Archaeological Bulletin* 54: 128–132.

Hollmann, J.C. 2004. (ed.) *Customs and Beliefs of the /Xam Bushmen*. Johannesburg: Witwatersrand University Press.

Jolly, P.A. 1994. Strangers to brothers: interaction between south-eastern San and Southern Nguni/Sotho communities. Unpublished MA thesis. Cape Town: University of Cape Town.

Jolly, P.A. 1996a. Symbiotic interaction between Black farmers and south-eastern San: implications for southern African rock art studies, ethnographic analogy, and hunter-gatherer cultural identity. *Current Anthropology* 37: 277–305.

Jolly, P.A. 1996b. Interaction between south-eastern San and southern Nguni and Sotho communities, c. 1400 to c. 1800. *South African Historical Journal* 35: 30–61.

Jolly, P.A. 2000. Nguni diviners and the south-eastern San: some issues relating to their mutual cultural influence. *Natal Museum Journal of Humanities* 12: 79–95.

Jolly, P.A. 2006. The San rock painting from the 'Upper cave at Mangolong', Lesotho. *South African Archaeological Bulletin* 61: 68–75.

Lee, D.N. & Woodhouse, H.C. 1970. *Art on the Rocks of Southern Africa*. New York: Scribner's.

Lewis-Williams, J.D. 1981. *Believing and Seeing: Symbolic Meanings in Southern San Rock Paintings*. London: Academic Press.

Loubser, J.H.N. & Laurens, G. 1994. Paintings of domestic ungulates and shields: hunter-gatherers and agro-pastoralists in the Caledon River valley area. In: Dowson, T.A. & Lewis-Williams, J.D. (eds) *Contested Images: Diversity in Southern African Rock Art Research*: 83–118. Johannesburg: Witwatersrand University Press.

Manhire, A.H., Parkington, J.E., Mazel, A.D. & Maggs, T.M.O'C. 1986. Cattle, sheep and horses: a review of domestic animals in the rock art of southern Africa. *South African Archaeological Society Goodwin Series* 5: 22–30.

Solomon, A. 1996. Some questions about style and authorship in later San paintings. In: Skotnes, P. (ed.) *Miscast: Negotiating the Presence of the Bushmen*: 291–295. Cape Town: University of Cape Town Press.

Vinnicombe, P. 1960. General notes on Bushman riders and the Bushman's use of the assegai. *South African Archaeological Bulletin* 15: 49.

Vinnicombe, P. 1976. *People of the Eland: Rock Paintings of the Drakensberg Bushmen as a Reflection of their Life and Thought*. Pietermaritzburg: Natal University Press.

Woodhouse, H.C. 1990. Wagons in rock art. *Africana Notes and News* 29: 86–88.

Wright J.B. 1971. *Bushman Raiders of the Drakensberg 1840–1870*. Pietermaritzburg: University of Natal Press.

Wright, J.B. 2007. Bushman raiders revisited. In: Skotnes, P. (ed.) *Claim to the Country: The Archive of Lucy Lloyd and Wilhelm Bleek*: 118–129. Johannesburg: Jacana Press.

Wright, J.B. & Mazel, A.D. 2007. *Tracks in a Mountain Range: Exploring the History of the Ukhahlamba-Drakensberg*. Johannesburg: Witwatersrand University Press.

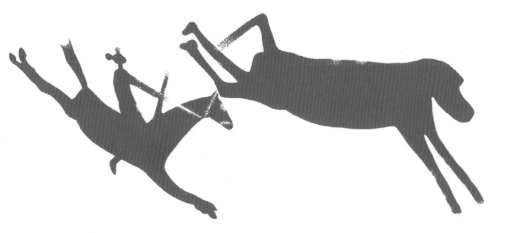

▲ **Figure B8.3**
Horseman and baboon painting. Tracing and redrawing by Sam Challis.

Ecological region	INTERGLACIAL		STADIAL	
	Senqu Valley	Sehlabathebe Basin/ East Griqualand	Senqu Valley	Sehlabathebe Basin/ East Griqualand
Themeda-Festuca grassland	Summer at Sehonghong ↕ Winter at Melikane		Summer occupation only	
Highland sourveld		Summer occupation (aggregation sites)		Summer occupation (but abandoned at times of greatest cold)
Valley bushveld		Sporadic, transient use		
Thornveld		Winter occupation (by smaller bands)	Winter occupation	Winter occupation
Ngongoniveld				
Coastal forest and thornveld				

◀ **Figure 7.3**
Models of hunter-gatherer land use in the southern Maloti-Drakensberg under interglacial and stadial conditions (after Carter 1976,1978)

loomed largest in Carter and Vinnicombe's 'dirt' archaeology research. Inspired by Eric Higgs's work in Greece (Higgs & Vita-Finzi 1967), Carter (1970) employed known climatic and ecological variation to argue that people would have spent their summers in the highland sourveld areas of the KwaZulu-Natal Drakensberg and the adjacent Sehlabathebe Basin, moving downslope to winter in the lower-lying thornveld, which offered year-round grazing for game. Fieldwork refined and elaborated this model (Figure 7.3). A key element was the identification of the Senqu Valley as a second and separate exploitation territory, consistent with nineteenth century historical descriptions of the ranges of named Bushman groups (Vinnicombe 1976: 61). Contrasts in temperature, aspect and catchment, differences in formal tool frequencies thought to indicate seasonally linked

activities like hide preparation, and biological indicators such as summer-spawning fish and summer-flowering plants then led Carter (1978) to propose that Sehonghong would have been preferred as a summer campsite, Melikane as a winter one.

For the Sehlabathebe Basin, catchment, temperature and aspect data identified Ha Soloja as a summer-occupied site within an exploitation territory spanning the Escarpment. Belleview was thought, from changes in its artefact assemblage, to have switched from summer to winter occupation around 1600 BP, with Moshebi's – largely from its position between the two – scheduled for spring and autumn use. These models were developed for the Holocene, but Carter (1976) also modelled land-use patterns under stadial conditions, suggesting that the

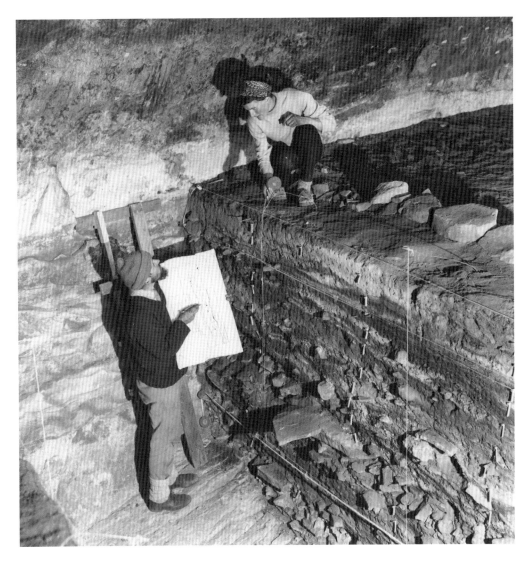

▲ **Figure 7.4**
Patricia Vinnicombe and Pat Carter
working at Sehonghong. From RARI
archive.

excavations was incomplete, but she drew on the interpretations I have outlined as background for her own study, while noting other finds and themes still relevant over three decades later.[4] One example is her reference to the marine shells (many made into jewellery) from the later levels at Sehonghong (Figure 7.4) that attest to the time-depth of connections between the inhabitants of highland Lesotho and those of the Indian Ocean coast (Vinnicombe 1976: 74, note 27). The overall similarity of rock art across the region also showed that its inhabitants had been in close contact with each other, something reinforced by the distributions of specific motifs like the fishing scenes (Vinnicombe 1976: 293–296) discussed by Hobart (2003b). Fish images and shell jewellery remain of interest, not least in attempts to tie together rock art depictions and excavated evidence in understanding people's long-distance connections across the region (cf. Ouzman 1995).

A second example relating rock art and excavated data comes from Carter and Vinnicombe's interest in comparing the Maloti-Drakensberg's archaeozoological record as recovered from excavation with the choice of wild ungulates depicted in its art. An early conclusion was, of course, the absence of any direct correlation between the two: eland, for example, are vastly more common in the art than other taxa, while species such as black wildebeest that certainly occurred in the region are avoided (Vinnicombe 1976: 209). Carter (1978) expanded this argument, noting that Lesotho's modern fauna is but a weak guide to what was there before the late nineteenth century: paintings of elephant, rhinoceros, hippopotamus, hartebeest and a hippotragine antelope might thus indicate the regional presence of these species in the past. More recent excavations at Sehonghong and Likoaeng confirm that hartebeest – which was, in fact, still present in highland Lesotho in the late 1800s (Germond 1967: 418–423) – and two hippotragine taxa (bluebuck, *Hippotragus leucophaeus*, and roan, *H. equinus*) are indeed present in local faunal assemblages (Plug & Mitchell 2008b). Such attempts to relate painted and excavated evidence in turn raise the question of the age of the rock art itself. Exfoliated fragments of painted sandstone excavated at Sehonghong in contexts pre-dating 1400 BP remained until recently some of the earliest evidence for parietal rock art production in the Maloti-Drakensberg (Vinnicombe 1976: 143; Mazel, this volume).

Perhaps surprisingly, another topic was not really taken up by either Vinnicombe or Carter. I refer here to the fact

Senqu Valley and the highland sourveld were only used in summer at such times and that the latter was too marginal for any kind of settlement during the coldest parts of the Pleistocene. The lack of radiocarbon dates for MIS 2 from Moshebi's and Ha Soloja, in contrast to Sehonghong and Melikane, supported this, while rockfall and spall horizons in excavated sequences were interpreted as proxy evidence for a significantly colder Upper Pleistocene climate (Carter 1976, 1978: 329–330).

In broad terms this was the picture that Pat knew as she completed *People of the Eland*. Analysis of individual

▲ **Figure 7.5**
View of Melikane Shelter. Photo by
Neil Lee.

that two of the sites that they excavated (Sehonghong and Melikane) were visited in 1873 by Joseph Orpen (1874), who obtained from his Bushman guide Qing explanations of what some of their paintings meant. This information constitutes the only such data in southern Africa provided by someone from a community among whom the tradition of painting was still alive. Along with the rest of Qing's statements, it has been crucial to developing the ethnographically informed shamanistic paradigm that has transformed Bushman rock art research (Lewis-Williams 1981, 1995; Lewis-Williams & Pearce 2004). Carter (1978: 34) himself merely noted that Orpen had reproduced some of the Sehonghong and Melikane paintings (Figure 7.5), and though mentioning the existence of several other ethnohistoric reports used none of them in his analysis. Focusing on the art and history of the Maloti-Drakensberg Bushmen as they lost their independence to the advancing frontiers of European, Sotho and Nguni settlement, Pat used both sources more extensively, for example in discussing the medicine dance and rainmaking beliefs (Vinnicombe 1976: 314–319, 336–339). However, the degree to which this ethnohistoric material might have been affected by centuries of interaction with agropastoralist Bantu-speaking peoples remained unexplored for another 20 years (Jolly 1994).

What has happened since *People of the Eland* was published?

Where Carter and Vinnicombe ignored the distinction between South Africa and Lesotho in their fieldwork, excavating, surveying and tracing on both sides of the border, their successors have been less fortunate. Changed political circumstances, personal choice, and funding and logistical constraints have meant that when archaeologists have engaged in fieldwork they have done so in *either* South Africa *or* Lesotho, but not both. Hobart (2003a: 93) rightly deplores the lack of cross-referencing that this has sometimes produced. With this in mind, I now outline who has done what since Carter and Vinnicombe's pioneering efforts (Figure 7.6). Mitchell (1992, 2001), Hobart (2003a) and Wright and Mazel (2007) provide more detail. Carter and Vinnicombe last collaborated in the field in 1974 when excavating Melikane. Vinnicombe subsequently – 1976 – recorded, but did not excavate, several dozen more sites, many with paintings, in the lower Senqunyane Valley (Bousman 1988). Thereafter, a long hiatus intervened in highland Lesotho, punctuated by survey work ahead of road construction along its southern perimeter that included excavation at Bolahla, a small rock shelter next to the Senqu (Jobling *et al.* 1984; Parkington *et al.* 1987; Smits 1992; Mitchell *et al.* 1994). More recent environmental impact mitigation efforts, focused on the Lesotho Highlands Water Project (LHWP), have mostly taken place just to the north-west of the Maloti-Drakensberg as defined here. Within the region, however, Kaplan (1996) has sampled open-air artefact scatters and excavated at a rock shelter in the catchment of the Mohale Dam. Happily, the archaeologically much richer areas farther downstream along the Senqu and its major tributaries remain unaffected by LHWP's activities (Mitchell 2005).

Here, the Sehonghong area has been the chief focus of renewed fieldwork, preceded by survey work in 1971 and 1985 that photographed rock paintings between there and Melikane (Smits 1973). Analysis of the cultural assemblages from Carter and Vinnicombe's excavations identified Sehonghong as a key site for understanding hunter-gatherer adaptations in the Lesotho Highlands and monitoring changes in them over the shifting climates of the late Quaternary (Mitchell 1987; Carter *et al.* 1988). Whereas the original excavations had employed ten centimetre thick spits that inevitably cross-cut the site's natural stratigraphy,

work in 1992 proceeded stratigraphically to recover well-contextualised samples of artefacts, fauna and plant remains spanning the last 25 000 years (Mitchell 1994, 1995, 1996a, 1996b, 1996c; Plug & Mitchell 2008a, 2008b). This work did not, however, extend into the MSA part of the Sehonghong sequence as field survey located an open-air, multiphase Late Holocene site with excellent faunal preservation at Likoaeng, a few kilometres distant on the banks of the Senqu River. Given the extreme rarity of such sites in southern Africa, fieldwork shifted there in 1995 and 1998, when three smaller rock shelters in the vicinity were also sampled, the first time such sites were investigated in highland Lesotho (Mitchell & Charles 2000; Mitchell 2004; Mitchell *et al.* 2006, in press). Subsequently, John Hobart (2003a, 2004) followed up this approach by excavating at Pitsaneng Shelter, most likely the third site at which paintings were interpreted by the nineteenth century Bushman Qing (Orpen 1874). Located one kilometre upstream of Sehonghong, its second millennium AD sequence yielded the only human burial thus far recovered from the Maloti-Drakensberg. More recently, highland Lesotho has seen survey work in the upper Senqunyane Valley (Aitken *et al.* 2000), tracing of rock paintings at Likoaeng (Challis *et al.* 2008), and the opening up of Carter and Vinnicombe's trenches at Sehonghong and Melikane for Optically Stimulated Luminescence and accelerator radiocarbon dating (Jacobs *et al.* 2008). Melikane, which boasts the region's most comprehensive MSA sequence, has recently been re-excavated by Brian Stewart of Cambridge University in a project that, one hopes, may also involve serious re-analysis of the MSA assemblages excavated by Carter and Vinnicombe at all of their four highland Lesotho sites.

In South Africa, the initial follow-up to Carter and Vinnicombe came from Charles Cable, a doctoral student of Pat Carter's, who undertook a more detailed exploration of the latter's seasonal mobility model. Working mostly with material excavated or collected by others, he also published the Good Hope site (Cable *et al.* 1980) and excavated at two rock shelters near the coast (Cable 1984). Back in the Escarpment, Maggs and Ward (1980) excavated at Driel in 1974 shortly after the former had been appointed to the first professional archaeological position in Natal. However, systematic hunter-gatherer research awaited the arrival of Aron Mazel in 1979, who initiated three decades of research with a cultural heritage management plan for

some of the Drakensberg's rock art (Mazel 1981, 1984a) and showed (*pace* Willcox 1974) that evidence exists for at least ephemeral MSA activity in the northern Natal Drakensberg (Mazel 1982b). Subsequently, Mazel surveyed and excavated widely across the upper Thukela Basin. His initial sample of eight excavated sites (Mazel 1989) has since doubled, with the large mid-Holocene assemblages from Maqonqo and exceptionally well-preserved organics from Collingham Shelter being especially important (Mazel 1992a, 1996).

Mazel has also begun building a reliable chronology for the region's rock art using Accelerator Mass Spectrometry radiocarbon dating (Mazel & Watchman 1997, 2003). Despite obvious problems of scale, resolution and possible contamination, the dates obtained allow a start to be made on relating temporal patterning in the art with other changes in the archaeological record (Mazel, this volume). Detailed studies of superpositioning and style contribute additional elements to the emerging framework (Russell 2000; Swart 2004). Models of social change have previously been elaborated in the absence of such dates, often by assuming that the imagery's associations or content pin it down to the last few centuries of independent hunter-gatherer existence (Campbell 1987; Dowson 1994, 1995, 1998, 2000; Ouzman & Loubser 2000; Blundell 2004). However, since the rest of the archaeological record **is** chronologically structured – and generally investigated along a temporal axis – the integration of rock art and excavated data will certainly proceed more effectively if the former is also temporally better controlled. To do otherwise risks producing an unvarying, ahistorical interpretation of the **entire** archaeological record (Mazel 1993; Parkington 1998). Over three decades on from *People of the Eland*, this remains a major challenge. Its importance is shown by Geoff Blundell's (2004) work in Nomansland. Here at the Drakensberg's southern end, synthesis of historical sources and rock art imagery offers a compelling narrative of social change focused on the production and consumption of paintings as nineteenth and early twentieth century Bushmen confronted rapidly expanding agropastoralist communities and the structures of the colonial state. Regrettably, however, the excavated record that would relate to this and provide a much longer time-depth remains slight, effectively the opposite situation to that found elsewhere and demonstrating that the problem of connecting parietal and excavated records cuts both ways.

Bonawe, Colwinton and Ravenscraig all have evidence of LSA occupation, but were excavated on a small scale and using spits, not the natural stratigraphic subdivisions that might provide a more highly resolved chronostratigraphy (Opperman 1987). Reaching farther back in time, Strathalan B has yielded a series of terminal MSA assemblages; both it and the purely Holocene sequence at nearby Strathalan A boast excellent palaeobotanical preservation (Opperman & Heydenrych 1990; Opperman 1992, 1996a, 1996b).

Having reviewed what has been done since *People of the Eland* was first published (Table 7.2), I now consider what this research has taught us about the hunter-gatherers who produced the paintings that Pat Vinnicombe made her life's work. In tandem, I also try to identify some key issues for the next generation of researchers to follow in her footsteps.

Maloti-Drakensberg hunter-gatherers: An archaeological synthesis

While fieldwork during the last 30 years has concentrated almost entirely on LSA sites, it is worth stressing at the outset the importance of developing a history of Maloti-Drakensberg hunter-gatherers that frees itself from the outdated taxonomic straitjacket of 'Middle Stone Age' and 'Later Stone Age' subdivisions. Research elsewhere shows that anatomically modern humans have been able to produce art and jewellery for ≥80 000 years (Barham & Mitchell 2008). Even though this capacity may not always have been deployed, and even though (more likely) it may not always be archaeologically preserved or recovered, the conclusion seems inescapable that across this period no substantial difference in cognitive capacity exists. Comparing the Middle/Upper Palaeolithic transition in Eurasia with the shift from MSA to LSA stone tool technologies in southern Africa is thus wholly misplaced. We ought instead to abandon some of our accumulated conceptual baggage, find alternatives to the stadial taxonomy inherited from Goodwin and Van Riet Lowe (1929), avoid terminologies that conflate periods of time with particular patterns of material culture, and dissociate (at least as a starting point in our enquiries) changes in the manufacture, use and organisation of stone tools from other aspects of people's lives (Mitchell 1994, 2008a; Clark 1999). One small step might be to eschew the very terms 'Middle

TABLE 7.2. EXCAVATED ARCHAEOLOGICAL SITES OF THE MALOTI-DRAKENSBERG

Site	Date	Maximum area (m²)	Method	Sieve (mm)	LSA/MSA presence		Principal references
NORTHERN KWAZULU-NATAL DRAKENSBERG							
Clarke's	1980	10	Layers + spits	2.0	LSA		Mazel (1984a)
Collingham	1988	n/a	Layers	2.0	LSA		Mazel (1992a)
Diamond 1	1980	20	Layers + spits	2.0	LSA		Mazel (1984a)
Driel	1974	16	Layers	?	LSA		Maggs & Ward (1980)
Mhlwazini	1987	8	Layers + spits	2.0	LSA		Mazel (1990)
SOUTHERN KWAZULU-NATAL DRAKENSBERG							
Belleview	1969	4?	10 cm spits	5.0	LSA		Carter (1978); Hobart (2003a)
Good Hope	1971	7	10 cm spits	5.0	LSA		Cable et al. (1980)
LESOTHO HIGHLANDS							
Bolahla	1982/83	28	2-5 cm spits	2.0	LSA		Mitchell et al. (1994)
Ha Soloja	1971	12	10 cm spits	5.0	LSA	MSA	Carter (1978)
Likoaeng	1995 + 1998	30	Layers	2.0	LSA		Mitchell et al. (2006, in press)
Lithakong	1995	7	Layers + 5 cm spits	3.0	LSA		Kaplan (1996)
Melikane	1974	12	10 cm spits	5.0	LSA	MSA	Carter (1978)
Moshebi's	1969	10	10 cm spits	5.0	LSA	MSA	Carter (1969a, 1978)
Pitsaneng	2000	10	5 cm spits	2.0	LSA		Hobart (2003a, 2004)
Sehonghong	1971	10	10 cm spits	5.0	LSA	MSA	Carter et al. (1988)
	1992	12	Layers	1.5	LSA		Mitchell (1996c)
2928DB29	1998	1	Layers	2.0	LSA		Mitchell et al. (in press)
2928DB33	1998	1	Layers	2.0	LSA		Mitchell et al. (in press)
2928DB34	1998	2	Layers	2.0	LSA		Mitchell et al. (in press)
NOMANSLAND							
Bonawe	1980	4	Mostly 5 cm spits	3.0	LSA		Opperman (1987)
Colwinton	1978/79	9	Layers + 5 cm spits	3.0	LSA		Opperman (1987)
Ravenscraig	1981	1	5 cm spits	3.0	LSA		Opperman (1987)
Strathalan A	1994-97	19	Layers	3.0?	LSA		Opperman (1996b, 1999)
Strathalan B	1987, 1988-91	26	Layers + 5 cm spits	3.0?	MSA		Opperman (1992, 1996a; Opperman & Heydenrych 1990)
Te Vrede	1981	2	Mostly 5 cm spits	3.0	LSA		Opperman (1987)

Source: *Compiled by Peter Mitchell*

Stone Age', 'Later Stone Age' and 'Iron Age' and focus on modes of production, or at least modes of producing stone tools (cf. Barham & Mitchell 2008).

This does not mean that we should open the floodgates to the projection ever farther back in time of (our principally Kalahari- and Karoo-derived) Bushman ethnography. Broader comparative approaches are at least as useful (Humphreys 2004/05; cf. Kelly 1995; Binford 2001). It does, though, emphasise the importance of the sites excavated by Vinnicombe and Carter for exploring the archaeology of behaviourally modern hunter-gatherers throughout the last 80 000 years and under a wide diversity of climatic conditions. As argued elsewhere (Mitchell 2008a), the Maloti-Drakensberg stands out in southern Africa for its exceptionally high density of deep-sequence rock shelters dating to MIS 4 and 3, ~75–25 kya. Moreover, Melikane and possibly Ha Soloja extend this span back beyond the Howieson's Poort, while Sehonghong (and to a degree Melikane) extend it forward into MIS 2. Nowhere else in southern Africa can one find so many sites of this age within such a short distance of each other.[5] Recalling Strathalan B, less than 150 kilometres to the south, the numerous open-air sites identified by Carter and Vinnicombe's surveys that could be linked with excavation-based data in an integrated study of landscape use, and the complementary observations offered by Umhlatuzana (Kaplan 1990) and Sibudu (Wadley 2006), the attractions of such a regionally focused study only increase. In a field still dominated by a handful of sites in the Cape, the Maloti-Drakensberg and its surrounds have much to commend them, and it is thus all to the good that new field research in highland Lesotho bears these concerns in mind. This, however, is for the future. For now, I identify five themes:

1. better understanding of the region's cultural-stratigraphic sequence;
2. the degree to which hunter-gatherer occupation has been punctuated or continuous;
3. the ways in which people moved across the landscape and organised their exploitation of its resources;
4. the connections between people living in different parts of the region and with those living in adjacent areas;
5. the impact on hunter-gatherer societies of agropastoralist settlement.

Chronostratigraphy and settlement (dis)continuity

As they are closely related, I discuss the first two themes together. When *People of the Eland* was published, 36 radiocarbon dates existed for hunter-gatherer sites in the Maloti-Drakensberg, almost half of them for MSA assemblages that strain the limits of the radiocarbon technique. Excluding these results and others where stratigraphic inconsistencies are clearly apparent, the number of reliable radiocarbon determinations has now more than quintupled, from 23 to 120 (Table 7.3). Though still small, using materials that produce results of variable accuracy and precision, and affected by variation in the intensity with which individual sites have been dated, this data set gives some sense of changes in the distribution of human settlement over the past 30 000 years (Figure 7.7). It is immediately obvious that occupation has been highly punctuated. Several clusters of dates stand out: immediately before the Last Glacial Maximum, at the end of the Pleistocene (~13–12 kya), in the mid-Holocene (~7–6 kya), and within the last 3 000 years. Moreover, for the latter period dates are notably more abundant before 1800 BP, though this may partly result from archaeologists making less use of radiometric dating at the very recent end of the timescale and/or the frequently disturbed context of the uppermost deposits in rock shelter contexts.

Disaggregating Figure 7.7 and dividing the Maloti-Drakensberg into four sub-regions, further patterns emerge. Table 7.4 summarises the cultural-stratigraphic sequences for Nomansland, the southern KwaZulu-Natal Drakensberg from Sani Pass to Qacha's Nek, the northern Escarpment, and highland Lesotho, while Figure 7.8 illustrates temporal variation in the numbers of dated sites and radiocarbon dates in each of these areas.

For the Pleistocene the contrasts are twofold. First, only highland Lesotho and Nomansland were occupied 30–20 kya, though assemblages and stratigraphies from Melikane, Sehonghong and Strathalan B suggest that people were only episodically present (Carter 1978; Opperman & Heydenrych 1990; Opperman 1992, 1996a; Mitchell 1994). After 20 kya, evidence of occupation is restricted to Lesotho, where Sehonghong has two substantial pulses, the first of them also evident at Melikane. The palaeoclimatic context needed to understand these patterns remains poorly defined, with past periglacial processes difficult to date (Grab 2000) and the exceptionally well-preserved charcoal sequence from Sehonghong not yet analysed.

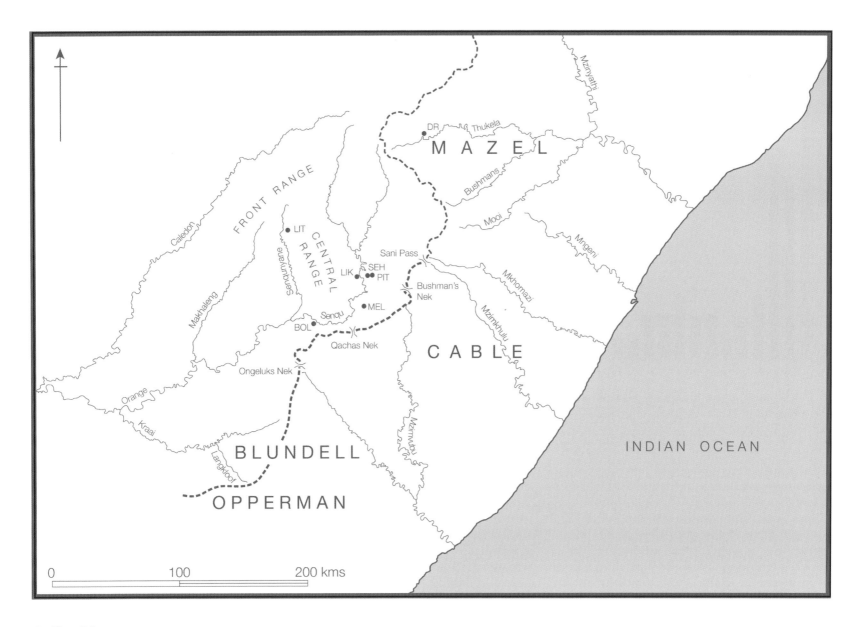

▲ **Figure 7.6**

The Maloti-Drakensberg region showing the location of major archaeological research projects 1976-2009. Site names are abbreviated thus with dates of fieldwork: BOL Bolahla (Parkington et al. 1981); DR Driel (Maggs and Ward 1974, but published 1980); LIK Likoaeng (Mitchell 1995, 1998, 2006); LIT Lithakong (Kaplan 1995); MEL Melikane (Jacobs et al. 2007; Stewart 2008, 2009); PIT Pitsaneng (Hobart 2000); SEH Sehonghong (Mitchell 1992, 1993; Jacobs et al. 2007; Stewart 2009). Fieldwork by archaeologists named on the map concentrated in the following periods Blundell 1992-2004; Cable 1978-1982; Mazel 1978-1996; Opperman 1978-1997. The dashed line indicates the uKhahlamba-Drakensberg Escarpment.

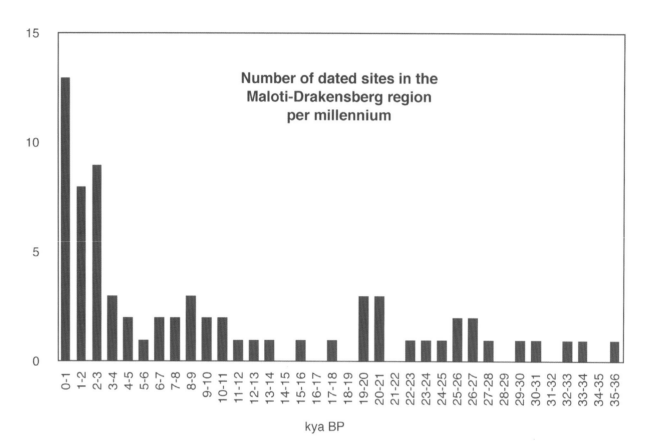

Figure 7.7
The Maloti-Drakensberg region: Temporal patterning in radiocarbon dates.

However, with mean annual temperatures ≥6°C lower than today and oxygen isotope analysis of zebra teeth at Melikane indicating a significant depression of higher altitude C_3 grasslands (Vogel 1983), Carter's (1976) intuition that the Senqu Valley offered a more sheltered environment than the Drakensberg Escarpment seems well founded. This assessment is further supported by the scanty evidence for MSA presence in the KwaZulu-Natal Drakensberg above 1 200 metres asl (Mazel 1982b). Even so, the available dates suggest that people exploited even the Lesotho Highlands during milder interstadial events,[6] abandoning the area as the Last Glacial Maximum was reached *c.* 18 kya and again during the cold intervals registered in some key terrestrial archives ~12.2–11.6 and ~10.8–10.0 kya (Coetzee 1967; Abell & Plug 2000). A further point to note is how the Strathalan B, Sehonghong and Melikane sequences help confirm the late survival of Mode 3 (i.e. MSA) lithic technologies in southern Africa, raising the possibility that the transition to fully microlithic (Mode 5) assemblages was causally related to the deterioration of climate that marked the onset of MIS 2 (Mitchell 2002).

Intuitively, one might expect that the shift to generally warmer, wetter (and thus ecologically more productive) conditions in the Holocene should have encouraged human settlement across the region. Figure 7.8 indicates that this was not uniformly so. Certainly, people were again present in Nomansland from 10 000 years ago (for the first time since 21 kya), and there are indications of occupation (for the first time) in the southern KwaZulu-Natal Drakensberg, as well as highland Lesotho. Overturning one of Carter's (1978) principal conclusions about the regional sequence, excavations in Nomansland and at Sehonghong have now established the regional presence of people using Oakhurst, 'later Oakhurst' and Classic Wilton toolkits (Opperman 1987; Mitchell 1996a); Oakhurst assemblages are also present in the southern KwaZulu-Natal Drakensberg at Good Hope (Cable *et al.* 1980) and probably Belleview (Carter 1969b). Re-excavation of Melikane may well add to this picture. Strikingly different,

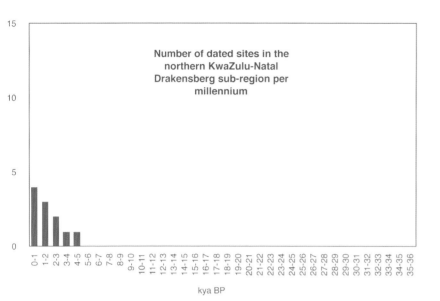

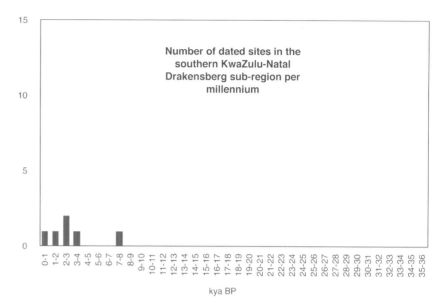

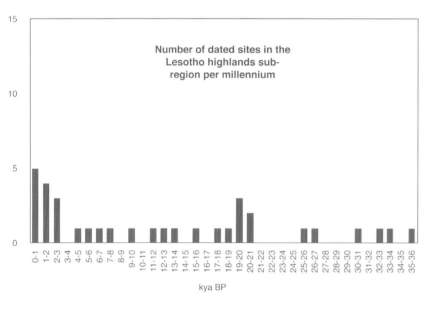

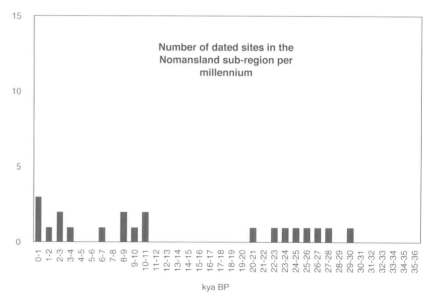

▲ **Figure 7.8**

The Maloti-Drakensberg region: Temporal patterning in
radiocarbon dates by sub-region

TABLE 7.3 MALOTI-DRAKENSBERG REGION: LIST OF RADIOCARBON AND OSL DATES

NORTHERN KWAZULU-NATAL DRAKENSBERG

320	± 40	Mhlwazini	Pta-4850	Charcoal	Ceramic Wilton
330	± 90	Esikolweni	OZB127U	Plant fibres in painting	
420	± 340	Clarke's	OZB13OU	Plant fibres in painting	
580	± 50	Mhlwazini	Pta-4864	Charcoal	Ceramic Wilton
650	± 50	Collingham	Pta-5092	Wood	Ceramic Wilton
1060	± 65	Barnes Shelter	OZD-446	Crust above painting	
1260	± 50	Collingham	Pta-5408	Charcoal	Ceramic Wilton
1580	± 50	Clarke's	Pta-2973	Charcoal	Ceramic Wilton
1770	± 50	Collingham	Pta-5274	Charcoal	Ceramic Wilton
1775	± 40	Driel	Pta-1381	Charcoal	Ceramic Wilton
1800	± 50	Collingham	Pta-5096	Charcoal	Ceramic Wilton
1810	± 60	Collingham	Pta-5265	Charcoal	Ceramic Wilton
1830	± 50	Collingham	Pta-5098	Wood	Ceramic Wilton
1880	± 45	Collingham	Pta-5101	Charcoal	Ceramic Wilton
1930	± 65	White Elephant	OZD-452	Crust above painting	
2160	± 50	Clarke's	Pta-2971	Charcoal	Postclassic Wilton
2280	± 50	Mhlwazini	Pta-4868	Charcoal	Postclassic Wilton
2310	± 70	Highmoor 1	OZD-450	Crust below painting	
2360	± 70	Main Caves N	OZD-449	Accretion under painting	
2380	± 50	Clarke's	Pta-3247	Charcoal	Postclassic Wilton
2570	± 60	Mhlwazini	Pta-5045	Charcoal	Postclassic Wilton
2760	± 50	Mhlwazini	Pta-4876	Charcoal	Postclassic Wilton
2760	± 75	Main Caves N	OZD-448	Accretion under painting	
2770	± 75	Highmoor 1	OZD-451	Crust below painting	
2900	± 80	Main Caves N	OZD-447	Crust below painting	
3020	± 60	Diamond 1	Pta-2974	Charcoal	Postclassic Wilton
4900	± 60	Diamond 1	Pta-3246	Charcoal	Postclassic Wilton

SOUTHERN KWAZULU-NATAL DRAKENSBERG

820	± 35	Belleview	Pta-448	Charcoal	Ceramic Wilton
1030	± 50	Belleview	Pta-449	Charcoal	Ceramic Wilton
1590	± 60	Belleview	Pta-291	Charcoal	Ceramic Wilton
2160	± 40	Good Hope	Pta-838	Charcoal	Postclassic Wilton
2330	± 60	Belleview	Pta-292	Charcoal	Postclassic Wilton
* 2610	± 50	Belleview	Pta-309	Charcoal	'Early LSA'
3280	± 60	Belleview	Pta-293	Charcoal	Postclassic Wilton
7670	± 55	Good Hope	Pta-1480	Charcoal	Oakhurst
8650	± 50	Belleview	Pta-309	Charcoal	Oakhurst

LESOTHO HIGHLANDS

* 90	± 45	Bolahla	Pta-5413	Charcoal	Ceramic Wilton
260	± 46	Moshebi's	Pta-314	Charcoal	Ceramic Wilton
510	± 40	Lithakong	Pta-7072	Charcoal	Ceramic Wilton
565	± 35	2928DB34	GrA-26179	Ostrich eggshell	Ceramic Wilton
810	± 50	Pitsaneng	Pta-8360	Bone	Ceramic Wilton
840	± 40	Pitsaneng	Pta-8491	Charcoal	Ceramic Wilton
890	± 35	Lithakong	Pta-7077	Charcoal	Ceramic Wilton
910	± 45	Bolahla	Pta-5549	Charcoal	Ceramic Wilton
1240	± 50	Sehonghong	Pta-8064	Charcoal	Ceramic Wilton
1285	± 40	Likoaeng	GrA-23237	Bone	Ceramic Wilton
1290	± 30	Likoaeng	GrA-26831	Iron	Ceramic Wilton
1310	± 80	Likoaeng	Pta-7877	Charcoal	Ceramic Wilton
1400	± 50	Sehonghong	Pta-885	Charcoal	Ceramic Wilton
1440	± 40	Melikane	Pta-1364	Charcoal	Ceramic Wilton
1710	± 20	Sehonghong	Pta-6063	Charcoal	Ceramic Wilton
1830	± 15	Likoaeng	Pta-7865	Charcoal	Post-classic Wilton
1850	± 15	Likoaeng	Pta-7097	Charcoal	Post-classic Wilton
1850	± 40	Likoaeng	Pta-7092	Charcoal	Post-classic Wilton
2000	± 70	Likoaeng	Pta-9048	Charcoal	Post-classic Wilton
2020	± 60	Likoaeng	Pta-7876	Charcoal	Post-classic Wilton
2060	± 45	Likoaeng	Pta-7098	Charcoal	Post-classic Wilton
* 2100	± 80	Likoaeng	Pta-7870	Charcoal	Post-classic Wilton
2180	± 45	Moshebi's	Pta-319	Charcoal	Post-classic Wilton
2390	± 60	Likoaeng	Pta-7101	Charcoal	Post-classic Wilton
2555	± 45	Likoaeng	GrA-23236	Bone	Post-classic Wilton
2640	± 70	Likoaeng North	Pta-9067	Bone	Post-classic Wilton
2650	± 60	Likoaeng	Pta-7093	Charcoal	Post-classic Wilton
2810	± 45	Likoaeng	GrA-23233	Bone	Post-classic Wilton
2875	± 35	Likoaeng	GrA-26178	Bone	Post-classic Wilton
2860	± 45	Likoaeng	GrA-23239	Bone	Post-classic Wilton
* 3110	± 50	Likoaeng	GrA-23535	Charcoal	Post-classic Wilton
* 3970	± 30	Sehonghong	Pta-6071	Charcoal	'Later Oakhurst'
4790	± 50	Lithakong	Pta-7075	Charcoal	Post-classic Wilton
5950	± 70	Sehonghong	Pta-6154	Charcoal	Classic Wilton
* 6270	± 50	Sehonghong	Pta-6076	Charcoal	Robberg
6870	± 60	Sehonghong	Q-3174	Charcoal	'Later Oakhurst'
* 6960	± 40	Sehonghong	Pta-6354	Charcoal	Oakhurst
7010	± 70	Sehonghong	Pta-6083	Charcoal	'Later Oakhurst'
7090	± 80	Sehonghong	Pta-6280	Charcoal	'Later Oakhurst'
7210	± 80	Sehonghong	Pta-6072	Charcoal	'Later Oakhurst'

7290	± 80	Sehonghong	Pta-6278	Charcoal	'Later Oakhurst'
9280	± 45	Sehonghong	Pta-6368	Charcoal	Oakhurst
9740	± 140	Sehonghong	Pta-6057	Charcoal	Oakhurst
11090	± 230	Sehonghong	Pta-6065	Charcoal	Robberg
12180	± 110	Sehonghong	Pta-6282	Charcoal	Robberg
12250	± 300	Sehonghong	Q-3165	Bone	Robberg
12200	± 250	Sehonghong	Q-3176	Bone	Robberg
12410	± 45	Sehonghong	Pta-6062	Charcoal	Robberg
12800	± 250	Sehonghong	Q-3173	Charcoal	Robberg
13000	± 140	Sehonghong	Pta-884	Charcoal	Robberg
13200	± 150	Sehonghong	Q-3172	Charcoal	Robberg
15700	± 150	Sehonghong	Pta-6060	Charcoal	Robberg
17820	± 270	Sehonghong	Q-1452	Charcoal	Robberg
19400	± 200	Sehonghong	Pta-6281	Charcoal	Robberg
19700	± 150	Melikane	Pta-1367	Charcoal	'Early LSA'
19860	± 220	Sehonghong	Pta-918	Charcoal	Transitional MSA/LSA
20000	± 170	Melikane	Pta-1406	Charcoal	'Early LSA'
20200	± 100	Sehonghong	Pta-6077	Charcoal	Transitional MSA/LSA
20200	± 150	Melikane	Pta-1407	Charcoal	'Early LSA'
20240	± 230	Sehonghong	Pta-919	Charcoal	Transitional MSA/LSA
20500	± 230	Sehonghong	Pta-6059	Charcoal	Transitional MSA/LSA
* 20900	± 270	Sehonghong	Pta-789	Charcoal	Robberg?
25100	± 300	Sehonghong	Pta-6271	Charcoal	Transitional MSA/LSA
26000	± 300	Sehonghong	Pta-6268	Charcoal	Transitional MSA/LSA
* 28870	± 520	Sehonghong	Pta-920	Charcoal	MSA
* 30400	± 560	Melikane	Pta-1371	Charcoal	MSA
30900	± 550	Sehonghong	Pta-787	Charcoal	Transitional MSA/LSA
32150	± 770	Sehonghong	Pta-785	Charcoal	MSA
33100	± 600	Melikane	Pta-1408	Charcoal	MSA
* 33800	± 960	Melikane	Pta-1369	Charcoal	MSA
35800	± 920	Melikane	Pta-1331	Charcoal	MSA
* 37000	± 1050	Melikane	Pta-1372	Charcoal	MSA
* 38800	± 2200	Ha Soloja	Pta-741	Charcoal	MSA
* 40200	± 1650	Melikane	Pta-1370	Charcoal	MSA
* 42000	± 1700	Melikane	Pta-1534	Charcoal	MSA
* 42300	± 2100	Melikane	Pta-1330	Charcoal	MSA
* 42500	+ 2500 / - 1900	Ha Soloja	Pta-771	Charcoal	MSA
* >43000		Ha Soloja	Pta-760	Charcoal	MSA
* 45000	+ 2600 / - 3900	Ha Soloja	Pta-936	Charcoal	MSA

NOMANSLAND

* 70	± 40	Colwinton	Pta-2547	Charcoal	Ceramic Wilton
300	± 40	Strathalan A	Pta-7144	Sorghum	Ceramic Wilton
460	± 45	Ravenscraig	Pta-3192	Charcoal	Ceramic Wilton
920	± 50	Colwinton	Pta-2608	Charcoal	Ceramic Wilton
1890	± 45	Colwinton	Pta-2549	Charcoal	Postclassic Wilton
2250	± 80	Bonawe	Pta-1711	Charcoal	Postclassic Wilton
2470	± 45	Strathalan A	Pta-4678	Charcoal	Postclassic Wilton
2830	± 60	Bonawe	Pta-3497	Charcoal	Postclassic Wilton
2960	± 60	Bonawe	Pta-3499	Charcoal	Postclassic Wilton
3040	± 50	Ravenscraig	Pta-3450	Charcoal	Postclassic Wilton
6270	± 40	Colwinton	Pta-2550	Charcoal	Classic Wilton
8040	± 100	Bonawe	Pta-1709	Charcoal	Oakhurst
8100	± 80	Te Vrede	Pta-3204	Charcoal	Oakhurst
* 9400	± 900	Strathalan A	Pta-4634	Charcoal	Oakhurst?
10000	± 80	Ravenscraig	Pta-3194	Charcoal	Oakhurst
10100	± 120	Te Vrede	Pta-3203	Charcoal	Oakhurst?
10200	± 100	Ravenscraig	Pta-3451	Bone	Robberg
20900	± 350	Strathalan B	Pta-4944	Grass	MSA
22500	± 230	Strathalan B	Pta-4858	Charcoal	MSA
22800	± 530	Strathalan B	Pta-5059	Grass	MSA
23100	± 530	Strathalan B	Pta-4874	Grass	MSA
23200	± 300	Strathalan B	Pta-4869	Grass	MSA
24200	± 640	Strathalan B	Pta-4931	Grass	MSA
25700	± 400	Strathalan B	Pta-4644	Charcoal	MSA
26900	± 450	Strathalan B	Pta-5040	Charcoal	MSA
27600	± 420	Strathalan B	Pta-4642	Charcoal	MSA
29250	± 260	Strathalan B	Pta-5569	Charcoal	MSA

OSL DATES LESOTHO HIGHLANDS

AD 1580	± 60	Pitsaneng	OxL-1314	Pottery	Ceramic Wilton
AD 1140	± 80	Pitsaneng	OxL-1316	Pottery	Ceramic Wilton
AD 1040	± 90	Pitsaneng	OxL-1315	Pottery	Ceramic Wilton

OSL = Optically stimulated luminescence

* Dates marked with an asterisk are not reliable

Source: *Compiled by Peter Mitchell*

For new OSL dates from the MSA levels at Melikane and Sehonghong see Jacobs *et al.* (2008).

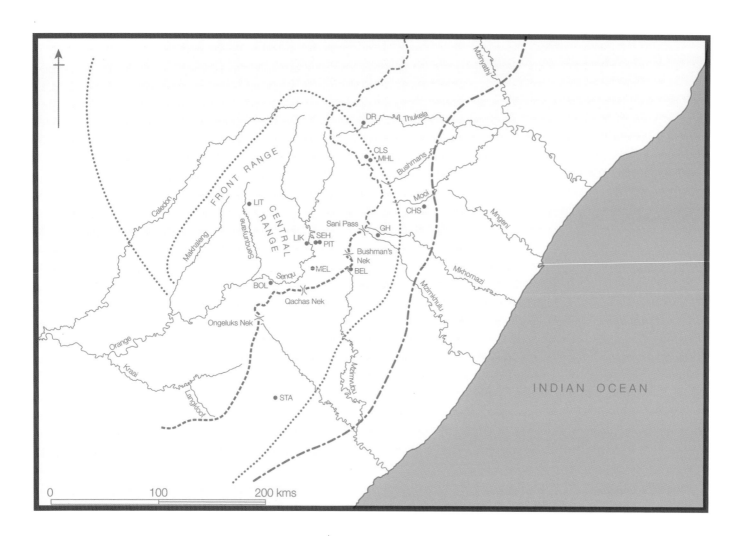

however, is the complete absence of dates or plausible sites farther north, even though we know that hunter-gatherers were living in lower-lying parts of the Thukela Basin from the start of the Holocene (Mazel 1989). If the northern Escarpment was exploited at all, it must have been on a very limited basis, presumably by people based elsewhere in the Thukela catchment. A comprehensive assessment of the reasons for the difference between it and the rest of the Maloti-Drakensberg remains to be undertaken.

During the last 5 000 years, on the other hand, all four parts of the Maloti-Drakensberg register occupation. Whether the term is employed or not, all assemblages belong to the post-classic phase of the Wilton Industry, with pottery a typical addition after 2 000 years ago. On a millennial scale, occupation is most striking between 3000 and 2000 BP, though in Lesotho this results almost

entirely from the fortuitous discovery of the Likoaeng open-air site (Table 7.3). Whether this reflects the vagaries of archaeological sampling (of sites and site types), or a more profound aspect of people's settlement choices, is one of several questions that future fieldwork should examine. Contrary to earlier supposition (Mitchell & Vogel 1994), however, the Neoglacial cold interval of ~3.5–2.3 kya was clearly not inimical to hunter-gatherer settlement of the Lesotho Highlands.

Chronology and palaeoclimate are most highly resolved for the last 2 000 years,[7] allowing quite detailed modelling of changes in the distribution of the Iron Age agropastoralists who settled southern Africa from the early centuries AD (Huffman 1996, 2007). In highland Lesotho and Nomansland, the lack of dates for the cooler, drier climatic pulses that prevailed in southern Africa's

▲ **Figure 7.9**
The Maloti-Drakensberg region and adjacent areas: Distribution of Iron Age agriculturalist settlement in relation to selected excavated hunter-gatherer sites. Site names are abbreviated thus: BEL Belleview; BOL Bolahla; CHS Collingham Shelter; CLS Clarke's Shelter; DR Driel; GH Good Hope; LIK Likoaeng; LIT Lithakong; MEL Melikane; MHL Mhlwazini; PIT Pitsaneng; SEH Sehonghong; STA Strathalan A. The heavy dashed and dotted line represents the approximate limit towards the southern African interior of agriculturalist settlement during the first millennium AD (Early Iron Age), the dotted line its limit c. AD 1800 (Later Iron Age). The lighter dashed line indicates the uKhahlamba-Drakensberg Escarpment.

TABLE 7.4. CULTURAL STRATIGRAPHIC SEQUENCE FOR THE MALOTI-DRAKENSBERG BY SUB-REGION*

kya	Northern KwaZulu-Natal Drakensberg	Southern KwaZulu-Natal Drakensberg	Lesotho Highlands	Nomansland
≤ 1.9	Ceramic Wilton	Ceramic Wilton	Ceramic Wilton	Ceramic Wilton
4.9-1.9	Post-classic Wilton	Post-classic Wilton	Post-classic Wilton	Post-classic Wilton
6.3-6.0			Classic Wilton	Classic Wilton
7.2-6.9			'Later Oakhurst'	'Later Oakhurst'
10.0-7.8		Oakhurst	Oakhurst	Oakhurst
19.4-10.2			Robberg	Robberg
?30.9-19.9			Transitional MSA/LSA	Final MSA (Strathalan B)
≥32.1			Late MSA	
57			Post-Howieson's Poort MSA	
61			Howieson's Poort	
80			Pre-Howieson's Poort MSA	

* Dates until ≥32.1 kya are based on uncalibrated radiocarbon determinations, while those earlier in time are based on OSL. Dates given are for the industries represented across the region and may vary within sub-regions. Divisions of the MSA sequence in the Lesotho Highlands await confirmation from renewed excavation and analysis at Melikane and other sites.

Source: Compiled by Peter Mitchell

summer rainfall zone *c.* 1150–950 and 650–450 BP (Tyson & Lindesay 1992) is particularly striking. If borne out by future work targeting a wider range of sites and applying Accelerator Mass Spectrometry dating for enhanced chronological precision, this might suggest that these areas were little used for much of the second millennium AD until pressure from expanding agropastoralists encouraged more intensive hunter-gatherer settlement. That the presence of farmers in adjacent parts of the regional landscape *did* affect the settlement decisions made by hunter-gatherers seems likely, for the northern Drakensberg has an almost complete hiatus in radiocarbon dates 1580–650 BP. Mazel (1990, 1992a, this volume) interprets this as evidence of foragers abandoning the area to establish themselves closer to immigrant agriculturalist communities in lower-lying reaches of the Thukela Basin. In turn, the re-emergence of evidence for hunter-gatherer activity immediately below (c. 650 BP) and within (c. 580 BP) the Escarpment seems tied to the expansion of agriculturalist settlement to the adjacent grasslands, something likely promoted by an ecological crisis sparked by the onset of a colder, drier Little Ice Age climate

(Whitelaw, this volume). The relatively recent age of these changes holds out hope of integrating them with rock art data better to understand the social dynamics that may have been involved, at least on the hunter-gatherer side of the equation. Farther south, while Good Hope has little evidence of occupation during the last 2 000 years, Belleview was certainly visited repeatedly. This area may thus have had a settlement history distinct from the northern Escarpment and more similar to those of highland Lesotho and Nomansland. The scarcity of relevant research in southern KwaZulu-Natal and the former Transkei makes it difficult to be sure, but ecological and historical data suggest that a greater extent of grassland (much of it sourveld) constrained the availability of agriculturally favourable wooded areas south of the Thukela. This, and a scarcity of iron ore, may have rendered it more marginal for agropastoralist settlement (Whitelaw, this volume). Outside the coastal belt, foragers probably saw fewer attractions in relocating closer to farmer communities than was the case in the Thukela Basin. Greater continuity in hunter-gatherer settlement within the southern Escarpment may have been the result (Figure 7.9).

People on the landscape: Seasonal mobility and resource use

Vinnicombe (1976: 163) took seasonal mobility to be a key structuring principle of Bushman society. Archaeological interest in this topic has since waned as part of a general shift from ecological questions to ones with a more obvious social or symbolic import (Mazel 1987), but the Maloti-Drakensberg remains one of the principal regions in which it has been investigated in southern Africa.[8] As already noted, Cable (1984) undertook a more detailed exploration of Carter's (1970) model, concluding that there was little archaeological evidence for LSA hunter-gatherers having exploited the thornveld region of the KwaZulu-Natal Midlands and proposing instead that the optimal strategy would have been one of seasonal movement between the highlands of the Escarpment and eastern Lesotho (summer) and the coastal forest belt (winter). He thus stretched Carter's model to tie together all of eastern Lesotho and southern KwaZulu-Natal within a single pattern of exploitation, arguing, however, that the situation might well have been different in the northern Drakensberg. As with Carter's (1978) own work, patterning in the formal tool content of excavated and surface artefact assemblages and assumptions that cross-cutting the region's north–south ecological gradient would have supported more people than alternative land-use patterns informed these conclusions. Cable did not, however, convincingly show why coastal belt populations should have moved inland for half the year, rather than staying put in a resource-rich environment, nor did he address the likely impacts on hunter-gatherers of increasingly dense agropastoralist settlement. The limited scale of his fieldwork in the coastal belt and the considerable distances envisaged (≥200 kilometres each way) for seasonal movements are additional concerns (Opperman 1987: 14).

Three responses have followed. In the southern Drakensberg, Opperman (1987) took a sharply contrasting view of seasonal mobility. Here, alcelaphines, zebra and bluebuck dominate mid-Holocene faunas, with grey rhebuck and eland more common after 3000 BP when charcoal evidence indicates that moister conditions encouraged the growth of shrubs at the expense of grasses. Nomansland may thus be an area in which large grazers remained the most important source of meat significantly longer than elsewhere (Deacon 1995). Opperman (1987) stressed the close proximity of patches of sourveld (grazable

in summer) and mixed grassveld (grazable all year round), the former above, the latter below the Escarpment. With game able to move over short distances using predictable routes along mountain valleys, people otherwise based above the Escarpment, for example at Colwinton or Ravenscraig, may thus have used sites in mixed grassveld areas as specialist hunting camps for procuring and processing meat. Higher bone and lower artefact densities, and high frequencies of bone points and scrapers, identify Bonawe as one such site.

Such shorter movements accord better with the degree of mobility attested in Kalahari ethnography, but relate to a different combination of habitats than that for which Carter's (1970) model was initially developed. They are, however, compatible with his later suggestion (Carter 1978) that Sehonghong and Melikane were integrated in a separate seasonal round along the Senqu Valley, one in which movements would necessarily have been in the order of tens, rather than hundreds, of kilometres. However, it would be foolish to assume too rigid a pattern of land use and Carter's model needs testing against results from additional sites in the Senqu Valley, as well as the incorporation of newer data (for example, the seasonality evidence from Likoaeng pointing to a later spring/early summer focus at this open-air site; see Plug et al. 2003). If it does hold water, at least for parts of the Holocene, then new excavations at Melikane should provide faunal and material cultural signatures that contrast with those from Sehonghong. In the meantime, more intensive field survey has emphasised how LSA and MSA site distributions cluster in areas providing easiest access to food plants, firewood and the surrounding topography. Above 2 050 metres asl, in contrast, flaked stone artefacts are virtually absent, suggesting that higher elevations lacking rock shelters and scarce in edible plants, game and fuel were only ephemerally exploited, perhaps to access specific raw materials or when moving between more favoured areas (Mitchell 1996e). Elderly Basotho informants interviewed in 1971 recalled that eland moved seasonally up- and downslope, but did not leave the Sehonghong area, supporting arguments for year-round occupation of the Senqu Valley (Vinnicombe, this volume).

A wholly different approach has been taken by Aron Mazel in the Thukela Basin. As his research began, seasonal mobility was still to the fore, though small faunal and botanical assemblages precluded definite inferences on the seasonality of occupation at Diamond 1, Clarke's Shelter and Gehle (Mazel 1984b, 1984c). However, paintings of summer-related

phenomena (blue cranes [*Anthropoides paradiseus*], herd groupings of eland, families of rhebuck) supported summer occupation of the northern Drakensberg (Mazel 1982a, 1983). But while agreeing with Cable (1984) that year-round occupation was unlikely on ecological, archaeological and ethnohistoric grounds, Mazel (1984d) was also conscious of the difficulties of neatly connecting these different strands of evidence. Formal tools, for example, do not pattern coherently with ecological zones and further work revealed considerable temporal variation in assemblage content and site occupation. By the late 1980s, however, Mazel (1989) had re-evaluated the theoretical basis of his research and jettisoned the ecological paradigm with which his project had begun in favour of investigating questions of social organisation and change. How people occupying different parts of the regional landscape interacted has remained important, but with a focus on exchange and the self-conscious identification of social groups. Seasonal mobility and attempts at detailed understanding of how people integrated the resource suites of particular sections of the landscape into their subsistence economies and choice of campsites are thus yet to re-emerge as key concerns of Maloti-Drakensberg research. When and if they do, we should expect that people pursued different strategies at different times and in different parts of the region and that where patterning in the key resources that they exploited (plants, animals, fuel, shelter, etc.) is less tightly determined by ecology and topography, these strategies will have been more flexible – and thus less easy to identify – than elsewhere (cf. Humphreys 1987).

One element to feed into such investigations is the emerging evidence for significant change in the region's faunal record and the possibility that it documents more intensified exploitation of certain resources in later stages of the Holocene. We have already seen that Opperman's (1987) excavations in Nomansland produced evidence of a major change in people's hunting patterns in the Holocene, from an earlier emphasis on big grazers to a later one on mixed feeders and smaller grazers. The Sehonghong fauna strengthens the case for a major transformation of the wider region's ecology. As might be expected, some taxa (Cape horse, *Equus capensis*, and giant hartebeest, *Megalotragus priscus*) that became completely extinct are restricted to the Pleistocene, but the early and mid-Holocene assemblages too include species that were historically absent from highland Lesotho. These include blesbok (*Damaliscus dorcas*), springbok (*Antidorcas marsupialis*), bluebuck, and two perhaps more surprising candidates, zebra (*Equus burchelli*) and black wildebeest (*Connochaetes gnou*). All seem to have disappeared from the Senqu Valley by 3600 BP at the latest, although roan antelope were still present after 1700 BP (Plug & Mitchell 2008b) and were painted in at least two localities in the KwaZulu-Natal Drakensberg (Pager 1971; Russell 2000). It is still too early to make sense of these data, but the losses suggest ecological change(s) of some magnitude, with the selective grazing strategies of blesbok, wildebeest and roan pointing to changes in grassland ecology (and perhaps possible interdependencies between taxa in grazing successions) as factors to consider.

The Sehonghong sequence may also attest to an increased late Holocene interest in exploiting animals that, while occurring in small package sizes, also occur more plentifully than many large game species. Ground game in the form of rock hyrax (*Procavia capensis*) is the prime example of this, but small, territorial antelope may also have become more important in the last 1 200 years of the site's occupation (Plug & Mitchell 2008b). Mazel (1989) has emphasised how, in the Thukela Basin, people may have intensified their use of plant foods, fish and small game during the last 4 000 years, a trend that he (controversially) links to changes in male/female gender relations (cf. Wadley 1989). Sites in the northern Drakensberg provide less support for this than those elsewhere in his research area,[9] and certainly as far as plant foods are concerned preservation issues make it impossible to infer clear patterns of change over time; Sehonghong remains, for example, the only highland Lesotho site in which plant remains other than charcoals have been found (Vinnicombe 1976: 284; Carter *et al.* 1988). Data from there and from Likoaeng also warrant caution when canvassing the notion that fish were another resource that came under increasing use in recent millennia. While the interception of annual spawning runs was certainly the principal reason people repeatedly camped at Likoaeng *c.* 3100–1800 BP, this was a seasonal event and there is no evidence for storage or removal of fish offsite for consumption elsewhere (Mitchell *et al.* in press). Moreover, the much longer Sehonghong sequence shows that fishing was important at times in the late Pleistocene, as well as after 2 000 years ago. Arguments for unidirectional change in the use of freshwater fish of the kind developed elsewhere in southern Africa (e.g. Hall 1988) must therefore be applied with care (Plug & Mitchell 2008a).

Patterns of interaction

Models of seasonal mobility typically assume that complementary ecologies are most effectively exploited by moving across the grain of the landscape, thus supporting larger populations than if settlement were restricted to smaller areas. However, it may make more sense to try to identify socially self-conscious groups in the archaeological record and only **then** explore patterning in land use within the territories so defined (Sampson 1988: 13). Providing more reason to believe that the same group of people really did exploit the sites we are trying to link together, this would, of course, require far more detailed levels of archaeological coverage than currently exist anywhere in the Maloti-Drakensberg to be effective, plus well-resolved chronostratigraphies and environmental records. It is not, however, an impossible goal, as the gradually growing evidence for how Maloti-Drakensberg hunter-gatherers structured their relations with each other shows. The key case study here remains Mazel's (1989) identification of 'social regions' in the Thukela Basin. Defined by variation in the frequencies of lithic raw materials, formal stone tools, worked bone artefacts, and non-local items such as ostrich eggshell beads, these regions are thought to give material expression to alliance networks between hunter-gatherer groups, perhaps differentiated too by dialect as recorded for the nineteenth century /Xam Bushmen (Deacon 1986). Before 4000 BP, Mazel envisages one such region occupying the entirety of the Thukela Basin, while from then until about 2 000 years ago three (perhaps four) are defined. One of these, the Injasuthi region, encompasses sites in the northern Drakensberg, including Driel and Collingham, as well as Gehle, which lies some way from the Escarpment (Mazel 1984c). Distinguishing characteristics include an absence of ostrich eggshell, ground stone tools and segments, and low densities of ochre and worked bone (Mazel 1989: 106). Compared with sites north of the Thukela, the Injasuthi region also shows fewer signs of social or economic intensification by way of identifiable exchange items or enhanced plant food/ground game/fish procurement.

Mazel's research has been extensive, innovative and marked by an exemplary record of prompt, detailed publication. His conclusions have not, however, gone unchallenged, with Barham (1992) and Mitchell (2002: 218–220) expressing concern over some of the sample sizes and attributes used to distinguish between 'social regions'. Other patterning, such as differences in the frequencies of non-local

ostrich eggshell jewellery or worked bone artefacts, does, however, seem more robust on a Thukela Basin-wide scale, and certainly the former may identify genuine differences in how people interacted with their neighbours. A more far-reaching criticism is that of Wadley (1989). Emphasising that cultural systems are differentially organised, with sites sometimes used for different purposes at different times or by differently sized groups of people, she reinterprets Mazel's (1989) data using her own aggregation/dispersal model. Space does not allow a full discussion, but Mazel's (1992b) rebuttal emphasises her critique of other aspects of his overall interpretation of Thukela Basin prehistory, not the possibility that the differences he identifies between sites could also be explained in functional or seasonal terms. More recent comments kick reassessment of the validity of this particular manifestation of the social region model into the long grass (Mazel 1997a: 31).

At a much larger spatial scale, Mitchell (1996d) has explored spatial patterning in items for which at least some provenance information exists. Marine shell jewellery, for example, must ultimately derive from the Indian Ocean coast and is thus non-local when found inland. Similarly, the absence of ostriches from the Maloti-Drakensberg, most of KwaZulu-Natal and the former Transkei means that ostrich eggshell beads or fragments found there must also come from a distance. Faunal analyses that point to people having transported inland the bones (body parts?) of species ecologically restricted to forest areas close to the Indian Ocean coast provide a third data set (Plug 1997). Without invoking specific parallels to the *hxaro* system of the Ju/'hoansi Bushmen of the Kalahari, the distances involved (both direct and after allowing for topographical barriers) suggest that all these items were distributed through gift-exchange networks.

Summarising this information, Indian Ocean seashells travelled up to 300 kilometres inland in the early Holocene and both at this time and in the mid-Holocene people in highland Lesotho directly or indirectly acquired marine shells from coastal KwaZulu-Natal, as well as finished ostrich eggshell beads from areas west of the Maloti or to its north on the plains near Harrismith. Moreover, they also show that such contacts existed in the late Pleistocene. Nomansland remained outside these areas of interaction, lacking marine shells and transported faunal elements and having virtually no ostrich eggshell beads. Interestingly, and despite ready access to opalines, people there also preferred

to make stone tools from hornfels, not the finer-grained rocks used in Lesotho or southern KwaZulu-Natal; this preference was perhaps another means of distinguishing themselves from adjacent populations (Mitchell 1996d). Observations from the northern Drakensberg are few, but when occupation there starts after 4000 BP, the extreme rarity of ostrich eggshell again suggests that people did not participate in the same ties with South Africa's central interior as those living in Carter and Vinnicombe's research area (Mazel 1989). Marine shells and transported red duiker (*Cephalophus natalensis*) bones at Mhlwazini do, however, confirm ties with KwaZulu-Natal's coastal belt 2800–2300 BP (Mazel 1990; Plug 1990).

The last 2 000 years show further interesting contrasts. First, hunter-gatherers in highland Lesotho and perhaps also the Drakensberg Escarpment substantially reoriented their contacts to the west and away from the coast. Supporting evidence comes from markedly reduced frequencies of marine shells but significantly enhanced frequencies of ostrich eggshell beads and pieces at highland sites. The latter still reached the coastal belt, but in very small numbers (Mitchell 1996d). This change is reinforced by the presence in highland Lesotho from ~2 000 years ago of pressure-flaked points and backed microliths otherwise almost entirely restricted to South Africa's central interior (Mitchell 1999). One interpretation of these patterns is that as hunter-gatherers in lowland KwaZulu-Natal started to encounter more interesting opportunities for exchange in the form of incoming farmers, they lost interest in their 'upcountry' Maloti-Drakensberg 'cousins', who intensified ties with people to their west in response. Geographically placed somewhat between the two, foragers in the northern Escarpment may have retained a wider set of ties as evidenced by the marine shell jewellery, red duiker bones and ostrich eggshell beads from Collingham Shelter, which also produced pressure-flaked backed microliths of the kind known from highland Lesotho (Mazel 1992a; Plug 1992; Mitchell 1999).[10] As already noted, to the north, Mazel (1989, 1997b) shows convincingly that settlement patterns and excavated evidence in the Thukela Basin indicate a movement of hunter-gatherers towards newly established agropastoralist villages and the initiation of a wide range of exchange connections between the two populations.

These data and other processes (such as marriage and kinship ties) that we can only infer identify multiple interaction pathways that must have been crucial in transmitting ideas, knowledge and innovations. Rock art has yet to be systematically investigated for such evidence, though Ouzman's (1995) analysis of the distribution of paintings of mormyrid fish makes a promising start. These occur in and close to the Maloti-Drakensberg, but the fish are native to areas ≥200 kilometres to the north-east. Probably valued as symbols of supernatural potency, the mormyrid images document a further connection between hunter-gatherers in the Maloti-Drakensberg and those living farther afield. Still undated, they cannot readily be brought into relation with other archaeological evidence, though Ouzman and Wadley (1997) have attempted to do this at Rose Cottage Cave. However, they certainly underline the need to study interactions on a large spatial scale and through many different data sets. Such interactions may have been particularly important, and were certainly affected by agropastoralist settlement of the wider region within the last 2 000 years.

Hunter-gatherers and farmers: The last 2 000 years

Southern Africa offers excellent possibilities for studying interactions between communities practising different forms of subsistence and organised at different levels of socio-political complexity. The Maloti-Drakensberg is no exception and such interactions form a large part of *People of the Eland*. Their context is provided by the fact that iron-working, Bantu-speaking, mixed farming communities began settling the coastal belt of KwaZulu-Natal *c.* AD 400 (Mitchell 2002). Their location was constrained by the temperature and rainfall requirements of their two staple crops, sorghum and pearl millet, and only from the fourteenth century did Nguni speakers successfully settle in upland regions of KwaZulu-Natal (Huffman 1996; Whitelaw, this volume). Despite the possibility of earlier movements across the northern edge of the Drakensberg into the Free State, substantive colonisation of southern Africa's Grassland Biome probably only began in the 1600s (Mitchell & Whitelaw 2005; Huffman 2007). Movement into the Maloti, the Senqu Valley, Nomansland, and the Escarpment itself was a much later nineteenth century phenomenon precipitated by population growth, military conflict, European colonial expansion, and the acquisition of maize as a substitute for sorghum and millet (Eldredge 1993; Huffman 1996).

As a result, the Maloti-Drakensberg was among the last areas south of the Limpopo in which hunter-gatherers could

TABLE 7.5 EVIDENCE OF POTENTIAL CONTACT BETWEEN MALOTI-DRAKENSBERG LSA HUNTER-GATHERERS AND FARMERS OVER THE PAST 2000 YEARS

	Pottery		Iron	Glass beads	Domestic plants	Domestic animals
	LSA	IA				
NORTHERN KWAZULU-NATAL DRAKENSBERG						
Clarke's (Mazel 1984a)	Yes	-	Yes	-	-	-
Collingham (Mazel 1992a)	Yes	-	Yes	-	-	-
Diamond 1 (Mazel 1984a)	-	-	-	-	-	-
Driel (Maggs and Ward 1980)	Yes	?	Awl	2	Drilled gourd	-
Mhlwazini (Mazel 1990)	Yes	Yes	Yes	1	Sorghum, maize	Sheep (NISP 1)
SOUTHERN KWAZULU-NATAL DRAKENSBERG						
Good Hope (Cable *et al.* 1980)	Yes	-	-	-	-	Cattle (NISP 1)
Belleview (Carter 1978; Hobart 2003a)	Yes	-	Yes	-	-	-
LESOTHO HIGHLANDS						
Bolahla (Mitchell *et al.* 1994)	Yes	?	Yes	Yes	-	Sheep (NISP 2)
						Goat (NISP 1)
						Sheep/goat (NISP 14)
						Cattle (NISP 2)
Likoaeng (Mitchell 2004)	Yes	Yes	Yes	-	-	Sheep (NISP 7)
						Cattle (NISP 6)
Lithakong (Kaplan 1996)	-	Yes	Yes	-	-	-
Melikane (Carter 1978; Hobart 2003a)	Yes	-	-	-	-	Sheep (NISP 1)
Pitsaneng (Hobart 2003a, 2004)	Yes	Yes	Yes	32	-	Sheep (NISP 253)
						Cattle (NISP 69)
						Dog (NISP 6)
Sehonghong (Mitchell 1996a)	Yes	-	-	5	-	Sheep (NISP 57)
						Cattle (NISP 35)
NOMANSLAND						
Bonawe (Opperman 1987)	Yes	-	-	-	-	-
Colwinton (Opperman 1987)	Yes	-	-	-	-	-
Ravenscraig (Opperman 1987)	Yes	-	-	-	-	-
Strathalan A (Opperman 1999)	Yes	-	-	-	Sorghum, calabash	-

Source: Compiled by Peter Mitchell

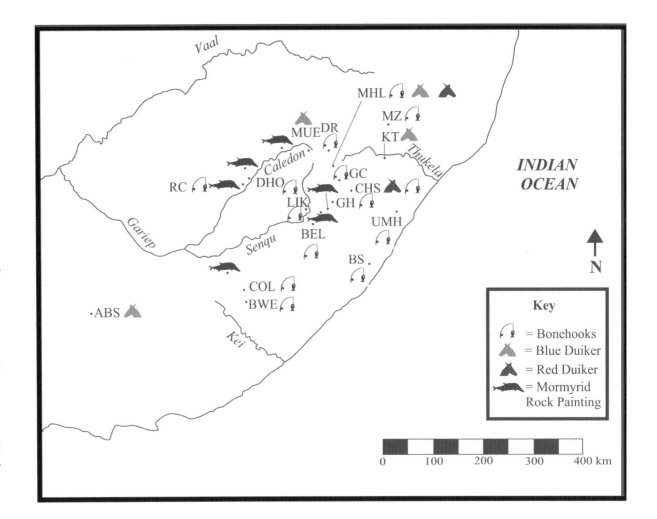

Figure 7.10

The Maloti-Drakensberg region showing some of the evidence for long-distance interaction within central and southeastern southern Africa: distributions of bone fish hooks, rock paintings of mormyrid fish and finds of red duiker (*Cephalophus natalensis*) and blue duiker (*Philantomba monticola*) bones beyond their likely natural range. Site names are abbreviated thus: ABS Abbot's Shelter; BEL Belleview; BS Borchers Shelter; BWE Bonawe; CHS Collingham Shelter; COL Colwinton; DHO De Hoop; DR Driel; GC Giant's Castle; GH Good Hope; KT KwaThwaleyakhe; LIK Likoaeng; MHL Mhlwazini; MUE Muela; MZ Mzinyashana; RC Rose Cottage Cave; UMH Umhlatuzana.

pursue an independent existence, as Pat herself discussed in detail (Vinnicombe 1976). More recently, Campbell (1987), Dowson (1994) and Blundell (2004) have used rock art to investigate social change among nineteenth century hunter-gatherers, emphasising in different ways how shamans employed their visions, ritual skills and paintings to enhance their own status and power through a variety of interactions with agropastoralists, including trade, the provision of rainmaking services and raiding. These interactions are all documented in oral and written histories, while DNA and linguistic data confirm a substantial Khoisan input into the genes and speech of today's Nguni and (to a lesser degree) Sotho speakers (Richards *et al.* 2004). Looking at these interactions over a longer timescale, Mazel (1989,

1997b) argues for relatively equable, though perhaps socially ambivalent, ties between hunter-gatherers and farmers in the Thukela Basin during the first millennium AD, succeeded by others framed increasingly in terms of patronage and clientship as farming communities became more numerous and foragers saw their movements and access to resources become more constrained. Differences in ideology between first and second millennium farming populations may also have affected how they constructed their relationships with hunter-gatherers. Meanwhile, Jolly (1994, 1995, 1996, 2006a, 2006b) has marshalled oral and written histories to argue that the paintings at Melikane and Pitsaneng discussed by Qing (Orpen 1874) show parallels with Nguni and Sotho beliefs and ritual practices

and thus reflect cultural borrowings as part of a wider process of hunter-gatherer encapsulation and assimilation. However, there is no reason why such borrowings should have flowed in only one direction and Hammond-Tooke (1998) demonstrates that the reconfiguration of Bushman shamanism into Nguni divining practices likely stems from hunter-gatherer women marrying into Nguni lineages and finding in this a means of contesting their marginal social position; mtDNA analyses confirm that marriage patterns did indeed emphasise hypergamy of this kind (Salas *et al.* 2002).

However, if Jolly's primary challenge to using Qing's testimony to support a shamanistic understanding of Bushman rock art is forestalled, the broader question of long-term continuity between nineteenth century Maloti-Drakensberg foragers and their predecessors remains. This question gains urgency as some surviving paintings are over 2000 years old and potentially significant changes in imagery (and meaning?) are identifiable over this period (Swart 2004; Mazel, this volume). Moreover, some elements of hunter-gatherer artistic and religious practice (such as wearing beaded bandoliers) do seem to come from Bantu-speaking sources (Jolly 2005). For additional insights on farmer/forager interactions we must turn to excavated evidence.[11]

Bearing in mind the difficulties of distinguishing agropastoralist and hunter-gatherer occupations of the same site (Mazel 1999) and the general (but perhaps unwise) assumption that certain categories of evidence (stone tools, domestic livestock) 'must' identify one mode of production or the other (Hobart 2003a), Table 7.5 summarises the relevant data. Four newly introduced technologies warrant discussion (cf. Mazel 1997b). The first concerns the impact of metal tools and weapons, which are well represented in rock art (Vinnicombe 1976: 267), were certainly available to foragers from the mid-first millennium AD, and probably came partly to substitute for some kinds of stone tools, for example backed microliths used in arrow armatures or knife blades. Moreover, some Iron Age settlements may have engaged in iron production specifically for trade with foragers (Maggs 1980).

A second new technology was pottery. Common on hunter-gatherer sites of the last 2 000 years, its lack of decoration, smooth, thin (±5–7 mm) walls, and occasional burnishing differentiate it from the ceramics made by first or second millennium farmers. Ethnohistoric references confirm its manufacture by Bushmen (Ellenberger 1953: 86). Mazel (1992c) reviewed data for pottery's appearance in the Maloti-Drakensberg, arguing that at Clarke's Shelter it was perhaps already used *c.* 2200 BP. More recently, he has revised this date to one of 1900 BP based on the presence of pottery immediately thereafter at Collingham Shelter and its absence in immediately earlier deposits at iNkolimahashi (Mazel 1999). Even this, however, is still ≥200 years before the oldest Iron Age pottery known from KwaZulu-Natal (Sadr & Sampson 2005). Knowledge of ceramics thus long preceded the wider regional establishment of farming communities. The source of this knowledge remains unknown, complicated by differences in production technology from Early Iron Age wares and in form and decoration from early pottery in hunter-gatherer/herder contexts in the Cape and Namibia. Independent invention is one possibility (Sadr & Sampson 2005). Alternatively, perhaps the idea was transmitted ahead of actual farmer settlement through archaeologically as yet unknown forager communities in eastern southern Africa, although this would still not explain the profound differences between the various hunter-gatherer/herder wares or between them and those made by farmers.

The social and economic context of Maloti-Drakensberg ceramics also requires investigation. Neither residue analyses nor studies of the *chaînes opératoires* used in production have been undertaken, while physicochemical sourcing has only been applied (rather inconclusively) to a few sherds (Jacobson 2003). All these approaches warrant application across the region if we are to understand when, how and why pottery was introduced and used. In the meantime, the minimal evidence for decoration or economic intensification works against the notion that ceramics were acquired in the context of competitive feasting or other prestige-building activities as may have happened in some parts of the world (Hayden 1995). This may not, however, have always been the case, since hunter-gatherers also acquired pots (or at least sherds) from farmers, for example at Likoaeng and Pitsaneng in the Senqu Valley (Hobart 2003a). While the scarcity of such instances suggests that farmer pottery had little economic impact, this was probably not so for pottery made by hunter-gatherers themselves: boiling meat and plant foods and extracting fat offered completely new ways of cooking, and perhaps storing, food, ways that may *inter alia* have facilitated infant survival (Mazel 1989).

Alongside new ways of preparing food, hunter-gatherers

also acquired new foodstuffs. Rare finds such as the sorghum from Strathalan A (Opperman 1999) testify to their obtaining cultivated cereals from farming communities, but the absence of such plant foods at other sites with good botanical preservation (Collingham, Sehonghong, etc.) suggests that this was uncommon. Difficulties in transporting bulky vegetable produce through frequently difficult terrain may have limited the incorporation of domesticated plants into forager diets except where foragers settled – seasonally or permanently – close to farmer villages. Cultivated narcotics (cannabis, tobacco) were probably a different matter. Direct botanical or residue evidence is lacking, but ethnohistoric records confirm that Maloti-Drakensberg foragers used both substances; as well as trading for them, they may also have grown them, perhaps using them not only recreationally but also to help access the altered states of consciousness sought by shamans (Mitchell 2001; Mitchell & Hudson 2004).

Domestic animals are easier for hunter-gatherers to acquire than domesticated plants as they are more readily incorporated into a mobile lifestyle. That nineteenth century Maloti-Drakensberg Bushmen used horses to hunt, raid and travel is well established (Wright 1971; Vinnicombe 1976; Challis, this volume). So, too, is their assimilation into the belief systems depicted in rock art (Campbell 1987). Cattle, which show many behavioural and physical similarities to eland, also became part of the art's repertoire, as the cattle therianthropes from Giant's Castle make clear (Lewis-Williams 1981). Such examples demonstrate the dynamism of both the rock art and the beliefs – and perhaps the practices – associated with it, but we must also consider whether domesticated animals had yet broader impacts and ones preceding the nineteenth century. Hobart (2003a, 2004) has argued this from the many sheep and cattle bones excavated at Pitsaneng. While the site's small size makes it an implausible kraal, the presence of a few chicken and pig bones, like the rare donkey and pig remains at Sehonghong (Plug 2003; Plug & Mitchell 2008b), confirms that the site has been used since the late nineteenth century establishment of Basotho villages in the area. Some sheep and cattle remains may therefore be intrusive into older deposits, even if the residues themselves in part derive from the very last hunter-gatherers to live locally in the 1890s, such as those described to Pat in 1971 (Vinnicombe, this volume).

Proof that this is not the whole story comes from Layer I at Likoaeng, where a sheep bone is directly dated to 1285 ± 40 BP (GrA-23237). Two further radiocarbon determinations (one on a piece of iron) confirm an age in the eighth/ninth centuries AD, fitting the likely age of an Early Iron Age potsherd also recovered. Other sheep bones and a few cattle bones were also found, all from the same context. What form the acquisition of these animals took is uncertain. However, the totality of the Likoaeng evidence (iron, pottery, sheep, cattle) speaks to quite close relations with farmers – presumably in KwaZulu-Natal – perhaps organised via regular (seasonal?) trading visits across the Escarpment. Alternatively, and bearing in mind that both sheep and cattle must have travelled ≥100–150 kilometres and over a 3 000 metre high mountain range from the nearest known farming villages, perhaps Likoaeng is sampling, as Hobart (2004) argues, a situation in which some foragers had acquired livestock and integrated them into their own economy. If so, then Sadr's (2003) 'neolithic' phase of hunters-with-sheep as outlined for the south-western Cape may be paralleled in parts of the Maloti-Drakensberg (though not, apparently, Nomansland; Table 7.5). More direct dates on domestic livestock remains from Sehonghong, Pitsaneng and other sites are now required, but the possibility that not all Maloti-Drakensberg hunter-gatherers were the 'pure' or 'pristine' foragers that we have previously imagined must now be seriously entertained (Mitchell 2009).[12]

Conclusion: Back to the future

The last comments emphasise the continued dynamism of Maloti-Drakensberg hunter-gatherer research, something that would undoubtedly have pleased not only Pat Vinnicombe but also Pat Carter. Reference to the need to engage in direct dating of domestic livestock remains from already excavated sites also serves two other purposes. First, it reiterates the need to approach Maloti-Drakensberg prehistory in the way that Pat herself approached it, that is, without reference to modern boundaries or disciplinary divisions. As far as the possibility of early acquisition of domestic livestock is concerned, both Rose Cottage Cave (Plug & Engela 1992) and Mhlwazini (Plug 1990) are also relevant. For understanding the take-up of pottery by hunter-gatherers a similarly broad geographic vision is required, one that again spans political frontiers and those between archaeological fieldwork projects. Both

questions also demand the integration of a diverse set of data, including not only excavated materials and their laboratory-based scientific analyses, but also ethnographic and historical sources. Importantly, both also require the exchange of ideas between archaeologists whose primary interest is hunter-gatherers and those whose primary interest is farming communities. Rock art is central to discussions of the relationship between these two populations, as the debate surrounding Pieter Jolly's (1994) work has shown. But to reiterate a point already made, we desperately need a better chronology for the art if we are to relate it to the rest of the archaeological record, or the data of historical linguistics and genetics. Conversely, if archaeologists wish to contribute to debates framed using historical data, then they will also need to identify and excavate sites at which a suitable level of temporal resolution can be found: telephone booth excavations into deep-sequence rock shelters with disturbed recent deposits will not suffice. As I have shown, these concerns are evident at many points in *People of the Eland* and are ones of which Pat was well aware. The extent to which today's archaeologists, working over a much longer timescale than that emphasised by *People of the Eland*, can successfully address them depends considerably on the pioneering work that she and Pat Carter undertook almost four decades ago.

Acknowledgements

My thanks go to Aron Mazel, Ben Smith, Brian Stewart and Gavin Whitelaw for commenting on an earlier draft of this chapter and to Patrick Walton for having researched Pat Vinnicombe's contribution to excavations in highland Lesotho and the KwaZulu-Natal Drakensberg. Any remaining faults are, of course, my own.

Notes

1 After Blundell (2004).

2 Field notes, section drawings and finds from the excavations undertaken in Lesotho are archived at the University Museum of Archaeology and Anthropology, Cambridge, United Kingdom. Those for Good Hope and Belleview are housed at the Natal Museum, Pietermaritzburg, South Africa.

3 These include several potentially attributable to the Howieson's Poort, but uninvestigated since Carter and Vinnicombe's original surveys (Patrick Carter pers. comm. 1991).

4 In addition to those discussed in the main text, one could also cite Vinnicombe's (1976: 284, note 24) reference to the plant remains recovered from the Sehonghong deposits when she discussed paintings relevant to plant food gathering, or the comparison she drew between the fishing techniques depicted in the art and the excavated evidence for the use of bone hooks (Vinnicombe 1976: 296).

5 Only a few kilometres from Sehonghong, as yet unexcavated deposits immediately outside another rock shelter preserve another extensive (≥10 metres thick) MSA sequence, complete with some degree of faunal and charcoal preservation. Over 20 stratigraphically distinct horizons are evident.

6 Proxy evidence for this comes from the wide diversity of antelope present in Sehonghong's Robberg levels. The presence of two taxa (common duiker, *Sylvicapra grimmia*, and steenbok, *Raphicerus campestris*) that typically require browse and/or dense cover suggests that when people used the site, conditions may not have differed radically from those of the Holocene (Plug & Mitchell 2008b).

7 That most of the surviving rock art is of this date means that it is also within this period that we should look for connections between it and the archaeological evidence recovered from excavation and field survey.

8 Parkington's (1972, 1977, 2001) work in the Western Cape Province of South Africa is the most appropriate comparison, not least because he and Carter were contemporaries at Cambridge in the 1960s, both working under Eric Higgs, and because they submitted their theses at virtually the same time. Explicit influences of the one project on the other are, however, difficult to discern in the literature, though both have come in for similar criticisms over the years (cf. Sealy 1992 and Jerardino 1996 with Opperman 1987).

9 Although Mazel (1989: 77–78) does point to increased adze frequencies and the mostly smaller, territorial bovid profile at Clarke's Shelter as possible evidence for intensification there from a little before 2000 BP.

10 Two finds extend the distribution into the central Thukela Basin, most likely in the second half of the second millennium AD (Mazel 1994), but that this has little impact on the overall distribution.

11 Excavated finds may also attest to borrowings in the field of ritual and belief. Mazel (1993) and Plug (1993), for example, report examples of bone divining dice from apparently hunter-gatherer contexts at kwaThwaleyakhe Shelter in the central area of the Thukela Basin. Was this a local counterpart of the borrowing from farmers of divination as a means of directing hunting activity among the Ju/'hoansi of the Kalahari (Lee 1979: 149–151)? A second potential borrowing, the churning of ritual medicines in pots (Jolly 2005), may be more doubtful as the root word for churned medicine (*ubulawu*) is used in Zulu to refer to a Khoe or even (today) a Coloured person (*ilawu*) and to their language and cultural characteristics (*isilawu*). The medicine manufacturing process could well therefore have had a Khoisan origin (Gavin Whitelaw pers. comm. 2008).

12 Dogs are another introduction of the last 2 000 years and were used by hunter-gatherers in the Maloti-Drakensberg and elsewhere to hunt eland and other game, as well as being incorporated into people's belief systems (Mitchell 2008b). They could, of course, also have been used to help guard and marshal livestock if the Likoaeng data warrant generalisation to other sites.

References

Abell, P.I. & Plug, I. 2000. The Pleistocene/Holocene transition in South Africa: evidence for the Younger Dryas event. *Global and Planetary Change* 26: 173–179.

Aitken, S., Lake, Q., Mills, N. & Moshoeshoe, M. 2000. Lesotho rock art survey 2000. Unpublished report submitted to the Protection and Preservation Commission of the Kingdom of Lesotho.

Albino, R. 1947. Notes on the excavation of a rock shelter at Champagne Castle, Natal. *Annals of the Natal Museum* 2: 157–160.

Barham, L.S. 1992. Let's walk before we run: an appraisal of historical materialist approaches to the Later Stone Age. *South African Archaeological Bulletin* 47: 44–51.

Barham, L.S. & Mitchell, P.J. 2008. *The First Africans: African Archaeology from the Earliest Toolmakers to Most Recent Foragers.* Cambridge: Cambridge University Press.

Binford, L.R. 2001. *Constructing Frames of Reference: An Analytical Method for Archaeological Theory Building Using Hunter-Gatherer and Environmental Data Sets.* Berkeley: University of California Press.

Blundell, G. 2004. *Nqabayo's Nomansland: San Rock Art and the Somatic Past.* Uppsala: Uppsala University Press.

Bousman, C.B. 1988. Prehistoric settlement patterns in the Senqunyane valley, Lesotho. *South African Archaeological Bulletin* 43: 33–37.

Cable, J.H.C. 1984. *Late Stone Age Economy and Technology in Southern Natal.* Oxford: British Archaeological Reports, International Series 201.

Cable, J.H.C., Scott, K. & Carter, P.L. 1980. Excavations at Good Hope Shelter, Underberg District, Natal. *Annals of the Natal Museum* 24: 1–34.

Campbell, C. 1987. Art in crisis: contact period rock art in the south-eastern mountains of southern Africa. Unpublished MSc thesis. Johannesburg: University of the Witwatersrand.

Carter, P.L. 1969a. Moshebi's Shelter: excavation and exploitation in eastern Lesotho. *Lesotho Notes and Records* 8: 1–11.

Carter, P.L. 1969b. Unpublished field notes, Belleview Shelter. On file, Department of Archaeology, Natal Museum, Pietermaritzburg, South Africa.

Carter, P.L. 1970. Late Stone Age exploitation patterns in southern Natal. *South African Archaeological Bulletin* 25: 55–58.

Carter, P.L. 1976. The effects of climatic change on settlement patterns in eastern Lesotho during the Middle and Later Stone Ages. *World Archaeology* 8: 197–206.

Carter, P.L. 1978. The prehistory of eastern Lesotho. Unpublished PhD thesis. Cambridge: University of Cambridge.

Carter, P.L., Mitchell, P.J. & Vinnicombe, P. 1988. *Sehonghong: The Middle and Later Stone Age Industrial Sequence from a Lesotho Rockshelter.* Oxford: British Archaeological Reports, International Series 406.

Carter, P.L. & Vogel, J.C. 1974. The dating of industrial assemblages from stratified sites in eastern Lesotho. *Man* 9: 557–570.

Challis, W., Mitchell, P.J. & Orton, J. 2008. Fishing in the rain: control of rain-making and aquatic resources at a previously undescribed rock art site in highland Lesotho. *Journal of African Archaeology* 6: 203–218.

Chubb, E.C. & King, B.G. 1932. Remarks on some stone implements and strandloper middens of Natal and Zululand. *South African Journal of Science* 29: 765–769.

Clark, A.M.B. 1999. Late Pleistocene technology at Rose Cottage Cave: a search for modern behaviour in an MSA context. *African Archaeological Review* 16: 93–120.

Coetzee, J.A. 1967. Pollen analytical studies in East and southern Africa. *Palaeoecology of Africa* 3: 1–146.

Davies, O. 1947. Recent exploration of Stone Age sites in Natal. *Transactions of the Royal Society of South Africa* 31: 325.

Deacon, H.J. 1995. Two late Pleistocene-Holocene archaeological depositories from the southern Cape, South Africa. *South African Archaeological Bulletin* 50: 121–131.

Deacon, J. 1978. Changing patterns in the late Pleistocene/early Holocene prehistory of southern Africa, as seen from the Nelson Bay Cave stone artifact sequence. *Quaternary Research* 10: 84–111.

Deacon, J. 1986. 'My place is the Bitterputs': the home territory of Bleek and Lloyd's /Xam San informants. *African Studies* 45: 135–156.

Dowson, T.A. 1994. Reading art, writing history: rock art and social change in southern Africa. *World Archaeology* 25: 332–344.

Dowson, T.A. 1995. Hunter-gatherers, traders and slaves: the 'Mfecane' impact on Bushmen, their ritual and their art. In: Hamilton, C. (ed.) *The Mfecane Aftermath: Reconstructive Debates in Southern African History*: 51–70. Johannesburg: Witwatersrand University Press.

Dowson, T.A. 1998. Rain in Bushman belief, politics and history: the rock art of rain-making in the south-eastern mountains, southern Africa. In: Chippindale, C. & Taçon, P.S.C. (eds) *The Archaeology of Rock-Art*: 73–89. Cambridge: Cambridge University Press.

Dowson, T.A. 2000. Painting as politics: exposing historical processes in hunter-gatherer rock art. In: Schweitzer, P.P., Biesele, M. & Hitchcock, R. (eds) *Hunters and Gatherers in the Modern World: Conflict, Resistance and Self-Determination*: 413–426. Oxford: Berghahn Books.

Eldredge, E. 1993. *A South African Kingdom: The Pursuit of Security in Nineteenth-Century Lesotho*. Cambridge: Cambridge University Press.

Ellenberger, V. 1953. *La Fin Tragique des Bushmen*. Paris: Amiot Dumont.

Farnden, T.H.G. 1966. Excavation of a Late Stone Age shelter at New Amalfi, East Griqualand. *South African Archaeological Bulletin* 21: 122–124.

Germond, R.C. 1967. *Chronicles of Basutoland*. Morija: Morija Sesuto Book Depot.

Goodwin, A.J.H. & Van Riet Lowe, C. 1929. The Stone Age cultures of South Africa. *Annals of the South African Museum* 27: 1–289.

Grab, S. 2000. Periglacial features. In: Partridge, T.C. & Maud, R.R. (eds) *The Cenozoic of Southern Africa*: 207–217. Oxford: Oxford University Press.

Hall, S.L. 1988. Settlement and subsistence developments during the Later Stone Age in the Lower Fish River Basin, Eastern Cape. *Palaeoecology of Africa* 19: 221–232.

Hammond-Tooke, W.D. 1998. Selective borrowing? The possibility of San shamanistic influence on Southern Bantu divination and healing practices. *South African Archaeological Bulletin* 53: 9–15.

Hayden, B. 1995. The emergence of prestige technologies and pottery. In: Barnett, W.K. & Hoopes, J.W. (eds) *The Emergence of Pottery: Technology and Innovation*: 257–266. Washington: Smithsonian Institution Press.

Higgs, E.S. & Vita-Finzi, C. 1967. The climate, environment and industries of Stone Age Greece, part III. *Proceedings of the Prehistoric Society* 23: 1–29.

Hobart, J.H. 2003a. Forager-farmer relations in southeastern southern Africa: a critical reassessment. Unpublished DPhil thesis. Oxford: University of Oxford.

Hobart, J.H. 2003b. An old fashioned approach to a modern hobby: fishing in the Lesotho Highlands. In: Mitchell, P.J., Haour, A. & Hobart, J.H. (eds) *Researching Africa's Past: New Contributions from British Archaeologists*: 44–53. Oxford: Oxford University School of Archaeology.

Hobart, J.H. 2004. Pitsaneng: evidence for a neolithic Lesotho? *Before Farming* 3: 261–270.

Huffman, T.N. 1996. Archaeological evidence for climatic change during the last 2000 years in southern Africa. *Quaternary International* 33: 55–60.

Huffman, T.N. 2007. *Handbook to the Iron Age: The Archaeology of Pre-Colonial Farming Societies in Southern Africa*. Pietermaritzburg: University of KwaZulu-Natal Press.

Humphreys, A.J.B. 1987. Prehistoric seasonal mobility: what are we really achieving? *South African Archaeological Bulletin* 42: 34–38.

Humphreys, A.J.B. 2004/05. 'De-!Kunging' the Later Stone Age of the central interior of South Africa. *Southern African Field Archaeology* 11/12: 36–41.

Jacobs, Z., Roberts, R.G., Galbraith, R.F., Barré, M., Deacon, H.J., Mackay, A., Mitchell, P.J., Vogelsang, R. & Wadley, L. 2008. Ages for Middle Stone Age innovations in southern Africa: implications for modern human behavior and dispersal. *Science* 322: 733–735.

Jacobson, L. 2003. Appendix A: Report on chemical analysis of pottery sherds and clay samples from Lesotho. In: Hobart, J.H. Forager-farmer relations in southeastern southern Africa: a critical reassessment: 407–411. Unpublished DPhil thesis. Oxford: University of Oxford.

Jerardino, A. 1996. Changing social landscapes of the Western Cape coast of southern Africa over the last 4500 years. Unpublished

PhD thesis. Cape Town: University of Cape Town.

Jobling, H.E., Parkington, J.E., Poggenpoel, C.A. & Mazel, A.D. 1984. Patterning on a talus slope. In: Hall, M., Avery, G., Avery, D.M., Wilson, M.L. & Humphreys, A.J.B. (eds) *Frontiers: Southern African Archaeology Today*: 152–166. Oxford: British Archaeological Reports, International Series 207.

Jolly, P. 1994. Strangers to brothers: interaction between south-eastern San and Southern Nguni/Sotho communities. Unpublished MA thesis. Cape Town: University of Cape Town.

Jolly, P. 1995. Melikane and Upper Mangolong revisited: the possible effects on San art of symbiotic contact between south-eastern San and southern Sotho and Nguni communities. *South African Archaeological Bulletin* 50: 68–80.

Jolly, P. 1996. Symbiotic interactions between Black farmers and south-eastern San: implications for southern African rock art studies, ethnographic analogy and hunter-gatherer cultural identity. *Cultural Anthropology* 37: 277–306.

Jolly, P. 2005. Sharing symbols: a correspondence in the ritual dress of black farmers and the southeastern San. *South African Archaeological Society Goodwin Series* 9: 86–100.

Jolly, P. 2006a. Dancing with two sticks: investigating the origin of a southern African rite. *South African Archaeological Bulletin* 61: 172–180.

Jolly, P. 2006b. The San rock painting from 'the upper cave at Mangolong', Lesotho. *South African Archaeological Bulletin* 61: 68–75.

Kaplan, J. 1990. The Umhlatuzana Rock Shelter sequence: 100 000 years of Stone Age history. *Natal Museum Journal of Humanities* 2: 1–94.

Kaplan, J. 1996. Archaeological excavations at Lithakong Shelter (SQY 8), final report. Unpublished report to the Lesotho Highlands Development Authority.

Kelly, R. 1995. *The Foraging Spectrum: Diversity in Hunter-Gatherer Lifeways*. Washington: Smithsonian Institution Press.

Lee, R.B. 1979. *The !Kung San: Men, Women and Work in a Foraging Society*. Cambridge: Cambridge University Press.

Lewis-Williams, J.D. 1981. *Believing and Seeing: Symbolic Meanings in Southern San Rock Paintings*. New York: Academic Press.

Lewis-Williams, J.D. 1995. Modelling the production and consumption of rock art. *South African Archaeological Bulletin* 50: 143–154.

Lewis-Williams, J.D. & Pearce, D.G. 2004. 2004 *San Spirituality: Roots, Expression and Social Consequences*. Walnut Creek: AltaMira Press.

Maggs, T.M.O'C. 1980. Msuluzi Confluence: a seventh century Early Iron Age site on the Tugela River. *Annals of the Natal Museum* 24: 111–145.

Maggs, T.M.O'C. & Ward, V. 1980. Driel Shelter: rescue at a Late Stone Age site on the Tugela River. *Annals of the Natal Museum* 24: 35–70.

Malan, B.D. 1952. The final phase of the Middle Stone Age in South Africa. In: Leakey, L.S.B. (ed.) *Proceedings of the Pan-African Congress on Prehistory*: 188–194. New York: Philosophical Library.

Malan, B.D. 1955. A preliminary account of the archaeology of East Griqualand. *South African Bureau of Archaeology Survey Series* 8: 1–28.

Mazel, A.D. 1981. Up and down the Little Berg: archaeological resource management in the Natal Drakensberg. Unpublished MA thesis. Cape Town: University of Cape Town.

Mazel, A.D. 1982a. Distribution of painting themes in the Natal Drakensberg. *Annals of the Natal Museum* 25: 67–82.

Mazel, A.D. 1982b. Evidence for pre-Later Stone Age occupation of the Natal Drakensberg. *Annals of the Natal Museum* 25: 61–65.

Mazel, A.D. 1983. Eland, rhebuck and cranes: identifying seasonality in the paintings of the Drakensberg. *South African Archaeological Society Goodwin Series* 4: 34–37.

Mazel, A.D. 1984a. Archaeological survey of the Natal Drakensberg, Natal, South Africa. *Journal of Field Archaeology* 11: 345–356.

Mazel, A.D. 1984b. Diamond 1 and Clarke's Shelter: report on excavations in the northern Drakensberg, Natal, South Africa. *Annals of the Natal Museum* 26: 25–70.

Mazel, A.D. 1984c. Gehle Shelter: report on excavations in the uplands ecological zone, Tugela Basin, Natal, South Africa. *Annals of the Natal Museum* 26: 1–24.

Mazel, A.D. 1984d. Through the keyhole: a preliminary peep at the lithic composition of Later Stone Age sites in the central and upper Tugela Basin, Natal. In: Hall, M., Avery, G., Avery, D.M., Wilson, M.L. & Humphreys, A.J.B. (eds) *Frontiers: Southern African Archaeology Today*: 182–193. Oxford: British Archaeological Reports, International Series 207.

Mazel, A.D. 1987. The archaeological past from the changing present: towards a critical assessment of South African Later Stone Age studies from the early 1960s to the early 1980s. In: Parkington, J.E. & Hall, M. (eds) *Papers in the Prehistory of the Western Cape, South Africa*: 504–529. Oxford: British Archaeological Reports, International Series 332.

Mazel, A.D. 1989. People making history: the last ten thousand

years of hunter-gatherer communities in the Thukela Basin. *Natal Museum Journal of Humanities* 1: 1–168.

Mazel, A.D. 1990. Mhlwazini Cave: the excavation of late Holocene deposits in the northern Natal Drakensberg, Natal, South Africa. *Natal Museum Journal of Humanities* 2: 95–113.

Mazel, A.D. 1992a. Collingham Shelter: the excavation of late Holocene deposits, Natal, South Africa. *Natal Museum Journal of Humanities* 4: 1–51.

Mazel, A.D. 1992b. Gender and the hunter-gatherer archaeological record: a view from the Thukela Basin. *South African Archaeological Bulletin* 47: 122–126.

Mazel, A.D. 1992c. Early pottery from the eastern part of southern Africa. *South African Archaeological Bulletin* 47: 3–7.

Mazel, A.D. 1993. KwaThwaleyakhe Shelter: the excavation of mid and late Holocene deposits in the central Thukela Basin, Natal, South Africa. *Natal Museum Journal of Humanities* 5: 1–36.

Mazel, A.D. 1994. Extending the distribution of barbed and tanged arrowheads into central Natal. *South African Archaeological Bulletin* 49: 53.

Mazel, A.D. 1996. Maqonqo Shelter: the excavation of Holocene deposits in the eastern Biggarsberg, Thukela Basin South Africa. *Natal Museum Journal of Humanities* 8: 1–39.

Mazel, A.D. 1997a. Mzinyashana Shelters 1 and 2: excavation of mid and late Holocene deposits in the eastern Biggarsberg, Thukela Basin, South Africa. *Natal Museum Journal of Humanities* 9: 1–35.

Mazel, A.D. 1997b. Hunter-gatherers in the Thukela Basin during the last 1500 years, with special reference to hunter-gatherer/agriculturalist relations. In: Bank, A. (ed.) *The Proceedings of the Khoisan Identities and Cultural Heritage Conference*: 94–101. Cape Town: Arts and Culture Trust.

Mazel, A.D. 1999. iNkolimahashi Shelter: the excavation of Later Stone Age rock shelter deposits in the central Thukela Basin, KwaZulu-Natal, South Africa. *Natal Museum Journal of Humanities* 11: 1–21.

Mazel, A.D. & Watchman, A.L. 1997. Accelerator radiocarbon dating of Natal Drakensberg paintings: results and implications. *Antiquity* 71: 445–449.

Mazel, A.D. & Watchman, A.L. 2003. Dating rock paintings in the uKhahlamba-Drakensberg and the Biggarsberg, KwaZulu-Natal, South Africa. *Southern African Humanities* 15: 59–73.

Mitchell, P.J. 1987. The Sehonghong bladelet industry in the context of the southern African Later Stone Age. Unpublished DPhil thesis. Oxford: University of Oxford.

Mitchell, P.J. 1992. Archaeological research in Lesotho: a review of 120 years. *African Archaeological Review* 10: 3–34.

Mitchell, P.J. 1994. Understanding the MSA/LSA transition: the pre-20,000 BP assemblages from new excavations at Sehonghong rock-shelter, Lesotho. *Southern African Field Archaeology* 3: 15–25.

Mitchell, P.J. 1995. Revisiting the Robberg: new results and a revision of old ideas at Sehonghong rock-shelter, Lesotho. *South African Archaeological Bulletin* 50: 28–38.

Mitchell, P.J. 1996a. Filling a gap: the early and middle Holocene assemblages from new excavations at Sehonghong Rock Shelter, Lesotho. *Southern African Field Archaeology* 5: 17–27.

Mitchell, P.J. 1996b. Sehonghong: the late Holocene assemblages with pottery. *South African Archaeological Bulletin* 51: 17–25.

Mitchell, P.J. 1996c. The Late Quaternary of the Lesotho highlands, southern Africa: preliminary results and future potential of recent research at Sehonghong Shelter. *Quaternary International* 33: 35–44.

Mitchell, P.J. 1996d. Prehistoric exchange and interaction in south-eastern southern Africa: marine shell and ostrich eggshell. *African Archaeological Review* 13: 35–76.

Mitchell, P.J. 1996e. The archaeological landscape at Sehonghong, a hunter-gatherer site in the Lesotho highlands, southern Africa. *Antiquity* 70: 623–638.

Mitchell, P.J. 1999. Pressure-flaked points in Lesotho: dating, distribution and diversity. *South African Archaeological Bulletin* 54: 90–96.

Mitchell, P.J. 2001. Recent archaeological work in Lesotho: an overview of fieldwork 1988–2001. *National University of Lesotho Journal of Research* 9: 1–24.

Mitchell, P.J. 2002. *The Archaeology of Southern Africa*. Cambridge: Cambridge University Press.

Mitchell, P.J. 2004. Likoaeng: a Later Stone Age open air site in the Lesotho Highlands, southern Africa. In: Sanogo, K., Togola, T., Keita, D. & N'Daou, M. (eds) *Proceedings of the Eleventh Congress of the PanAfrican Association for Prehistory and Related Studies*: 246–263. Bamako: Institut des Sciences Humaines.

Mitchell, P.J. 2005. Archaeological resource management in Lesotho: thoughts on its past record, present situation and future prospects. In: Finneran, N. (ed.) *Safeguarding Africa's Past*: 37–46. Oxford: British Archaeological Reports, International Series 1454.

Mitchell, P.J. 2008a. Developing the archaeology of Marine Isotope Stage 3. *South African Archaeological Society Goodwin Series* 10: 52–65.

Mitchell, P.J. 2008b. The canine connection. In: Badenhorst,

S., Mitchell, P.J. & Driver, J. (eds) *Animals and People: Archaeozoological Essays in Honour of Ina Plug*: 104–116. Oxford: British Archaeological Reports, International Series 1849.

Mitchell, P.J. 2009. Hunter-gatherers and farmers: some implications of 2000 years of interaction in the Maloti-Drakensberg region of southern Africa. In: Ikeya, K., Ogawa, H. & Mitchell, P.J. (eds) *Interactions Between Hunter-Gatherers and Farmers: From Prehistory to Present*: 15–46. Osaka: National Museum of Ethnology. Senri Ethnological Studies 73.

Mitchell, P.J. & Charles, R.L.C. 2000. Later Stone Age hunter-gatherer adaptations in the Lesotho Highlands, southern Africa. In: Bailey, G.N., Charles, R.L.C. & Winder, N. (eds) *Human Ecodynamics: Proceedings of the Conference of the Association of Environmental Archaeology*: 90–99. Oxford: Oxbow Press.

Mitchell, P.J. & Hudson, A. 2004. Psychoactive plants and southern African hunter-gatherers: a review of the evidence. *Southern African Humanities* 16: 39–57.

Mitchell, P.J., Parkington, J.E. & Yates, R. 1994. Recent Holocene archaeology in western and southern Lesotho. *South African Archaeological Bulletin* 49: 27–56.

Mitchell, P.J., Plug, I. & Bailey, G.N. 2006. Spatial patterning at Likoaeng, an open air hunter-gatherer campsite in the Lesotho Highlands, southern Africa. *Archaeological Papers of the American Anthropological Association* 16: 81–94.

Mitchell, P.J., Plug, I. & Bailey, G.N. (eds) In press. *People of the Fish: The Archaeology of a Later Stone Age Hunter-Gatherer Campsite at Likoaeng, Lesotho Highlands, Southern Africa*. Oxford: Oxford School of Archaeology.

Mitchell, P.J. & Vogel, J.C. 1994. New radiocarbon dates from Sehonghong rock-shelter, Lesotho. *South African Journal of Science* 90: 380–388.

Mitchell, P.J. & Whitelaw, G. 2005. The archaeology of southernmost Africa *c.* 2000 BP to the early 1800s: a review of recent research. *Journal of African History* 46: 209–241.

Opperman, H. 1987. *Later Stone Age Hunter-Gatherers of the Drakensberg Range and its Foothills*. Oxford: British Archaeological Reports, International Series 339.

Opperman, H. 1992. A report on the results of a test pit in Strathalan Cave B, Maclear district, north-eastern Cape. *Southern African Field Archaeology* 1: 98–102.

Opperman, H. 1996a. Strathalan Cave B, north-eastern Cape Province, South Africa: evidence for human behaviour 29,000–26,000 years ago. *Quaternary International* 33: 45–54.

Opperman, H. 1996b. Excavation of a Later Stone Age deposit in Strathalan Cave A, Maclear district, northeastern Cape, South Africa. In: Pwiti, G. & Soper, R. (eds) *Aspects of African Archaeology*: 335–342. Harare: University of Zimbabwe Press.

Opperman, H. 1999. A 300 year old living floor in Strathalan Cave A, Maclear District, Eastern Cape. *Southern African Field Archaeology* 8: 76–80.

Opperman, H. & Heydenrych, B. 1990. A 22 000 year-old Middle Stone Age camp site with plant food remains from the north-eastern Cape. *South African Archaeological Bulletin* 45: 93–99.

Orpen, J.M. 1874. A glimpse into the mythology of the Maluti Bushmen. *Cape Monthly Magazine* 9: 1–13

Ouzman, S. 1995. The fish, the shaman and the peregrination: San rock paintings of Mormyrid fish as religious and social metaphors. *Southern African Field Archaeology* 4: 3–17.

Ouzman, S. & Loubser, J.N.H. 2000. Art of the Apocalypse. *Discovering Archaeology* 2: 38–44.

Ouzman, S. & Wadley, L. 1997. A history in paint and stone from Rose Cottage Cave, South Africa. *Antiquity* 71: 386–404.

Pager, H. 1971. *Ndedema Gorge*. Graz: Akademische Druck- und Verlagsanstalt.

Parkington, J.E. 1972. Seasonal mobility in the Late Stone Age. *African Studies* 31: 223–243.

Parkington, J.E. 1977. Follow the San. Unpublished PhD thesis. Cambridge: University of Cambridge.

Parkington, J.E. 1998. Resolving the past: gender in the Stone Age archaeological record of the Western Cape. In: Kent, S. (ed.) *Gender in African Prehistory*: 25–38. Walnut Creek: AltaMira Press.

Parkington, J.E. 2001. Mobility, seasonality and southern African hunter-gatherers. *South African Archaeological Bulletin* 56: 1–7.

Parkington, J.E., Poggenpoel, C.A. & Yates, R. 1987. *Lesotho Rescue Archaeology 1982–83*. Cape Town: University of Cape Town.

Plug, I. 1990. The macrofaunal remains from Mhlwazini Cave, a Holocene site in the Natal Drakensberg. *Natal Museum Journal of Humanities* 2: 135–142.

Plug, I. 1992. The macrofaunal remains of Collingham Shelter, a Late Stone Age site in Natal. *Natal Museum Journal of Humanities* 4: 53–59.

Plug, I. 1993. KwaThwaleyakhe Shelter: the faunal remains from a Holocene site in the Thukela Basin, Natal. *Natal Museum Journal of Humanities* 5: 37–45.

Plug, I. 1997. Late Pleistocene and Holocene hunter-gatherers in the eastern highlands of South Africa and Lesotho: a faunal interpretation. *Journal of Archaeological Science* 24: 715–727.

Plug, I. 2003. Appendix D: Report on Pitsaneng fauna. In:

Hobart, J.H. Forager-farmer relations in southeastern southern Africa: a critical reassessment: 425–428. Unpublished DPhil thesis. Oxford: University of Oxford.

Plug, I. & Engela, R. 1992. The macrofaunal remains from recent excavations at Rose Cottage Cave, Orange Free State. *South African Archaeological Bulletin* 47: 16–25.

Plug, I. & Mitchell, P.J. 2008a. Fishing in the Lesotho highlands: 26,000 years of fish exploitation, with special reference to Sehonghong Shelter. *Journal of African Archaeology* 6: 33-55.

Plug, I. & Mitchell, P.J. 2008b. Sehonghong: hunter-gatherer utilisation of animal resources in the highlands of Lesotho. *Annals of the Transvaal Museum* 45: 1–23.

Plug, I., Mitchell, P.J. & Bailey, G.N. 2003. Animal remains from Likoaeng: a post-classic Wilton open air fishing campsite on the Senqu River, Lesotho. *South African Journal of Science* 99: 143–152.

Richards, M., Macaulay, V., Carracedo, A. & Salas, A. 2004. The archaeogenetics of the Bantu dispersals. In: Jones, M. (ed.) *Traces of Ancestry: Studies in Honour of Colin Renfrew*: 75–88. Oxford: Oxbow Press.

Russell, T. 2000. The application of the Harris Matrix to San rock art at Main Caves North, KwaZulu-Natal. *South African Archaeological Bulletin* 55: 60–70.

Sadr, K. 2003. The Neolithic of southern Africa. *Journal of African History* 44: 195–209.

Sadr, K. & Sampson, C.G. 2005. Through thick and thin; early pottery in southern Africa. *Journal of African Archaeology* 4: 235–252.

Salas, A., Richards, M., De la Fe, T., Lareu, M.-V., Sobrino, B., Sánchez-Diz, P., Macaulay, V. & Carracedo, A. 2002. The making of the African mtDNA landscape. *American Journal of Human Genetics* 71: 1082–1111.

Sampson, C.G. 1974. *The Stone Age Archaeology of Southern Africa*. New York: Academic Press.

Sampson, C.G. 1988. *Stylistic Boundaries among Mobile Hunter-Foragers*. Washington: Smithsonian Institution Press.

Sealy, J.C. 1992. On 'Approaches to dietary reconstruction in the Western Cape: are you what you have eaten?' – a reply to Parkington. *Journal of Archaeological Science* 19: 459–466.

Shinnie, P.L. 1990. A personal memoir. In: Robertshaw, P.T. (ed.) *A History of African Archaeology*: 221–235. London: James Currey.

Smits, L.G.A. 1973. Rock-painting sites in the upper Senqu Valley, Lesotho. *South African Archaeological Bulletin* 28: 32–38.

Smits, L.G.A. 1992. Rock painting sites near the Southern Perimeter Road in southeastern Lesotho. In: Lorblanchet, M. (ed.) *Rock Art in the Old World*: 61–95. New Delhi: Indira Gandhi National Centre for the Arts.

Stein, H.B. 1933. Stone implements from Cathkin Peak area. *Bantu Studies* 7: 159–182.

Swart, J. 2004. Rock art sequences in uKhahlamba-Drakensberg Park, South Africa. *Southern African Humanities* 16: 13–35.

Tyson, P.D. & Lindesay, J.A. 1992. The climate of the last 2000 years in southern Africa. *The Holocene* 2: 271–278.

Vinnicombe, P. 1976. *People of the Eland: Rock Paintings of the Drakensberg Bushmen as a Reflection of their Life and Thought*. Pietermaritzburg: Natal University Press.

Vogel, J.C. 1983. Isotopic evidence for past climates and vegetation of South Africa. *Bothalia* 14: 391–394.

Volman, T.P. 1981. The Middle Stone Age in the southern Cape. Unpublished PhD thesis. Chicago: University of Chicago.

Wadley, L. 1987. *Later Stone Age Hunters and Gatherers of the Southern Transvaal: Social and Ecological Interpretations*. Oxford: British Archaeological Reports, International Series 380.

Wadley, L. 1989. Gender relations in the Thukela Basin. *South African Archaeological Bulletin* 44: 122–126.

Wadley, L. 1996. The Robberg industry of Rose Cottage Cave, eastern Free State: the technology, spatial patterns and environment. *South African Archaeological Bulletin* 51: 64–74.

Wadley, L. 2006. Partners in grime: results of multi-disciplinary archaeology at Sibudu Cave. *Southern African Humanities* 18(1): 315–341.

Wells, L.H. 1933. The archaeology of Cathkin Peak. *Bantu Studies* 7(2): 113–129.

Willcox, A.R. 1957. A cave at Giant's Castle Game Reserve. *South African Archaeological Bulletin* 12: 87–97.

Willcox, A.R. 1974. Reasons for the non-occurrence of Middle Stone Age material in the Natal Drakensberg. *South African Journal of Science* 70: 273–274.

Wilson, A.L. 1955. Wilton material on the slopes of the Drakensberg. *South African Archaeological Bulletin* 10: 20–21.

Wright, J.B. 1971. *Bushman Raiders of the Drakensberg 1840–1870*. Pietermaritzburg: University of Natal Press.

Wright, J.B. & Mazel, A.D. 2007. *Tracks in a Mountain Range: Exploring the History of the uKhahlamba-Drakensberg*. Johannesburg: Witwatersrand University Press.

▶ Extraordinary image of what is probably a rain-animal, recorded in 1960. One of the many hundred of important unpublished recordings by Patricia Vinnicombe. Tracing by Patricia Vinnicombe, redrawing by Justine Olofsson.

PERSONAL COMMUNICATIONS

Dr Patrick Carter, 1991
Mr Gavin Whitelaw, 2008

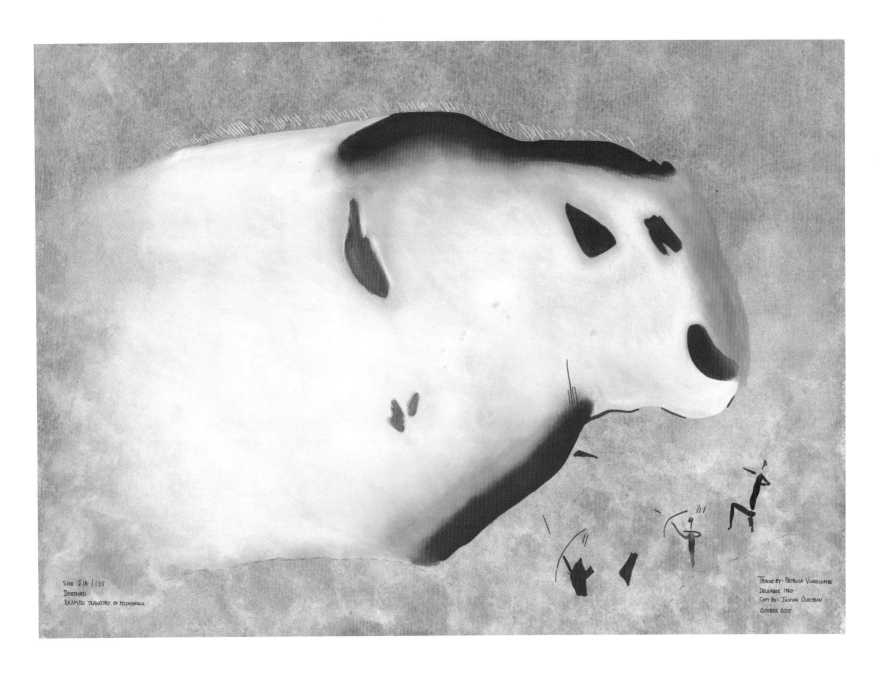

Site J15/188
Dartford
Ekamazi Tributary of Mzimkhulu

Tracked by: Patricia Vinnicombe
December 1960
Copy by: Justine Olofsson
October 2000

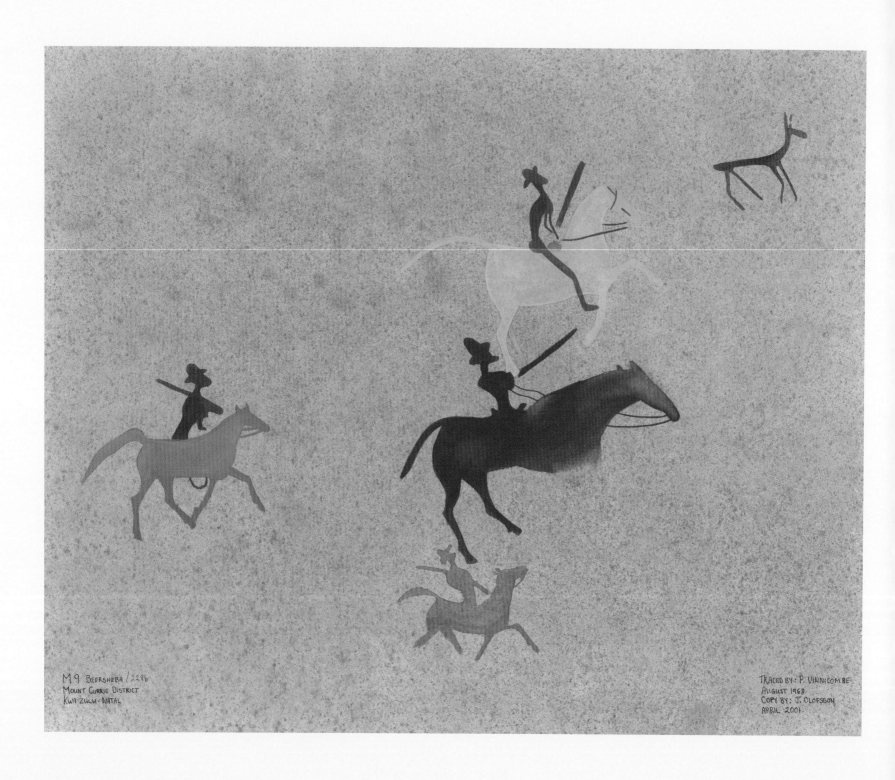

M 9 Beersheba / 2296
Mount Currie District
Kwa Zulu - Natal

TRACED BY: P. VINNICOMBE
AUGUST 1968
COPY BY: J. OLOFSSON
APRIL 2001

"Their village is where they kill game":
Nguni interactions with the San

Gavin Whitelaw

Patricia Vinnicombe's historical focus in *People of the Eland* was largely on the nineteenth century, for which there is significant archival evidence of mixed bands of San and Bantu speakers operating on the fringes of colonial society. Not too many years later, the San had ceased to exist as a distinct entity in south-eastern southern Africa; they were absorbed into other communities, and took up farming in areas allocated by the colonial authorities.

For the centuries prior to 1800, Vinnicombe perceived contact between hunter-gatherers and farmers in terms of an advancing frontier, with "loosely bonded and mobile" bands on the one side and "highly institutionalised and settled" communities on the other. Their "confrontation" was probably characterised by "a combination of extermination, retreat, absorption and acculturation" (Vinnicombe 1976: 9). Hunter-gatherer lifeways were variously modified but endured, perhaps because of a degree of respect among Bantu speakers for San territorial rights (Vinnicombe 1976).

Language provides the most obvious evidence of contact between Khoisan and Nguni speakers. One-sixth to one-fifth of Xhosa words contain clicks derived from Khoisan, though the proportion drops off in Nguni dialects to the north (Bourquin 1951; Hammond-Tooke 1998: 10). Genetic data match the linguistic evidence, with the Khoisan contribution to the gene pool greater among the southern Nguni (Jenkins *et al.* 1970). Further, as is well known, the San contributed significantly to Nguni divinatory practice. Again, contact with the southern Nguni seems to have been more intense (see below).

In establishing the nature of this contact more precisely, I focus on interaction east of the Drakensberg from the

point of view of Nguni farmers (see Jolly [1996a] for a different view of this topic). I am particularly interested in rainmaking, which several scholars have argued was a key forum of interaction between San hunter-gatherers and Iron Age farmers (e.g. Vinnicombe 1976; Jolly 1986; Campbell 1987; Prins 1990; Van der Ryst 1998; Schoeman 2006). Hammond-Tooke (1998) offered a cautionary note, however, so here I explore Nguni rainmaking practice. For comparison, I also consider divination.

To frame the discussion, I start with a brief outline of the culture–historical sequences for hunter-gatherers and farmers of the region. More detail of these sequences is available elsewhere (for hunter-gatherers, see Mazel 1989, 1998, 2004; for Nguni farmers, see Maggs 1980, 1989; Whitelaw 1998, 2008; Huffman 2004).

Culture–historical framework

Hunter-gatherers

Mazel (1989, 1993) argues that three, or possibly four, hunter-gatherer social regions existed in the Thukela Basin between 4 000 and 2 000 years ago. The regions are archaeologically recognisable from the distribution of artefacts such as ostrich eggshell beads, scrapers and backed blades. Each represents the extent of a *hxaro*-like exchange network, and each contained the resources for social reproduction. Hunter-gatherers must have moved across the landscape according to social and economic needs, but not necessarily in the way envisaged by Carter (1970) and Cable (1984), that is, summer aggregation in the upland

◄ Pat Vinnicombe recorded more 'contact images' of horsemen, guns, and wagons in the southern Drakensberg than David Lewis-Williams and Harald Pager recorded in the central and northern Drakensberg. It is clear that this is not a product of sample bias, it is a true pattern. The reasons for this are discussed in Chapters 6 and 7 as well as Box 8. Tracing by Pat Vinnicombe. Redrawing by Justine Olofsson.

grasslands, alternating with a winter dispersal phase in the lowland bushveld. Indeed, three of Mazel's social regions are located in the grasslands, with the possible fourth in the bush- and thornveld of the central basin.

This patterning dissolved around the beginning of the first millennium AD, following the appearance of Iron Age farmers. The focus of hunter-gatherer activity shifted from grassland areas towards the more heavily wooded central Thukela Basin (Figure 8.1). Also, the distribution patterns of key items of material culture became more diffuse (Mazel 1989, 1993, 1998).

The new archaeological signature reflects the extension of hunter-gatherer networks beyond the previously established social regions. In addition, hunter-gatherers established relationships with farmers, hence the greater emphasis on the wooded environments where farmers had settled. Mazel (1998: 99) characterises this new relationship as an "ambivalent coexistence", and at least some hunter-gatherers continued to use grassland and mountain resources while belonging to interaction networks that included farmers. The open-air fishing site of Likoaeng in Lesotho is a notable example (Mitchell 2009).

Hunter-gatherer exploitation of the grasslands intensified again after 1300, when farmers settled in the grasslands for the first time. Interaction continued, but its form may have been substantially different from the first millennium pattern. Mazel (2004) suggests it shifted more towards the sale and purchase of services and products.

Some have questioned Mazel's social regions (Wadley 1989; Barham 1992; Mitchell 2002), but their concerns are not relevant here. What is important is that the pattern of dated archaeological deposits, including paintings (Mazel & Watchman 1997, 2003), suggests that hunter-gatherers initiated contact and then interacted with farmers throughout the Iron Age.

Farmers

Iron Age farmers first entered the region in the mid-fifth century AD. Studies of settlement pattern – specifically the identification of the Central Cattle Pattern – show that from their first arrival in southern Africa, farming societies have been patrilineal and hierarchical, with status defined in terms of concepts such as age and gender. Hereditary male leadership was the norm, but men competed with one another in the accumulation and control of human creative and productive potential, or labour power. Men

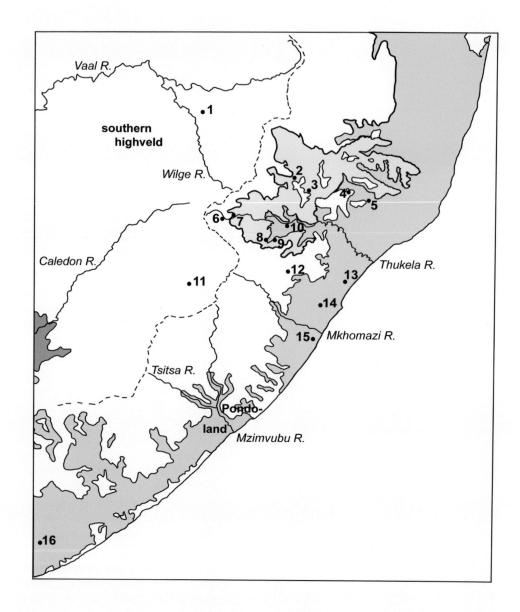

1 = Ntsuanatsatsi	5 = uMgungundlovu	9 = iGujwana	13 = Sibudu
2 = Dundee	6 = Driel	10 = iNkolimahashi	14 = Shongweni
3 = Mzinyashana	7 = Bergville	11 = Likoaeng	15 = Umzinto
4 = Babanango	8 = Estcourt	12 = Karkloof	16 = Grahamstown

Southeastern southern Africa. Dashed line indicates Drakensberg watershed. Orange shading indicates karoo-type vegetation. Blue shading indicates the more heavily wooded lowlands. Unshaded areas represent grasslands of various types. Yellow shading indicates the wooded grasslands of the Thukela Basin. They contain good pasture. These grasslands are relatively open and were retained that way by fire. The signature tree is the soft-wood *Acacia sieberana*. Since the 1800s they have been increasingly invaded by woody vegetation moving up the valleys. Map after Low and Rebelo (1996).

accumulated labour power primarily through marriage: access to female creative and productive capacity was acquired in exchange for cattle. Throughout the Iron Age, this competition for labour power would have been a source of shifts in power (Huffman 1982, 2001; Kuper 1982; Guy 1987; Whitelaw 1994, 1994/95; Greenfield & Van Schalkwyk 2003).

The earliest farmers belonged to the Urewe Tradition. They were followed in the mid-seventh century by Kalundu Tradition farmers who settled throughout much of the coastal and bushveld regions of KwaZulu-Natal and farther south, reaching the western limits of summer rainfall probably by 750. The Kalundu sequence in KwaZulu-Natal ends by the mid-eleventh century and is replaced by Blackburn, an Urewe Tradition facies associated with the earliest Nguni speakers in southern Africa. Blackburn sites are known from the coastal belt (Davies 1971; Robey 1980) and from two rock shelters within 20 kilometres of the coast – Sibudu (Wadley 2001) and Shongweni (Davies 1975) (Figure. 8.1).

Blackburn develops into the Moor Park facies, which in KwaZulu-Natal has dates of 1300–1650/1700. The distribution of Moor Park sites indicates that for the first time Iron Age farmers expanded into the higher altitude sweetveld grasslands. Sites are recorded near Estcourt, Bergville and Dundee, though they also occur in the coastal belt (Davies 1974; Maggs 1984; Anderson 1997; Whitelaw 2004; Natal Museum records).

Farther south, Umgazana Ware resembles NC2 (Schofield 1938, 1948; cf. Derricourt 1977: 216), which for the most part is Moor Park (excluding the NC2a/NC2D component, which is Mzonjani). Umgazana Ware was originally known only from the Pondoland coast (Derricourt 1977), but Simon Hall (1986) recovered sherds with Moor Park-like lip notching from north of Grahamstown. The sherds date to the fifteenth century. These data extend the distribution of the Moor Park facies into the Eastern Cape. In the early 1900s, southern Nguni ceramics still retained Moor Park decorative features (cf. Davies 1974; Shaw & Van Warmelo 1974: plates 20–24; Whitelaw 2004).

Radiocarbon dates show that some farmers settled in the Free State between 1400 and 1600. Slightly later readings from north of the Vaal River suggest a spread to the north-west. These were the Fokeng, who are archaeologically identifiable by Type N stonewalled sites and Ntsuanatsatsi pottery (Maggs 1976: 315; Huffman 2002). New research

gives them an Nguni origin on the basis of a resemblance between Ntsuanatsatsi and Blackburn and suggests that the Fokeng originated in northern KwaZulu-Natal (Huffman 2007; cf. Bryant 1929: 356–357).[1] In time they spread across the southern highveld and towards the Caledon Valley, which they reached by the late 1600s (Maggs 1976).

The Fokeng later became Sotho, probably under the influence of western Sotho–Tswana communities who settled on the southern highveld in the 1600s. (Ellenberger's [1912] estimate of 1500–1550 [Maggs 1976: 142] seems too early on archaeological grounds [Huffman 2002: 20].) By the 1800s, the Free State Fokeng had become 'people of the dew', scattered communities regarded as close to the San, apparently without political ambition but nevertheless respected because of their antiquity and cleverness (Maggs 1976: 308).

East of the Drakensberg a third facies in the Nguni sequence, Nqabeni, dates from around 1650/1700. It is best known from sites on the Babanango plateau and around Bergville in the upper Thukela Basin (Hall & Maggs 1979; Maggs 1982, 1988; Maggs *et al*. 1986). These have a high visibility because of their stone or earth walls and grassland situation. Sites are less visible in wooded areas, where organic materials were used for livestock pens (Hall & Mack 1983). Nqabeni-style ceramics occur at uMgungundlovu, the capital of the Zulu state in the 1830s. Colonial expansion into Zululand in the late 1800s brought an end to the facies (cf. Jolles 2005).

I turn now to points of contact between these two culture–historical sequences.

Interactions

I take as a starting point the statement by the Rev. Henry Callaway's informant Mpengula Mbanda, also quoted by Vinnicombe (Callaway 1866: 352–355; Vinnicombe 1976: 11–12):

> The Abatwa are very much smaller people than all other small people; they go under the grass, and sleep in anthills; they go in the mist; they live in the upcountry in the rocks; they have no village of which you may say, 'There is a village of Abatwa.' Their village is where they kill game; they consume the whole of it, and go away. That is their mode of life.

But it happens if a man is on a journey, and comes suddenly on an Umutwa, the Umutwa asks, 'Where did you see me?' But at first through their want of intercourse with the Abatwa, a man spoke the truth, and said, 'I saw you in this very place.' Therefore the Umutwa was angry, through supposing himself to be despised by the man; and shot him with his bow, and he died. Therefore it was seen that they like to be magnified; and hate their littleness …

They are dreaded by men; they are not dreadful for the greatness of their bodies, nor for appearing to be men; no, there is no appearance of manliness; and greatness there is none; they are little things, which go under the grass. And a man goes looking in front of him, thinking, 'if there come a man or a wild beast, I shall see.' And, forsooth, an Umutwa is there under the grass; and the man feels when he is already pierced by an arrow; he looks, but does not see the man who shot it. It is this, then, that takes away the strength; for they will die without seeing the man with whom they will fight. On that account, then, the country of the Abatwa is dreadful; for men do not see the man with whom they are going to fight. The Abatwa are fleas, which are unseen whence they came; yet they teaze a man; they rule over him … their strength is like that of the fleas, which have the mastery in the night, and the Abatwa have the mastery through high grass, for it conceals them; they are not seen. That then is the power with which the Abatwa conquer men … The bow with which they shoot beast or man, does not kill by itself alone; it kills because the point of their arrow is smeared with poison … But that poison of theirs, many kinds of it are known to hunters of the elephant. That then is the dreadfulness of the Abatwa, on account of which they are dreaded.

Some years later, in 1905, Mahaya kaNongqabana, another informant, told colonial public servant James Stuart:

The *Bushmen* used to eat *hippopotamus*, the *elephant* being finished. They ate *hippopotamus* at the Mzimkulu, near the mouth. When we increased in numbers at the Mzimkulu, the *Bushmen*, unable to associate with us, retreated to the Ingele bush, near Harding, where there were to be found buffalo and *elephant*. (Webb & Wright 1979: 133; italics recorded in Zulu)

For both informants, the San were quite distinctive. There is first a question over their humanity. "Very much smaller" than Nguni farmers, with whom they were "unable to associate", they dwelt outside the order of settled village life, in the "bush" at the places where they killed animals. They were impossible to control and given to quick, irrational anger, such that farmers lied to appease them and, indeed, to save their own lives. More than this, despite their puny frames and weapons, the San had pharmacological knowledge which they used to inflict death, even on the mighty elephant.

To understand why the San were so poorly regarded, we must look at the way a basic social principle was manipulated in frontier contexts (Kopytoff 1987: 53–54). Seniority and at least certain kinds of authority were typically conferred on the aged, or those who came first. In addition, by virtue of their longevity and proximity to death, the aged were commonly believed to have an intimate relationship with the ancestors and the land and its spirits. In frontier contexts such as those described by the two informants, this principle presented an ideological challenge to newcomers, who handled it according to the specific politics of the interaction. Politically dominant newcomers might give firstcomers ritual authority, especially in connection with the land and its productivity (Kopytoff 1987: 53–54). The respect given to the Free State Fokeng, coupled with their supposed lack of political ambition, is an example. Similarly, ownership of the land "from time immemorial" apparently gave the Tolo a "natural inclination" for prestigious roles in non-Tolo chiefdoms (Webb & Wright 1982: 133–134).

Alternatively, newcomers might claim that they chased the firstcomers away, or that the firstcomers fled before them (Kopytoff 1987: 54). This is exactly the claim made by Stuart's informant. On the other hand, newcomers could undercut the ideology by dehumanising firstcomers, treating them as part of the untamed wilderness (Kopytoff 1987: 56–57). Thus, when the Cele took control of the coastlands south of the Thukela River in the 1770s, they cast their new subjects as *inyakeni* – "those who knew nothing", with "dirty habits" and unable to "distinguish between what was good and what was bad. A person of the *inyakeni* did not pay respect to chiefs, nor did he wash or keep himself

neat" (Hamilton & Wright 1990: 20). Callaway's informant expresses this same strategy. As hunter-gatherers, the San were far more easily demonised than the farmers of the coastlands.

Nevertheless, interaction occurred and some San achieved high status in some farmer communities. Moorosi, partly San, and Moletsane, raised by San, were respectively Phuthi and Taung chiefs. On the other hand, Moshoeshoe of the Basotho reputedly stated that "a Bushman cannot rule" (Maggs 1976: 307). And possibly a century earlier, at what would have been the peak of the Little Ice Age, tradition has it that friction over resources in the Ntsuanatsatsi area resulted in secession of the Kwena and some Fokeng from a newly installed Fokeng chief. That the chief was of San descent provided a useful excuse (Maggs 1976: 142).

Different versions of the Mpondomise chiefly lineage reveal the same contradictory positions. The early chief Ncwini stands out as the progenitor of the clan. He captured a rather interesting wild animal who turned out to be a San woman, of whom he grew especially fond. Ncwini's councillors advised him to pay bridewealth for her after she fell pregnant. This he did, sending bridewealth cattle to "a voice" in Mzumbe Forest (Prins & Lewis 1992: 137). Critically, the transaction recast his lover as a social being and so legitimised the birth of her son Cira. Cira eventually became a famous chief.

In an alternative version of this tale, Ncwini paid no bridewealth for his lover because the "Bushmen did not demand it". Cira became chief after Ncwini's death, but died "very young" and was succeeded by his son Umte (*Report and Proceedings* 1883, II: 403).

Cira's story expresses a concern (the intervention of the councillors) about a San capacity to disrupt social order (Cira's untimely death), even unconsciously. Taken together, all these accounts show clearly that the San were ambiguous beings, straddled between nature and culture (Prins & Lewis 1992). And like all ambiguous entities, they would have posed a disruptive, polluting threat to the ordered world (cf. Douglas 1966). Consequently, farmers would have tried to limit the threat by carefully controlling interaction, as some important archaeological evidence suggests.

In the Caledon Valley, excavation data, historical accounts and the negative spatial correlation between stonewalled sites and shelters with cattle and shield paintings strongly suggest that the San operated largely on the margins of farmer society (Loubser & Laurens 1994). It seems possible that paintings of cattle and sheep in the Drakensberg foothills of the upper Thukela Basin reflect something similar (cf. Mazel 1982; Manhire *et al.* 1986).

The Thukela Basin paintings probably pre-date 1800. Farther afield, hunter-gatherer deposits occur behind houses on a Madikwe phase (1500–1700) Sotho–Tswana site in North West Province. Their distribution suggests that hunter-gatherer movement around the homestead was tightly controlled because of their polluting ambiguity. They were restricted to the outer margin of the homestead and excluded from its inner, ordered world (Hall 2000). Importantly, this evidence shows that San ambiguity was not a perception restricted to Nguni speakers, nor to the recent past.

In the next section I consider how San ambiguity structured their involvement in Nguni divination and rainmaking.

Divination

Most scholars accept that Nguni divination was influenced by San practice and belief. Some of this influence is obvious. For example, the Xhosa term for diviner is *igqirha* (pl. *amagqirha*), derived from the /Xam *!gi:xa* (medicine man or shaman) (Botha & Thackeray 1987), and women diviners are sometimes addressed as *mthwakazi*, meaning Bushwoman (Prins & Lewis 1992). Significantly, many southern Nguni diviners claim to have apprenticed themselves to San shamans rather than Nguni diviners. Indeed, much of the Nguni divinatory paraphernalia (rattles, sticks, flywhisks) appears to have been adopted from the San (Prins & Lewis 1992).

There are other, less obvious adoptions. The well-known southern Nguni witch familiar, the *thikoloshe*, is most probably an Nguni-ised version of Cagn, the San trickster deity (Hammond-Tooke 1997). Similarly, divinatory animals were probably derived from San animals of potency. Divinatory animals are special manifestations of the ancestors. Unconnected to lineages, they form an "extra-societal" component of the ancestral body (Hammond-Tooke 1999: 130). These beings are mostly absent from the thought of Nguni speakers farther north.

Hammond-Tooke (1998) showed that these adoptions are best understood in relation to Nguni perceptions of married women. Wives in all southern African Bantu-speaking communities are ambiguous because they

BOX 9. CAN ROCK ART CONSERVATION BE LEGISLATED?

Janette Deacon

All conservation laws aim to uphold principles that are of value to society because they aim to conserve scarce or non-renewable resources. Because some form of incentive is required to get the majority to adhere to these principles, the question is not so much 'Can rock art conservation be legislated?' but 'Can rock art be conserved without legislation?'

I would argue that far more can be done by legislating than by not legislating. Laws governing rock art conservation are needed both to give government the mandate to act, and to empower it to set standards and guidelines for activities that might affect the significance of the art. Success or failure depends on the commitment of government to fund the officials tasked with implementing the laws. If no legislation exists, government cannot commit funds for conservation and it is left to individuals in the private sector to follow their own conscience.

Principles

Successive laws that protect rock art in South Africa have sought to maintain the following principles:

- rock paintings and engravings are a unique and irreplaceable record of the beliefs and experiences of indigenous people;
- rock art should remain in its original place;
- integrity and authenticity must be maintained by keeping the original elements and fabric of rock art, including its setting, intact;
- rock art may not be destroyed, damaged or altered;
- all work undertaken with a permit must be documented;
- any interventions made to protect rock art should be reversible;
- ownership of rock art rests with the state and not with individuals or particular cultural groups, although property owners retain the right to limit access to their land; and
- original rock art has no commercial value and therefore may not be sold.

Implementation

Currently, the National Heritage Resources Act or NHRA (Act No. 25 of 1999) includes the following provisions that reflect an accumulation of legal responses that have built up over almost a century (Table B9.1):

1. Section 35 protects rock art and other archaeological sites by stating that no person may, without a permit issued by the responsible heritage resources authority, destroy, damage, excavate, alter, deface, disturb, remove from its original position, collect, own, trade in, sell for private gain or export original rock paintings or engravings that are more than 100 years old. Although it might be difficult to bring offenders to justice, the advantage of the permit system is that heritage resources authorities are able to stipulate conditions to permits, and will receive a report on the activities of the permit holder. These reports provide information on the distribution, quality and condition of rock art sites. They enable authorities to guide, monitor and evaluate research and conservation activities and to correct mistakes.

2. Section 29 provides for places of special significance to be declared as Provincial or National Heritage Sites. As part of the process, the heritage resources authorities can call for conservation management plans for declared sites that are open to the public. With the implementation of the Act in 2000, all previously declared national monuments automatically became Provincial Heritage Sites. Twelve of the approximately 4000 former national monuments were declared for the significance of their rock art (Table B9.2). If images of rock art from a declared National or Provincial Heritage Site are used by anyone other than the landowner for commercial purposes (e.g. advertising), a permit is required from the South African Heritage Resources Agency (SAHRA) or the provincial heritage resources authority to ensure that the images are used in a sensitive manner and do not denigrate the significance of the original.

3. Section 38 requires impact assessments that might be followed by mitigation or 'rescue' of sites threatened by development. Prosecution can be considered only when there is evidence of sites having been destroyed without an impact assessment being undertaken.

Lessons learned

Almost all permits relating to rock art over the past 70 years have been issued to professional archaeologists for the removal of paintings or engravings to museums when they are unavoidably threatened by development such as dam construction or mining; for the removal of graffiti at rock art sites; and for the removal of small samples of paint for dating or other types of analysis. In KwaZulu-Natal, a few permits have been issued for tracing since the implementation of the relevant provincial legislation.

There have been very few prosecutions for damage to rock art sites since South Africa's first national heritage legislation was enacted in 1911, but it is difficult to gauge whether we would have had the same level of petty vandalism if the law had not been in place. It is certain nevertheless that the wholesale removal and export of rock art was successfully halted. Many rock art sites would also have been destroyed during large commercial projects, such as dam and road building, if the law had not been in place. In this sense, then, legislation has been of great assistance in conserving rock art.

As the legislation is framed around the concept of protecting the setting, integrity and original fabric of rock art, we can stop people from 'touching up' faded paintings. However, there is no legislation to prevent them from creating their own 'new' rock art inspired by the old. Essentially, rock art can be copied as long as the method does not destroy, damage, alter or remove the original. Permits are therefore needed to make casts of engravings and to trace on surfaces that are fragile. In all cases, copyright rests with the photographer or artist/copier. We might cringe at the crude copies painted onto slate and sold at tourist shops but, more seriously, there is no legislation to prevent or control those who create

Date	Legislation	Results
1911	The Bushman-Relics Protection Act protected rock art and the contents of the graves, caves, rock shelters, middens or shell-mounds of 'the South African Bushmen or other aboriginals' for the first time from damage or destruction. A permit was required from the Minister of the Interior for the export of all 'Bushman-relics' from the country (Deacon & Pistorius 1996).	Successfully limited the removal and export of rock engravings and rock paintings.
1923	The Natural and Historical Monuments Act established the Commission for the Preservation of Natural and Historical Monuments of the Union. It was charged, amongst other tasks, with compiling a register of places of aesthetic, historical or scientific value, including 'Bushman paintings'.	A short list of sites was drawn up and published (Van Riet Lowe 1941) but has never been updated.
1934	The Natural and Historical Monuments, Relics and Antiques Act broadened the range of heritage resources to be protected and established a permanent Secretariat for the Historical Monuments Commission.	About 300 sites were declared as national monuments (including three with rock art). Notice boards at selected sites informed visitors that the art was protected. A general policy was adopted to limit public access to rock art sites by not publicising their location. The purpose was to protect them from vandalism and although partly successful, it possibly contributed to public ignorance. Amongst others, Patricia Vinnicombe's project to copy paintings in the Drakensberg was supported (Vinnicombe 1976).
1969	The National Monuments Act was promulgated and the National Monuments Council (NMC) was established.	More than 3000 sites, mostly buildings but including nine more rock art sites, were declared national monuments. The NMC was a partner in a Council for Scientific and Industrial Research project to research rock art conservation methods in the 1970s (Rudner 1989). By the 1990s, a high rate of vandalism was noted at sites with unsupervised public access. Pamphlets and posters for public awareness of rock art legislation were distributed. Rock art management plans were developed for sites open to the public. Graffiti removal techniques were tested, mainly in the Western Cape (Deacon 1996). Following closure of the Archaeological Data Recording Centre at the South African Museum, the NMC and practitioners decided in 1980 to send rock art and other archaeological site location information to one of four museums according to the provinces that existed at the time (Cape Province: South African Museum, Cape Town; Orange Free State: National Museum, Bloemfontein; Natal: Natal Museum, Pietermaritzburg; Transvaal: National Cultural History Museum, Pretoria).
1998	Legislation that established Amafa aKwaZulu-Natali, the provincial heritage resources authority in KwaZulu-Natal, was published in 1998, a year before the National Heritage Resources (NHRA).	An additional clause makes it necessary for a permit to be obtained before rock paintings can be traced or casts made of rock engravings.
2000	The NHRA established SAHRA and devolved management of rock art to provincial heritage resources authorities.	Provincial Acts and Regulations that refer specifically to rock art have been promulgated in KwaZulu-Natal and the Western Cape, but not as yet in other provinces. SAHRA Regulations specify protection of rock paintings during excavation and request conservation management plans for sites open to the public. Guidelines have been developed. A national inventory of all heritage sites is being developed by SAHRA.

new paintings or engravings at sites where there are no originals, or where no heritage protection exists. This is difficult to legislate for because it requires conservation of the original intention of the art – the intangible part of the heritage – as well as the tangible art itself. This impacts in turn on the essence of copyright laws that have time limits and allow for inexact copies to be made as long as the originals are acknowledged.

In summary, some might argue that tighter legislation has made it more difficult for researchers to operate and that the bureaucracy limits conservation opportunities.

On the other hand, it does ensure that those who have not been trained and have therefore not been given permits are not allowed to take paint samples, move rock engravings into their home or make multiple casts of engravings.

Conclusion

The proven advantage of legislation for rock art conservation is that it specifies the responsibilities of the heritage authority, giving it the mandate to appoint staff and set parameters for implementing the law. Without such a mandate, South African Heritage Resources Association (SAHRA) and the provincial heritage resources authorities would not be able to budget for public funds and spend resources on conservation, public education or research, and would have no law enforcement capabilities.

The successful implementation of conservation measures nevertheless still rests with rock art professionals whose experience and research informs the authorities whenever the law is updated.

TABLE B9.2. ROCK ART SITES IN SOUTH AFRICA DECLARED AS NATIONAL MONUMENTS

Historical Monuments Commission 1936–43

Stowlands-on-Vaal	Free State	1936
Modderpoort	Free State	1936
Ventershoek	Free State	1936
Nooitgedacht	Northern Cape	1936
Schaapplaats	Free State	1937
Bosworth	North West	1940
Driekopseiland	Northern Cape	1943

National Monuments Council 1969–99

Kalkoenkrans	Free State	1969
Redan	Gauteng	1970
Mpongweni	KwaZulu-Natal	1979
Tandjesberg	Free State	1992
Collingham	KwaZulu-Natal	1996

Note: Sites declared as national monuments by the Historical Monuments Commission and the National Monuments Council are now Provincial Heritage Sites (Deacon 1993). Sites are listed with their current province and year of declaration.

REFERENCES

Deacon, J. 1993. Archaeological sites as national monuments in South Africa: a review of sites declared since 1936. *South African Historical Journal* 29: 118–131.

Deacon, J. 1996. Case studies of conservation practice at archaeological and palaeontological sites. In: Deacon, J. (ed.) *Monuments and Sites South Africa*: 53–70. Colombo: ICOMOS.

Deacon, J. & Pistorius, P. 1996. Introduction and historical background to the conservation of monuments and sites in South Africa. In: Deacon, J. (ed.) *Monuments and Sites South Africa*: 1–8. Colombo: ICOMOS.

Rudner, I. 1989. *The Conservation of Rock Art in South Africa*. Cape Town: National Monuments Council.

Van Riet Lowe, C. 1941. *Prehistoric Art in South Africa: An Explanation of a Map and Index of Sites Showing the Distribution of Prehistoric Rock Engravings and Paintings in the Union of South Africa*. Pretoria: Department of the Interior, Bureau of Archaeology, Archaeological Series 5.

Vinnicombe, P. 1976. *People of the Eland: Rock Paintings of the Drakensberg Bushmen as a Reflection of their Life and Thought*. Pietermaritzburg: Natal University Press.

represent their fathers and yet are integral components of their husbands' homesteads. The strict exogamy of Nguni marriage sharply emphasises their ambiguity. Wives are clan strangers and regarded with suspicion on a cosmological level: "You simply come to kill us," a man's ancestors might ask of his wife's, "Who are you?" (Webb & Wright 1986: 320). And yet, his wife provides the material from which his ancestors mould his children, and the place in which they do it. It is this creative potential that men struggle to accumulate, but it comes with risk. It exposes the homestead to danger – potentially a wife can plan against the homestead, from deep within it. Wives are therefore watched and carefully controlled (Ngubane 1977: chapter 5; Hammond-Tooke 1993; cf. Guy 1987).

The control mechanisms include *inhlonipho* (respect), an institution of formalised speech and behaviour by which people avoid reference to or inappropriate contact with others. The principle applies to all people, but women especially suffer its burden because they live in their husband's homestead after marriage. The rules imposed by *inhlonipho* are most restrictive for new wives. They are gradually (but never completely) relaxed as women age (and especially after menopause) and become trusted members of the homestead (Krige 1962).

Pollution beliefs are more directly related to ambiguity. Pollution is most strongly associated with birth, when a wife's creative potential is fully realised, and with death, which is birth reversed. Consequently, other expressions of creative potential such as menstruation, pubescence and sexual intercourse are also polluting (as are, by extension, all ambiguous circumstances and entities). Pollution is commonly conceptualised as heat and (among the Zulu) as darkness. Contamination can be inadvertent and people always take steps to ensure that they are ritually pure before embarking on activities related in any way to the creative process. Contamination renders people and things (livestock, crops) vulnerable to bad luck and sickness, most notably in terms of productive and reproductive success. In other words, pollution beliefs make uncontrolled creative potential a danger to this success. They provide a rationale for the control of people who carry that potential (Ngubane 1977: chapter 5; Hammond-Tooke 1981; cf. Guy 1987).

The diviner's role offers a niche within this ideological framework for people who do not fit into normative social categories, or who are dissatisfied with their assigned roles and might, therefore, challenge social order. Not surprisingly,

the "overwhelming majority" of Nguni diviners are women (Berglund 1976: 136). Significantly, Hammond-Tooke (1989: 116) found many of them to be "impressive", with a "keen intelligence and a well-developed sense of humour". For the same reason, divination provides a role for men who do not conform to accepted definitions of maleness (Ngubane 1977; Hammond-Tooke 1989), and for other ambiguous figures such as hunter-gatherers (Jolly 2000: 85). The diviner's role captures and tames their dangerous ambiguity and places it at the interface of the ancestral and ordinary worlds in the service of the dominant ideology.

This same ideological framework probably generated the distinctive, mediumistic character of Nguni divination. Conceptually, the diviner as spirit medium (Hammond-Tooke 1998) resembles Ngubane's (1977) metaphor of women in childbirth as channels to the ancestral world. From a social perspective, ecstatic religious cults tend to emerge in disempowered sections of society. Certain kinds of ecstatic cults are used by women as a strategy to achieve goals that are normally unreachable. The cults deflect attention from individual motivation towards spiritual forces (Lewis 1971), in our case the ancestors. And indeed, female diviners are able to acquire a prestige and wealth that they would not otherwise attain. It seems entirely possible that San individuals exploited the profession for the same purpose.

The ancestors select diviners. Their call brings dreams and inner turmoil, discomfort and pain to the novice, which she (or he) seeks to cure or at least make manageable during training. The curing includes medicinal treatment and a dance during which the novice confesses her dreams. The novice dances alone to a clapping audience, leaps up and down and 'quivers' her body. The dance is peculiar to diviners. Its form is unusual (see Berglund 1976: 153, for the Zulu; Hammond-Tooke 1998) and it evidently contains elements of the San trance dance. Diviners originally adopted it probably because its ecstatic character meshed usefully with mediumistic divination (Hammond-Tooke 1998). Most probably, this attribute is also responsible for its widespread adoption in the Nguni world.

Few diviners admit to being unable to assist people, and most will rely to some extent on whatever resources are available in making diagnoses. The resources can include non-local understandings of the world and even different belief systems (Berglund 1976: 21–24, 172–173). Credo Mutwa was a notable example in a very different context.

Adding elements from elsewhere, filtered through an appropriate sieve, very likely provokes awe and respect for diagnoses. In this sense, diviners are *bricoleurs* (Prins 1996).

It seems inconceivable, then, that diviners of San descent, or those simply possessing knowledge of San belief and practice, would not employ elements from the San cosmos in their work. This was probably the key mechanism by which aspects of San belief, knowledge and ritual were incorporated into the Nguni world view. I argue that this altered cosmos more than just reflects integration on the ground. It was a necessary device to accommodate the incorporation of people of San descent into farming society, as wives, hunting colleagues and diviners. Just as the farmers' social world expanded to encompass new and different people, so their world view had to follow.

Rainmaking

Rainmaking was an interaction arena in which some archaeologists believe hunter-gatherers wielded considerable power. Interpretations draw heavily on southern Nguni data. The San, some argue, were "rainmakers without equal". Their skill was "an obvious advantage over the agrarian Cape Nguni-speaking groups and gave them a ritual niche that also had political and economic advantages" (Blundell 2004: 65). Dowson (1995: 60), following Campbell (1987: 44), went so far as to claim that San rainmaker shamans "had (ideological) control over the farmers' economy", derived from their authority as autochthons and owners of the land (Dowson 1995: 95). Their work was facilitated by subcontinent-wide beliefs about snakes and the rain (Dowson 1998: 75–77, 80). Jolly (1998: 258–263) considers this same set of beliefs to be evidence for San acculturation by Nguni and Sotho farmers.

But, as we have already seen, San autochthony did not translate into a prestigious authority among Nguni farmers. Rather, the archaeological and historical data indicate that the San were asocial beings who posed a threat to society. To what extent, then, were San and Nguni rainmaking compatible? In answering, I start with a description of Nguni rainmaking practice.

Rain comes from God. Various things can affect its falling, but it was made at the same time as everything else. God has a "haphazard way of acting" that inspires fearful respect (Berglund 1976: 42). Rain can be equally unpredictable. It has the power to destroy and to create life. This capacity associates it closely with chiefs and kings, who

similarly have power over life and death. The same principle applies in watered-down form at lower levels of authority. A homestead head, for instance, is closely identified with the virility and dangerous unpredictability of the bull at the head of his herd (Poland *et al.* 2003). The shared dangerous unpredictability of God, rain, chiefs, homestead heads and bulls indicates an ideological relationship to fertility that resonates at every level of the social and political hierarchy.

Chiefs are responsible for procuring rain, just as they are responsible for the timing of other activities of the annual cycle (Hunter 1961; Sansom 1974; Berglund 1976). The actual work of making rain was usually given to specialists who, under normal circumstances, had no claim to political power. Generally, it was an inherited profession, almost in a genetic sense, and therefore associated with particular clans. Rainmaking was similar in this respect to other specialisations, such as iron production or preparing the dead chief for burial (Hunter 1961: 80; Berglund 1976; cf. Hammond-Tooke 1993).

Hunter (1961: 79–84) provides a useful account of rainmaking. Typically, men of particular clans approach an Mpondo chief to ask for rain. The delegation calls out praises and appeals for rain to the chief's ancestors as it approaches his homestead. This appeal alone might bring the rain. If it does not, the chief turns to a specialist rainmaker. Many prominent Mpondo rainmakers have come from the Yalo clan. The chief sends a black beast with "special men" who know the customs of the rainmaker's clan, to ask that he go to work. The animal's colour symbolises the darkness of rain clouds (Hammond-Tooke 1993, 1998).

The beast is slaughtered at the rainmaker's place and eaten. The rainmaker smears the animal's fat on his ox-hide robe (alternatively, the hide of the slaughtered beast) and wraps it around himself. He goes to "his pool" and lies all night on a rock projecting out of the water (alternatively, he waits in a hut in his homestead). During the night a mist covers the pool and the water rises. A great snake emerges and licks the fat on the hide. The water subsides and rain starts falling. In one account the snake is identified as an *intlantu* (python – Zandile Mbhele pers. comm. 2007). It is not an ancestor-snake (Hunter 1961: 83).

Berglund (1976: 55–56) recorded the same account for the Zulu, though with some important additional details. Instead of a beast, a fat black sheep or goat was provided for slaughter. Berglund's informants emphasised both the importance of the animal's fatness – "only fatness will bring

rain" – and the need for quietness; in the case of a goat, the animal's mouth is held closed to prevent it bleating. Both requirements point clearly to the preferred outcome, that is, a gentle, soaking rain that brings health and well-being to the land. The snake that emerges from a "very deep pool" is a python. Once it has licked the fat off the skin, it lies next to the rainmaker on his four rain-medicine horns, before soundlessly disappearing again. In the morning, the rainmaker makes rain beside the river, causing a mist to rise. The mist becomes clouds and rain falls.

Pythons are potent symbols of fertility. Males are believed to fertilise females with their spit and python spittle is considered effective in the treatment of infertility. Doctors (izinyanga) collect it from the bodies of animals 'rescued' from ingestion by pythons (Berglund 1976: 140). It is like semen, and the rain which fertilises the earth. I suspect that one of the reasons the rainmaker engineers his encounter with the python is to collect the spittle it leaves on the hide for his rain medicine.

These ideas about pythons are drawn from life. Pythons are most active at night. They enjoy water and will frequently stay submerged for long periods in deep pools. Females stay with their eggs until they hatch, incubating them by coiling themselves around the clutch. They lay 30–100 eggs, each about ten centimetres in diameter; most other oviparous snakes for which figures are known lay fewer than ten (Marais 2004).

Pythons are also regarded as the coldest of all animals, both literally and in terms of their demeanour. As is well known, rainmakers make every effort to retain the potency of rain medicines by keeping them cool. Sometimes pythons will visit a rainmaker's homestead to lie on and cool the rain medicine (Berglund 1976: 53–63). The python does the same at the pool. Cooling the rainmaker is critical. His attempt to make rain would fail if he were 'hot' because of recent contact with or participation in a polluting situation. Indeed, pollution is the primary cause of drought (Hunter 1961: 82; Berglund 1976: 58–60; Hammond-Tooke 1981).

It is worth noting here the emphasis given in the ethnography to the rainmaking taboo regimen, and to the sacrifice of an animal of a single (unambiguous) colour (Hunter 1961; Berglund 1976). The python provides the final cleansing step. Strictly speaking then, the encounters with the python are concerned with the effectiveness of the rainmaker and his medicines, rather than with the actual act of rainmaking.

Berglund's informant declined to say how he made rain at the poolside, but provided the following details in a different context. The medicine is stored in four horns, two male and two female. In a cool quiet place, either in his homestead or elsewhere, the rainmaker pours male medicine into the female part of a firestick kit and dips the male firestick into the female medicine. The sexual symbolism is unmistakeable and the heat generated by the firesticks is like the heat of sexual intercourse. For this reason, rainmakers are necessarily married.

As the rainmaker works, he calls out praises to the royal ancestors and to God, asking for rain. God here is called Nsondo, a name which refers to the cyclical repetition of good things (Berglund 1976: 36, 55). When the fire is going, the rainmaker adds green branches to generate black smoke, which rises and becomes rain clouds. A name given to the preferred branches (Cassia occidentalis)[2] translates as 'egg of a snake', an obvious reference to the python's extraordinary fecundity.

This rite, or elaborations of aspects of it, was and still is widespread among Bantu speakers in South Africa. Rainmaking rituals in more centralised polities are typically more elaborate, involving public praise of the chief and his ancestors and deployment of state resources (e.g. Webb & Wright 1986: 115–116). Also, the locus of rainmaking is commonly shifted to the chief's homestead, though his personal identification with any failure is buffered by the complexity of the process and the variety of resources (originally dependent on the size of the chiefdom) he controls (e.g. Junod 1962: 320–323, 350; Krige 1962: 319–320; Mönnig 1967: 157; Webb & Wright 1982: 136; Schapera 1984: 60).

San rainmakers in an Nguni world

Southern San rain shamans dreamed rain or made rain in trance, where they captured a rain animal and led it to drought-stricken areas, or cut or killed it and distributed its meat so that its blood and milk became rain. Rain animals seem to have been somewhat idiosyncratic in form and painted depictions have bovine-, hippo- or snake-like features. They lived in water holes. The males were especially fierce; similarly, male rain was fierce, with strong winds and thunder and lightning, while gentle, soaking rains were considered female (Vinnicombe 1976; Dowson 1998; Hollmann 2004: 163–196). It is conceivable that the ritual was sometimes acted out with a real animal (Lewis-Williams

1981: 105) and perhaps rainmaking was conceptually similar to the distribution of hunted meat. Evidently, only men could become rain shamans. The skill and knowledge required for hunting rain animals ensured that rain shamans were older men (Hollmann 2004: 130). They learnt their skills through apprenticeships (Vinnicombe 1976: 334), which suggests the role was open to any man with the required attributes.

Differences between the two rainmaking systems include, first, that rain's gendered associations in Nguni belief are the reverse of those of the Southern San, with female rain being the more feared (Berglund 1976). Secondly, the rain animal and Nguni python are different kinds of creatures, as should be clear from my brief survey. Thirdly, the distribution of rain by the Southern San rain shaman is somewhat akin to the distribution of largesse by an Nguni chief in the sense that it represents his control of production and reproduction. By contrast, praise of chiefs was a central feature of the Nguni rainmaker's work.

One could argue that these differences would not have mattered. That, however, could have been true only for Iron Age communities with limited political stratification, where rainmakers operated on their own at a distance from the chief's homestead. But even in such communities, the essence of the San – their ambiguity, their inherently polluting nature – would have posed a greater problem.

And yet there is evidence showing that some San rainmakers worked for some southern Nguni chiefs (e.g. Jolly 1986; Prins 1990, 1996). Clearly, chiefs could have requested the services of San rainmakers for various idiosyncratic reasons, but such arbitrary choices are unlikely to have embedded the San as rainmakers in the thinking of some southern Nguni people. Rainmaking is not an isolated event, but is part of the annual cycle of agricultural activities. Rainmakers have work to do during the course of the cycle's turning, and are an integral part of farming society (Berglund 1976; cf. Murimbika 2006; Schoeman 2006).[3]

Looking within Nguni society is instructive. Nguni women can become rainmakers, most appropriately, because they "see the children crying" (Ntombifuthi Mkhize pers. comm. 2007), and two of Berglund's three rainmaker informants were women. Importantly, both were married and highly respected. Significantly, both were midwives (Berglund 1976). Midwives are always older women, past childbearing age and largely free of the gender-related ambiguity (and therefore pollution) associated with younger women (Krige 1962).

San rainmakers, then, must have been somehow socialised. I suggest that their socialisation was a product of the altered cosmology that emerged from the thinking of diviners with knowledge of San belief. Particularly important here was the transformation of animals of potency into divinatory animals. The creation of these "extra-societal" ancestors "allowed for the incorporation of Nature as well as Culture … into the diviners' cognitive system and practice" (Hammond-Tooke 1999: 130). Not surprisingly, divinatory animals are commonly associated with the San (Prins 1996). I suggest that in the past they provided some San groups with an ancestral body, giving them a clan-like identity. This new identity made possible the employment of some San rainmakers by Nguni chiefs.

As Hammond-Tooke and Prins have shown, there was no *en bloc* borrowing of the San world view. Instead, elements of it were adopted in modified form so that they were consistent with farmer belief. We should expect that this kind of filtered adoption also applied to practice, and this seems to have been the case in rainmaking.

In the 1800s, for instance, the Mpondomise sent cattle to San rainmakers "as an application for rain". The cattle were clearly sent for the ritual, because the rainmakers had the right to a small share of the harvest in return for their work (*Report and Proceedings* 1883, II: 409). Towards the end of that century, San rainmakers lived in a homestead among the Mpondomise. And in the early twentieth century, the San rainmaker, Lindiso of Tsolo, was an accepted member of Mpondomise society and married to an Mfengu woman (Prins 1990, 1994).

More recently, the rainmaker Bhidi of Tabankulu would submerge himself in a river, be smeared with pig fat, and retire to his hut (Prins 1990). It is tempting to interpret this as a cleansing (cooling) of pollution and a visit to the spirit world through the hut. Huts and pools, of course, are identified with the womb (Berglund 1976). After his death, Bhidi's descendants were sometimes forcibly dunked in the river in an effort to make rain, despite them not having any rainmaking knowledge (Prins 1990). Their treatment possibly reflects the Nguni expectation that rainmaking abilities are transmitted through descent. Alternatively, it was perhaps an attempt to treat the polluting ambiguity of their San ancestry.

The recent testimony of Nthini and Willie Slamulela is especially interesting. The brothers are San descendants, both genetically and in terms of identity. Years ago their

▲ **Figure 8.2**
Grassland at Mgoduyanuka in the upper
Thukela Basin. Photo : Natal Museum.

in another the eland is a representative of !Khwa (Lewis-Williams 1981; Hollmann 2004). Whatever the case, the rite is interpretable by farmers as consistent with their own tradition.

From this broad outline it is clear that the classification of the San as asocial beings set limits on the kinds of roles they could play in Nguni society. The requirements of divination and rainmaking differ: whereas divination depends upon and provides a haven for the ambiguity of its practitioners, this quality is counter-productive for rainmaking. It is also clear that rainmaking was an integral part of the farming economy. Nguni farmers did not concede ideological control of their economy to the San. To work for farmers, San rainmakers had to become social beings. This suggests a relative chronology. San groups were first incorporated into farming society as clan-like entities, primarily through the work of diviners. Specialists such as rainmakers were then able to practise as integral members of farming society. In the next section I focus on the socio-economic context of these developments.

Raiding and hunting

The nineteenth century resistance to colonisation by San in southern Natal and the eastern Cape is well documented (Wright 1971; Vinnicombe 1976). From early in the century San groups were involved in hunting, trading, raiding and a struggle for survival in the Drakensberg and surrounding areas. Their documentary life is brief, a mere 50 years, and by 1880 most San had lost all independence in the face of crushing colonial pressure. The story of Dumisa kaMvenya captures some of the essence of this period.

Dumisa was apparently dispossessed of his land and cattle during the early years of the Zulu Kingdom. He wandered about southern Natal and eventually sought permission from Fodo kaNombewu, an Nhlangwini chief in the middle Mkhomazi Valley, to use local San hunters to procure elephant ivory for trade to white settlers at Port Natal (Bryant 1929; Vinnicombe 1976). Fodo was apparently not a hunter, so these same San could have supplied him with the crane feathers and genet and blue (samango) monkey skins that he paid as tribute to the Zulu king Dingane (Webb & Wright 1986: 8). No doubt Fodo also benefited from the ivory trade.

father led a small group of San and Bantu speakers from Lesotho down Sani Pass. They lived sporadically at Good Hope Shelter before settling in Stepmore Location in the upper Mkhomazi Valley. Nthini and Willie's father evidently made rain by burning a mixture of eland urine and fat with various water-loving plants. The smoke that rose became rain clouds. Similar data were recorded in the Kamberg area from Duma informants, who also claim San ancestry (Frans Prins pers. comm. 2007; see later).

There are a few ways of looking at the Slamulela and Duma data. /Xam women apparently burnt antelope (eland?) horns to divert the rain's anger (Lewis-Williams & Pearce 2004), but this rite was not rainmaking. Instead, it was related to the fraught relationship between pubescent girls and !Khwa, a powerful masculine personification of rain (Hollmann 2004; cf. Lewis-Williams 1981). It is also possible that Prins's informants are referring to the use of medicinal smoke to enter trance to make rain (cf. Lewis-Williams & Pearce 2004: 210). It is at least as likely, considering the context, that the rite was a blend of Nguni rainmaking practice and San beliefs about the rain and eland. In one sense the eland is rain (a rain animal),

According to one of Stuart's informants, the:

> Bushmen used to kill elephants, eat them, and leave the horns. These horns Dumisa used to pick up and collect, and barter to the Boers. Dumisa was in league with the Bushmen who, when they had killed an elephant, would remain there and eat it till they finished it. Then they would go off and kill another big wild beast (buffalo or *eland*) and there halt till that beast was finished. (Mabonsa kaSidhlayi in Webb & Wright 1979: 34; italics recorded in Zulu)

Besides linking Dumisa and San hunters to the ivory trade, this statement reveals a perception of San life identical to that of Callaway's informant: "Their village is where they kill game."

Dumisa's success in trade earned him a following which included a number of San, the descendants of whom today claim membership of the Duma clan (Frans Prins pers. comm. 2007). Dumisa ultimately fell out with the San and left the area to settle closer to the coast near Umzinto, where the colonial authorities recognised him as a chief. In the 1860s, he and his followers were relocated by Shepstone to the upper Mkhomazi Valley near the Mpendle Location. It is presumably from here that Dumisa – an astute choice – was involved in hunting the San and wild animals on behalf of the colonial authorities, clearing the way for white settlement (Bryant 1929; Vinnicombe 1976; Webb & Wright 1976: 276; Guy 2007).

This kind of relationship – the sale of labour and products – is the sort of interaction that Mazel (2004) suggests existed in the second millennium AD. Callaway's informant also labels the San as elephant hunters, but the scale and degree of specialisation of this work was directly related to the integration of the region in the world economy. In smaller-scale economies, Iron Age farmers often got over 90 per cent of their meat from domestic animals. On occasion they hunted (Plug & Brown 1982). The significance of trade in hunted produce would then have been in the opportunities it provided for contact between hunter-gatherers and farmers.

From the 1840s, two San groups living on the south-eastern side of the mountains stand out in the documentary evidence, one led by Mdwebo and the other by Nqabayo. They ranged with relative autonomy from the headwaters of the Mkhomazi to those of the Tsitsa, far to the south. Both groups included Bantu speakers and were in contact with farmers. This was also true of the first Drakensberg San group to enter the documentary record, encountered by Andrew Geddes Bain on the Mzimvubu River in 1829. Further, Mdwebo's name is apparently of Nguni origin and he was reputedly related to the Mpondomise chief Mandela, while Nqabayo's group included rainmakers (Wright 1971, 2007; Vinnicombe 1976; Jolly 1996b; Blundell 2004). It seems likely that these and other San groups in the region were already, at the beginning of the nineteenth century, incorporated into farming societies in the way envisaged earlier. Certainly, chiefs at times frustrated colonial attempts to rein in San rustlers; instead, they admired and "subtly" encouraged them (*Report and Proceedings* 1883, I: 279).

Data indicating a greater time-depth for this relationship are limited. Rock shelters contain paintings and have yielded sherds and other material generally associated with farmers, but there are no data from Late Iron Age sites east of the Drakensberg suggesting any kind of interaction with the San.

Links between archaeological and oral data are nevertheless suggestive. The post-1650/1700 Nqabeni facies is best known from the grasslands of the Thukela Basin, around the village of Bergville (Figure 8.2). Extensive dolerite intrusions provide soils suitable for cultivation, but the grasslands are of mixed palatability. This would have placed limits on the accumulation of cattle. The settlement unit here was simple, consisting of a stone- or earthwalled livestock pen, surrounded by a residential area containing houses and stone grain-basket platforms. Features of the residential area are generally ephemeral and poorly preserved, but rock engravings of settlement patterns complement and add to archaeological data. Larger sites are indicated by two or more livestock pens in a line along the slope contour. Differences in site size suggest limited political stratification (Maggs 1982, 1988; Maggs *et al.* 1986), with perhaps only two levels: homestead and district head. Similar stone- and earthwalled sites occur in the upper Mkhomazi Valley (Maggs *et al.* 1982) (Figure 8.3).

The Thukela Basin sites were most likely occupied by Zizi people, a section of a larger Dlamini clan (Maggs 1982). Other Dlamini peoples in this area, and south into the Mkhomazi Basin, include the Bhele, Nhlangwini and Tolo. The latter two groups had a reputation as rainmakers; tradition has it that the daughter of a Tolo rainmaker was

▲ **Figure 8.3**

Stonewalled site in the upper Mkhomazi Valley. Photo : Natal Museum.

mother of the Yalo clan, rainmakers of Mpondo chiefs (Bryant 1929; Berglund 1976; Webb & Wright 1979, 1982; Wright & Mazel 2007). Also, the Tolo and Zizi, who were closest to the Drakensberg, had a history of close interaction with the San, such that "we need not be astonished at the marked traces of Bushman blood and Bushman features prevalent among the members of [the Zizi] clan" (Bryant 1929: 355, 358). Such interaction should probably be expected at the farming frontier, far from areas of significant agricultural productivity and political centralisation (Maggs 1976: 307).

According to Bryant, conflict early in the 1700s over the distribution of an eland carcase caused a section of the Zizi to cross the Drakensberg into the southern highveld, where they settled along the Wilge River. There they were influenced by Sotho speakers and became the Phuthi. In the late 1700s, conflict over an eland carcase again resulted in a move for the Phuthi, this time south towards the Caledon River. Bryant (1929: 359) writes as if this was a common source of dispute: "the essential quarrel arose – as usual, over an eland carcase." The eland is obviously metaphorical, but its choice suggests that the San influence on the Zizi was considerable. The wild animal most intimately associated

with the San had come to symbolise key resources for the Zizi and related peoples. This eland symbol very likely contains, in reworked form, the polysemy of the San eland central symbol (cf. Lewis-Williams 1981).

Other Zizi offshoots, the Phetla and Polane, had apparently crossed the Drakensberg even earlier. Pottery in Driel and iNkolimahashi shelters in the Thukela Basin (Figures 8.1 and 8.4) provides support for connections across the Drakensberg (Maggs & Ward 1980; Mazel 1999). The iNkolimahashi sherds (Figure 8.5) were sandwiched between layers with Moor Park dates (1300–1650/1700). At both sites, the pottery resembles that of the Free State Fokeng cluster. If not of Fokeng origin, the iNkolimahashi sherds could represent an as-yet-unidentified line out of Blackburn in KwaZulu-Natal. Such a facies could be ancestral to Nqabeni, which is not easily derived from Moor Park (Huffman 2007: 444).

The nature of deposits at iNkolimahashi suggests that farmers occupied the shelter occasionally during Moor Park times (Mazel 1999, 2004). For the same reason, Mazel (1997) considers Mzinyashana Shelter in the grasslands near Dundee (Figure 8.6) to have been occupied by farmers. This site contains Moor Park ceramics, in this case from layers with Moor Park dates. This period is of special interest because it coincides with the onset of the Little Ice Age, when temperatures plummeted worldwide.

The annual rings of a yellowwood (*Podocarpus falcatus*) felled in the Karkloof Forest in 1916 reflect the impact of the Little Ice Age (Figure 8.7). Growth rates were low from 1360 to 1540, but then increased towards 1600. Growth rates were rather higher in the 1600s, but returned to almost pre-1540 rates in the 1700s (Vogel *et al.* 2001; cf. Hall 1976) (re-analysis shows that the period 1220–1360 is hidden by scarring). The tree is a single-point reading, but the general pattern is backed by other data (Tyson *et al.* 2000).

Agricultural productivity must have been affected in a similar way. Indeed, the severity of the crisis is indicated by the situation of Moor Park sites in the grasslands, on steep-sided, defendable hilltops or spurs (Davies 1974; Maggs 1980; Whitelaw 2004) (Figure 8.8). These are rocky, uncomfortable places to live, often far from arable land and water. Their choice strongly suggests that Moor Park people lived in fear of raiding bands. One of the principal ways of resolving tension was to move away from it, so this social stress was possibly the motor that originally drove

Nguni farmers from the wooded lowlands. They did not escape the crisis.

The Moor Park hilltop sites possibly represent men with some degree of wealth and power. Perhaps they raided each other for livestock, women and grain. More desperate, destitute people might have lived off the land in temporary camps and rock shelters such as Mzinyashana and, perhaps, iNkolimahashi. This was a common survival strategy for impoverished people. Mqaikana kaYenge told James Stuart:

> I was born [around 1830] *in the open country*, i.e. in the veld … There were no kraals in the country at the time owing to Tshaka's wars. There were many wild beasts; these we lived on, especially *buffalo* … also *elephants* … [and] *hippopotamuses* … When a *buffalo* was killed, or an elephant, the men would have their belongings packed and all proceed to where the animal had been killed and there proceed to live for a time, erecting temporary shelters with branches where the dead animal was. And when a report came of another such animal having been killed, others would repair to it in the same way and erect temporary shelters there. (Webb & Wright 1986: 1; italics recorded in Zulu)

Mqaikana gives the impression of a shattered homestead economy in southern Natal. The emergence of states north of the Thukela River had contributed to this, but famine caused by adverse climatic conditions could have a similar impact (e.g. Webb & Wright 1979: 111). Mqaikana's description of life in the 1830s is remarkably similar to the description of San life given by Mpengula, Callaway's informant. This is reinforced by a comment on the Ngwane and Tsonga from another of Stuart's informants:

> At first their huts were like those of the Bushmen. They would stay at one place for a few years and then move off and settle at another. Food was not plentiful. They depended on hunting game. When the numbers of game in one place dwindled they would go on to another. (John Gama in Webb & Wright 1976: 141; italics recorded in Zulu)

Of course, these accounts are not value-free, objective records of the situations described, but that is what is of

Figure 8.4
View up the Mtshezi (Bushman's) River from iNkolimahashi Shelter. Photo: Natal Museum.

Figures 8.5a & b
Ntsuanatsatsi/Makgwareng (Fokeng cluster) or possibly Blackburn sherds from iNkolimahashi Shelter (top) and a Moor Park sherd from Mzinyashana Shelter (bottom).

Figure 8.7
Tree ring-width curve. After Vogel, Fuls and Visser (2001: fig. 4).

▲ **Figure 8.6**
Mzinyashana Shelters 1 and 2. Photo: Natal Museum.

interest. Lifeways of the San and impoverished farmers were perceived to be similar.

I suggest that the harsh conditions of the Little Ice Age encouraged a similar confluence of lifeways. The social barrier that farmers in frontier contexts had constructed between themselves and hunter-gatherers no longer existed. Settled homestead life was no longer a defining attribute. San and Nguni speakers lived off the land and men of both groups found a forum in which they could act together, as hunters and most probably as raiders. Mixed bands of San and impoverished Nguni men probably posed the greatest threat to those in the hilltop homesteads, acting for themselves and in concert with hilltop leaders against others. This was not a transient relationship. The sustained impact of the Little Ice Age allowed for significant integration on the ground, and made necessary the cosmological incorporation described earlier.

Summary and some implications

Nguni speakers encountered San hunter-gatherers and Kalundu Tradition farmers when they settled east of the Drakensberg. As farmers, Kalundu people would have posed the greatest ideological and political threat. For the previous four centuries they had lived, farmed, made rain, mined and smelted on this land, and so established a claim as its owners. Any prestigious role for first people would have been allocated to them. Hunter-gatherers, without cattle and a settled lifestyle, were cast to the lowest rung of the social hierarchy as barely human.

Conflict following the onset of the Little Ice Age drove some Nguni farmers out of the wooded lowlands onto the agriculturally more hostile grasslands. This ecological zone was historically associated with the San, though farmers had perhaps used it as summer pasture (Maggs & Ward 1984), for hunting, and for gathering medicinal substances. Men who had managed to retain their cattle and followers established homesteads in defendable locations on hilltops. Others, impoverished, adopted a hunting and gathering lifestyle. They lived and collaborated and intermarried with San groups, hunting and probably raiding.

This social contact posed a new ideological challenge, because the San had already been constructed as asocial beings. Their ideological reinvention necessarily followed, to legitimise the interaction and mutual support, and to help

Nguni speakers cope with their destitute state. Importantly, it was among people of lower status that San beliefs were first incorporated into Nguni cosmology. Such people, on the margins of social and political power, typically comprise the group that supplies society with diviners, the ritual specialists best placed to modify belief systems. It was through the work of diviners with knowledge of San belief that some San groups were transformed sufficiently into clan-like entities. Some of these entities then became identified with specialist work, such as rainmaking. Others might have worked as herdsmen.

It was almost certainly in this social context that Nguni speakers in the economically marginal grasslands took the polysemous eland symbol to represent key resources. The normative references are more obvious and probably older. The word for eland, *impofu*, also refers to a tan or dun colour (like that of the eland) and to poverty, presumably because of the animal's association with the cattleless, homeless San. These meanings were retained in less marginal areas.

Incorporation did not result in complete assimilation. The difference in status of rainmakers in farmer and hunter-gatherer society suggests one reason for the survival of a hunter-gatherer lifestyle into the nineteenth century. Nguni rainmakers were agents of chiefs. While they were no doubt generally respected, they were excluded from political power and, consequently, from the accumulation of wealth. The slaughter of the black sacrificial animal meant that it contributed nothing to the rainmaker's labour power. This principle extended to incorporate San rainmakers too. They received cattle in "application" for rain, but were paid with grain, a "commodity of equality" (*Report and Proceedings* 1883, II: 409; Jolly 1986: 6; cf. Sansom 1974: 154).

In contrast, rain shamans in San society controlled the productivity of all resources on which people depended; they "exercised more power over more people than other healers", and wielded this power to enhance their status (Campbell 1987; Lewis-Williams & Pearce 2004: 219). They commanded respect and were even feared. Some probably claimed a leadership role (Lewis-Williams & Pearce 2004).

The status of rain shamans would have been even further enhanced by the receipt of applications for rain in the form of domestic animals. Now their specialist work merged with that of shamans of the game; at times of the year dictated by the agricultural cycle they were literally able to control the movements of animals and provide meat

▲▲ **Figure 8.8a**
The Moor Park name site in true grassland southwest of Estcourt.
Photo: Natal Museum.

▲ **Figure 8.8b**
Ntomdadlana Hill, location of a Moor Park site in wooded grassland east of Estcourt. Photo: Natal Museum.

for distribution (Campbell 1987). 'Living in two worlds' allowed rain shamans to exploit social relations on both sides of the economic fence (Prins 1994). More than this, their authority in San society was an ideal position from which to retain a following, and to construct and reinforce an ideology of egalitarianism that masked their status (cf. Lewis-Williams & Pearce 2004). Thus, incorporation "paradoxically ... helped preserve [San] independence" (Campbell 1987: 43).

The cosmological incorporation of the San (but not interaction) was perhaps slowed after climatic conditions ameliorated in the late 1500s. The improved climate meant that people could return to farming, that is, become social again. Their take-up of farming was possibly facilitated by the introduction of maize through Delagoa Bay: iGujwana, a Moor Park site near Estcourt with sixteenth and seventeenth century dates, yielded what looks like a maize grindstone (Natal Museum data). Maize was grown in the Thabazimbi area in the 1600s by Sotho-speaking Madikwe people (Huffman 2006), and there are suggestive data for knowledge and possession of Portuguese imports in the Thukela Basin by the late 1500s (Theal 1898: 326;

Maggs & Miller 1995; Whitelaw 2008). Perhaps maize was one of these.

This complex scenario is based on relatively few data, but it does at least suggest a social and ecological context for early Nguni–San relations that might be tested archaeologically. Most of the current archaeological data come from the Thukela Basin, but the greatest impact of incorporation is today evident much farther south. The settlement and ceramic sequences provide an explanation.

Moor Park settlement layout emphasises the front/back axis (Huffman 2004). Often the effect is enhanced by the narrowness of the hilltop spurs on which sites are located. Houses were located at the back of the settlements, where the hill slopes are steepest and ascents most arduous. Cattle pens and courts were sited in front of the houses. Transverse front walls generally cross the width of the spurs entirely (Davies 1974; Whitelaw 2004) (Figure 8.9). This layout was no doubt a defensive response to the social turmoil of the time.

Huffman (2004) links the Moor Park layout to the modern settlements of Southern Ndebele people, who claim Musi as an ancestral leader. The Musi Nguni cluster

▶ **Figure 8.9**
Ntomdadlana, showing front/back layout.
Map by Gavin Whitelaw and Programme of Geomatics, University of KwaZulu-Natal.

WALLING
HUTS
? STANDS
STONE MOUNDS
COBBLING

0 50 100 M

HUT 15

DOWN

0 20 CM

therefore originated in the Moor Park facies. By contrast, the Zizi and Bhele Dlamini groups of the upper Thukela Basin claim Langa as an ancestral leader (Bryant 1929). People of the Langa Nguni cluster built homesteads with a centre/sides layout (a set of concentric circles) (Huffman 2004), and Nqabeni phase sites associated with the Zizi are indeed organised this way (Maggs 1982, 1988; Maggs *et al.* 1986) (Figure 8.10). The Langa cluster appears to have originated in northern KwaZulu-Natal (Huffman 2004).

Because Nqabeni pottery seems not to be derived from Moor Park, the historical sequence in the upper Thukela Basin is not straightforward. Current evidence indicates that people of the Langa cluster moved from the north-east into the Thukela Basin grasslands between 1500 and 1700, most probably in the 1600s when agricultural conditions improved. Perhaps they introduced maize to

this region; it was certainly cultivated during the 1700s. This interpretation of the archaeological data suggests that the Zizi and other groups such as the Tolo included people of Moor Park descent under Langa leadership, hence their reputation for closeness to the San. The Langa movement was not necessarily a single, coordinated event and it is possible that tension between Moor Park people, early Langa settlers and later arrivals prompted the departure over the mountains of the Phetla and Polane.

Grassland is a relatively more extensive vegetation type south of the Thukela Basin, even reaching the coast in the Transkei. Also, a significant proportion is sourveld – described by sixteenth century Portuguese shipwreck survivors as deserts, devoid of habitation (Theal 1898). Agriculturally favourable wooded areas are relatively restricted and this affected the distribution of Iron Age

▲ **Figure 8.10**

Left: site at Mgoduyanuka with earthwalled enclosures (from Maggs 1982: fig. 12). The earthworks are faced with stone. Right: engraved settlement patterns about 15 km downstream of Mgoduyanuka (from Maggs 1988: fig. 7).

sites (Derricourt 1977; Feely 1986). The region's economic marginality was further enhanced by the absence of significant iron ore bodies (Whitelaw 1991), and it is possible that the resource crisis during the Little Ice Age was especially severe there. Nevertheless, since the southern Nguni ceramic sequence (from Moor Park) seems to continue into recent times, there is greater continuity in the history of people there than in the Thukela Basin. The impact of the San world on the southern Nguni reflects this history.

Acknowledgements

Bronwen van Doornum was a source of knowledge, inspiration and caution throughout the course of this work. I am also especially grateful to Frans Prins and Ntombifuthi Mkhize for their generosity with information and time, as well as Simon Hall, Jeremy Hollmann and David Lewis-Williams. Peter Mitchell, Aron Mazel, Frans Prins, Lyn Wadley and Tom Huffman made comments on drafts. Zandile Mbhele provided key information. Nkululeko Sibetha prepared Figure 8.1. I thank my colleagues at the Natal Museum for the support and space they gave me.

This book honours Patricia Vinnicombe's contribution to southern African archaeology. I dedicate this chapter also to the memory of David Green of Estcourt and Robin Guy of Underberg, who died within a month of each other around Christmas 2007. Both made significant contributions to archaeology in KwaZulu-Natal and I believe this book would have been of interest to them. I would like to believe that the day will come when tragedies such as theirs no longer occur in South Africa.

Notes

1 Note, however, that neither the early dates for Fokeng settlement on the southern highveld nor their original Nguni identity are universally accepted (Vogel & Fuls 1999; Tim Maggs pers. comm. 2008).

2 *Cassia* (now *Senna*) *occidentalis* is a naturalised alien from tropical Central and South America, including Brazil. For the same purpose, Junod (1962) recorded *Cassia* (*Senna*) *petersiana*, which occurs in bushveld areas from a Swaziland/northern Maputaland latitude northwards. *C. occidentalis* is a food plant and serves as a strong laxative and purgative (MacDevette *et al.* 1989; Raintree Nutrition

1996). It is tempting to wonder if it was an early introduction through Delagoa Bay, along with maize.

3 My understanding is that rainmakers are in principle excluded from access to political power, but are not necessarily outsiders (*contra* Hunter 1961: 80, 84). The Mpondo practice that Hunter observed would then have been a consequence of Christianity.

References

Anderson, G. 1997. Archaeological survey on the proposed casino site. Unpublished Cultural Resource Management report for Tongaat Hulett. Natal Museum: Pietermaritzburg.

Barham, L.S. 1992. Let's walk before we run: an appraisal of historical materialist approaches to the Later Stone Age. *South African Archaeological Bulletin* 47: 44–51.

Berglund, A.-I. 1976. *Zulu Thought-Patterns and Symbolism*. Bloomington: Indiana University Press.

Blundell, G. 2004. *Nqabayo's Nomansland: San Rock Art and the Somatic Past*. Uppsala: Uppsala University Press.

Botha, L.J. & Thackeray, J.F. 1987. A note on southern African rock art, medicine-men and Nguni diviners. *South African Archaeological Bulletin* 42: 71–73.

Bourquin, W. 1951. Click-words which Xhosa, Zulu and Sotho have in common. *African Studies* 10(2): 59–81.

Bryant, A.T. 1929. *Olden Times in Zululand and Natal*. London: Longmans.

Cable, C. 1984. A model for terminal Later Stone Age subsistence strategies in southern Natal. In: Hall, M., Avery, G., Avery, D.M., Wilson, M.L. & Humphreys, A.J.B. (eds) *Frontiers: Southern African Archaeology Today*: 167–181. Oxford: British Archaeological Reports, International Series 201.

Callaway, H. 1866. *Izinganekwane, Nensumansumane, Nezindaba zaBantu (Nursery Tales, Traditions, and Histories of the Zulu), Volume 1 (1)*. Pietermaritzburg & London: Davis and Sons & Trübner and Co.

Campbell, C. 1987. Art in crisis: contact period rock art in the south-eastern mountains of southern Africa. Unpublished MSc thesis. Johannesburg: University of the Witwatersrand.

Carter, P.L. 1970. Late Stone Age exploitation patterns in southern Natal. *South African Archaeological Bulletin* 25: 55–58.

Davies, O. 1971. Excavations at Blackburn. *South African Archaeological Bulletin* 26: 165–178.

Davies, O. 1974. Excavations at the walled Early Iron-Age site in Moor Park near Estcourt, Natal. *Annals of the Natal Museum* 22: 289–323.

Davies, O. 1975. Excavations at Shongweni South Cave: the oldest evidence to date for cultigens in southern Africa. *Annals of the Natal Museum* 22: 627–662.

Derricourt, R.M. 1977. *Prehistoric Man in the Ciskei and Transkei*. Cape Town: C. Struik.

Douglas, M. 1966. *Purity and Danger: An Analysis of the Concepts of Pollution and Taboo*. London: Routledge.

Dowson, T.A. 1995. Hunter-gatherers, traders and slaves: the 'mfecane' impact on Bushmen, their ritual and their art. In: Hamilton, C. (ed.) *The Mfecane Aftermath: Reconstructive Debates in Southern African History*: 51–70. Johannesburg: Witwatersrand University Press.

Dowson, T.A. 1998. Rain in Bushman belief, politics and history: the rock-art of rain-making in the south-eastern mountains, southern Africa. In: Chippindale, C. & Taçon, P.S.C. (eds) *The Archaeology of Rock Art*: 73–89. Cambridge: Cambridge University Press.

Ellenberger, D.F. 1912. *History of the Basuto, Ancient and Modern*. London: Caxton.

Feely, J.M. 1986. The distribution of Iron Age farming settlement in Transkei. Unpublished MA thesis. Pietermaritzburg: University of Natal.

Greenfield, H.J. & Van Schalkwyk, L. 2003. Intra-settlement social and economic organization of Early Iron Age farming communities in southern Africa: a view from Ndondondwane. *Azania* 38: 121–137.

Guy, J. 1987. Analysing pre-capitalist societies in southern Africa. *Journal of Southern African Studies* 14: 18–37.

Guy, R. 2007. Underberg District centenary history. Unpublished document.

Hall, M. 1976. Dendrochronology, rainfall and human adaptation in the Late Iron Age of Natal and Zululand. *Annals of the Natal Museum* 22: 693–703.

Hall, M. & Mack, K. 1983. The outline of an eighteenth century economic system in south-east Africa. *Annals of the South African Museum* 91: 163–194.

Hall, M. & Maggs, T. 1979. Nqabeni: a Later Iron Age site in Zululand. *South African Archaeological Society Goodwin Series* 3: 159–176.

Hall, S. 1986. Pastoral adaptations and forager reactions in the eastern Cape. *South African Archaeological Society Goodwin Series* 5: 42–49.

Hall, S. 2000. Forager lithics and early Moloko homesteads in Madikwe. *Natal Museum Journal of Humanities* 12: 33–50.

Hamilton, C. & Wright, J. 1990. The making of the *amalala*: ethnicity, ideology and relations of subordination in a precolonial context. *South African Historical Journal* 22: 3–23.

Hammond-Tooke, W.D. 1981. *Patrolling the Herms: Social Structure, Cosmology and Pollution Concepts in Southern Africa*. 18th Annual Raymond Dart Lecture, Institute for the Study of Man in Africa, 30 April 1980. Johannesburg: Witwatersrand University Press.

Hammond-Tooke, W.D. 1989. *Rituals and Medicines: Indigenous Healing in South Africa*. Johannesburg: A.D. Donker.

Hammond-Tooke, W.D. 1993. *The Roots of Black South Africa*. Johannesburg: Jonathan Ball Publishers.

Hammond-Tooke, W.D. 1997. Whatever happened to /Kaggen?: a note on Khoisan/Cape Nguni borrowing. *South African Archaeological Bulletin* 52: 122–124.

Hammond-Tooke, W.D. 1998. Selective borrowing? The possibility of San shamanistic influence on Southern Bantu divination and healing practices. *South African Archaeological Bulletin* 53: 9–15.

Hammond-Tooke, W.D. 1999. Divinatory animals: further evidence of San/Nguni borrowing? *South African Archaeological Bulletin* 54: 128–132.

Hollmann, J. 2004. *Customs and Beliefs of the /Xam Bushmen*. Johannesburg: Witwatersrand University Press.

Huffman, T.N. 1982. Archaeology and ethnohistory of the African Iron Age. *Annual Review of Anthropology* 11: 133–150.

Huffman, T.N. 2001. The Central Cattle Pattern and interpreting the past. *Southern African Humanities* 13: 19–35.

Huffman, T.N. 2002. Regionality in the Iron Age: the case of the Sotho–Tswana. *Southern African Humanities* 14: 1–22.

Huffman, T.N. 2004. The archaeology of the Nguni past. *Southern African Humanities* 16: 79–111.

Huffman, T.N. 2006. Maize grindstones, *Madikwe* pottery and ochre mining in precolonial South Africa. *Southern African Humanities* 18(2): 51–70.

Huffman, T.N. 2007. *A Handbook to the Iron Age: The Archaeology of Precolonial Farming Societies in Southern Africa*. Pietermaritzburg: University of KwaZulu-Natal Press.

Hunter, M. 1961. *Reaction to Conquest: Effects of Contact with Europeans on the Pondo of South Africa*. London: International African Institute.

Jenkins, T., Zoutendyk, A. & Steinberg, A.G. 1970. Gammaglobulin groups (Gm and Inv) of various southern African populations. *American Journal of Physical Anthropology* 32: 197–218.

Jolles, F. 2005. The origins of the twentieth century Zulu beer vessel styles. *Southern African Humanities* 17: 101–151.

Jolly, P. 1986. A first generation descendant of the Transkei San. *South African Archaeological Bulletin* 41: 6–9.

Jolly, P. 1996a. Interaction between south-eastern San and southern Nguni and Sotho communities *c.* 1400 to *c.* 1880. *South African Historical Journal* 35: 30–61.

Jolly, P. 1996b. Symbiotic interaction between black farmers and the south-eastern San: implications for southern African rock art studies, ethnographic analogy, and hunter-gatherer cultural identity. *Current Anthropology* 37: 277–305.

Jolly, P. 1998. Modelling change in the contact art of the south-eastern San, southern Africa. In: Chippindale, C. & Taçon, P.S.C. (eds) *The Archaeology of Rock-Art*: 247–267. Cambridge: Cambridge University Press.

Jolly, P. 2000. Nguni diviners and the south-eastern San: some issues relating to their mutual cultural influence. *Natal Museum Journal of Humanities* 12: 79–95.

Junod, H.A. 1962. *The Life of a South African Tribe* (2 volumes). New York: University Books.

Kopytoff, I. 1987. The internal African frontier: the making of African political culture. In: Kopytoff, I. (ed.) *The African Frontier: The Reproduction of Traditional African Societies*: 3–84. Bloomington: Indiana University Press.

Krige, E.J. 1962. *The Social System of the Zulus*. Pietermaritzburg: Shuter and Shooter.

Kuper, A. 1982. *Wives for Cattle: Bridewealth and Marriage in Southern Africa*. London: Routledge and Kegan Paul.

Lewis, I.M. 1971. *Ecstatic Religion: An Anthropological Study of Spirit Possession and Shamanism*. Harmondsworth: Penguin.

Lewis-Williams, J.D. 1981. *Believing and Seeing: Symbolic Meanings in Southern San Rock Paintings*. London: Academic Press.

Lewis-Williams, J.D. & Pearce, D.G. 2004. Southern San rock painting as social intervention: a study of rain-control images. *African Archaeological Review* 21: 199–228.

Loubser, J.N.H. & Laurens, G. 1994. Depictions of domestic ungulates and shields: hunter/gatherers and agro-pastoralists in the Caledon River Valley area. In: Dowson, T.A. & Lewis-Williams, J.D. (eds) *Contested Images: Diversity in Southern African Rock Art Research*: 83–118. Johannesburg: Witwatersrand University Press.

Low, A.B. & Rebelo, A.G. (eds) 1996. *Vegetation of South Africa, Lesotho and Swaziland*. Pretoria: Department of Environmental Affairs and Tourism.

MacDevette, D.R., MacDevette, D.K., Gordon, I.G. & Bartholomew, R.L.C. 1989. Floristics of the Natal Indigenous Forests. In: Geldenhuys, C.J. (ed.) *Biogeography of the Mixed Evergreen Forests of Southern Africa*: 124–145. Pretoria: Foundation for Research Development.

Maggs, T.M.O'C. 1976. *Iron Age Communities of the Southern Highveld*. Pietermaritzburg: Natal Museum.

Maggs, T.M.O'C. 1980. The Iron Age sequence south of the Vaal and Pongola rivers; some historical implications. *Journal of African History* 21: 1–15.

Maggs, T.M.O'C. 1982. Mgoduyanuka: terminal Iron Age settlement in the Natal grasslands. *Annals of the Natal Museum* 25: 83–113.

Maggs, T.M.O'C. 1984. Iron Age settlement and subsistence patterns in the Tugela River Basin, Natal. In: Hall, M., Avery, G., Avery, D.M., Wilson, M.L. & Humphreys, A.J.B. (eds) *Frontiers: Southern African Archaeology Today*: 194–206. Oxford: British Archaeological Reports, International Series 207.

Maggs, T.M.O'C. 1988. Patterns and perceptions of stone-built settlements from the Thukela Valley Late Iron Age. *Annals of the Natal Museum* 29: 417–432.

Maggs, T.M.O'C. 1989. The Iron Age farming communities. In: Duminy, A. & Guest, B. (eds) *Natal and Zululand from Earliest Times to 1910*: 28–48. Pietermaritzburg: University of Natal Press.

Maggs, T.M.O'C., Mazel, A.D. & Ward, V. 1982. Report on the archaeological survey of the Mkhomazi Dam site, Natal. Unpublished Cultural Resource Management report for the Directorate of Water Affairs. Pietermaritzburg: Natal Museum.

Maggs, T.M.O'C. & Miller, D. 1995. Sandstone crucibles from Mhlopeni, KwaZulu-Natal: evidence of precolonial brassworking. *Natal Museum Journal of Humanities* 7: 1–16.

Maggs, T.M.O'C., Oswald, D., Hall, M. & Rüther, H. 1986. Spatial parameters of Late Iron Age settlements in the upper Thukela Valley. *Annals of the Natal Museum* 27: 455–479.

Maggs, T.M.O'C. & Ward, V. 1980. Driel Shelter: rescue at a Late Stone Age site on the Tugela River. *Annals of the Natal Museum* 24: 35–70.

Maggs, T.M.O'C. & Ward, V. 1984. Early Iron Age sites in the Muden area of Natal. *Annals of the Natal Museum* 26: 105–140.

Manhire, A.H., Parkington, J.E., Mazel, A.D. & Maggs, T.M.O'C. 1986. Cattle, sheep and horses: a review of domestic animals in the rock art of southern Africa. *South African Archaeological Society Goodwin Series* 5: 22–30.

Marais, J. 2004. *A Complete Guide to the Snakes of Southern Africa*. Cape Town: Struik Publishers.

Mazel, A.D. 1982. Distribution of painting themes in the Natal Drakensberg. *Annals of the Natal Museum* 25: 67–82.

Mazel, A.D. 1989. People making history: the last ten thousand years of hunter-gatherer communities in the Thukela Basin. *Natal Museum Journal of Humanities* 1: 1–168.

Mazel, A.D. 1993. KwaThwaleyakhe Shelter: the excavation of mid and late Holocene deposits in the central Thukela Basin, Natal, South Africa. *Natal Museum Journal of Humanities* 5: 1–36.

Mazel, A.D. 1997. Mzinyashana Shelters 1 and 2: excavation of mid and late Holocene deposits in the eastern Biggarsberg, Thukela Basin, South Africa. *Natal Museum Journal of Humanities* 9: 1–35.

Mazel, A.D. 1998. Hunter-gatherers in the Thukela Basin during the last 1500 years, with special reference to hunter-gatherer/agriculturalist relations. In: Bank, A. (ed.) *The Proceedings of the Khoisan Identities and Cultural Heritage Conference*: 94–101. Cape Town: Institute for Historical Research & Infosource.

Mazel, A.D. 1999. iNkolimahashi Shelter: the excavation of Later Stone Age rock shelter deposits in the central Thukela Basin, KwaZulu-Natal, South Africa. *Natal Museum Journal of Humanities* 11: 1–21.

Mazel, A.D. 2004. The last two thousand years of Thukela Basin hunter-gatherer history: new developments. In: Sanogo, K., Togola, T., Keïta, D. & N'Daou, M. (eds) *Proceedings of the 11th Congress of the PanAfrican Association for Prehistory and Related Studies*: 83–92. Bamako, February 2001. Bamako: Soro Print Colour.

Mazel, A.D. & Watchman, A.L. 1997. Accelerator radiocarbon dating of Natal Drakensberg paintings: results and implications. *Antiquity* 71: 445–449.

Mazel, A.D. & Watchman, A.L. 2003. Dating rock paintings in the uKhahlamba-Drakensberg and the Biggarsberg, KwaZulu-Natal, South Africa. *Southern African Humanities* 15: 59–73.

Mitchell, P.J. 2002. *The Archaeology of Southern Africa*. Cambridge: Cambridge University Press.

Mitchell, P.J. 2009. Hunter-gatherers and farmers: some implications of 2000 years of interaction in the Maloti-Drakensberg region of southern Africa. In: Ikeya, K. & Ogawa, H. & Mitchell, P. (eds) *Interactions between Hunter-Gatherers and Farmers: From Prehistory to Present*: 15-46. Osaka: National Museum of Ethnology, Senri Ethnological Series 73.

Mönnig, H.O. 1967. *The Pedi*. Pretoria: J.L. van Schaik.

Murimbika, M. 2006. Sacred powers and rituals of transformation: an ethnoarchaeological study of rainmaking rituals and agricultural productivity during the evolution of the Mapungubwe state, AD 1000 to AD 1300. Unpublished PhD thesis. Johannesburg: University of the Witwatersrand.

Ngubane, H. 1977. *Body and Mind in Zulu Medicine: An Ethnography of Health and Disease in Nyuswa-Zulu Thought and Practice*. London: Academic Press.

Plug, I. & Brown, A. 1982. Mgoduyanuka: faunal remains. *Annals of the Natal Museum* 25: 115–121.

Poland, M., Hammond-Tooke, W.D. & Voigt, E.A. 2003. *The Abundant Herds*. Vlaeberg: Fernwood Press.

Prins, F.E. 1990. Southern Bushman descendants in the Transkei – rock art and rainmaking. *South African Journal of Ethnology* 13: 110–11

Prins, F.E. 1994. Living in two worlds: the manipulation of power relations, identity and ideology by the last San rock artist in Tsolo, Transkei, South Africa. *Natal Museum Journal of Humanities* 6: 179–193.

Prins, F.E. 1996. Praise to the Bushman ancestors of the water: the integration of San-related concepts in the beliefs and ritual of a diviners' training school in Tsolo, Eastern Cape. In: Skotnes, P. (ed.) *Miscast: Negotiating the Presence of the Bushmen*: 211–223. Cape Town: University of Cape Town Press.

Prins, F.E. & Lewis, H. 1992. Bushmen as mediators in Nguni cosmology. *Ethnology* 31: 133–147.

Raintree Nutrition. 1996. *Tropical Plant Database: Fedegoso (Cassia occidentalis)*. http://rain-tree.com/fedegosa.htm. Site accessed 27 July 2007.

Report and Proceedings, with Appendices, of the Government Commission on Native Laws and Customs. 1883. Cape Town: W.A. Richards.

Robey, T. 1980. Mpambanyoni: a Late Iron Age site on the Natal south coast. *Annals of the Natal Museum* 24: 147–164.

Sansom, B. 1974. Traditional economic systems. In: Hammond-Tooke, W.D. (ed.) *The Bantu-Speaking Peoples of Southern Africa*: 135–176. London: Routledge and Kegan Paul.

Schapera, I. 1984. *The Tswana*. London: Kegan Paul International.

Schoeman, M.H. 2006. Imagining rain-places: rain-control and changing ritual landscapes in the Shashe-Limpopo confluence area, South Africa. *South African Archaeological Bulletin* 61: 152–165.

Schofield, J.F. 1938. A description of the pottery from the Umgazana and Zig-zag caves on the Pondoland coast. *Transactions of the Royal Society of South Africa* 25: 327–332.

Schofield, J.F. 1948. *Primitive Pottery: An Introduction to South African Ceramics, Prehistoric and Protohistoric*. Cape Town: South African Archaeological Society.

Shaw, E.M. & Van Warmelo, N.J. 1974. The material culture of the Cape Nguni, Part 2: Technology. *Annals of the South African Museum* 58(2): 103–214.

Theal, G.M. 1898 [1964]. *Records of South-Eastern Africa, Volume II.* Cape Town: C. Struik.

Tyson, P.D., Karlén, W., Holmgren, K. & Heiss, G.A. 2000. The Little Ice Age and medieval warming in South Africa. *South African Journal of Science* 96: 121–126.

Van der Ryst, M.M. 1998. *The Waterberg Plateau in the Northern Province, Republic of South Africa, in the Later Stone Age.* Oxford: British Archaeological Reports, International Series S715.

Vinnicombe, P.V. 1976. *People of the Eland: Rock Paintings of the Drakensberg Bushmen as a Reflection of their Life and Thought.* Pietermaritzburg: University of Natal Press.

Vogel, J.C. & Fuls, A. 1999. Spatial distribution of radiocarbon dates for the Iron Age in southern Africa. *South African Archaeological Bulletin* 54: 97–101.

Vogel, J.C., Fuls, A. & Visser, E. 2001. Radiocarbon adjustments to the dendrochronology of a yellowwood tree. *South African Journal of Science* 97: 164–166.

Wadley, L. 1989. Review article: gender relations in the Thukela Basin. *South African Archaeological Bulletin* 44: 122–126.

Wadley, L. 2001. Preliminary report on excavations at Sibudu Cave, KwaZulu-Natal. *Southern African Humanities* 13: 1–17.

Webb, C. de B. & Wright, J.B. 1976, 1979, 1982, 1986. *The James Stuart Archive of Recorded Oral Evidence Relating to the History of the Zulu and Neighbouring Peoples, Volumes 1–4.* Pietermaritzburg: University of Natal Press.

Whitelaw, G. 1991. Precolonial iron production around Durban and in southern Natal. *Natal Museum Journal of Humanities* 3: 29–39.

Whitelaw, G. 1994. KwaGandaganda: settlement patterns in the Natal Early Iron Age. *Natal Museum Journal of Humanities* 6: 1–64.

Whitelaw, G. 1994/95. Towards an Early Iron Age worldview: some ideas from KwaZulu-Natal. *Azania* 29/30: 37–50.

Whitelaw, G. 1998. Twenty one centuries of ceramics in KwaZulu-Natal. In: Bell, B. & Calder, I. (eds) *Ubumba: Aspects of Indigenous Ceramics in KwaZulu-Natal*: 3–12. Pietermaritzburg: Tatham Art Gallery.

Whitelaw, G. 2004. Iron Age hilltop sites of the early to mid-second millennium AD in KwaZulu-Natal, South Africa. In: Sanogo, K., Togola, T., Keita, D. & N'Daou, M. (eds) *Proceedings of the 11th Congress of the Pan African Association for Prehistory and Related Studies*: 38–51. Bamako, February 2001. Bamako: Soro Print Colour.

Whitelaw, G. 2008. A brief archaeology of precolonial farming in KwaZulu-Natal. In: Carton, B., Laband, J. & Sithole, J. (eds) *Zulu Identities: Being Zulu, Past and Present*: 43–57. Pietermaritzburg: University of KwaZulu-Natal Press.

Wright, J.B. 1971. *Bushman Raiders of the Drakensberg 1840–1870: A Study of their Conflict with Stock-Keeping Peoples in Natal.* Pietermaritzburg: University of Natal Press.

Wright, J.B. 2007. Bushman raiders revisited. In: Skotnes, P. (ed.) *Claim to the Country: the Archive of Lucy Lloyd and Wilhelm Bleek*: 118–129. Johannesburg: Jacana.

Wright, J.B. & Mazel, A.D. 2007. *Tracks in a Mountain Range: Exploring the History of the uKhahlamba-Drakensberg.* Johannesburg: Witwatersrand University Press.

PERSONAL COMMUNICATIONS

Tim Maggs, 2008

Zandile Mbhele, 2007

Ntombifuthi Mkhize, 2007

Frans Prins, 2007

Basotho oral knowledge:
The last Bushman inhabitants of the Mashai District, Lesotho

Patricia Vinnicombe (with additional notes by Peter Mitchell)

O ral knowledge gathered from Basotho on their recollections of the last Bushmen to inhabit the central Maloti mountain massif of Lesotho has been recorded in a number of publications, notably by the English missionary Rev. SS Dornan (1909), the French missionary Rev. Victor Ellenberger (1953; Mitchell 2006/07) and Mrs Marion Walsham How (1962), daughter and subsequently wife of long-term civil servants in what was then Basutoland.[1]

This chapter presents interviews recorded in 1971 from two old men who lived near the celebrated Sehonghong rock shelter, which is often cited as the last stronghold of the Mountain Bushmen, where they are reputed to have made a last heroic stand before being exterminated (Stow 1905: 229). The accounts, which deal not so much with heroics as with the last struggling survivors after the massacre in Sehonghong Shelter, corroborate the published data to some extent, but also add sometimes conflicting details, as well as interesting ethnographic observations.[2]

Background

While excavating Sehonghong rockshelter (Figures 9.1 and 9.2) in the Mashai area of Lesotho with Patrick Carter in 1971, I was fortunate to meet two old Mosotho residents of the nearby Khomo-ea-Mollo village. These two patriarchs, Liselo Rankoli and Sello Mokoallo, both remembered Bushmen living in that area towards the end of the nineteenth century.

Liselo Rankoli, visibly a very old man, first came to the

rockshelter out of curiosity to see what we were doing, and once I discovered that he remembered Bushmen actually living in the shelter, I made a point of visiting him at his home in Khomo-ea-Mollo on several occasions.

Sello Mokoallo, on the other hand, was more elusive; I first interviewed him in the village, and he subsequently came to the rockshelter on two occasions. Once, on request, he demonstrated how the Bushmen smoked *dagga* (cannabis) by inhaling the smoke through a straw buried underground (note 18 [see later in the chapter for explanation and discussion of these note references]).

My more formal, note-taking discussions with these old men took place on two successive days, the 1st and 2nd of August 1971. Since they knew no English and I knew no Sotho, we conversed in our only common language, a mixture of Zulu and Xhosa. This procedure was not, however, entirely satisfactory since none of us was fully conversant with these languages, and I eventually co-opted the help of Regina, daughter of Zacharia, also of Khomo-ea-Mollo, who spoke good English and translated the Sotho spoken by the old men. Although I took notes, I much regretted that we had no tape recorder on the excavation. However, when a visiting journalist arrived armed with this equipment, I quickly took advantage of the situation and sent a message inviting the old men to come for a recorded interview.

Half the village trailed down the hill to the rockshelter. It was frosty weather with a biting August wind, so everyone was muffled up in gay blankets and knitted woollen caps or balaclavas. It soon transpired, however, that Sello Mokoallo and my valued interpreter Regina were not among the

◀ **Figure 9.1**
Sehonghong Shelter. ARAL Collection.

◀ **Figure 9.2**
Sehonghong Shelter from above looking down into the Sehonghong Valley. Photo by Peter Mitchell.

Figure 9.3
Khomo-ea-Mollo village. Photo by
Brian Stewart.

blanketed figures; they had gone off to another village for a few days. Liselo Rankoli, who was extremely deaf and whose eyes were clouded with cataracts, looked more than a little bewildered when he became the centre of attention.

There followed a veritable pantomime. Almost everyone present, it seemed, joined in the shouted attempts to explain to poor old Liselo what was happening. An added confusion was that we were again confronted with the language problem. I had reverted to the unsatisfactory compromise of conducting the interview through the medium of the Zulu/Xhosa language, when a confident young man who spoke Zulu well emerged from the crowd and took over the task of translating the old man's Sotho into Zulu for my benefit. I never did discover the name or status of the young man who virtually took over the interview proceedings, but since he appeared to be held in high respect by even the older men present and was addressed by the terms *Morena* (Chief) and *Ntate* (Sir), I felt obliged to concur with his self-appointed position without too much resistance. The young man often took initiatives like repeating questions that I had already

put to Liselo, which led to considerable duplication and caused me such concern over the unnecessary trauma to which Liselo was being subjected that I barely heard what was being said. It is certain that Liselo heard even less, for in between all the shouting from various directions, he gazed uncomprehendingly into the middle distance, uttering the typically drawn out Basotho expressions of 'Ee', 'Ehe', 'Oho' and 'Hmm', occasionally focusing his eyes on a more immediate subject and asking, "*Ho thoeng he?*" (What is being said?)

These factors all combined to create an atmosphere which, to say the least, was not conducive to easy communication. However, the scene finally settled into some form of coherence. Liselo eventually warmed to what was happening, but needless to say much of the information that I was given during the initial untaped interviews was never repeated; even unethical promptings and leading questions were resorted to in vain. At the same time, however, new information was also imparted that I had not heard before.

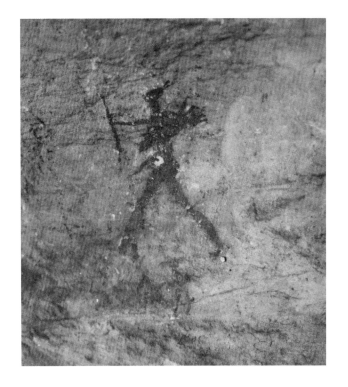

▶ **Figure 9.4**

Painting of an armed man and dog (now damaged) from a site near Sehonghong. Photo by Peter Mitchell.

The oral knowledge

First, I outline the information given by Sello Mokoallo, who was not interviewed on tape, and whose information was obtained quite independently of that from Liselo Rankoli.

Sello Mokoallo

Sello Mokoallo was born in Khomo-ea-Mollo village (Figure 9.3), which is situated on the hill slope above Sehonghong rockshelter. This was at the time of the War of the Guns, when, according to his explanation, there was a Zulu and Basotho uprising and the Boers were fighting the Basotho during the reign of Lerotholi. This was in 1880–81.

Sello remembered that Bushmen were living in the Sehonghong cave until he was about nine years old.[4] The Bushmen, he said, were expelled by the Basotho under Chief Tlhakanelo, who lived at Ha Tlhakanelo (note 1, see notes on page 179, under 'Discussion and assessment'). The reason for the attack was because the Bushmen had caught a Basotho boy and had taken his eyes out. When I questioned this further, Sello explained that the Bushmen shot a Basotho boy in the eye with an arrow. When the trouble arose, some Bushmen were killed, some ran away. It happened at this Sehonghong cave. After the Bushmen were punished and dispersed, the only Bushmen who remained were Ou Jan (an old man), Rasethla (a medicine man) and Baroli (who died at Matebeng and was buried there). The other two Bushmen, Rasethla and Ou Jan, died of old age; he did not know where they were buried, but he thought Ou Jan had died at Tlhakanelo's village. These three men were the Bushmen whom Sello really knew. The Bushmen spoke a language that Sello did not understand, but they could also speak Sesotho.

According to the information given by Sello, the Bushmen moved about to kill wild animals. They were nomads; where they killed an animal, there they lived. They had dogs that helped them to kill.[5] Bows and arrows were also used. When Bushmen were on the move, they carried their arrows stuck in a skin band worn around their heads (note 9). The arrows were poisoned, and were pointed with a stone.[6] The arrows also had bone shafts that were rubbed to get them round. The poison used was snake's poison.[7] They extracted the poison from the puff adder, but did not kill the snake. The Bushmen did not fear the snakes because they were like animals themselves. They were very shy and did not want to meet people.

When our work on the excavation was completed, I took the tape of the recorded interview to the University of the Witwatersrand, where Mr IM Moephuli of the Department of African Languages kindly undertook the arduous task of transcribing the tape and translating both the Sotho and the Zulu into English. His painstaking handwritten results, together with a letter dated 10/7/1972, were posted to me at Clare Hall in Cambridge, United Kingdom, where I held a Research Fellowship.

By the time I received the translation in 1972, *People of the Eland* had already been written, although not yet published, and the dual research project undertaken by Patrick Carter and myself, of integrating the art and archaeology of Lesotho and the Natal uplands, sadly did not materialise. Patrick Carter independently presented a doctoral thesis on the archaeology of the area (Carter 1978), but the rock art aspect of the study has been in 'cold storage' ever since, along with this remnant of oral history.

Sehonghong shelter was re-excavated by Peter Mitchell of the University of Oxford (then at the University of Cape Town) in 1992, and it now seems fitting that my storage boxes should also be excavated in order that some of the contents may see the light of day.[3]

The Bushmen could send smoke signals; if an animal was killed, they lit a fire and all the other Bushmen came. They made fire from the roots of a willow tree – they made a small hole in the root and rubbed it with an upright stick, also of willow. There used to be many trees in the valley in the early days.

The Bushmen were very strong, tough people. You could hit them, and they didn't feel anything. They used their heads as weapons; if you caught them, they butted with their heads.

The Bushmen fished. They shot the fish with their arrows (note 13). Game was plentiful when Sello was young. *Phofu* (eland) were like cattle.[8] When the eland were killed and chased, some ran away to KwaZulu-Natal, to Underberg. The eland weren't seasonal; they stayed around the Mashai area all the time.[9] They grazed far away, but always returned to their young.[10]

At the Leqoa River, some Basotho married Bushman wives.[11] They wore the skins of sheep and cattle. They softened the skins and wore them like blankets. They had a musical instrument, the *lesiba*, which the Basotho have taken over. It was a bowed stick with a hair string and a resonator.

Early on, the Basotho were on good terms with the Bushmen, but later the Bushmen stole cattle and horses. They killed the horses and cattle – anything to eat. They used to catch young horses and ride them without ropes or anything. Even if the horse bucked and jumped, they could sit on it (note 17).

The Bushmen wanted dogs more than horses (Figure 9.4). If they saw someone with a dog they liked, they would look at the footprints and do something magic. After that, the dogs would follow the Bushmen. They were good at magic. They would smear stones with medicine so that wild animals would be unable to move away from a certain place (note 10). Magic was also used to prevent the Basotho from hunting their animals; for example, the sun would set before the animals could be reached.

Sello never saw the Bushmen painting, but the paintings were new at the time he was a young man.[12] They wanted to draw the animals they killed. They did a painting after they killed an animal. Sello thought they used the blood of killed animals for paint.[13] They drew a ghost. Sello was told by the Bushman named Ou Jan that a ghost had been drawn there in Sehonghong Shelter, and

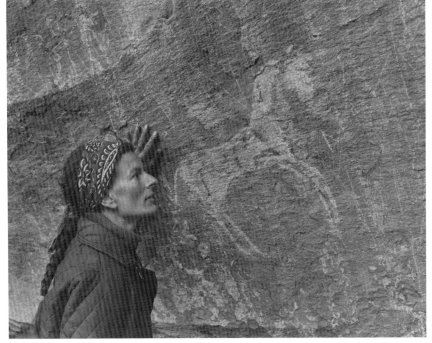

◀ **Figure 9.5**

The black 'ghost' image from Sehonghong Shelter referred to by Sello Mokoallo. Photo by Peter Mitchell.

◀▼ **Figure 9.6**

Vinnicombe looking at Lerotholi's white horse, Tabure, Sehonghong Shelter. RARI archive.

▶ **Figure 9.7**

Sello Mokoallo demonstrating how Bushmen used to smoke dagga (cannabis). RARI archive.

this same ghost could be seen at night (Sello pointed out a black painting of a human figure with a long tail as being the ghost in question) (Figure 9.5).[14] There was also a white horse painted in the shelter (Figure 9.6). The white horse, named Tabure, was said to belong to the Basotho chief Lerotholi, who was popular with the Bushmen.[15] Lerotholi was against those who wanted to expel the Bushmen. Lerotholi stayed at Matsieng, near Maseru.

The Bushmen would trade anything or do anything for *dagga*. No *dagga* meant death to a visitor. After eating, they smoked *dagga* when they would behave 'abnormally'. I was unable to obtain more explicit details of what Sello meant by 'abnormal', other than that they coughed and threw themselves about.

As a result of this discussion, I asked Sello whether the Bushmen used pipes for smoking *dagga*. Although he did not know of the use of pipes, he went on to describe a ground-smoking procedure in some detail. I requested him to demonstrate the technique used, which he readily agreed to do, provided that I purchased a supply of *dagga* for his use! Sello subsequently came to the rockshelter, where he selected a suitable location, crouched down on the ground and dug a small depression into which he placed the dried *dagga* leaves. He then made a shallow furrow leading to the *dagga*, in which he placed a pre-selected hollow straw, which he then covered with soil, leaving the end protruding. He ignited the *dagga* leaves, applied his mouth to the straw and inhaled deeply (Figure 9.7). He closed his eyes, coughed vehemently and then proceeded to sing the praise song of Lerotholi, called *Matagwana* (note 18).

BOX 10. PROTECTING ROCK ART IN LESOTHO

Peter Mitchell

Much of Pat Vinnicombe's fieldwork took place not in South Africa, but in the highlands of eastern Lesotho, including the comprehensive tracing of the three sites for which some images were, uniquely, interpreted by a nineteenth century Bushman informant, Qing (Orpen 1874). Continued deterioration of the paintings at these sites – Melikane, Sehonghong and Pitsaneng – and at others makes her tracings of them of enduring importance.

As discussed more fully elsewhere (Khits'ane 1991; Ambrose et al. 2000; Mitchell 2005), Lesotho's rock paintings were first given legal protection by a Proclamation (No. 40 of 1938) issued by the British colonial authorities. This was reinforced by a further Proclamation (No. 36 of 1969) soon after independence, and at the same time protection was extended to all archaeological deposits. By an Act of Parliament of 1967 a commission, commonly known as the Protection and Preservation Commission (PPC), was also established, charged with protecting and preserving Lesotho's natural and cultural heritage. Regrettably, a history of underfunding and under-resourcing handicapped the PPC from the start, severely compromising its ability to do anything except when provided, for brief spells, with external support. Attempts to develop the well-known rock art site of Ha Baroana near Maseru therefore failed and, if anything, only resulted in further damage being done to the paintings there as local 'guides' poured water on to them to 'enhance' their photogenic qualities (Ambrose 1983). On a happier note, the PPC was successful in lobbying for the incorporation of archaeology into the environmental impact studies undertaken ahead of the construction of the Southern Perimeter Road between Mohales Hoek and Qacha's Nek in the early 1980s. The Analysis of the Rock Art of Lesotho (ARAL) Project set up by Lucas Smits, then Professor of Geography at the National University of Lesotho, located, photographed and recorded sites along the course of the road, building on earlier work in other parts of the country (Smits 1992). By the time ARAL came to an end in the mid-1980s, it had recorded in all close on 700 sites, the written and photographic records for which are now archived at the Rock Art Research Institute, Johannesburg.

Other initiatives have been on a far smaller scale, and there is no question that it is the work of Pat Vinnicombe (1976) and Lucas Smits (1973, 1983, 1992) that has made the most important contributions to rock art recording and research in Lesotho. With the exception of Loubser's (1993) tracing of paintings at sites in the Phase I area of the Lesotho Highlands Water Project, paintings have typically taken a back seat in subsequent archaeological research, with relatively little dedicated survey or recording work carried out since the mid-1980s (but see Aitken et al. 2000; Challis et al. 2008).

The reasons for this are not hard to identify and in fact affect archaeological research of all kinds in Lesotho. Put simply, the combination of a troubled political history in the decades immediately following independence (1966–1998), an economy lacking significant natural resources other than labour and the water exported to South Africa from the Highlands Water Project, and the ravages of the HIV/AIDS epidemic has not created circumstances favourable to the spending of significant sums on cultural heritage protection. At the time of writing, Lesotho thus remains without a functioning national museum (although the museum supported by the Lesotho Evangelical Church at Morija provides a partial substitute in the field of education), and only since 2008 has an archaeologist been on the staff of the National University in Roma. Other opportunities to build capacity have not been well seized. Despite recommendations to the contrary (Lehmeyer MacDonald & Oliver Shand 1986; Lesotho Highlands Development Authority 1989; Lewis-Williams & Thorp 1989), the Lesotho Highlands Development Authority conspicuously failed to create any sort of national archaeological infrastructure. The likelihood – at least for now – that Phase III of its activities, which would flood a major section of the main Senqu Valley, will not proceed makes it even more unlikely that it will do so, as it is here that the largest concentration of threatened archaeological sites is to be found. Instead, it handed all archaeological work over to South African-based contract archaeologists, one consequence of which has been that virtually nothing of that work has ever appeared in print (Loubser & Brink 1992 and Mitchell et al. 1994 are the exceptions). Regrettably, precisely the same result – and another wasted opportunity for sustainable infrastructural development – followed more recently from the Maloti-Drakensberg Transfrontier Project (MDTP) (cf. Cain 2006).

Lesotho's rock paintings continue to be damaged by or for tourists as water or other liquids are thrown on to them. They also continue to be damaged by people, especially children, writing or drawing over them in charcoal, chalk, or sometimes even paint (Figure B10.1). The removal of ochre for use in traditional medicines, the drying of cattle dung (lisu) on rock shelter walls so that it can be used as fuel, and the rubbing of animals against painted surfaces are additional problems. Beyond all this, the sandstone on which virtually all the paintings were made is itself a friable surface subject to ongoing exfoliation and sometimes also to damage by dripping water (Loubser 1991; Meiklejohn 1997). Given all of this, the long-term outlook for Lesotho's rock art has to be bleak, unless a bottom-up approach is taken that can successfully inculcate a sense of the value of the art. Such value is, of course, in part a matter of heritage, and at the local level some communities are clearly concerned with this. Greater education about Lesotho's past and about the importance of rock art as a testimony to that past can only help here, and the work of Pieter Jolly in securing funding for the distribution of posters to all of Lesotho's schools is an important development. But value is also economic, especially given the extreme poverty that affects so many Basotho. Developing community-based tourism, even at a relatively low level, might help the long-term conservation of rock paintings in at least some parts of Lesotho, but for it to be successful visitor access will require supervision, provision of appropriate information and guidance will be essential and, most crucially of all, all revenues will need to be retained at the community level. That MDTP did not go down this route is to be regretted, but recent initiatives, such as the archaeological work underway in the catchment of the Metolong Dam, may be able to achieve more. Hopefully, too, its introduction of funds from abroad will further the establishment of a permanent indigenous archaeological and heritage management infrastructure at national level that will, by involving all key players, and especially the Department of Culture and the National University, help conserve for future generations of Basotho the heritage to which Pat Vinnicombe devoted so much of her life.

► **Figure B10.1**
Graffiti damage to rock paintings in Sehonghong Shelter, Lesotho. ARAL collection.

REFERENCES

Aitken S., Lake, Q., Mills, N. & Moshoeshoe, M. 2000. Lesotho rock art survey 2000. Unpublished report submitted to the Protection and Preservation Commission of the Kingdom of Lesotho.

Ambrose, D. 1983. *Lesotho's Heritage in Jeopardy*. Maseru: Protection and Preservation Commission of the Kingdom of Lesotho.

Ambrose, D., Motebang Pamela, E. & Talukdar, S. (eds) 2000. *Biological Diversity in Lesotho*. Maseru: National Environment Secretariat of Lesotho.

Cain, C.R. 2006. Summary report of the Cultural Heritage Project for MDTP-Lesotho. Report submitted to the Maloti-Drakensberg Transfrontier Project.

Challis, W., Mitchell, P.J. & Orton, J. 2008. Fishing in the rain: control of rain-making and aquatic resources at a previously undescribed rock art site in highland Lesotho. *Journal of African Archaeology* 6:203-218.

Khits'ane, N.J. 1991. Efforts in the preservation of cultural heritage in Lesotho. In: Slotta, R. & Skalli, M. (eds) *International Symposium on Preservation and Protection of the Cultural Heritage of Lesotho*: 36–38. Bochum: German Mining Museum.

Lehmeyer MacDonald Consortium & Oliver Shand Consortium. 1986. *Lesotho Highlands Water Project Feasibility Study. Supporting Report C: Environmental and Social Impact in Lesotho*. Maseru: Government of Lesotho.

Lesotho Highlands Development Authority. 1989. *Lesotho Highlands Water Project – Phase IA: Draft Environmental Action Plan*. Maseru: Lesotho Highlands Development Authority Environment Division.

Lewis-Williams, J.D. & Thorp, C.R. 1989. Archaeology: Lesotho Highlands Water Project environmental study. Report by Environmental Resources Ltd, London, submitted to the Lesotho Highlands Development Authority.

Loubser, J.N.H. 1991. The conservation of rock paintings in Australia and its applicability to South Africa. *Navorsinge van die Nasionale Museum Bloemfontein* 7: 113–143.

Loubser, J.N.H. 1993. Provisional report on the conservation of fourteen painted rock shelters affected by Phase IA of the Lesotho Highlands Water Project. Report submitted to the Lesotho Highlands Development Authority.

Loubser, J.N.H. & Brink, J.S. 1992. Unusual paintings of wildebeest and zebra-like animals from north-western Lesotho. *Southern African Field Archaeology* 1: 103–107.

Meiklejohn, K.I. 1997. The role of moisture in the weathering of the Clarens Formation in the KwaZulu/Natal Drakensberg: implications for the deterioration and preservation of indigenous rock art. *South African Geographical Journal* 79: 199–206.

Mitchell, P.J. 2005. Archaeological resource management in Lesotho: thoughts on its past record, present situation and future prospects. In: Finneran, N. (ed.) *Safeguarding Africa's Past*: 37–46. Oxford: British Archaeological Reports, International Series 1454.

Mitchell, P.J., Parkington, J.E. & Yates, R. 1994. Recent Holocene archaeology in western and southern Lesotho. *South African Archaeological Bulletin* 49: 27–56.

Orpen, J.M. 1874. A glimpse into the mythology of the Maluti Bushmen. *Cape Monthly Magazine* 9: 1–13.

Smits, L.G.A. 1973. Rock-painting sites in the upper Senqu Valley, Lesotho. *South African Archaeological Bulletin* 28: 32–38.

Smits, L.G.A. 1983. Rock paintings in Lesotho: site characteristics. *South African Archaeological Bulletin* 38: 62–76.

Smits, L.G.A. 1992. Rock painting sites near the Southern Perimeter Road in southeastern Lesotho. In: Lorblanchet, M. (ed.) *Rock Art in the Old World*: 61–95. New Delhi: Indira Gandhi National Centre for the Arts.

Vinnicombe, P.V. 1976. *People of the Eland: Rock Paintings of the Drakensberg Bushmen as a Reflection of their Life and Thought*. Pietermaritzburg: Natal University Press.

Liselo Rankoli

Liselo Rankoli was also born during the War of the Guns (1880–81). According to him, the Sotho were fighting the Zulu at Mosefulu at that time. He was born at Maphuteng in the Maseru district and then moved to Matatiele. War with the Zulu scattered the Basotho and trouble spread to Matatiele.[16] It was then that Basotho people moved to this highland area.[17] When Liselo arrived here, Khomo-ea-Mollo was chief and there was already a settled village. Liselo was about seven years old when he arrived and there were Bushmen still living in Sehonghong Shelter at that time.[18]

The Basotho under Chief Jonathan came and killed the Bushmen, but some escaped and ran away (note 4). When the Basotho *impi* (army) came, the Bushman chief, whose name was Soai (note 3), was busy collecting honey. His friends held him by a rope while he hung over a cliff to reach the beehive. When the *impi* appeared on the horizon, the Bushmen all ran away and Soai fell to his death. Liselo did not know what had become of his body.

Liselo remembered a very pretty Bushwoman called Serupi, who lived among the Basotho. He described her as pale in skin colour, decorated with tattoos[19] and with large thighs – indeed, the memory of her brought quite a glint to his otherwise hazy eyes. Another woman called Xamagu (spelled Qamoko by Mr Moephuli) also used to visit the Basotho. She had a child, a boy aged about seven years old (Liselo indicated the age by pointing to a Basotho child who was listening). There were also two men named Mutsapi and Moutloanyana. Mutsapi was killed, but Moutloanyana escaped the massacre by hiding in the river. Later he was called by Chief Tlhakanelo to herd his animals, but after this he disappeared – he ran away (note 1). Chief Tlhakanelo lived near the present site of the Sehonghong airstrip (see also Vinnicombe 1976: 101; Figure 9.8).[20]

There were many eland in those days.[21] The eland used to choose warm places in the valleys during the winter. When it was warm, they grazed on the mountains and browsed on the many trees that were in the valleys. The Bushmen moved around hunting, but the women were left. Their work was to sing for their husbands. When the men hunted, they chased the eland and other buck from up the mountain to near the shelter (note 15). When they were approaching, the women used to sing and make a noise to make the hunters stronger.[22] The Bushmen had a lot of magic, but Liselo did not know how they worked it. The eland were very fat, but he said they were all enticed over

the border to KwaZulu-Natal, where they were given salt.[23]

The Bushmen very much liked the animals known as *sele* (described as being like a jackal, but black and white[24]) and *phuti*.[25] Liselo never saw any zebra or quagga in the area,[26] but he did see *caama* (red hartebeest).[27]

The women collected *tsane* seed (or *moseka*) and ground it with stones (note 8). They collected *moseka* with a 'sickle' made of stone. Liselo used to find these sickles lying about when he was young, but threw them away. They were wooden with a stone blade (note 11). When collecting *moseka*, the women would carry the load of grass on their heads. They had no baskets. They used skin bags. They used to hit the grass with sticks to obtain the seeds, then they would leave the grass in the rockshelter.[28] The women also collected *monakalali* (a small edible bulb); *monakalali* is best in September, but can be eaten throughout the year.[29] *Tsane* (*moseka*) was collected and eaten from February to March. They used to mix *moseka* with *monakalali*.

Liselo did not know what poison the Bushmen used, nor what paint they used to make the pictures in the cave. They

▲ **Figure 9.8**
Sehonghong village. Photo by Brian Stewart.

just painted where it was their home. They cooked in clay pots and used wooden vessels. They used to trade pots from the Basotho. They traded them for meat (note 12).[30]

The Bushmen wore skins of killed animals. They could sew the skins together. They used needles made from wood.

Liselo never saw Bushmen with horses, but they used to eat them (note 17). They used to fish in the Senqu (Orange) River. They used hooks made from wood and baited with meat. The thread was made from eland sinew. Most fish were found … [unfortunately, I did not understand what he said, and further questioning did not prompt him to repeat the information]. In summer they used hooks; in winter they shot the fish with bows and arrows in the pools (note 13).

The Bushmen made a sort of hut in the cave (note 14). They took branches from trees, tied them together with ropes and covered them with grass. The huts were not good out in the rain; they were really just to keep the wind out. The ropes were plaited from grass called *lelele* or *leloli*,[31] also from *tsane*[32] and *mohlomo*.[33]

When I enquired about the religion of the Bushmen and whether they believed in a God, Liselo replied, "No, they were heathens. There were no churches then. They had no idea of right or wrong."

I questioned Liselo about the Bushmen Sello Mokoallo had named; he knew Ou Jan and Rasethla, but did not know Baroli. Ou Jan used to stay with Tlhakanelo (note 1) until the time that Liselo was aged about 22.[34] This was after the Bushmen living in the shelter had been dispersed. Ou Jan didn't have a wife; he just stayed at Tlhakanelo's and did nothing. Tlhakanelo chased Ou Jan on a horse, caught him and made him look after his cattle. But Ou Jan did not like looking after cattle – he used to run away (note 2).

Rasethla was a doctor and lived near Matebeng. He had a Bushman wife, but lived like a Mosotho in a hut. Liselo did not know if they had any children. He only visited there when he was sick – he didn't know Rasethla well because his village was not nearby. Sick people used to go to him. He gave medicine and cut people (that is, he treated them by cicatrisation and by drawing blood). He didn't work with rain.[35]

Liselo knew nothing of Tlhakanelo punishing the Bushmen; according to Liselo, it was Jonathan (son of Moshesh)[36] who came with an *impi* and chased the Bushmen away, and this is corroborated by other published records (note 4).

Liselo claimed that a white man at Mashai store took some of the skulls of Bushmen who were killed in Sehonghong Shelter (note 5). Liselo also claimed to know the place where the tragedy of Soai falling to his death had occurred and, despite his considerable age, agreed to take me there. The site proved to be a cleft in the sandstone cliff on the left bank of the watercourse that runs past Sehonghong Shelter and joins the Orange River a few kilometres beyond.[37] The lower end of the cleft was smoke blackened and, indeed, there were still bees flying in and out of a hive about three-quarters of the way up the rock face (note 6). Liselo assured me that both the Bushmen and the Basotho used smoke to calm bees down when they were collecting honey. To my surprise, there were even some faded paintings of human figures on the relatively exposed cliff face near the cleft, but the subject matter did not appear to be obviously related to the honey incident described.[38]

The above information is abstracted from my diary and from the notes taken when Regina assisted me with the Sotho/English translation.

Record of the taped interview with Liselo Rankoli

There now follows a translated transcription, made by Mr IM Moephuli of the University of the Witwatersrand, of the taped interview with Liselo Rankoli. This interview, as I have explained, left much to be desired from the point of view of procedure and general control. In order to enhance intelligibility and eliminate some of the duplication, I have edited portions of the verbatim translation. Mr Moephuli, who did not have access to my field notes, spelt the name of the Bushman chief Swai.[39] Where the same subject was spoken of at different times during the interview, such as the death of Soai or the names of game animals, I have relocated sections of speech so that the information is less scattered. Such relocations have been indicated with a series of asterisks.

Liselo Rankoli's words appear in **bold**, those of the unknown young man who assisted with the translation in this font and myself in *italics*.

Liselo: The Bushmen, they used to live right here in the caves here. Mmm-mmm! Like a regiment. mmm!
They [the Sotho warriors] **came out – the ones who came**

out from over there at Molopo's place, then they [the Bushmen] died out. Mmm!

They, the Bushmen, they were with their wives. The warriors came from Molopo, Jonathan's place.* * * He [Soai] was extracting honey – in the cliff over here. Now then, it so happened that when the warriors appeared, they left him and he fell. Now then, he was injured. Now we do not know what they did to him (notes 3 and 4).

Then they [the Bushmen] left him [Soai]. He was injured. Yes, they ran away, as for them. Now then, whether they came back to fetch him, I do not know. He fell, he fell down the cliff, they left him and he fell, then he fell. As for them, they ran away, yes, they fled. The Bushmen fled. He, as for him, he was injured. * * * * He was held with ropes such as these (Liselo was holding a *riem* or thong made of hide at the time of the interview). He [Soai] was extracting honey – in the cliff over here (indicating with his stick to the cliffs he had previously shown me).

* * * *

Young man: He died?

Liselo: He died, yes. Now we do not know where they went and buried him.

* * * *

During this entire conversation, which has been abbreviated above, Liselo did not actually name the Bushman who fell to his death, despite having readily volunteered the name during previous discussions. It took a considerable amount of prompting before he finally uttered:

It was he, the chief, Soai.

Self: Soai?

Liselo: Ee, Soai, Soai.

Self: Was it he who died?

Liselo: He was with Motsapi. As for Motsapi, he, they killed him. In that big village. With a gun. He was trying to flee. He was trying to get among the rocks, then they killed him. Ohoo! Ee!

* * * *

Self (addressing the young man): Ask him whose warriors arrived?

Young man: Whose warriors were they?

Liselo: Ee, they were Jonathan's, he merely killed them. They were not even stealing, he merely killed them for fun. Nobody knows why he made them pay this tribute. Imagine him leaving Lesotho over there at Molopo's place there![40] Hmm! Ee! He [presumably Motsapi]

descended right here. He came running, he crossed, went and ran on the other side. Now listen then, the eldest one, Motsapi, they killed him when he tried to get into those rocks of the place Khomo-ea-Mollo, among these houses belonging to – to Litaelo. Those others saw them; they abandoned the poor man and he fell. The others ran away and hid themselves.

Young man: Had they tied him with ropes?

Liselo: Yes, he was held by means of ropes. Just imagine, in that frightening precipice! They used to hold and lower a person from above. He would then descend into that frightening hollow![41]

* * * *

Young man: Please tell us now, because you said once that, long ago, you once saw the chief of the Bushmen, that is Soai.

Liselo: No, I do not have a personal knowledge of him, in truth. Rumour says that he was collecting honey in that hollow, where I had taken this lady to. [He was] tied with ropes and hanging over the cliff. My eyes, no, do not know him. I merely know those others who lived at my village over there, women this big (indicating diminutive stature), having been with a child.

* * * *

They once lived over there at my home, women such as these. They were with their children, hmm! Now then, they again scattered. I do not know where they went to. I then tried to get Liselo to name the women as he had previously done, but after repeated questioning which he clearly did not properly follow, he answered:

Liselo: Oo oo! Ee ee! They used to live in an ordinary way; they used to go and wash in the river only. Wash themselves. Humm! Ee! Now then, I do not know where they went to – I do not know.

Later, I tried again.

Self: Now you told us (before) the name of a Bushwoman you remembered. You said there was one woman who was pretty indeed.

Liselo: Oo! Serope? … It was said she is Serope. She had tattoos on the face. She was light brown, like this. A pretty one.

Young man: Was she beautiful?

Liselo: Good gracious! She was not beautiful, *Ntate* [Sir] (negative form used for emphasis), she had tattoos on the face, these [were] usually made by Basotho. Now they were greenish, Mofokeng. A beauty! Ehe!

Self: Very good!

Liselo: The other was Qamoko and their son who was called Sekoqo, a boy. Hmm, as for them, they stayed for some time, when we were young boys. They lived for some time here at home. They dispersed much later. Now, we do not know where they went to … And [the one who was adopted (note 7)] then remained with them here. Now, Thakane used to do this: when he had taken 'drinks', he would give him a horse, saying he should go and herd his cattle. Now he would refuse, and run away. Run away. He would run away, he [Thakane] chasing him on horseback. It so happened that – [he] appeared right there, in that cliff which is opposite Mmakoanyane's place. Hey! He was being called over here, to the chief's court. He was being called. Oo! He ran towards another direction. He climbed [scaled] until he reached the other side. That is the day he went for good. Yes … ! (note 2).

* * * *

Self: Now then, what did they eat?

Liselo: Hmm?

Self: What was their food, the Bushmen?

Liselo: Their thing? Hmm! Oo! It was – what's its name? There is a type of grass they used to cut. There is *moseka* (a seed-bearing grass), and then it will be threshed. They used to eat it. And buck, wild herd animals, were killed. They used to hunt, then. Ee! These were then eaten. Hee!

Self: What sort of animals were to be found?

Liselo: Of animals? Hmm. Oo! It is only meat [venison]. It does not resemble the meat of domestic animals; it does not resemble mutton. It is merely meat.[42] They used to eat them [the animals]. They also ate dassies. They were still to be found over there on that cliff. Dassies.[43] Hmm! Oo! They were still to be found! Hmm!

Self: Now, how did they kill them?

Liselo: Oo! They used to go after them very early in the morning while they [the dassies] were still out hunting for food, for during the day, like this, they sit near their natural fortress [burrows]. Yes, when they see a person, they get into their burrows. Now then, they [the Bushmen] used to go then, while it was still very early, when dawn begins to break. And then kill them. Hmm! Hmm![44]

* * * *

Self: Now, would you tell us a little about the names of the animals you know? All of them – were they plentiful or not?

Liselo: What is being said?

Young man (repeating the question): Can you tell us the names of animals which you know – animals of that time?

Liselo: The ones they used to eat?

Young man: No, this is, those which you knew.

Liselo: Oo! They used to eat elands and dassies and wild rabbits [hares] and buck, yes. All these animals they used to eat them, for they were still plentiful, animals around here; people were not walking about here, the animals were many. They have just died off … And red hares were plenty right here[45] … Ee! … And blue duiker were still to be found.[46] Hmm!

Self: Now, what did the women collect to eat?

Liselo: They, of the Bushmen?

Self: Yes.

Liselo: Oo! It seems they too ate wild herbivorous animals. They used to eat those animals. Ee. There is also some grass. Yes, it is called *moseka*. They used to cut this grass, it would be threshed, threshed. It looks something like … what you call it? Then they would grind, grind. Then they would cook.

(Later on, the young man again asked Liselo the name of the grass.)

Liselo: Yes, *moseka*, Sir. It is *moseka*. You also know it, the one found in the mountain, this reddish-brown one. At my home, it is said that it makes *liqhakoa* (note 8).[47]

Young man: How did they cut?

Liselo: *Hela!* [Goodness!] There are things … their instruments … spears which they used to cut with (note 11).

Young man (pointing to the workbench where stone artefacts were being sorted and bagged): Ones similar to those over there?

Liselo: Yes, ones similar to those over there. Ee! They would cut grass with them, saying: Ghatch! Ghatch! (demonstrating the noise made by the grass being cut with a stone blade). They would then leave, to go and thresh – over there on the flat rocks (pointing to flat rocks above the rockshelter).

Young man: Thresh on flat rocks?

Liselo: Yes, thresh on flat rocks. They used to have their small grinding stones then, which they used to grind with, yes.[48] You know it – [*moseka*] – it makes a white flour. You may mistake it for *mabele* [sorghum flour].

Young man: Oo! It makes a flour which is like that of *mabele* – a white one.

Liselo: Ee, a white one. Now then, they would cook. Now then, their custom when they are full, they scatter the food.[49]

Young man: When they are full, they scatter the food?

Liselo: It is scattered. In the morning, a person wakes up hungry, then they start picking the food they threw away. Picking and picking – even the meat of wild animals – scattered – they wake up to collect the remains – picking up what remained, to come and eat … Because dassies were still plentiful. Even now, over there, they are still to be found, but it is more difficult to kill them.

Young man: At what time did they find them?

Liselo: Oo! When it begins to clear. While they are out, they would surprise them.

Young man: Oo! Surprise them. How did they kill them?

Liselo: With their arrows – there were arrows.

Young man: Oo! With arrows!

Liselo: Yes! They speared them with arrows. Those arrows of theirs are poisonous. Now if he can wound a thing [an animal] with it [an arrow], these poisons at once spread through the body. Spread through the body.

Young man: How did they skin it?

Liselo: Ee? [What?]

Young man: With what did they skin it?

Liselo: Oo! They skinned them with their knives. They were still to be found, which resembles these stones. Yes! Long ago [at first] we used to find them, when we were still small boys. Small razor blades which are sharp. They skinned by means of these then. For there were many dassies – and wild rabbits were plentiful also here – and red hares, they killed them! Then they cooked, right here, and ate. They would eat – when they are full, scatter, waste the food.

Young man: With what did they cook?

Liselo: Aha! With small pots made of – hyee! – of clay.

Young man: Oo! Clay pots.

Liselo: Yes! They used to mould clay pots and use them for cooking, yes.

(Long silence)

Self: On one occasion, you told me how the Bushmen used to speak. Please tell us how they speak.

Liselo: When they speak?

Self: Yes.

Liselo (sounding a series of clicks): It is Gha-nqha-qha! Atjhee!

Self: Again!

Liselo: Ee! Qha-qha, qha-qha. We wouldn't hear [understand] what they are saying.

Self: Their song … ?

Liselo (singing): Haa thai! Haa thai! Thai! They are playing – they are playing then!

(Silence)

* * * *

Self: Now I beg that you should explain to us very clearly how they made their dwellings?

Liselo: Oo!

Self: How did they build?

Liselo: Ee-e. They used to gather these twigs and shrubs and willow trees for they were still plentiful.[50] They would make something resembling *maphephe* [reed mats]. Yes, now then they would roof then – having made some crude structures here, inside here. They would build right inside the cave here.

Young man: With what did they roof?

Liselo: Oo! They used to roof with it, this *chaleng* (reed mat).

Young man: Having woven some rope?

Liselo: For what purpose? To roof with?

Young man: Yes.

Liselo: Yes, they used to gather reeds, *Ntate* [Sir]. Yes, they sewed with it. Yes, with *loli* [reeds]. Now, *moseya* [*moseka*? – a grass] was still plentiful even in the gorge across over there. Hmm! They made with it. Ee! It was not firm houses because it is inside a cave here. They only made crude drooping structures like this (indicating a low semicircular shape). Hmm! (note 14).

Self: Now these small houses, did they place them here, outside also, or all the time under the overhanging rock?

Young man: These small huts of theirs, did they place them outside here or inside the cave?

Liselo: They were inside here. Even the grass was spoilt by the cattle. Refuse was still visible here. Yes, they were placed inside here.

Self: Now, these small huts, did they not build them outside here on top, or over there, the place where the aeroplanes land now?

(Question repeated by young man.)

Liselo: Over there? There were no houses there, *Ntate* [Sir].[51] They were right here. Now, over there, they merely went to hunt there. And eland, then they would force them down that cliff, you know it also, that one which is in front of Masakoane's place, on the other

side. Eland used to lick there.[52] Now then, they will see [choose] a big one, strike it with an arrow there. The poison [of the arrow] would at once begin to spread through its body, it would then come running like that, they already forcing it down this way, until it reaches right here then. Then it would fall then. They would then make a rumbling sound, and skin it then. They hanged the meat all over, on rocks over here, on trees there. Hmm! Hmm! (note 15)

Young man (translating to me in Zulu): He says there were no houses over there (out in the open). Yes, they used to go there when going to hunt. Then they would force it [the eland] down this way, where they were hunting, force it down this way. Now, at their place, there is something resembling salt, over there, on top, that side, where eland used to lick. Where they used to find them. They would choose a big one, and kill it by striking it with an arrow, for it to come and fall, when the others [Bushmen] already blocked the way for it to fall over here. Then they would skin it, placing portions of the carcase here. They start by spreading it here and even hanging it on trees here.

Liselo: Now then, their women would do this: when they [the men] had gone out hunting eland, they [the women] would appear over there, on top of the cliff over there, so they would see it [the eland] when it appeared from over there. Then they would ululate over there, the one giving chase would hurry to reach it [the eland].

Young man: Oo! The women, at the time the men have gone out hunting, would sit over there, on top there. It will happen that when they [the hunters] come with it [the eland] they will ululate thus: Yii! Yii! Yii!

Liselo: Then the one giving chase will be encouraged [literally, his knees will stiffen, that is, he will run faster].

Young man: He will be encouraged at this time, and will hit and kill it.

Liselo: Yes, arrive quickly [at the fallen beast].

* * * *

Self: Now, this old man, did he see an eland – with his own eyes?

Liselo: Yes, I once saw it. Even there, they came having wounded it already, already having stabbed it. Do you see that narrow passage which descends from the waterfall? He forced it down there, he came hurrying after it, until it came – and appeared over here, at Khomo-ea-Mollo's place. We were still small boys then; beer was being drunk. Then just as people were eating at Likalakala's over here … they came rushing … one

had already wounded it, it died right there on the flat rock, on top, on top of that thing, that cliff belonging to Mmamolapo, which is on a flat rock, on that precipice – Hmm!

* * * *

Self: Now, you said there was a place over there on top which was loved by eland, said to be a place of salt?

Young man: Yes, salt, where they used to lick … I also know it.

Self: You also know this place. Is it far?

Young man: No, it is near. The place is nearby.

Self: You will show it to us then?

Young man: I will show it to you Madam. It is nearby.

Self (trying to direct the discussion back to Liselo): *Now, did the eland frequent that place?*

Young man: It is where they used to lick.

Self (turning again to Liselo): *So, the Bushmen would find the eland there when they went hunting. Is there a stone there?*

Young man: Yes! Even to this day the stone [flat rock] with salt is still to be found … Yes, you may think it is salt.

Self (directed at Liselo): *Now, is this the only place where there is salt?*

Young man: It is that one place only.

* * * *

(At this stage, I turned the tape off in desperation and walked across to the bench where stone artefacts were being sorted and bagged. After collecting an assortment of thumbnail and duckbilled scrapers, I walked back to Liselo and placed them in his hands. He felt the artefacts carefully and then peered at them closely).

Liselo: Oo! Are those for skinning? Hmm. They were sharp. They cut. They used them to cut and skin. These are their knives and little spears which are of this size [indicating the terminal phalanx of his forefinger].

Young man: They used this thing to skin. Making also their spears with it.

Self (turning again to Liselo): *How did they make this thing?*

Liselo: It cuts.

Young man: With what do they make this thing?

Liselo: That thing?

Young man: Yes.

Liselo: Oo! I do not know. Their thing is for them, because their things [implements] are many, and these small spears also, which are this size, we do not know where they got them from.

Young man: He says he does not know where they got them.

Self: Oo!

Young man: Ee!

Self: Alright! Now, concerning fire – how did they make fire?

Young man: Where did they get fire? Where did they strike it?

Liselo: E..e! You understand, I am unable to know, *Ntate* [Sir], because they used to kindle (*fehla*) with that thing called *kuje* [The word *fehla* means to kindle fire with apparatus that causes friction]. **Yes, they used to churn with it then. It would churn. *Toala*** [tinder or cinder?] **was still plentiful around the trees here.**

Young man: How did they operate this *toala*?

Liselo: A stick. A stick would be plucked off; as he continued to churn this root of the willow tree [with it], it would eventually smoulder, then he would pour cinder over (at that time).

Young man: When they wanted to kindle fire with a flame – what did they do?

Liselo: Hmm! E … e. No, the one [fire] with shooting flames, as for it then, indeed … they used to take that very one [from the cinder] … They would nurse it until it burst into flames on the cinder. Because they used to place the cinder here while continuing to churn. E—e (note 16).

Young man: Over here, was there a big forest here or there was no forest here?

Liselo: Goodness me! The trees were so thick, they had blocked out the sun! Willow trees and *cheche* (*Leucosidea sericea*) trees here – it was just black [very thick] and *lelothoane* (*Buddleia salviifolia*), it had turned itself into a big forest full of trees. Ee … it was very frightening.[53]

* * * *

Young man: Did the Bushmen ride horses or what did they do?

Liselo: They did not ride horses (note 17). **But they used to kill them, hmm! Should they see them, they killed them and ate them. They used to kill them, the horses. These very horses** (pointing to a saddled horse in the shelter which had been dismounted and left standing by a passing rider). **Ehe! They used to kill them and come and eat them, right here, over here. Hmm!**

* * * *

Self: Now, you told me before, there was a Bushman who ran away. He fled to Chief Tlhakanelo's kraal. Now, what was his name?

Liselo: Oo! Jan! Yes, Jan, who was this height (indicating a short stature, less than five feet (1.5 m)). **He was already**

an old person. **He lived there. Now I do not know where he went and died. I do not know where he died. Ee! Hmm!**

Self: How old were you at that time, when Chief Jonathan came this way, with his army?

Liselo: Goodness, we were still very small. I was as old as that little girl – the very youngest. We were very small still. I had not even attended the initiation school. Yes, we were still small boys.

* * * *

Self: You once mentioned one Bushman who was a doctor. Moreover, he was a very good doctor. What was his name?

Liselo: Rasoetsa.[54] **Ee, - - - as for him, he had already studied medicines** (herbs, etc.) **over there at the Orange River. Now, he already practised this art. He eventually came and died over here in that shop. Over here, when Maphehello and family still lived here; you see, next to those peach trees over there? The ones belonging to Maphehello. He already lived there** (he had settled there).

* * * *

At this point, Liselo had clearly had enough of the interview. He carefully took out a pouch and a pipe from under his blanket, then methodically began filling the pipe from the contents of the pouch.

Young man: It is dagga (cannabis). He is smoking dagga. He will fill here and ignite it, and then smoke. Do you understand then? When he smokes this, he throws himself into the water (into a river).

Self: Oho!

A hearty spasm of coughing is then recorded on the tape, followed by laughter and the words:

Phakathi emanzini! [Into the water!] (note 18)

After a short pause, Liselo began to sing a praise poem of one of the Basotho chiefs (note 18), and it is at this point that Mr Moephuli ended the transcription.

Discussion and assessment

The information given independently by Sello Mokoallo and Liselo Rankoli correlates reasonably well, although the names of the individual Bushmen whom they remembered, as well as those of some Basotho chiefs, differ to some extent. The process of oral communication, in conjunction with selective memory spanning many decades, no doubt accounts for most of the discrepancies.

The following points of discussion are numbered consecutively and correlate with notes 1 to 18 marked in the text above.

Variations of name

1. The information given by Sello Mokoallo that Chief Tlhakanelo expelled the Bushmen from Sehonghong Shelter was not borne out by the other informant, Liselo Rankoli, nor by other published references (see note 4). However, it is quite possible that Tlhakanelo (or Thakane?) was also responsible for some depredations against the Bushmen and that there may have been more than one skirmish centred on Sehonghong Shelter when Bushmen lost their lives.

 When I initially interviewed Liselo, I recorded the name of the Sotho chief who instructed a Bushman survivor to herd his cattle as Tlhakanelo. However, in the tape translated by Mr Moephuli, Liselo gave the name Thakane as the Mosotho who ordered the Bushman to do this work. Since I did not receive the translated tape until long after we had left Lesotho, I was not able to check this discrepancy with Liselo. I am, however, inclined to think that the mistake was mine and that I may have misheard the name, or at least linked it with a name with which I was already familiar. I do recall being puzzled at the time and having difficulty transcribing the name he was saying.

2. Although Liselo did not mention the name of the Bushman herdsman to whom he was referring during the taped conversation, he told me, during our initial interviews, that a Bushman named Moutloanyana escaped from the Sotho warriors by hiding in the river. Subsequently, this man was summoned by Tlhakanelo (or Thakane?) to herd domestic animals, but he ran away. Later, when I questioned Liselo about the Bushman whom the other informant had named Ou Jan, Liselo gave similar information, that is, Ou Jan had deserted his post as herdsman. It is therefore possible that Ou Jan is the Europeanised name for Moutloanyana, but I did not clarify this point at the time.

3. Liselo gave the name of the Bushman chief who fell to his death as *Soai*, a name with which I was already familiar from published literature. In case I was interpreting the name according to my own expectations, I asked my interpreter, Regina, to write the name in my notebook. The first mention of this name is therefore in her writing, and it was Regina who spelt it *Soai*. Mr Moephuli, on the other hand, wrote the name as *Swai*. In the literature there are other variations, such as Tsuayi, Sweni, Zwei and Zweei.

Discrepancies in historical data

4. There are a number of accounts of the last integrated band of Mountain Bushmen in Sehonghong Shelter that vary in detail (Jacottet 1893: 511; Stow 1905: 229–230; Dornan 1909: 449–450; Ellenberger 1953: 246–247, 253–258; Willcox 1956: 31–32; How 1962: 21–22; Germond 1967: 416, 418, 425, 428; Wright 1971: 174; Smits 1973: 32; Vinnicombe 1976: 101). The discrepancies in the accounts from the two old men from Khomo-ea-Mollo therefore simply add to the already numerous variations. The story of Soai crashing to his death when gathering honey is another variation; a published account claims this to have been a Bushman named Sehonghong (How 1962: 16), while others claim that it was Melikane (Stow 1905: 199; Dornan 1909; How 1962: 19).

 It is evident that the Sehonghong massacre, the escape by hiding in the river, and the honey-collecting episode have become part of the local mythology, and variations on the theme have been told and retold through the years. I feel confident that the version told by Liselo derives solely from oral sources and that it is highly unlikely to have been influenced in any way by written accounts. Liselo and his generation of villagers in that remote mountain village were wholly illiterate.[55] However, as in so many similar cases of oral history, the basic facts remain recognisable, but become embroidered by details often borrowed from other stories. It is unlikely that the true story will ever be fully unravelled.

5. It is of interest that Liselo reported that a white man at Mashai store took some Bushman skulls from Sehonghong Shelter. When Don Morrison and I walked to Sehonghong Shelter and Mashai store in 1957, I noticed a fragmentary skull on a shelf among a conglomeration of merchandise for sale. Mrs How (1962: 26) had also mentioned these skulls in her publication, and all accounts, including that of the

trader, agreed that the skulls had originated from Sehonghong Shelter. I subsequently negotiated with the owner of Mashai store, Mr Edgar Calder-Potts, to have the skull professionally identified. James Kitching, who was visiting a relative in the Underberg District soon after I took delivery of the skull, carried the relict to the University of the Witwatersrand on my behalf, and Dr Hertha de Villiers inspected the morphology. Disappointingly, the features showed a predominance of Bantu rather than Bush (*sic*) characteristics, which rather spoilt the story (Vinnicombe 1976: 101). James Kitching nevertheless catalogued the specimen, and the skull fragment is currently housed in the Raymond Dart Palaeontological Museum at the University of the Witwatersrand, Johannesburg.[56]

Additional notes made by Mr Moephuli

6. There are several instances where Mr Moephuli made notes within the translation, and the identification of the names given for animals and plants, which I have included in the text, were all made by him solely on linguistics grounds. I have not checked this information independently with a zoologist or a botanist.

7. Other notes by Mr Moephuli are worthy of mention, for instance Liselo's rather enigmatic use of the phrase 'adopted one' when explaining the relationship between the Bushwomen and an unnamed man. The word used by Liselo was *mmotloanyana*, meaning adopted child. Mr Moephuli noted that the verb *otla* means to feed (an adopted child or animal). *Mootloana* means one who has been adopted, irrespective of age. Mr Moephuli concluded that the Bushman referred to could therefore have been very old which, in the context of the story, therefore means that the person referred to is probably Ou Jan or Moutloanyana.

8. Regarding the grass called *moseka* or *motseka* or *moseya* (it is spelt variously in the translation, but I have consistently used only the first spelling), Mr Moephuli notes that the seed of this grass, as well as of other grasses, is eaten by the Basotho in times of famine. Liselo also gave the name *tsane*, which is apparently an alternative name for *moseka*.[57]

Ethnography

Arrows in headbands

9. Stow (1905: 71) recorded that the Bushmen frequently carried arrows in a fillet round their heads. Some wore them sticking out like rays all around, others arranged them on either side of their heads so as to represent horns, and others fixed them so that the ends alternately crossed over one another until they formed a kind of ridged roof over the head. Rock paintings showing such protrusions from the head have been interpreted as arrows carried in headbands (Vinnicombe 1976: 53). The independent observation made by Sello Mokoallo that when Bushmen were on the move, they carried their arrows stuck into a skin band worn round their heads would seem to corroborate the information recorded by Stow.

Magic

10. It is of note that a Zulu man, who was assisting the team that excavated Good Hope Shelter in the Underberg District of KwaZulu-Natal in 1971 (Cable *et al.* 1980), told me of a similar belief. He said that when Bushmen hunted eland they put a scented herb in the footprints of the eland they were following, and that this gave them control over the movements of their quarry and facilitated their ability to stalk and shoot it.

Grass cutting

11. I tried to get a more detailed description of the grass-cutting implement mentioned by Liselo and understood from his admittedly uncertain response that the pieces of sharp stone were small and set in gum. He said he knew the kind of stones used – there were many about. I later showed him a thumbnail scraper, at which he peered with his hazy eyes, and declared that that was the stone. On another occasion, however, I showed him a backed blade, and he similarly declared that that was the stone. I do not believe that Liselo's eyesight was good enough to distinguish detail and, similarly, his descriptions of the implement were too uncertain to use as sound evidence.[58]

Pottery

12. Much of the ethnographic evidence given by the old men is well corroborated by other historical sources, which are so well known that it is not necessary to make full

▲ **Figure 9.9**
Sehonghong Shelter, section of the 1971 Carter/Vinnicombe excavation showing stake holes that could have derived from the kinds of structure described by Liselo Rankoli. Photo by Pat Carter.

are not known to me. The only written ethnographic reference to line fishing among the Bushmen of which I am aware is DF Ellenberger's (1912: 8) passing note that the Lesotho Bushmen caught fish with hooks made from ivory, but this evidence is now firmly corroborated by archaeological finds. The first bone fish hooks located in the central mountain massif were in the excavation of Belleview Shelter by Patrick Carter in December 1969, and subsequently at Good Hope in 1971 (Cable *et al.* 1980). The information regarding Bushmen fishing obtained from these two old Basotho men is therefore good corroborative documentation, and the seasonal variation in the technology used is especially noteworthy. Liselo said the Bushmen shot fish with the bow and arrow during the dry winter months when the flow of water is reduced and fish are concentrated in pools, but that they fished with baited hooks in the wet summer months when the rivers flow swiftly.[60]

The construction of huts

14. The information that flimsy huts were constructed within the rockshelter is particularly interesting in relation to evidence noted during the archaeological excavation at Sehonghong. A clear feature could be seen in the stratigraphic section which cut vertically through the horizontal floor deposits and which we interpreted as a possible stake hole. In view of the evidence given by Liselo, this feature may be explained as archaeological confirmation of the presence of huts within the shelter (see Fig. 9.9).

Driving eland

15. I am not aware of any published references to the Bushmen having driven game animals to the vicinity of their camp before despatching them. It is, however, a logical and labour-saving method to have used, and there are published accounts of European hunters, especially when on horseback, having driven eland to their camps before shooting them (Harris 1841: 68; Sparrman 1975[1786]: 210; Vinnicombe 1976: 296).[61]

Fire-making

16. The description of fire-making given by Liselo is somewhat confusing because of the apparently interchangeable use that is made of the words cinder and tinder. *Toala* is the cinder of the plant *toane* used as tinder.[62]

comparative references here. What is not so well known, however, is that the Bushmen made and used crude pottery, in addition to trading for pots with their Iron Age neighbours. Many rockshelters formerly used by the Mountain Bushmen still show evidence of broken pottery, and there are historical accounts of pottery having been found in rockshelters occupied by Bushmen (Vinnicombe 1976: 28, 78, 83, 112, 114, 123, 281).[59]

Fishing techniques

13. The Bushmen's use of spears and traps for securing fish is well documented (Schapera 1930: 137–138), but records of Bushmen fishing by using the bow and arrow

Horse riding

17. The information that the Bushmen did not ride horses is not in accord with the historical facts. It is well known that many of the Mountain Bushmen raided, traded and rode horses during the latter part of the nineteenth century (Wright 1971; Vinnicombe 1976), a fact which is also well documented in their paintings. The information given by the other informant, Sello Mokoallo, that the Bushmen were fearless and skilled riders, is likely to be more correct.[63]

The effects of smoking cannabis (*dagga*)

18. Schapera (1930: 101–102, 241) summarises the use of narcotics among the Khoisan peoples, and Stow (1905: 52–53) gives a vivid description of Bushmen smoking *dagga* using a pipe made from an eland horn with a fitted clay bowl. As in this description, both Sello Mokoallo and Liselo Rankoli recited praise poems immediately after smoking *dagga*. The description provided by Dornan (1925: 122–123) also exactly fits the method demonstrated by Sello Mokoallo: "Usually the Bushmen do not carry complete pipes. The bowl, sometimes made of stone or sun-baked clay, is carried in the wallet, and the pipe-stick is slung round the neck by a cord. Often the bowl is dispensed with, and the Bushman, when he wants to smoke, makes a small hole in the ground, into which he puts the tobacco and inserts his pipe-stick through a small tunnel and smokes." It is also of note that when Lucas Smits and his party walked to Sehonghong Shelter in May 1971, they located some interesting surface finds that included a partly broken bored stone very similar to published illustrations of Bushman smoking pipes (How 1962: 45; Smits 1973).

The final reference in the tape likens the effects of smoking *dagga* to throwing oneself into water or the river. This analogy is particularly interesting in the light of the trance hypothesis developed by David Lewis-Williams (1981) after the above information was recorded and *People of the Eland* was written. A key link in the trance interpretation is the mythology recorded by JM Orpen in 1874, obtained from a Bushman named Qing, in whose company he visited two (*sic*)[64] rockshelters in Lesotho, including Sehonghong. Orpen discussed particular paintings with Qing, who referred to depictions of men with rhebok's heads as men who "live under water" (Orpen 1874: 10). In *People of the Eland*, I suggested that this rather enigmatic interpretation could perhaps be explained by the fact that the Bushman language had but one word for both water and rain (Bleek 1933: 304), and that the text recorded by Orpen may simply mean that the men and the animals were in the rain, rather than underwater (Vinnicombe 1976: 336). Lewis-Williams (1981: 34), on the other hand, suggested that the underwater reference was a metaphor for trance, and that what Qing meant was that the men had entered trance and were in an experience analogous to being underwater.

The expression 'into the water' used for describing the state of mind produced by inhaling cannabis in the episode recorded above certainly provides collaboration for Lewis-Williams's explanation, and strongly suggests that the smoking of cannabis may have played a part in the symptoms produced by the trance dances of the Mountain Bushmen.[65]

NOTES

1 More recent accounts include those obtained from Nguni-speaking people of Bushman descent in the Tsolo District of the Eastern Cape Province (Jolly 1986, 1992; Lewis-Williams 1986; Prins 1990) and from Basotho individuals living in various parts of the Lesotho Highlands (Jolly 1994).

2 The paper, which was probably compiled in 1992, is published here almost exactly as first written and communicated to Mitchell in 1993. Two paragraphs on the history of how Sehonghong Shelter was identified with Orpen's (1874) Mangolong site and some notes at the very end addressed to Mitchell and to Pat Carter have been omitted. A few typographic errors have also been corrected and figures have been selected and inserted in the text to illustrate the account given. The footnotes provide additional commentary and references, in large part drawn from a document prepared by Mitchell and sent to Pat Vinnicombe in 1994. Regrettably, her intention to "take up the cudgels again" and complete publication of this extraordinary material was not fulfilled.

3 Relevant publications are Mitchell (1993, 1994, 1995, 1996a, 1996b, 1996c), Mitchell and Vogel (1994), Binneman and Mitchell (1997), and Mitchell and Charles (2000). Results of the excavation in which Pat Vinnicombe herself played an active part can be found in Carter (1976, 1978), Carter and Vogel (1974) and Carter *et al.* (1988).

4 Thus, around 1889–90 and almost two decades after the well-known attack on Soai and his followers at the same shelter. Note, however, that Sir Marshall Clarke, Resident Commissioner of Basutoland, who visited Sehonghong Shelter in October 1887, makes absolutely no mention of Bushmen living there at that time; nor does Rev. E Jacottet, who was there in March 1893 (Germond 1967: 421–422, 425). It may be that the reoccupation of which both Ntate Mokallo and Ntate Liselo spoke was therefore quite short-lived.

5 A narrow, tunnel-shaped shelter slightly downstream and to the south of the main Sehonghong Shelter contains a painting of a male figure with what appears to be a dog (Figure 9.4) immediately to his left (recorded by Mitchell as Lesotho site 2928DB25). Other paintings of dogs were recorded elsewhere in Vinnicombe's (1976: 157) research area. Lee (1979: 142–144) states that dogs were widely used in the 1960s by Ju/'hoan Bushmen to track game and to kill steenbok, duiker, warthog and gemsbok, although the amount of meat obtained with their help appears to have fluctuated considerably over time (see Mitchell [2008] for a fuller discussion of dogs and southern African hunter-gatherers).

6 Along with comments recorded later on from Ntate Rankoli, this is significant in indicating that stone was still used to form arrow armatures in the late nineteenth century, despite the availability of iron and at least partial access to European-made firearms.

7 Although Marion How's (1962: 44) informant denied it, Ellenberger (1953: 133) states that 'all the blacks asked in Basutoland who had known the Bushmen were unanimous in mentioning the venom of snakes such as the viper 'Qoanè or Maloti viper, the red snake Mŏnyŏfi found in the Makhakeng Valley, the cobra … etc.' (my translation). Various other poisons were also in use by the Maloti-Drakensberg Bushmen, including beetle larvae, the amaryllis Boŏphane disticha (Ellenberger 1953: 138–139) and the tree Acokanthera sp. (Cable 1984: 56; cf. How 1962: 44–46). Shaw et al. (1963) discuss Bushman poisons in detail.

8 The similarity with Qing's comment to Orpen (1874: 3) that he did not know where /Kaggen was, but that /Kaggen was where 'eland are in droves like cattle' is uncanny. Both Vinnicombe (1976: 163, 177) and Lewis-Williams (1981: 106) have stressed the many similarities between the two species, which include their general size and massiveness, similar spoor, resting postures and gestation period, and their practice of jointly defending calves against predators.

9 That eland were present in the Senqu Valley all year round is an important observation and strengthens the case developed by Carter (1978) that hunter-gatherers living in this part of the Maloti-Drakensberg area may have been able to sustain themselves under interglacial conditions without the necessity of long-distance movements beyond the area. It also fits with information cited by Vinnicombe (1976: 74) from a mid-nineteenth century informant, Qinti, that while the Thola Bushmen lived on both sides of the Escarpment a different, but unnamed, group lived along the Senqu.

10 Ntate Mokoallo's statement here may, perhaps, relate to features of eland social organisation. Estes (1991: 189) reports that on the Athi-Kapiti Plains of Kenya, for example, during the rainy season eland form herds in which young outnumber adults and "one may even see herds composed entirely of calves and juveniles". Moreover, calf–calf attraction seems to be a major feature of eland social life and "eland herds tend to be spread out except for clusters of young animals" (Estes 1991: 189). Closer to Sehonghong, Smithers (1983: 680) cites a study by Underwood (1975) in the Loskop Dam area who observed that, "By the end of April the nursery groups consisted principally of young individuals and these remained as independent units through the winter months to form the core of the following year's juvenile groups when the cows joined them again." If similar practices were followed by eland in the Senqu Valley, then perhaps young animals remained closer to the main Senqu River, with adults, or at least some of them, tending to graze farther away (and higher up on the plateaux and in the uplands) at some times of the year.

11 According to How (1962: 16), the son of the Bushman leader known as Sehonghong and another Bushman managed to flee on horseback to the Leqoa Valley, where they fought valiantly before eventually being killed by chief Jonathan's commando. Vinnicombe (1976: 103, 108) collected oral reports indicating that Bushmen groups survived along the Leqoa River as late as 1886.

12 This is consistent not only with his own statement that one of them showed a horse belonging to Paramount Chief Lerotholi, but also with the evidence of an elderly Sotho woman reported by Ellenberger (1953: 148–149) who had visited Sehonghong Shelter c. 1872 and seen three men painting inside it.

13 The use of eland blood and fat as ingredients in paint is confirmed by two other informants (How 1962: 35–36; Jolly 1986: 6; Jolly & Prins 1994: 20), as well as less specific

comments recorded by Ellenberger (1953: 164).

14 The figure in question is still quite visible and recalls the Eldritch figures discussed by Blundell (2004) from the Maclear area of the Eastern Cape Province in having a large, bulbous, almost deformed head, although details of this are lacking. The figure's large size in relation to those painted immediately in front of it also recalls Dowson's (1994) discussion of what he terms 'pre-eminent shamans', individuals who used their shamanistic abilities to assume more formal positions of leadership during the nineteenth century.

15 Son of Letsie I and thus grandson of Moshoeshoe, Lerotholi was Paramount Chief of the Basotho from 1891 to 1905. Matsieng was his capital and remains the traditional seat of Lesotho's Royal Family.

16 At the same time as the Basotho fought against the Cape Colony's attempt to prevent them from carrying guns, the Mpondomise chief Mhlontlo also rebelled. A few Europeans were killed in clashes at Sulenkama near Qumbu and others besieged at Maclear and Ugie in the Eastern Cape Province. Mhlontlo and his followers then fled into Lesotho.

17 This is completely consistent with known historical facts. When Orpen (1874) and Grant (1873/74) rode through the eastern highlands of Lesotho in the summer of 1873/74 they encountered no Basotho villages there (Mitchell & Challis 2008). Subsequently, Moshoeshoe I's nephew, Maluke, led his people to the Upper Senqu in 1878, the same year as Tlhakanelo founded the settlement that lies at the core of the modern village of Sehonghong. Whole villages later moved into the highlands during the Gun War and by 1885 there were over 600 estimated to be present between the sources of the Senqu and Mount Moorosi (Eldredge 1993: 63). Jacottet's reference to the presence of Basotho villages 'at intervals as far as Sehonghong' as early as 1865 is inexplicably at odds with this and his own citation of the Orpen/Grant expedition to the effect that it 'scarcely found a single village' along its route (Germond 1967: 428–429).

18 Thus, around 1887/88, consistent with Ntate Mokoallo's account and again many years after the historically attested attack on Soai and his group at Sehonghong Shelter. See also note 4 above.

19 Though Liselo in his later taped interview said that these tattoos were the work of Basotho, such scarifications are well attested among the women of some Kalahari Bushman groups where a primary motivation is aesthetic (Bleek 1928; Thomas 1959; Van der Post & Taylor 1984), though with strong associations to the cultural construction of gender (Biesele 1993).

20 i.e. at the site of the modern village of Sehonghong.

21 This was confirmed as late as 1887 by the High Commissioner of Basutoland, Sir Marshall Clarke, who reported seeing fresh eland spoor along the upper Senqu (Germond 1967: 418–423), although eland were probably extinct within Lesotho by 1905 (Ambrose et al. 2000: 40).

22 It is worth noting that in the contemporary Giraffe Dance of the Ju/'hoansi of the Kalahari and other such trance dances this is exactly the role of the women, i.e. to sing medicine songs that will activate the spiritual potency of, and lend support to, the (male) dancers as they seek to attain an altered state of consciousness (Katz 1982). The parallel is striking, given the spiritual significance of eland to both Kalahari and Maloti-Drakensberg Bushmen and the close connections seen between the behaviour of a dying eland and that of a shaman who 'dies' to enter trance (Lewis-Williams 1981).

23 Ntate Rankoli's reference here is puzzling, though it recalls later discussion in his taped interview about attracting eland to salt licks close to Sehonghong Shelter. If he meant that eland were enticed over the Escarpment and then returned to Lesotho later in the year, this is at odds with his own words a few sentences earlier, as well as with the comments made by Ntate Mokoallo. On the other hand, perhaps this is an attempt to explain the local extinction of eland at the very end of the nineteenth century.

24 This is the honey badger (Mellivora capensis). The species is present in late Holocene levels at Likoaeng (Plug, in press) and Pitsaneng (Plug 2003), but not at Sehonghong Shelter itself. It was not recorded by Lynch (1994) in his survey of the present-day mammals of Lesotho and appears to have become extinct there in the 1940s (Ambrose et al. 2000: 41).

25 This is the common or Grimm's duiker (Sylvicapra grimmia). It is present in faunal assemblages from Sehonghong, Likoaeng and Pitsaneng (Plug, in press, 2003; Plug & Mitchell 2008a) and probably still occurs in isolated portions of the Senqu Valley and associated valleys. My interpreter at Sehonghong in 1992, 'Me Makhalane Mahasete, reported that she had eaten duiker meat killed by her father near Qacha's Nek.

26 Consistent with this, zebra are completely absent from the archaeozoological assemblage excavated from Pitsaneng (second millennium AD; Plug 2003) and from late (but not mid-) Holocene contexts at Sehonghong (Plug & Mitchell

2008a). It is represented by only a single enamel fragment from Likoaeng (Plug, in press) and thus seems not to have been present in the Sehonghong area after around 1600 CAL BC.

27 Red hartebeest survived in the Lesotho Highlands until the end of the nineteenth century and are reported by Clarke (1888) and others. As Vinnicombe (1976: 203) herself noted, the last herd in the Underberg/Sani Pass area perished in a snowstorm in 1918.

28 It seems possible that this is a reference to the collection of grass for use as bedding materials, something widely attested from southern African hunter-gatherer contexts, especially in the Western Cape Province and at the southern Drakensberg site of Strathalan, where grass bedding patches are well preserved (Opperman 1996a, 1996b; Parkington & Mills 1991). At least some of the grass found during excavation at Sehonghong Shelter presumably derives from the same practice, but neither Carter's 1971 trench nor that opened up by Mitchell in 1992 were on a sufficiently large horizontal scale to allow such areas to be identified. Carter and Vinnicombe's excavation produced remains of two taxa, *Themeda triandra* and *Cymbopogon* sp. (Carter *et al.* 1988: 223).

29 This is *Cyperus usitatus*, likely to be widely distributed in river valley and plateau locations around the Sehonghong area. Small bulbs of it were collected very close to the Likoaeng archaeological site in July/August 1995. Corms of this plant were recovered from Carter and Vinnicombe's excavations at Sehonghong Shelter in 1971 (Carter 1978; Carter *et al.* 1988).

30 The reference to trade here is of interest since a minority of the sherds found in Mitchell's 1992 excavation at Sehonghong Shelter are of an orange-buff colour strongly associated with local Basotho pottery traditions, to judge from the make-up of a sample collected from an abandoned village site a few kilometres farther upstream between Khomo-ea-Mollo and the village of Ha Masakoane. More direct evidence of such trade in pottery comes from excavations at two other sites in the vicinity. At Pitsaneng, just one kilometre upstream from Sehonghong Shelter, Hobart (2003, 2004) found a Moloko sherd, directly dated using Optical Luminescence to AD 1580 ± 60 (OxL-1315), which seems likely to have been made north of the Vaal River, and certainly outside of Lesotho. Excavations at Likoaeng, on the other hand, produced a small ceramic assemblage dated to around 800 CAL AD that includes a single sherd attributable to the Ndondonwane phase of the Early Iron Age of KwaZulu-Natal

and undoubtedly introduced to the site from across the Drakensberg Escarpment (Mitchell *et al.* 2008).

31 The term *leloli* refers to grasses that are still highly prized today for use in weaving mats, ropes and the traditional Basotho hat. Increasingly rare, in some areas they can now only be collected with the permission of local chiefs.

32 i.e. *moseka, Eragrostis curvula*.

33 *Mohlomo* is the thatching grass *Hyparrhenia hirta* (van Wyk & Gericke 2000: 316).

34 Thus, around 1902/03.

35 The reference here to cutting people and drawing blood sounds more like Basotho medical practice, although perhaps Bushmen in the Maloti-Drakensberg area also did this. The explicit denial that Rasethla made rain is of interest since the likelihood that Bushman shamans may have done so for Bantu-speaking neighbours is commonly suggested in the archaeological literature, although only known with certainty in the case of the Mpondomise of the Eastern Cape Province (Dowson 1994).

36 Actually, his grandson. Jonathan was the son of Molapo, himself a son of Moshoeshoe I and in charge of much of northern Lesotho at this time.

37 The Sehonghong joins the Senqu approximately three kilometres downstream of Sehonghong Shelter.

38 Pat recorded this site as Soai's Honey Shelter (number 10 in the Sehonghong area) and this has subsequently been given the number 2928DB5 by Mitchell, although it could not be relocated when sought in 1992.

39 Here and elsewhere in his transcriptions Mr Moephuli used South African orthography for translating Sotho names and terms. Given that Vinnicombe is writing here about events inside Lesotho, I have preferred to make use of the correct Lesotho forms. The key differences are the use of *ea* for *ya*, *oa* for *wa*, *ch* for *tjh* and *li* for *di*.

40 See note 36.

41 How (1962: 47) records that she was told by a Mr Crooks that near Mashai the remains of a ladder made by driving wooden pegs into fissures in the sandstone and of an accompanying grass hand-rope could still be seen at a site along the Senqu Valley.

42 Ntate Rankoli's disparaging reference to venison as 'merely meat' is of interest in reflecting the high value placed by Basotho on domesticated meat and the importance of this in consolidating social distinctions between themselves and Bushmen, who did not normally have access to mutton or beef.

43 And were still living on a massive boulder immediately in front of Sehonghong Shelter on Mitchell's first visit there in 1985. Though not noted, they were said to be still present in the vicinity in 1992.

44 Killing dassies at dawn would seem to make sense. They come out of rocky crevices as it gets light to sit in the sunshine and warm up. At dawn they would still be fairly torpid and sluggish and thus probably easier to catch (Estes 1991: 252).

45 The Sesotho word *'mutlanyana* can refer to Smith's red rock rabbit (*Pronolagus rupestris*) as well as to the Cape hare (*Lepus capensis*) and the scrub hare (*L. saxatilis*). Specific names also exist for all three species, though *tlholo*, another term for the first of them, can also refer to a fourth taxon, the Natal red rock rabbit (*Pronolagus crassicaudanus*). The presence of the latter requires confirmation, but Smith's red rock rabbit is known from the Sehonghong area (Lynch 1994). Scrub hare is also reported there (Lynch 1994) and was seen in both 1998 and 2006 only a few kilometres north-west of Sehonghong Shelter. It is the only lagomorph known from late Holocene archaeological assemblages in the area.

46 This must be a mistranslation into English since blue duiker (*Philantomba monticola*) requires considerable cover and is now found in forested areas of the lowlands of KwaZulu-Natal. It is impossible to imagine it having been present in the Sehonghong area in the nineteenth century. The solution is, in fact, quite simple, as the Sesotho word *phuthi* refers not only to this species and the red duiker (*Cephalophus natalensis*), which has similar habitat preferences, but also to the common duiker (*Sylvicapra grimmia*), which is still extant in Lesotho, though very rare (Lynch 1994).

47 Dunn (1931: 84), writing of his experiences of the /Xam Bushmen of the Karoo, refers to their use of pots to cook "a kind of porridge made from ground grass seed" that may provide a relevant comparison here.

48 Numerous grindstones were found during excavation of Sehonghong Shelter in 1992 (e.g. Mitchell 1996b) and many more are still present on the surface of the site or on the talus below (cf. Smits 1973: 33); yet others form part of the backfill to Carter and Vinnicombe's 1971 excavation trench (Peter Mitchell pers. obs. August 2007). Interestingly, Kannemeyer (1890) notes that grindstones were also used to break down grass stalks before working them into clay used to make pots, although none of the hunter-gatherer ceramics known from Lesotho is grass-tempered. As well as being used in some instances to grind ochre, grindstones were probably

also used to process geophytes (such as those recovered from the Sehonghong Shelter excavations; Carter *et al.* 1988: 223) and, perhaps, meat (Vogelsang 2006).

49 This part of the interview is puzzling, and indeed maybe there is not much sense to be made of it. Might the reference to 'scattering' imply that the Bushmen had no long-term storage and thus brought in food on a more-or-less day-to-day basis?

50 Although the exotic European willow (*Salix babylonica*) occurs in the Sehonghong Valley today, fragments of wood recovered from Carter and Vinnicombe's 1971 excavations at Sehonghong Shelter confirm the local presence of the indigenous species, *S. capensis* (Carter *et al.* 1988: 223).

51 Nonetheless, an extensive scatter of stone artefacts, of both Middle and Later Stone Age kind, is present around the airstrip at Sehonghong; it is recorded as Lesotho site 2928DB39.

52 Ha Masakoane (the literal translation of which is 'Masakoane's place') is the name of a village a few kilometres upstream from Sehonghong Shelter. Like Khomo-ea-Mollo, it too lies on the south side of the Sehonghong River.

53 Both *Leucosidea* and *Buddleia* are still present in the area today and their presence in the past is confirmed by analysis of charcoals from Likoaeng (Esterhuysen & Mitchell, in press) and fragments of *Leucosidea* wood recovered from Sehonghong Shelter in 1971 (Carter *et al.* 1988: 223). A dense stand of *Buddleia* occurs immediately in front of the shelter at the base of the footpath leading from it up to Khomo-ea-Mollo.

54 Presumably the same person as the Rasethla mentioned by Ntate Mokoallo.

55 This is undoubtedly true, but we should note that the Lesotho Evangelical Church mission station at Sehonghong was founded in 1892 and that soon thereafter people began to leave their names (with accompanying dates) on the accessible parts of the rear wall and roof of Sehonghong Shelter (Figure B10.1).

56 The predominantly 'Bantu', i.e. negroid features, of this skull are not inconsistent with it being that of a Bushman individual killed in Jonathan's attack on Sehonghong Shelter around 1873. There is good evidence for intermarriage between the Maloti-Drakensberg Bushmen and surrounding Bantu-speaking groups (Jolly 1994), as well as for the last hunter-gatherer groups in the Maloti-Drakensberg Mountains being of ethnically and racially mixed origins (Challis 2008). Regrettably, the skull in question seems not to have been accessioned by the Department of Anatomy (**not** Palaeontology) at the University of the Witwatersrand,

or at least it is untraceable in its catalogue (Alan Morris pers. comm. 11 January 2007).

57 *Moseka* is the grass *Eragrostis curvula*, known as a famine food among recent Basotho (Eldredge 1993: 66). The grains can be ground into flour (Guillarmod 1971).

58 Liselo's admittedly hazy recollection is consistent with the possibility raised by archaeological evidence that microliths, whether backed or not, may have been inset into wooden handles to form composite artefacts ('sickles') suitable for harvesting wild grasses. Binneman's (1982) analysis of segments from Wilton levels at Boomplaas in the Western Cape Province indicates that they may have been hafted in series to form this kind of cutting implement. These possibilities are reinforced by results of microwear and residue analysis of late Pleistocene Robberg Industry bladelets from Sehonghong (Binneman & Mitchell 1997) and Rose Cottage Cave, Free State (Binneman 1997; Williamson 1997).

59 Bollong *et al.* (1997) provide a thorough discussion of the ethnohistoric evidence for Bushman manufacture of pottery in southern Africa. Ellenberger's (1953: 86) informant, 'Me Môhanoè, who visited Sehonghong Shelter *c.* 1872 apparently observed ceramics being made too, but offers a less than convincing account of the process (Mitchell 2006/07).

60 The information obtained from Ntate Mokoallo and Ntate Rankoli on Bushman fishing techniques assumes added significance in the light of the fish assemblages excavated from the site of Likoaeng after Vinnicombe originally wrote this paper. Plug's (in press; Plug & Mitchell 2008b) analysis of these and of the smaller, but temporally much more extensive, assemblages from Sehonghong Shelter itself suggests that a variety of fishing methods were used. Line-fishing was probably among them, since a beautifully preserved bone hook was recovered from Likoaeng. Since many of the fish there were probably caught during spring spawning runs, other techniques, such as the use of basket traps or simply picking up fish by hand, are also likely. Direct evidence for spearing (or perhaps shooting) fish is also available as several cranial bones bear circular perforations that are clearly the result of impact from pointed weapons.

61 In *People of the Eland*, Vinnicombe (1976: 163) noted that it is fairly easy to drive eland. They always run against the wind, will not turn into it and will only gallop when hard-pressed (Estes 1991: 190). Their size and fatness also make them easy prey. Vinnicombe (1976: 291) also considered that the apparently dead eland at her site W17 on the Tsoelike River in south-eastern Lesotho was shown in a way consistent with it having been driven over a cliff. However, the presence of trance-related imagery, such as a person bent at the waist with arms back, must query a straightforward interpretation of this scene.

62 The word *toane* can refer to a number of plant taxa, but the one probably meant here is *Helichrysum tenuiculum*, which was once widely used as tinder since, having been lit, it keeps glowing for a very long time (Schmitz 1980: 186). The shoots of the plant, which was previously known as *H. kuntzei*, are also edible and remains of it were found in the Holocene deposits excavated by Carter and Vinnicombe at Sehonghong Shelter (Carter 1978; Carter *et al.* 1988: 223). *Diospyros austroafricana*, a hardwood favoured for making firesticks, still occurs in the Sehonghong Valley, and a possible firestick fragment was found on the surface of Ha Lepeli Shelter a few kilometres away in 1992.

63 One of the best-known Lesotho sites at which horses are represented is Melikane, where Bushman riders are shown chasing red hartebeest and part-eland/part-horse creatures are also depicted (Campbell 1987). At Matebeng, midway between there and Sehonghong, Bushman riders are also shown hunting eland from horseback (Vinnicombe 1976: 159). Ellenberger (1953: 247) states that, "We have traced … precisely also in Soai's cave, Bushman paintings representing galloping horses." Paintings of horsemen hunting eland and of other horses were also traced by Vinnicombe and, though now badly preserved, were still identifiable in 2007.

64 Orpen visited three rockshelters in Lesotho, as evident in his paper (Orpen 1874).

65 Evidence for the use of narcotics, including hallucinogens, by southern African hunter-gatherers is reviewed by Mitchell and Hudson (2004). In particular, they note that the stories retold by Qing to Orpen (1874) make frequent reference to *canna*, which is most likely to be identified with *Sceletium* spp., a known narcotic. Underwater imagery suggestive of the experience of altered states of consciousness is well known in southern African hunter-gatherer rock art (e.g. Lewis-Williams & Dowson 1989: 54–57). According to the interpreter who worked for Mitchell at Sehonghong Shelter in 1992, local medicine men still go down to the river at night to make 'death magic', and belief in the existence of water snakes thought to have supernatural powers is widespread, not just in Lesotho, but also elsewhere in southern Africa; it may well have connections to Bushman beliefs (cf. Orpen 1874).

REFERENCES

Ambrose, D., Talukdar, S. & Pomela, E.M. (eds) 2000. *Biological Diversity in Lesotho*. Maseru: National Environmental Secretariat.

Biesele, M. 1993. *Women Like Meat: The Folklore and Foraging Ideology of the Kalahari Ju/'hoan*. Johannesburg: Witwatersrand University Press.

Binneman, J.N.F. 1982. Mikrogebruikstekens op steenwerktuie: eksperimentele waarnemings en 'n studie van werktuie afkomstig van Boomplaasgrot. Unpublished MA thesis. Stellenbosch: University of Stellenbosch.

Binneman, J.N.F. 1997. Usewear traces on Robberg bladelets from Rose Cottage Cave. *South African Journal of Science* 93: 479–481.

Binneman, J.N.F. & Mitchell, P.J. 1997. Microwear analysis of Robberg bladelets from Sehonghong Shelter, Lesotho. *Southern African Field Archaeology* 6: 42–49.

Bleek, D.F. 1928. *The Naron: A Bushman Tribe of the Central Kalahari*. Cambridge: Cambridge University Press.

Bleek, D.F. 1933. Beliefs and customs of the /Xam Bushmen. Part V. The rain. *Bantu Studies* 7: 297–312.

Blundell, G. 2004. *Nqabayo's Nomansland: San Rock Art and the Somatic Past*. Uppsala: Uppsala University Press.

Bollong, C.A., Sampson, C.G. & Smith, A.B. 1997. Khoikhoi and Bushman pottery in the Cape Colony: ethnohistory and Later Stone Age ceramics of the South African interior. *Journal of Anthropological Archaeology* 16: 269–299.

Cable, J.H.C. 1984. *Late Stone Age Economy and Technology in Southern Natal*. Oxford: British Archaeological Reports, International Series 201.

Cable, J.H.C., Scott, K. & Carter, P.L. 1980. Excavations at Good Hope Shelter, Underberg District, Natal. *Annals of the Natal Museum* 24: 1–34.

Campbell, C. 1987. Art in crisis: contact period rock art in the south-eastern mountains of southern Africa. Unpublished MSc thesis. Johannesburg: University of the Witwatersrand.

Carter, P.L. 1976. The effects of climatic change on settlement patterns in eastern Lesotho during the Middle and Later Stone Ages. *World Archaeology* 8: 197–206.

Carter, P.L. 1978. The prehistory of eastern Lesotho. Unpublished PhD thesis. Cambridge: University of Cambridge.

Carter, P.L., Mitchell, P.J. & Vinnicombe, P. 1988. *Sehonghong: The Middle and Later Stone Age Industrial Sequence from a Lesotho Rockshelter*. Oxford: British Archaeological Reports, International Series 406.

Carter, P.L. & Vogel, J.C. 1974. The dating of industrial assemblages from stratified sites in eastern Lesotho. *Man* 9: 557–570.

Challis, W. 2008. The impact of the horse on the AmaTola 'Bushmen': New identity in the Maloti-Drakensberg Mountains of southern Africa. Unpublished DPhil thesis. Oxford: University of Oxford.

Clarke, M. 1888. Unexplored Basutoland. *Proceedings of the Royal Geographical Society* 10: 519–530.

Dornan, S.S. 1909. Notes on the Bushmen of Basutoland. *South African Journal of Philosophy* 18: 437–450.

Dornan, S.S. 1925. *Pygmies and Bushmen of the Kalahari*. London: Seeley, Service and Co.

Dowson, T.A. 1994. Reading art, writing history: rock art and social change in southern Africa. *World Archaeology* 25: 332–344.

Dunn, E.J. 1931. *The Bushman*. London: Griffin.

Eldredge, E. 1993. *A South African Kingdom: The Pursuit of Security in Nineteenth-Century Lesotho*. Cambridge: Cambridge University Press.

Ellenberger, D.F. 1912. *History of the Basuto, Ancient and Modern*. London: Caxton Publishing Company.

Ellenberger, V. 1953. *La Fin Tragique des Bushmen*. Paris: Amiot Dumont.

Esterhuysen, A.B. & Mitchell, P.J. in press. Charcoals. In: Mitchell, P.J., Plug, I. & Bailey, G.N. (eds) *People of the Fish: Hunter-Gatherer Occupation at an Open-Air Camp Site in the Lesotho Highlands*. Oxford: Oxford University School of Archaeology.

Estes, R.D. 1991. *The Behavior Guide to African Mammals*. Berkeley: University of California Press.

Germond, R.C. 1967. *Chronicles of Basutoland*. Morija: Morija Sesuto Book Depot.

Grant, J. 1873/74. A journey from Qacha's Nek via 'Milikane, Sehonghong, Linakeng, Kolobere, Lehaha-la-Sekhonyana, Senqunyane, Phuthiatsana-ea-ha-Molapo to Advance Post. Unpublished manuscript, Morija Museum and Archives.

Guillarmod, A.J. 1971. *Flora of Lesotho*. Lehre: Cramer.

Harris, W.C. 1841. *The Wild Sports of South Africa*. London: William Pickering.

Hobart, J.H. 2003. Forager-farmer relations in southeastern southern Africa: a critical reassessment. Unpublished DPhil thesis. Oxford: University of Oxford.

Hobart, J.H. 2004. Pitsaneng: evidence for a neolithic Lesotho? *Before Farming* 3: 261–270.

How, M. 1962. *The Mountain Bushmen of Basutoland*. Pretoria: Van Schaik.

Jacottet, E. 1893. The precise reference intended is now uncertain. However, the relevant text is reproduced in Germond (1967: 425).

Jolly, P. 1986. A first generation descendant of the Transkei San. *South African Archaeological Bulletin* 41: 6–9.

Jolly, P. 1992. Some photographs of late nineteenth-century San rainmakers. *South African Archaeological Bulletin* 47: 89–93.

Jolly, P. 1994. Strangers to brothers: interaction between south-eastern San and Southern Nguni/Sotho communities. Unpublished MA thesis. Cape Town: University of Cape Town.

Jolly, P. & Prins, F.E. 1994. M – a further assessment. *South African Archaeological Bulletin* 49: 16–23.

Kannemeyer, D.R. 1890. Stone implements: with a description of Bushman stone implements and relics: their names, uses, modes of manufacture and occurrence. *Cape Illustrated Magazine* 1: 120–130.

Katz, R. 1982. *Boiling Energy; Community-Healing Among the Kalahari !Kung.* Cambridge: Harvard University Press.

Lee, R.B. 1979. *The !Kung San: Men, Women and Work in a Foraging Society.* Cambridge: Cambridge University Press.

Lewis-Williams, J.D. 1981. *Believing and Seeing: Symbolic Meanings in Southern San Rock Paintings.* New York: Academic Press.

Lewis-Williams, J.D. 1986. The last testament of the southern San. *South African Archaeological Bulletin* 41: 10–11.

Lewis-Williams, J.D. & Dowson, T.A. 1989. *Images of Power: Understanding Bushman Rock Art.* Johannesburg: Southern Books.

Lynch, C.D. 1994. The mammals of Lesotho. *Navorsinge van die Nasionale Museum Bloemfontein* 10: 177–241.

Mitchell, P.J. 1993. Late Pleistocene hunter-gatherers in Lesotho: report on fieldwork at Sehonghong Rockshelter, July to September 1992. *Nyame Akuma* 39: 43–49.

Mitchell, P.J. 1994. Understanding the MSA/LSA transition: the pre-20,000 BP assemblages from new excavations at Sehonghong rock-shelter, Lesotho. *Southern African Field Archaeology* 3: 15–25.

Mitchell, P.J. 1995. Revisiting the Robberg: new results and a revision of old ideas at Sehonghong rock-shelter, Lesotho. *South African Archaeological Bulletin* 50: 28–38.

Mitchell, P.J. 1996a. Filling a gap: the early and middle Holocene assemblages from new excavations at Sehonghong Rock Shelter, Lesotho. *Southern African Field Archaeology* 5: 17–27.

Mitchell, P.J. 1996b. Sehonghong: the late Holocene assemblages with pottery. *South African Archaeological Bulletin* 51: 17–25.

Mitchell, P.J. 1996c. The Late Quaternary of the Lesotho Highlands, southern Africa: preliminary results and future potential of recent research at Sehonghong Shelter. *Quaternary International* 33: 35–44.

Mitchell, P.J. 2006/07. Remembering the Mountain Bushmen: observations of nineteenth century hunter-gatherers in Lesotho as recorded by Victor Ellenberger. *Southern African Field Archaeology* 15/16: 3–11.

Mitchell, P.J. 2008. The canine connection. In: Badenhorst, S., Mitchell, P.J. & Driver, J. (eds) *Animals and People: Archaeozoological Essays in Honour of Ina Plug*: 104–116. Oxford: British Archaeological Reports, International Series 1849.

Mitchell, P.J. & Challis, W. 2008. A first glimpse into the Maloti Mountains: the diary of James Murray Grant's expedition of 1873–74. *Southern African Humanities* 20(1): 399–461.

Mitchell, P.J. & Charles, R.L.C. 2000. Later Stone Age hunter-gatherer adaptations in the Lesotho Highlands, southern Africa. In: Bailey, G.N., Charles, R.L.C. & Winder, N. (eds) *Human Ecodynamics: Proceedings of the Conference of the Association of Environmental Archaeology*: 90–99. Oxford: Oxbow Press.

Mitchell, P.J. & Hudson, A. 2004. Psychoactive plants and southern African hunter-gatherers: a review of the evidence. *Southern African Humanities* 16: 39–57.

Mitchell, P.J., Plug, I., Bailey, G.N. & Woodborne, S. 2008. Bringing the Kalahari debate to the mountains: late first millennium AD hunter-gatherer/farmer interaction in highland Lesotho. *Before Farming*, online version 2008/2 article 4.

Mitchell, P.J. & Vogel, J.C. 1994. New radiocarbon dates from Sehonghong rock-shelter, Lesotho. *South African Journal of Science* 90: 380–388.

Opperman, H. 1996a. Strathalan Cave B, north-eastern Cape Province, South Africa: evidence for human behaviour 29,000–26,000 years ago. *Quaternary International* 33: 45–54.

Opperman, H. 1996b. Excavation of a Later Stone Age deposit in Strathalan Cave A, Maclear district, northeastern Cape, South Africa. In: Pwiti, G. & Soper, R. (eds) *Aspects of African Archaeology*: 335–342. Harare: University of Zimbabwe Press.

Orpen, J.M. 1874. A glimpse into the mythology of the Maluti Bushmen. *Cape Monthly Magazine* 9: 1–13.

Parkington, J.E. & Mills, G. 1991. From space to place: the architecture and social organisation of southern African mobile communities. In: Gamble, C.S. & Boismier, W.A. (eds) *Ethnoarchaeological Approaches to Mobile Campsites: Hunter-*

Gatherer and Pastoralist Case Studies: 355–370. Madison: International Monographs in Prehistory.

Plug, I. 2003. Appendix D: report on Pitsaneng fauna. In: Hobart, J.H. Forager-farmer relations in southeastern southern Africa: a critical reassessment: 425–428. Unpublished DPhil thesis. Oxford: University of Oxford.

Plug, I. In press. The terrestrial and molluscan faunas at Likoaeng. In: Mitchell, P.J., Plug, I. & Bailey, G.N. (eds) *People of the Fish: Hunter-Gatherer Occupation at an Open-Air Camp Site in the Lesotho Highlands*. Oxford: Oxford University School of Archaeology.

Plug, I. & Mitchell, P.J. 2008a. Sehonghong: hunter-gatherer utilization of animal resources in the highlands of Lesotho. *Annals of the Transvaal Museum* 45: 1–23.

Plug, I. & Mitchell, P.J. 2008b. Fishing in the Lesotho Highlands: 26,000 years of fish exploitation, with special reference to Sehonghong Shelter. *Journal of African Archaeology* 6: 33–55.

Prins, F.E. 1990. Southern Bushman descendants in Transkei – rock art and rainmaking. *South African Journal of Ethnology* 13: 110–116.

Schapera, I. 1930. *The Khoisan Peoples of South Africa*. London: Routledge & Kegan Paul.

Schmitz, M. 1980. *Wild Flowers of Lesotho*. Roma: Essa.

Shaw, E.M., Woolley, P.L. & Rae, F.A. 1963. Bushman arrow poisons. *Cimbebasia* 7: 2–41.

Smithers, R.N. 1983. *Soogdiere van die Suider-Afrikaanse Substreek*. Pretoria: University of Pretoria Press.

Smits, L.G.A. 1973. Rock-painting sites in the upper Senqu Valley, Lesotho. *South African Archaeological Bulletin* 28: 32–38.

Sparrman, A. 1975 [1786]. *A Voyage to the Cape of Good Hope Towards the Antarctic Polar Circle Round the World and to the Country of the Hottentots and the Caffres from the Year 1772–1776*. Cape Town: Van Riebeeck Society.

Stow, G.W. 1905. *The Native Races of South Africa*. London: Swan Sonnenschein.

Thomas, E.M. 1959. *The Harmless People*. London: Secker and Warburg.

Underwood, R. 1975. Social behaviour of the eland (*Taurotragus oryx*) on Loskop Dam Nature Reserve. Unpublished MSc thesis. Pretoria: University of Pretoria.

Van der Post, L. & Taylor, J. 1984. *Testament to the Bushmen*. Harmondsworth: Penguin.

Van Wyk, B.-E. & Gericke, N. 2000. *People's Plants: A Guide to Useful Plants of Southern Africa*. Pretoria: Briza Publications.

Vinnicombe, P.V. 1976. *People of the Eland: Rock Paintings of the Drakensberg Bushmen as a Reflection of their Life and Thought*.

Pietermaritzburg: Natal University Press.

Vogelsang, R. 2006. Seed grinding or pounding meat: the use of grindstones in north-western Namibia. Site accessed 8 July 2008 at http://cohesion.rice.edu/CentersAndInst/SAFA/emplibrary/Vogelsang,R.PosterSAfA2006.pdf.

Willcox, A.R. 1956. *Rock Paintings of the Drakensberg*. London: Max Parrish.

Williamson, B.S. 1997. Down the microscope and beyond microscopy and molecular studies of stone tool residues and bone samples from Rose Cottage Cave. *South African Journal of Science* 93: 458–464.

Wright, J.B. 1971. *Bushman Raiders of the Drakensberg 1840–1870*. Pietermaritzburg: University of Natal Press.

Personal communications

Peter Mitchell, August 2007
Alan Morris, 11 January 2007

▶ This redrawing shows one of the many examples of weird spirit-world creatures and spirit-world beings captured by Vinnicombe in her copies. Tracing by Patricia Vinnicombe. Redrawing by Justine Olofsson.

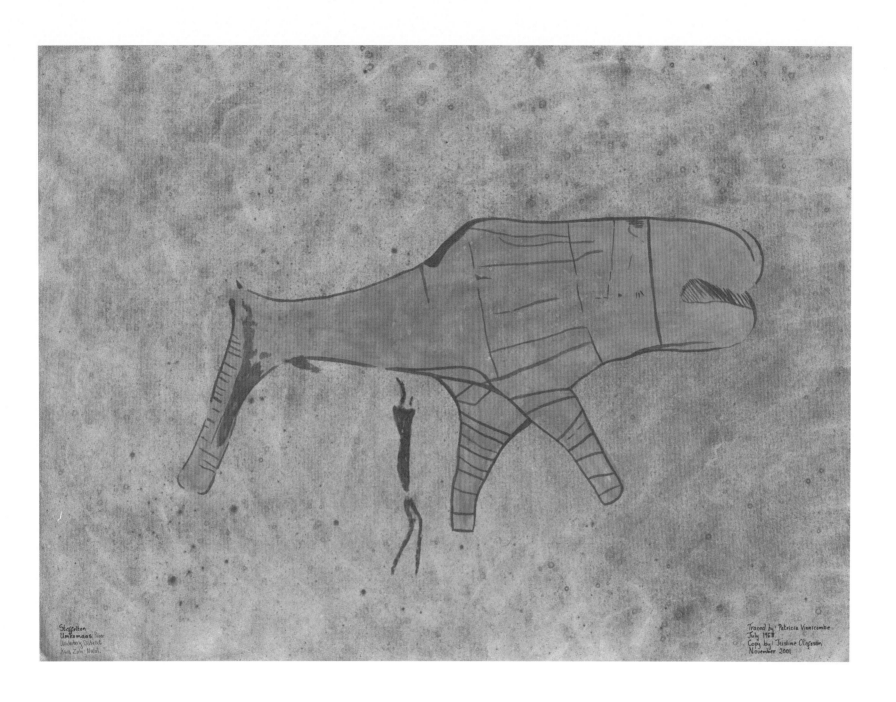

Stofferton
Umkomaas River
Underberg District
Kwa Zulu-Natal

Traced by: Patricia Vinnicombe
July 1968
Copy by: Justine Olofsson
November 2001

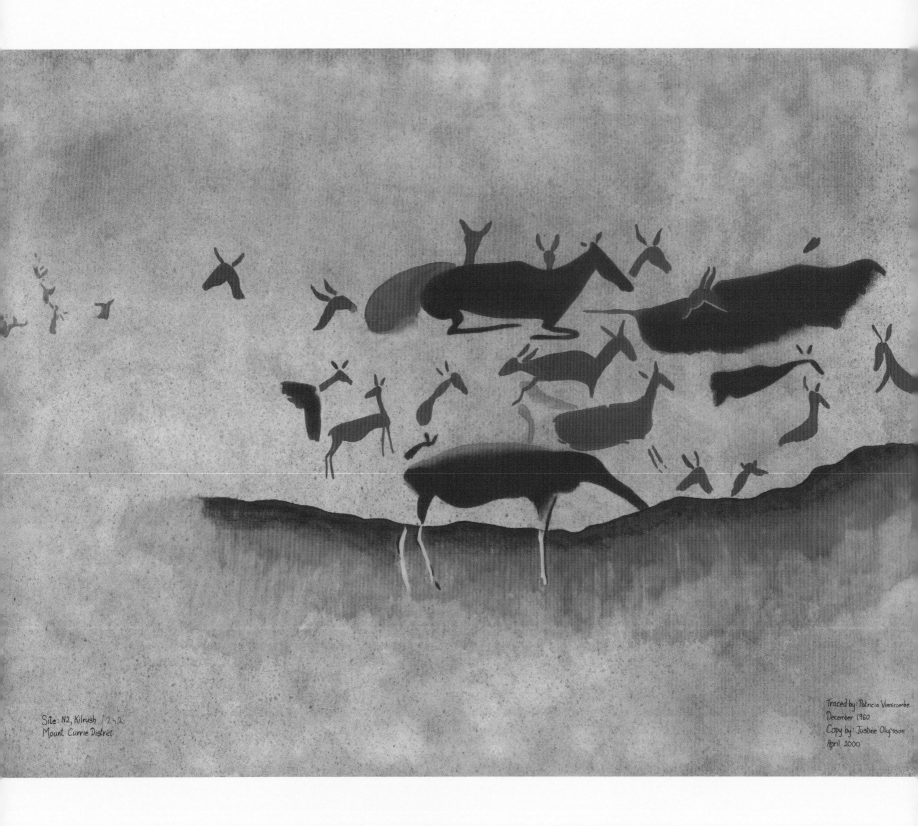

Site: N2, Kilrush /242
Mount Currie District

Traced by: Patricia Vinnicombe
December 1960
Copy by: Justine Olufsson
April 2000

Rereading
People of the Eland

David S Whitley

Pat Vinnicombe noted that, as in this panel, paintings of rhebuck and smaller antelope were rarely associated with human figures. Drawing on her observation that paintings of rhebuck are almost always depicted in their families, unlike other animals such as eland, Pat argued that the rhebuck symbolised the San family group. Whilst such a generalised societal identification for the symbolism of a particular animal has given way to more local and particular readings of symbolism in specific social and historical contexts, the use of painted animal behaviour as a marker of symbolic meaning remains a key part of San rock art research today.

"You are where you come from," Carlos Fuentes has repeatedly told us. Though his concern was self-identity, I take his statement as equally congruent with the archaeological imagination. This is a sensibility that, I believe, the authors in this volume and our readers share. We valorise antiquity by natural inclination, and this valuation and what we make of it animate our existence. But our own pasts – personal and intellectual – matter equally, as Fuentes knew, because they brand and define us. This volume is a celebration of these facts, and it is a well-deserved celebration partly because of the significance of the contribution it highlights – Pat Vinnicombe's landmark volume, *People of the Eland* – and in part due to the opportunity this affords us. This is a chance to look inward, three decades on, and to gauge our own intellectual journey as we struggle to know the southern African past.

As the authors in this volume amply illustrate, the 1976 publication of Vinnicombe's book was the start of our contemporary understanding of the cipher that is the San. It was a new start as remarkable for what it uncovered as for the break it represents from then-existing attitudes and approaches. And it was a start but not a finish, for the San and their rock paintings were to Vinnicombe still partly elusive, even in the last chapter of her book. Although there continues to be more to know today, we certainly apprehend these paintings better now than in 1976. But this is only because we have continued to walk along the bearing that she first set.

My original reading of *People of the Eland* was chronologically out of step and was marred by that fact. The book was not much distributed in North America, where I

work, and in the 1970s was essentially unknown among Americanist researchers. I obtained my copy by chance from a friend returning from Lesotho, in 1983. But I had read David Lewis-Williams's (1981) *Believing and Seeing* a year before, and this tempered my reaction to Vinnicombe's book. I knew where the story (or, at least, that episode) ended and (in a sense) I was out the exit door before the credits had begun to roll. My full appreciation of the importance of her contribution only developed when I came to the University of the Witwatersrand in 1987. There I saw better how her book was a central element in the development of African rock art research, and I recognised its international relevance.

Given these circumstances, I was pleased with the opportunity to revisit *The People of the Eland* for this volume. It was a chance to reread the book not from the perspective of what it tells us about San rock art – my first read – but instead for what it reveals about rock art research and our approaches to it. I reread the book first, before looking at the chapters in this current volume, in an effort to facilitate my own twenty-first century reaction to it.

David Lewis-Williams and Lynn Meskell, in their contributions, have admirably contextualised Vinnicombe's research at the local and personal, and the international and intellectual levels, respectively. There is no need to repeat their thoughtful points. Instead, I pick up some common threads that they and the other contributors to this volume raise in order to highlight the tensions that informed, maybe defined, Vinnicombe's book, and to consider what we make of them today. Three general topics stand out: culture, chronology and social practice.

▲ **Figure 10.1**

David Lewis-Williams and Patricia Vinnicombe discussing rock art interpretation at a site in the Drakensberg in 2000. Photo by Irene Staehelin.

Return to culture: Data, quantification and ethnography

One of the most intriguing aspects of *People of the Eland* is that it was written over a decade-long period. As such, it documents Vinnicombe's own intellectual journey as much as it does the rock paintings of the Maloti-Drakensberg. This journey began very traditionally (in an archaeological sense) and, at first, slowly. Punctuated by latitudes and longitudes – hard empirical **facts**, in other words – in its opening paragraph, it starts in the first chapter as a slow slog through scientific and historical arcana. But the pace quickens by the third chapter as, probably intuitively, Vinnicombe sensed that she was stepping into new intellectual terrain, and it

moves with celerity from that point on. The introduction and conclusion of the volume book-end the central tension of this analytical journey: the shift from literal readings of the paintings ("this is a depiction of a specific raiding party on a particular date") to symbolic interpretations ("this concerns the supernatural world of the medicine man"). It is clear that Vinnicombe eventually agreed with much of David Lewis-Williams's more detailed shamanistic interpretations, although we cannot know whether her agreement was complete. What is certain is that, by the last chapter, she herself had placed at least one foot through the veil that separates the literal from the symbolic, and saw some of the rock art as supernatural in intent and visionary in form. The book in this sense is a journey from

data collection for its own sake to symbolic interpretation, and many of the chapters in this current volume partly turn on the importance of and distinction between these two aspects of her work. Justine Olofsson, Jeremy Hollman and Val Ward describe Vinnicombe's contribution to documenting the rock art of the Maloti-Drakensberg and recount the efforts being made to preserve and protect that important legacy. Nessa Leibhammer usefully reminds us that even documentation is an interpretive process. Lewis-Williams and then David Pearce, Catherine Namono and Lara Mallen directly address the question of quantification as one approach to documentation and what, if anything, numbers alone tell us.

The distinction between quantification and interpretation certainly is a tension in Vinnicombe's work, as Lewis-Williams's personal account of their interactions makes clear, and the difference between these two aspects of the archaeological process is important, epistemologically and methodologically (Figure 10.1). That said, it is worth highlighting a related but perhaps more significant subtextual issue, one that Pearce and his co-authors directly acknowledge. This is not whether we count our data – quantification – but instead the related problem concerning what we emphasise as the **kinds** of data that are most useful for understanding rock art. The important break in *People of the Eland* from traditional rock art research was not how much (or how little) importance Vinnicombe placed on counting motifs and their attributes. Quantification had been common in much traditional rock art research (e.g. Heizer & Baumhoff 1962; Maggs 1967; Grant 1968), and it was a backbone of processual archaeology. What differed most was her ultimate recognition that the ethnographic record was the key to understanding rock art and, more, how she used that record. This last concern is well illustrated by her own contribution to this volume: you learn about the art not by studying the paintings so much as by analysing the beliefs and practices of their creators. Though I return to that last point below, it is valuable here to contextualise Vinnicombe's use of ethnography when she wrote *People of the Eland*. As Meskell observes in her chapter, influential processual archaeologists like Lewis Binford and James N Hill were, even during the 1960s and 1970s, willing to acknowledge the potential importance of ethnographic accounts. The problem was that they used them (as Meskell also notes) to build vapid generalisations and rigid evolutionary models. What was missing from

this approach partly involved a single word with profound implications: culture – the world view of a group of people. As Hill (my own undergraduate advisor) repeatedly told us during lectures, "culture cannot be operationalised". The implication was that culture is analytically irrelevant.

In fact, the archaeological dismissal of culture originated not from methodological problems, as Hill thought, but in deeper issues that he and other processualists did not fully recognise. One of these was the pervasiveness of behaviourist thinking. Anglophone archaeology in 1970 had more in common with the 1920s research of BF Skinner than the mid-century writings of Jean Piaget, Clifford Geertz or Noam Chomsky; what was important to know, from the Skinnerian perspective, was how humans reacted to their environment. The search for stimulus–response relationships, conceptualised with systems theory, was the intellectual motor of the period. Given that context, a remarkable fact about *People of the Eland* is exactly Vinnicombe's rediscovery of culture, even if she did not acknowledge it in these terms. The paintings were not linked to subsistence, and probably not to the environment in any straightforward fashion. They were motivated by cultural beliefs and practices – based on systems of thought and meaning – and these were important (and could only be understood) in their own right, not reduced to a response to the surrounding world. It may be hard to appreciate adequately today, but this was a profound intellectual leap, especially given the ostensible initial importance Vinnicombe placed on the scientific agenda of processual archaeology, including quantification.

It is easy to dismiss in hindsight the intellectual short-sightedness of the processual archaeologists on this central issue, and thus Vinnicombe's own starting point in her research. But (partly in their defence) it is worth noting that the tension between mind-blind behaviourism versus culture as cognition has its roots in one of the oldest and most pervasive intellectual divides in our Western consciousness. This is the distinction between biology and culture, or (as it is commonly labelled) nature versus nurture. Indeed, this very catchphrase was coined by none other than William Shakespeare in *The Tempest* (Act IV, Scene I: 188–189), where Prospero describes his foil, Caliban, as:

> A devil, a born devil,
> on whose nature
> nurture can never stick.

Yet we also see this same divide – truly, an intellectual antiphony – in René Descartes' Enlightenment separation of mind and body, and especially in the Reformation battle between proponents of predestination versus free will. Historicity aside, the debate between what we as biological humans *are*, and what we as social animals *can be*, still plays today. Social constructivists argue in favour of *becoming*; various brands of biological determinism instead support *innateness*.

The pertinence of these historical points stems from the trajectory of rock art research that has emerged from Vinnicombe's archaeological rediscovery of culture as cognition. As many readers will know, Lewis-Williams and his colleagues have developed one important thread subsequently as a by-product of the recognition that the art portrays visionary imagery – which Vinnicombe at least partly acknowledged. This has involved the neuropsychological implications of altered states of consciousness in the painted imagery (e.g. Lewis-Williams & Dowson 1988). Although neuropsychology is sometimes criticised by constructivists as reductionist, its use in conjunction with an explicit accommodation of culture is instead vitally realistic. Nature and nurture both play a role in human social life; we are not yet certain in all cases where the influence of one ends and the other begins, and any analytical framework that starts by denying these certain facts and uncertainties – emphasising one side to the exclusion of the other – has nowhere to go but down. Vinnicombe set the stage for the intellectual move toward fully accommodating both sides of this long-standing intellectual divide, by moving culture back into our archaeological equation.

But there was another side to the culture issue that has been influential in the history of Anglophone archaeology and played a key role in *People of the Eland*. This concerns the fact that, as Lewis-Williams observes, Vinnicombe's final conclusions retreated from detailed symbolic interpretations to bland functionalism ("all roads lead to social solidarity"): the eland as a metaphor for San society. Although in retrospect this was unfortunate, the historical cause of this shift is clear. It stems from the differing intellectual traditions in Anglophone anthropology, and archaeologists' connections to them.

There is danger of overgeneralisation here, but it is reasonable to say that British anthropology, traditionally at least, was always **social** anthropology. Led by figures such as AR Radcliffe-Brown (e.g. 1952), this emphasised society and social structure, with structural-functionalism (a social theory) providing its primary theoretical framework for much of the twentieth century. American anthropology, in contrast, was historically self-defined as cultural anthropology. Starting with the historical-particularism of Franz Boas (e.g. 1940), it developed into a concern with culture and personality (seen, for example, in Margaret Mead's [e.g. 2000] research), with psychological (now cognitive) and linguistic anthropology eventually emerging as dominant American sub-disciplines after the Second World War.

When I studied anthropology at the University of California, Los Angeles (UCLA) in the 1970s, for example, social theory was discussed in history of anthropology courses but otherwise was considered the concern of sociologists like Talcott Parsons, not of cultural anthropologists. The emphasis at UCLA, at least, was psychological anthropology, and many of the cultural anthropologists had joint appointments with (and their offices in) the Neuropsychiatric Institute within the medical school. Freud or Jung was more likely as a class reading assignment than Evans-Pritchard. (Note, though, that the department on the more purely cultural side also included Johannes Wilbert, Gerardo Reichel-Dolmatoff, Peter Furst, Barbara Meyerhoff, David Joralemon, Doug Sharon – and of course Carlos Castaneda – either as professors or students. UCLA cultural anthropology has been referred to as the 'school of shamanism' for good reason.) Meanwhile, as Ioan Lewis (2003) has noted, British anthropologists always viewed any concern with psychology as suspect, setting them on a different research path than their American counterparts.

The intellectual landscape of Anglophone anthropology and archaeology has changed in the last two decades, and there have always been exceptions to my generalisations. But the intellectual divide between the two anthropological traditions has been, and continues to be, substantial, in a fashion that archaeologists have not always appreciated. Yet this distinction greatly influences our archaeological thinking. When Anglophone processual archaeologists – regardless of home country – sought anthropological theories, they turned primarily to British social anthropology and its emphasis on functionalism, including the cultural ecology and evolutionism that were easily allied to the structural–functionalist perspective.

Indeed, processual archaeology was an explicit rejection of the particularism of the traditional cultural–historical approach in archaeology. This meant that it was also a rejection of the intellectual roots of (American) cultural anthropology, with its Boasian anti-evolutionist foundations. Although American processual archaeologists cited anthropologist Leslie White (1949) for theoretical justification, what they actually practised instead was Julian Steward's (1955) cultural ecology and multi-linear evolutionism. Their intellectual view was more akin to Radcliffe-Brown's than to the main currents of American cultural anthropology that were developing at the same time – especially the linguistic turn in social analysis, resulting from Noam Chomsky's (e.g. 1957) revolutionary generative grammars, and the wider interest in cognition that was an offshoot of post-structuralist linguistics allied to developments in psychological anthropology.

People of the Eland reflects these historical circumstances and tendencies. Vinnicombe rediscovered culture as cognition through her use of the San ethnography. But she was also intellectually and academically tied to British social anthropology, and she was unable to escape that link. That her final conclusion retreated to functionalism is, then, historically understandable. My guess is that, when she wrote *People of the Eland*, she had little awareness of anthropological theory beyond functionalism within which she could contextualise her work. Certainly, few processual archaeologists at that time did, and British social anthropologists dominated Africanist research. Their traditional approach was, for that reason alone, a logical place for her to land. Lewis-Williams (1981), in contrast, found an alternative theoretical approach for *Believing and Seeing*, and it allowed him to move beyond the traditional functionalism of social anthropology. But this was in Charles Sanders Peirce's (1931–35) semiotics – which is to say a linguistic, not anthropological, model – allied with historical materialism. Vinnicombe, in this sense, made the major empirical but not theoretical leap. Lewis-Williams independently and simultaneously made the same empirical move, but in the context of the then-developing intellectual shift towards linguistic approaches to social analysis.

People of the Eland, in short, was the start, not the finish, of our current approach to research. Rightly, it can (and should) be greatly appreciated for that fact alone.

History and chronology

A second set of themes raised by a number of authors concerns the Maloti-Drakensberg rock paintings as an expression of the history of the San, along with a related interest in the chronology of the art – both topics considered by Vinnicombe in her book. History and chronology are not always explicitly linked though, as is clear, they are conceptually and practically allied. History requires dates, as Claude Lévi-Strauss (1992) reminded us, and there is good reason to consider them jointly.

History has been a problematic topic and concept in much Western thought, partly because colonialist history was sectarian – a narrative of European conquest and progress – and exclusionary. As influential English historian RG Collingwood (1994: 227) contended, reflecting these facts, "very primitive societies" (his terms) lacked any real **historicity**, which is to say historical consciousness or knowledge. Indigenous groups like the San both stood outside of our historical meta-narrative, or at least were barely incidental to its main course, and putatively lacked any significant sense of their own past (Nabokov 2002). They were timeless; their pasts were monolithic; and we could – and did, especially in influential volumes like *Man the Hunter* (Lee & DeVore 1968) – treat them as fossilised in time. In this sense, the San were important not because of their role in human history but instead because of what they represented in terms of human evolution (cf. Kuper 1988). We now question this anti-historical view of the past, and the issue of San history in this current volume is acknowledged and raised directly by Pearce and his co-authors, and figures importantly in the contributions by Aron Mazel, Peter Mitchell, Shiona Moodley and Gavin Whitelaw. Mazel also raises the problem of chronology as the emphasis of his contribution, while Mitchell discusses temporal placement as one of a series of significant points concerning the larger relationship of the art to the archaeological record. The most immediate implication of Sam Challis's contribution is exactly the dating of the art.

There are two reasons for raising the issues of time and history. The first concerns the trajectory of Vinnicombe's research. Even in her first few chapters it is obvious that she had moved beyond sectarian colonialist history to ethnohistory (as it has long been termed in the Boasian anthropological tradition), that is, a history of a particular ethnic group. When her contribution to this current volume

was written (in 1971), it is also clear that she had recognised that historical information was available from indigenous sources. This was an implicit acknowledgement of historical consciousness, and it set the stage for recognising that indigenous history is memorialised and negotiated in the kinds of performances and art that, previously, were thought to be static and unchanging, especially in the rock paintings (e.g. Dowson 1994). The San always had a history. It just took a few centuries for European society to recognise and accommodate this fact, and Vinnicombe was one of the first to demonstrate this point.

But the second concern is the relationship of dating to history, and here I am troubled by the implicit intellectual constraints that chronometric dates place on our ability to conceptualise and meaningfully calibrate time in terms of temporality, scale, duration, continuity, succession and process. These are some of the many chronological qualities of history both as a narrative of past lives and societies (the history that we write), and of those lives and societies as they unfolded on the ground (the sequence of personal experiences that created the archaeological record). Our archaeological conceptualisation of time has certainly come under increasing scrutiny (e.g. Shanks & Tilley 1987; Hesjedal 1995; Thomas 1996; Lucas 2005; Robb & Pauketat 2008), and it has improved for that fact. But the systematics required to link chronometric data to the temporal qualities of the lives, events and processes that we study are still uncertain. (Note that I raise this concern despite the fact that I have spent substantial time working on rock art chronometrics, and even though I have a new suite of engraving ages on my desk as I write this chapter.) Linking historical interests with chronometric data is a difficult problem, yet it is clearly one that we need to resolve.

The problems start, in a simple way, with our common use of the misleading phrase 'absolute dates' for what are, in fact, statistical estimates of potential ages, based on calendrical calibrations with (known but) built-in errors. Perhaps tellingly, earth scientists revised their terminology two decades ago (see Colman et al. 1987) to eliminate misleading usage, but this terminological change has had spotty impact among archaeologists. Equally problematic from the technical side is our increasing reliance on Accelerator Mass Spectrometry (AMS) radiocarbon ages. Although there are obviously also advantages in our ability to age-constrain very small samples, two significant

problems are, insofar as I can tell, rarely acknowledged. The first concerns the confusion between accuracy and precision. AMS ages are very precise, but this precision is a function of the limits on the instrumental error of the AMS system. Usually this is very small (in the 50 years range), but it is *instrumental* error, not *sample* error, which is how we conceptualise the results; i.e. it represents the technical limits of the instruments, not the age-probability for the sample. This promotes a false sense of accuracy; notwithstanding the separate issue of whether the chronometric age correctly represents the antiquity of the artefact or event under investigation. Compounding this first confusion is the related fact that we have barely begun to understand the natural carbon cycle. We know, for example, that soils are open systems where carbon movement, exchange and diagenesis are continuous and ongoing processes (e.g. Frink 2006). We also know that radiocarbon dating – a laboratory process – assumes a closed system, where the natural cycling processes that affect soil carbon are not occurring. The contradiction between the assumptions of the technique and empirical reality is a substantial problem that we have not yet begun to address. The technical side of this last issue involves what we have learned from the rock-engraving dating controversy in the 1990s (see Whitley 2009). This demonstrated that carbon changes naturally in the environment in a fashion and at a speed that confounds the assumptions of radiocarbon dating, again precisely because the natural world is an open, not a closed, system. It also showed that we have little understanding of the nature of carbon in the very small sizes and masses that are used for AMS dating. Quite literally, we often have not known what we were dating, and we have no necessary knowledge of the inferential value of the resulting chronometric ages. Put another way, the smaller our radiocarbon sample – and samples are necessarily very small for the direct dating of rock art – the less confidence we should have in our results.

I am optimistic that, with additional research, we can resolve these technical problems. But what of history, and the conceptual aspects of time that it implies? As Loubser (2008) has noted, archaeologists often conceptualise time and change in catastrophic terms, especially with respect to the difference between the European and the indigenous pasts. These two pasts, we tend to think, are separated by a chasm, as if they are parallel worlds. Chronometrics, with their seeming pinpoint precision, promote a sense of antiquity as a series of discrete events, contributing to our

implicit view of change as catastrophic and the past in terms of slices in time ('comparative statics', as it is termed in mathematical modelling). The temporal scale and resolution of archaeological data further promote these perceptions. Sometimes this may be appropriate. But, as Lucas (2005) has shown, temporality can also involve duration, succession and retention, all of which are evident on the palimpsests that comprise many rock art panels. Accommodating these possibilities with chronometric thinking is a challenge. And as the discussions of the relationships between the San and their Bantu-speaking neighbours in many of the chapters here attest, it is a challenge we must overcome if we hope to realise a faithful chronology and an accurate history of southern African rock art. Determining how pinpoint chronometric ages relate to historical processes will be as important in this intellectual process as any dating results themselves. What we need next is not just better history or more chronometric ages, but a thoughtful approach that integrates the two.

Archaeology as social practice

F Scott Fitzgerald famously proclaimed that there are no second acts in life. But I think he was wrong, and Vinnicombe's own career illustrates this point – the last theme that I would like to highlight. My specific concern is her transition from archaeological research in southern Africa to heritage management in Australia. Although this topic may not appear directly relevant to *People of the Eland*, Janette Deacon, Meskell, Moodley and Ndlovu all tacitly raise it in their separate discussions of archaeological site management and/or the socio-politics of archaeology. Mitchell mentions the point specifically with reference to Vinnicombe's Australian work with indigenous peoples, and her ethical commitments (e.g. Vinnicombe & Mowaljarlai 1995). That these authors have raised this topic in the context of *People of the Eland* is not surprising. It is difficult to discuss contemporary archaeology without reference to the fact that the discipline has emerged from the somewhat rarefied confines of academia to a fully engaged, applied social practice: 'cultural resource management', as it is labelled in the United States, or 'heritage management' more generally. Anglophone archaeology worldwide experienced a sea change during the course of Vinnicombe's life. Her career not only reflects that change, it is exemplary of it.

This last fact speaks importantly to the central place of rock art in contemporary archaeology.

This change involves the way that archaeological employment and practice – and thus the discipline's guiding philosophies and theories – have shifted in the last four decades. My estimates for these changes are for the United States, and the American experience may have been (slightly) extreme. But at a general level, at least, the United States statistics and course of events are roughly representative of most of the Anglophone world, including post-apartheid South Africa. By my best calculations, 90 per cent of all American archaeologists in 1970 worked in academia (including museums), whereas less than 10 per cent then worked in heritage management. By 2000 the employment structure had fully reversed. Conservatively speaking, over 80 per cent of American archaeologists work today in some facet of heritage management, with less than 20 per cent at universities, colleges and museums (Whitley, in press). In California, my primary region of interest, the figures are even more heavily weighted, with more than 90 per cent in heritage management and less than 10 per cent in academia.

Although archaeologists now recognise that our discipline is a social practice, this recognition developed belatedly. (By the time that archaeologists discovered 'practice theory', the nature of archaeological practice had already fully rearranged the discipline.) Congress passed the National Historic Preservation Act in 1966 – over four decades ago – the effective start of the shift in the United States. Combined with subsequent and related legislation (especially the National Environmental Policy Act of 1969), the archaeological record changed from a focus for academic research and a commodity for looters to a resource managed by the government for the population as a whole, within the land-use planning process. The policies and regulations that resulted from this legislation represent a profoundly new kind of engagement with the archaeological record, and a dramatic broadening of this involvement to society as a whole. Our self-appointed role as 'stewards of the past' (an old slogan of the Society for American Archaeology) was also changed. Archaeologists are still responsible for much of the **mechanics** of site management, but policies and decisions about the archaeological record are now determined by law and politics, not by archaeologists. Archaeology today is predominantly a sub-discipline of planning and resource management, not a kind of research

or even a specialised component of higher education. These aspects of archaeology still exist, to be sure. But their relevance depends not on the strength of their ability to generate intellectual insight and advancement but, instead, on the way that archaeology as a larger social practice – which is to say, archaeology as conducted by heritage managers – articulates with social needs. Moreover, the articulation between archaeology and society, defined by law and policy, itself is a moving target for the simple fact that legislation and regulation always evolve and change (hence the purpose of standing legislative bodies, like the United States Congress). This evolution in the United States, at least, has been directional, is increasingly predictable and, for the archaeologist, is important to understand. It has involved the transference of involvement, management and control away from professional archaeologists to Native American tribal groups. In social terms, the archaeological record is not important so much for what it tells us about the past (or, as scientists, allows us to discover about human history or behaviour), but because it is a palpable link to indigenous patrimony. For the currently foreseeable future, we should expect increasing celebration and promotion of this patrimony, at the expense of many kinds of archaeological research. A similar tendency is evident in Canada and Australia, and is likely predictable for South Africa, if not already under way.

This circumstance (not surprisingly) has had some important implications. The most obvious concerns the most fundamental: the archaeological job description. This has changed, perhaps in unexpected ways, especially in former colonial regions, which is to say in those parts of the world co-occupied by non-Western, indigenous peoples: southern Africa, Australia and the Americas. The latter half of Vinnicombe's career highlights an important component of that job description, one that is particularly relevant to rock art. This is the archaeologist's formally appointed role as an interface between Western and indigenous peoples. In American bureaucratic parlance this is referred to as 'consultation' with tribal groups, and it is an increasingly significant part of most archaeologists' workload. Consultation has often been contentious – speaking to its importance and social significance – and the relationship between archaeologists and indigenous peoples has been the topic of professional discussion as a result (e.g. Biolsi & Zimmerman 1997; Layton 1989; Swidler *et al.* 1997; Watkins 2000). As useful as these discussions are, there

is a subtle and overlooked point that requires emphasis, and it goes far beyond the fact that archaeologists must understand and sympathise with indigenous perspectives. We have also *de facto* been appointed (by regulation and policy in the United States) as **cultural** negotiators, with the archaeological record serving as both the playing field and (sometimes) the flashpoint. Our job description requires us, as archaeologists, to negotiate our Western policies, laws and scientific concerns with the cultural beliefs and values of indigenous peoples.

This is a significant change for a discipline that, historically at least, denied the importance of culture, because it was putatively 'not-operational'. Not only are we now assigned to manage the archaeological record, we are also burdened with initiating interactions between different segments of our multicultural societies, and somehow accommodating Western agendas with traditional cultural beliefs and practices, as our society increasingly valorises these same non-Western traditions. Put another way, archaeology has emerged as the nexus for the cultural interactions between Western and indigenous members of our contemporary societies.

Two points need to be made in this last regard. The first is that our position as cultural negotiators was not self-appointed or necessarily even willingly accepted. It was bestowed on us by society as a whole (through laws, policies and also expectations). Due to our initial reticence to accept this new role (partly due to our unfamiliarity with culture, and hence our failure to understand this aspect of the new archaeological job description), it often resulted in contentious relationships with indigenous peoples. With experience, archaeologists as a group have become much better at this role, but there is still a need for improvement. Indeed, because legislation continues to evolve, progressively changing the relationship of all parties to the archaeological record, our job description too is changing on this key point. We need to be aware of this fact, and understand that our role will necessarily evolve in the future.

The second point, of course, is the exception. This is rock art research, and it has been central to the development of good cultural relations with indigenous peoples. It emphasises the importance (rather than denies the existence) of sacred sites, usually the primary points of conflict and debate. It highlights the great significance of indigenous knowledge and the continuity in beliefs

and practices, rather than asserts that contemporary indigenous peoples have no legitimate connection to the archaeological record, and it is conducted largely without artefact collection or destruction, hence tacitly emphasising preservation and protection.

The subtext here is already evident in North America and Australia, if not elsewhere, and it is an important one that few archaeologists (beyond rock art researchers perhaps) fully appreciate. At a time when sacred sites and artefacts are major points of contention, and seem to stand as impediments to research, rock art studies on these two continents continue not only unimpeded, but often with the support and participation of indigenous peoples. What this demonstrates, contrary to the claims of many archaeologists, is that indigenous cultures are not opposed to science and Western knowledge. Instead, they are just opposed to a kind of science that cannot accommodate any understanding of culture, the world view, systems of meaning, and beliefs and practices of people.

I do not know whether Pat Vinnicombe was consciously aware of these issues and their implications; perhaps it was just her intuition that set her on a career path that exemplifies the changes in and the future of our archaeological discipline. Either way, Vinnicombe was visionary, both in the writing of *People of the Eland*, and with her subsequent work as a heritage manager concerned with Australian Aboriginal issues and rights. She got these matters right, long before most of her colleagues. And now the discipline as a whole walks the bearing that she helped set, far beyond rock art alone.

Rereading Pat Vinnicombe

The remarkable achievement of *People of the Eland* is its elevation of the San from little more than an esoteric element of the colonialist imagination to an integral component of global history; more, it achieved this leap while stepping beyond the typological fixity of the neo-evolutionism that was, at the time of its publication, then current. Despite this significance – and it is great – Vinnicombe's work has perhaps not everywhere received the full appreciation it deserves, making this tribute all the more appropriate.

Though her research in the Maloti-Drakensberg constituted a major period of Vinnicombe's adult life, it also represented a key moment in the critical history of

our archaeological consciousness, as the preceding chapters in this volume demonstrate. This is when things changed, I continually felt as my rereading of her book progressed, imbuing the text with a historical urgency rarely found in scholarly works. It was the start of what Meg Conkey (2001) has, in another context, labelled an intellectual breakout. Like the passion in the pause before a first kiss, I reread *People of the Eland* unable to ignore its backbeat of anticipation.

Marcel Proust intellectualised that pause. But ee cummings had another take on it entirely and, I think, wholly got it right. This was his call to surrender to the moment and, unencumbered, follow its lead. I reread *People of the Eland* as an intellectual crossroads with cummings' spirit in mind, freely taking the path that Pat Vinnicombe had blazed for all of us to follow. And as I reread it, I repeatedly thought too of a poem by Stephen Spender (2004), 'I Continually Think of Those Who Were Truly Great'. As with many things, Spender said it best. His poem ends in a fashion that always brings to my mind the high Drakensberg, and sets Pat's contribution in proper light:

> Near the snow, near the sun, in the highest fields,
> See how these names are fêted by the waving grass
> And by the streamers of white cloud
> And whispers of wind in the listening sky.
> The names of those who in their lives fought for life,
> Who wore at their hearts the fire's centre.
> Born of the sun, they travelled a short while toward the sun
> And left the vivid air signed with their honour.

REFERENCES

Biolsi, T. & Zimmerman, L. (eds) 1997. *Indians and Anthropologists: Vine Deloria Jr and the Critique of Anthropology*. Tucson: University of Arizona Press.

Boas, F. 1940. *Race, Language and Culture*. New York: Macmillan.

Chomsky, N. 1957. *Syntactic Structures*. New York: Humanities Press.

Collingwood, R.G. 1994. *The Idea of History* (second edition). Oxford: Oxford University Press.

Colman, S.M., Pierce, K.L. & Birkeland, P.W. 1987. Suggested terminology for Quaternary dating methods. *Quaternary Research* 28: 314–319.

Conkey, M.W. 2001. Structural and semiotic approaches. In:

Whitley, D.S. (ed.) *Handbook of Rock Art Research*: 273–310. Walnut Creek: AltaMira Press.

Dowson, T.A. 1994. Reading art, writing history: rock art and social change in southern Africa. *World Archaeology* 25: 332–345.

Frink, D. 2006. A dynamic process-oriented approach to soil science. Unpublished PhD thesis. Tempe: Arizona State University.

Grant, C. 1968. *The Rock Drawings of the Coso Range, Inyo County, California*. Ridgecrest: Maturango Museum Publications.

Heizer, R.F. & Baumhoff, M.A. 1962. *Prehistoric Rock Art of Nevada and Eastern California*. Berkeley: University of California Press.

Hesjedal, A. 1995. Rock art, time and social context. In: Helskog, K. & Olsen, B. (eds) *Perceiving Rock Art: Social and Political Perspectives*: 200–206. Oslo: Novus-forlag.

Kuper, A. 1988. *The Invention of Primitive Society: Transformation of an Illusion*. London: Routledge.

Layton, R. (ed.) 1989. *Who Needs the Past? Indigenous Values and Archaeology*. London: Routledge.

Lee, R.B. & DeVore, I. (eds) 1968. *Man the Hunter*. Chicago: Aldine Publishing Company.

Lévi-Strauss, C. 1992. *Tristes Tropiques* (translated by John Weightman and Doreen Weightman). New York: Penguin Books.

Lewis, I.M. 2003. *Ecstatic Religion: A Study of Shamanism and Spirit Possession* (third edition). London: Routledge.

Lewis-Williams, J.D. 1981. *Believing and Seeing: Symbolic Meaning in Southern San Rock Paintings*. London: Academic Press.

Lewis-Williams, J.D. & Dowson, T.A. 1988. The signs of all times: entoptic phenomena in Upper Paleolithic art. *Current Anthropology* 29: 201–245.

Loubser, J.H.N. 2008. Mountains, pools, and dry ones: the discontinuity between political power and religious status among Venda-speaking chiefdoms of southern Africa. In: Whitley, D.S. & Hays-Gilpin, K. (eds) *Belief in the Past: Theorizing an Archaeology of Religions*: 189–208. Walnut Creek: Left Coast Press.

Lucas, G. 2005. *The Archaeology of Time*. London: Routledge.

Maggs, T.M.O'C. 1967. A quantitative analysis of the rock art from a sample area in the western Cape. *South African Journal of Science* 63: 100–104.

Mead, M. 2000 [1928]. *Coming of Age in Samoa: A Psychological Study of Primitive Youth for Western Civilization*. New York: William Morrow.

Nabokov, P. 2002. *A Forest of Time: American Indian Ways of History*. Cambridge: Cambridge University Press.

Peirce, C.S. 1931–35. *Collected Papers of Charles Sanders Peirce* (edited by C. Hartshorne and P. Weiss). Cambridge, Harvard University.

Radcliffe-Brown, A.R. 1952. *Structure and Function in Primitive Society*. New York: The Free Press.

Robb, J. & Pauketat, T. (eds) 2008. Time and change in archaeological interpretation. *Cambridge Archaeological Journal* 18: 57–99.

Shanks, M. & Tilley, C. 1987. *Re-constructing Archaeology*. London: Routledge.

Spender, S. 2004. *New Collected Poems of Stephen Spender*. London: Faber & Faber.

Steward, J.H. 1955. *Theory of Culture Change: The Methodology of Multilinear Evolution*. Urbana-Champaign: University of Illinois Press.

Swidler, N., Dongoske, K., Anyon, R. & Downer, A.S. (eds) 1997. *Native Americans and Archaeologists: Stepping Stones to Common Ground*. Walnut Creek: AltaMira Press.

Thomas, J. 1996. *Time, Culture and Identity*. London: Routledge.

Vinnicombe, P.V. & Mowaljarlai, D. 1995. That rock is a cloud: concepts associated with rock images in the Kimberley region of Australia. In: Helskog, K. & Olsen, B. (eds) *Perceiving Rock Art: Social and Political Perspectives*: 228–246. Oslo: Novus-forlag.

Watkins, J. 2000. *Indigenous Archaeology: American Indian Values and Scientific Practice*. Walnut Creek: AltaMira Press.

White, L. 1949. *The Science of Culture: A Study of Man and Civilization*. New York: The Grove Press.

Whitley, D.S. 2009. *Cave Paintings and the Human Spirit: The Origin of Creativity and Belief*. New York: Prometheus.

Whitley, D.S. In press. The past in the present tense: aspects of contemporary California archaeology. In: Kaldenberg, R. (ed.) *Festschrift for Paul H. Ezell*. Ridgecrest: Maturango Museum Publications.

▶ Unlike earlier colour copies, the Vinnicombe copies capture even the finest details of the art and retain the exact original relationships between figures. The Vinnicombe copies thus remain of huge value to current, ethnographically based interpretations of San rock art. Tracing by Pat Vinnicombe. Redrawing by Justine Olofsson.

List of figures

Figure 3.7
By using the ethnographic records compiled by Bleek and Lloyd, Vinnicombe recognised images like this to be representations of rain animals. Tracing by Pat Vinnicombe. Redrawing by Justine Olofsson.

Figure 3.8
Vinnicombe with son Gavin at Sehonghong. Her people oriented approach to archaeology and her strong social commitment created the strongest form of social archaeology. From RARI archive.

Figure B3.1
Visitors at the Wildebeest Kuil Rock Art Centre near Kimberley. From RARI archive.

Figure B3.2
South Africa's national coat of arms.

Figure 4.1
Joseph Orpen's rendering of the therianthrope panel at Melikane, Lesotho (after Orpen 1874).

Figure 4.2
Vinnicombe's rendering of the therianthrope panel at Melikane, Lesotho. From Natal Museum archive.

Figure 4.3
Rheinhard Maack's rendering of the 'White Lady of the Brandberg', Namibia. From RARI archive.

Figure 4.4
Henri Breuil's rendering of the 'White Lady of the Brandberg'. From RARI archive.

Figure 4.5
Harald Pager's rendering of the 'White Lady of the Brandberg'. From RARI archive.

Figure 4.6
Walter Battiss's rendering of a Free State contact period painting. From RARI archive.

Figure 4.7
A painted photographic reproduction by Harald Pager from Ndedema Gorge. From RARI archive.

Figure 4.8
A Vinnicombe tracing, showing her textual annotations. From RARI archive.

Figure 4.9
A Rock Art Research Institute tracing. From RARI archive.

Figure B4.1
Vinnicombe's colour rendering equipment. From RARI archive.

Figure B4.2
Example of a Vinnicombe polythene tracing. From RARI archive.

Figure B4.3
Colour rendering done by Justine Olofsson using Vinnicombe's method. From RARI archive.

Figure B4.4
Justine Olofsson working on rendering a Vinnicombe tracing in the Rock Art Research Institute. From RARI archive.

Figure 5.1
Patricia Vinnicombe, David Lewis-Williams and Emmanuel Anati at the Valcamonica rock art symposium in Italy in 1972. From RARI archive.

Figure 5.2
Vinnicombe argued that eland served as a link between the material and spiritual worlds of the San. Traced and redrawn by Justine Olofsson.

Figures 5.3a & b
David Lewis-Williams found that many paintings depicted actions and equipment related to the trance dance; conversely, he found few images that related to other rituals. Photo by Lorna Marshall. Photo from RARI archive.

Figure 5.4
Northern Sotho paintings have been linked to boys' initiation. Photo from RARI archive.

Figure 5.5
Vinnicombe saw contact imagery as a narrative record that she hoped to correlate with historically known events. Tracing by Pat Vinnicombe. Redrawing by Justine Olofsson.

Figure 5.6
Both Patricia Vinnicombe and Colin Campbell made a division between 'contact' and 'traditional' imagery. Images such as this one were classified as 'contact' based on their inclusion of horses. However, this kind of classification led both researchers to ignore a substantial corpus of rock art that may have played a major role in interactions. Tracing by Patricia Vinnicombe. Redrawing by Justine Olofsson.

Figure 5.7
One marker of interaction is that domestic ungulates took on symbolic meaning within the San shamanic worldview. Tracing by Patricia Vinnicombe. Redrawing by Justine Olofsson.

Figure 5.8
Nomansland. The southern Drakensberg was the home of the last San painters. From RARI archive.

Figure B5.1
Kamberg Rock Art Centre in the central Drakensberg. From RARI archive.

Figure B5.2
Ndukuyakhe Ndlovu (left) and the Didima Rock Art Centre in the northern Drakensberg. From RARI archive.

Figures B6.1a & b
Boardwalk at Main Caves, Giant's Castle, central Drakensberg. From RARI archive.

Figure 6.1
Bamboo Mountain 5: Vinnicombe copy showing horsemen with hats and guns, cattle and a wagon which may represent Captain Gardiner's 1835 expedition which passed nearby to the site. From Natal Museum archive.

Figure 6.2
Bundoran 1: Eland from which paint sample ND4 was taken. Photo by Aron Mazel.

Figure 6.3
Collingham Shelter: Piece of collapsed ceiling with paintings on it. Redrawing by Paul den Hoed.

Figure 6.4
Collingham Shelter: Painted slab from deposits dating to 1 800 years ago. Redrawing by Paul den Hoed.

Figure 6.5
Esikolweni Shelter: dated orange and white eland. Photo by Aron Mazel.

Figure 6.6
Main Caves North: Eland overlying dated crust (ANDRA 15 and 16). Photo by Aron Mazel.

Figure 6.7
Main Caves North: Rhebuck overlying dated crust (ANDRA 17). Photo by Aron Mazel.

Figure 6.8
Highmoor 1: Eland overlying dated crust (ANDRA 21). Photo by Aron Mazel.

Figure 6.9
Highmoor 1: Hartebeest overlying dated crust (ANDRA 19). Photo by Aron Mazel.

Figure 6.10
White Elephant Shelter: Human underlying dated crust (ANDRA 25). Photo by Aron Mazel.

Figure 6.11
Sigubudu 1: Crouching men with guns and guns by themselves. Photo by Aron Mazel.

Figure B7.1
Bamboo mountain redrawing depicting what appears to be a successful cattle raid and a rainmaking ceremony. From RARI archive.

Figure 7.1
The Maloti-Drakensberg region showing the location of archaeological sites excavated by Carter and Vinnicombe and other sites mentioned in the text. Site names are abbreviated thus: BEL Belleview; BOL Bolahla; BWE Bonawe; CHS Collingham Shelter; CLS Clarke's Shelter; COL Colwinton; DI1 Diamond 1: DR Driel; GEH Gehle; GH Good Hope; HAS Ha Soloja; HM Highmoor 1; INK iNkolimahashi; KP Kenegha Poort; LIK Likoaeng and Likoaeng North; LIT Lithakong; MAQ Maqonqo; MEL Melikane; MHL Mhlwazini; MCN Main Caves North (Giant's Castle); MOS Moshebi's Shelter; PIT Pitsaneng; RAV Ravenscraig; RC Rose Cottage Cave; SEH Sehonghong; STA Strathalan A and B; TV TeVrede. At this level of resolution some sites are not shown: Esikolweni is near Mhlwazini, Barnes Shelter and White Elephant Shelter near Main Caves North and 2928DB34 near Likoaeng. The dashed line indicates the uKhahlamba-Drakensberg Escarpment. Map by Peter Mitchell.

Figure 7.2
Life at Sehonghong during the excavation in 1971. From RARI archive.

Figure 7.3
Models of hunter-gatherer land use in the southern Maloti-Drakensberg under interglacial and stadial conditions (after Carter 1976,1978).

Figure 7.4
Patricia Vinnicombe and Pat Carter working at Sehonghong. From RARI archive.

Figure 7.5
View of Melikane Shelter. Photo by Neil Lee.

Figure 7.6
The Maloti-Drakensberg region showing the location of major archaeological research projects 1976-2009. Site names are abbreviated thus with dates of fieldwork: BOL Bolahla (Parkington *et al.* 1981); DR Driel (Maggs and Ward 1974, but published 1980); LIK Likoaeng (Mitchell 1995, 1998, 2006); LIT Lithakong (Kaplan 1995); MEL Melikane (Jacobs *et al.* 2007; Stewart 2008, 2009); PIT Pitsaneng (Hobart 2000); SEH Sehonghong (Mitchell 1992, 1993; Jacobs *et al.* 2007; Stewart 2009). Fieldwork by archaeologists named on the map concentrated in the following periods Blundell 1992-2004; Cable 1978-1982; Mazel 1978 1996; Opperman 1978-1997. The dashed line indicates the uKhahlamba-Drakensberg Escarpment.

Figure 7.7
The Maloti-Drakensberg region: Temporal patterning in radiocarbon dates.

Figure 7.8
The Maloti-Drakensberg region: Temporal patterning in radiocarbon dates by sub-region.

Figure 7.9
The Maloti-Drakensberg region and adjacent areas: Distribution of Iron Age agriculturalist settlement in relation to selected excavated hunter-gatherer sites. Site names are abbreviated thus: BEL Belleview; BOL Bolahla; CHS Collingham Shelter; CLS Clarke's Shelter; DR Driel; GH Good Hope; LIK Likoaeng; LIT Lithakong; MEL Melikane; MHL Mhlwazini; PIT Pitsaneng; SEH Sehonghong; STA Strathalan A. The heavy dashed and dotted line represents the approximate limit towards the southern African interior of agriculturalist settlement during the first millennium AD (Early Iron Age), the dotted line its limit c. AD 1800 (Later Iron Age). The lighter dashed line indicates the uKhahlamba-Drakensberg Escarpment.

Figure 7.10
The Maloti-Drakensberg region showing some of the evidence for long-distance interaction within central and southeastern southern Africa: distributions of bone fish hooks, rock paintings of mormyrid fish and finds of red duiker (*Cephalophus natalensis*) and blue duiker (*Philantomba monticola*) bones beyond their likely natural range. Site names are abbreviated thus: ABS Abbot's Shelter; BEL Belleview; BS Borchers Shelter; BWE Bonawe; CHS Collingham Shelter; COL Colwinton; DHO De Hoop; DR Driel; GC Giant's Castle; GH Good Hope; KT KwaThwaleyakhe; LIK Likoaeng; MHL Mhlwazini; MUE Muela; MZ Mzinyashana; RC Rose Cottage Cave; UMH Umhlatuzana. Pat Vinnicombe recorded more 'contact images' of horsemen, guns, and wagons in the southern Drakensberg than David Lewis-Williams and Harald Pager recorded in the central and northern Drakensberg. It is clear that this is not a product of sample bias, it is a true pattern. The reasons for this are discussed in Chapters 6 and 7 as well as Box 8. Tracing by Pat Vinnicombe. Redrawing by Justine Olofsson.

Figure B8.1
Horse dance painting. Redrawn by Sam Challis from Patricia Vinnicombe colour redrawing.

Figure B8.2
Baboon dance painting. Tracing and redrawing by Patricia Vinnicombe (1976; fig. 217).

Figure B8.3
Horseman and baboon painting. Tracing and redrawing by Sam Challis.

Figure 8.1
Southeastern southern Africa. Dashed line indicates Drakensberg watershed. Orange shading indicates karoo-type vegetation. Blue shading indicates the more heavily wooded lowlands. Unshaded areas represent grasslands of various types. Yellow shading indicates the wooded grasslands of the Thukela Basin. They contain good pasture. These grasslands are relatively open and were retained that way by fire. The signature tree is the soft-wood *Acacia sieberana*. Since the 1800s they have been increasingly invaded by woody vegetation moving up the valleys. Map after Low and Rebelo (1996).

Figure 8.2
Grassland at Mgoduyanuka in the upper Thukela Basin. Photo: Natal Museum.

Figure 8.3
Stonewalled site in the upper Mkhomazi Valley. Photo: Natal Museum.

Figure 8.4
View up the Mtshezi (Bushman's) River from iNkolimahashi Shelter. Photo: Natal Museum.

Figures 8.5a & b
Ntsuanatsatsi/Makgwareng (Fokeng cluster) or possibly Blackburn sherds from iNkolimahashi Shelter (top) and a Moor Park sherd from Mzinyashana Shelter (bottom).

Figure 8.6
Mzinyashana Shelters 1 and 2. Photo: Natal Museum.

Figure 8.7
Tree ring-width curve. After Vogel, Fuls and Visser (2001: fig. 4).

Figure 8.8a
The Moor Park name site in true grassland southwest of Estcourt. Photo: Natal Museum.

Figure 8.8b
Ntomdadlana Hill, location of a Moor Park site in wooded grassland east of Estcourt. Photo: Natal Museum.

Figure 8.9
Ntomdadlana, showing front/back layout. Map by Gavin Whitelaw and Programme of Geomatics, University of KwaZulu-Natal.

Figure 8.10
Left: site at Mgoduyanuka with earthwalled enclosures (from Maggs 1982: fig. 12). The earthworks are faced with stone. Right: engraved settlement patterns about 15 km downstream of Mgoduyanuka (from Maggs 1988: fig. 7).

Figure 9.1
Sehonghong Shelter. ARAL Collection.

Figure 9.2
Sehonghong Shelter from above looking down into the Sehonghong Valley. Photo by Peter Mitchell.

Figure 9.3
Khomo-ea-Mollo village. Photo by Brian Stewart.

Figure 9.4
Painting of an armed man and dog (now damaged) from a site near Sehonghong. Photo by Peter Mitchell.

Figure 9.5
The black 'ghost' image from Sehonghong Shelter referred to by Sello Mokoallo. Photo by Peter Mitchell.

Figure 9.6
Vinnicombe looking at Lerotholi's white horse, Tabure, Sehonghong Shelter. From RARI archive.

Figure 9.7
Sello Mokoallo demonstrating how Bushmen used to smoke dagga (cannabis). From RARI archive.

Figure 9.8
Sehonghong village. Photo by Brian Stewart.

Figure 9.9
Sehonghong Shelter, section of the 1971 Carter/Vinnicombe excavation showing stake holes that could have derived from the kinds of structure described by Liselo Rankoli. Photo by Pat Carter. Graffiti damage to rock paintings in Sehonghong Shelter, Lesotho. ARAL collection.

Figure 10.1
David Lewis-Williams and Patricia Vinnicombe discussing rock art interpretation at a site in the Drakensberg in 2000. Photo by Irene Staehelin.

Index